EARLY GOTHIC COLUMN-FIGURE SCULPTURE IN FRANCE

Richly illustrated, *Early Gothic Column-Figure Sculpture in France* is a comprehensive investigation of church portal sculpture installed between the 1130s and the 1170s. At more than twenty great churches, beginning at the Royal Abbey of Saint-Denis and extending around Paris from Provins in the east, south to Bourges and Dijon, and west to Chartres and Angers, larger than life-size statues of human figures were arranged along portal jambs, many carved as if wearing the dress of the highest ranks of French society. This study takes a close look at twelfth-century human figure sculpture, describing represented clothing, defining the language of textiles and dress that would have been legible in the twelfth century, and investigating rationale and significance.

The concepts conveyed through these extraordinary visual documents and the possible motivations of the patrons of portal programs with column-figures are examined through contemporaneous historical, textual, and visual evidence in various media. Appendices include analysis of sculpture production, and the transportation and fabrication in limestone from Paris. Janet Snyder's new study considers how patrons used sculpture to express and shape perceived reality, employing images of textiles and clothing that had political, economic, and social significances.

Professor of Art History at West Virginia University, Janet Snyder's research addresses medieval limestone sculpture and architecture, and representations of clothing, textiles, and of the human form.

For Jeff

Early Gothic Column-Figure Sculpture in France

Appearance, Materials, and Significance

Janet E. Snyder

ASHGATE

Published by
Ashgate Publishing Limited
Wey Court East
Union Road
Farnham
Surrey, GU9 7PT
England

Ashgate Publishing Company
Suite 420
101 Cherry Street
Burlington, VT 05401-4405
USA

www.ashgate.com

British Library Cataloguing in Publication Data
Snyder, Janet Ellen.
 Early Gothic column-figure sculpture in France :
 appearance, materials, and significance.
 1. Sculpture, Gothic--France. 2. Figure sculpture, French.
 3. Christian art and symbolism--Medieval, 500-1500.
 4. Clothing and dress in art--History--To 1500. 5. Art
 and society--France--History--To 1500. 6. Church
 doorways--France--History--To 1500.
 I. Title
 730.9′44′09021-dc22

Library of Congress Cataloging-in-Publication Data
Snyder, Janet Ellen.
 Early Gothic Column-figure Sculpture in France : Appearance, Materials, and
 Significance / Janet E. Snyder.
 pages cm
 Includes bibliographical references and index.
 ISBN 978-1-4094-0065-3 (hardcover : alk. paper)
 1. Column figures--France. I. Title.

 NA3683.C65S69 2011
 730.944′09021--dc22

 2010044258

ISBN 9781409400653

Research support from:
 The West Virginia Humanities Council
 West Virginia University Senate Research Grant

Subvention supporting the publication of visual evidence from:
 The Colonel Eugene Meyers and Florence Meyers Charitable Remainder Unitrust
 Drs. Paul and Laura Mesaros Foundation

This project is being presented by Janet Snyder with financial assistance from The West Virginia Humanities Council, a state program of the National Endowment for the Humanities.

Printed and bound in Great Britain
by the MPG Books Group, UK

CONTENTS

ILLUSTRATIONS

left jamb, two women column-figures, c. 1145. Photo: Janet Snyder

1.3 Notre-Dame, Chartres Cathedral, Royal Portal west façade, left jamb, left portal 1: mid-body, hair. Photo: Janet Snyder

1.4 *Game Piece with Episode from the Life of Apollonius of Tyre*, c. 1170, walrus ivory, Rhenish, Cologne, c. 1170. The Metropolitan Museum of Art, New York (1996.224)

1.5 Saint-Maurice, Angers, right 3 (detail): *bliaut* and chemise hems. Photo: Janet Snyder

1.6 Notre-Dame-en-Vaux at Châlons-sur-Marne, *Young Woman column-figure*. Photo: Janet Snyder

1.7 Notre-Dame-en-Vaux at Châlons-sur-Marne, *Young Woman*: upper body. Photo: Janet Snyder

1.8 Saint-Etienne, Bourges Cathedral, north lateral portal, left, column-figure. Photo: Janet Snyder

1.9 Saint-Etienne, Bourges Cathedral, north lateral portal, right, column-figure. Photo: Janet Snyder

1.10 Notre-Dame, Chartres Cathedral, Royal Portal west façade, left jamb, left portal 1: upper body. Photo: Janet Snyder

1.11 Notre-Dame, Chartres Cathedral, Royal Portal west façade, left jamb, left portal 1 (detail): belt ends, shoes, left sleeve tippet knot. Photo: Janet Snyder

1.12 Notre-Dame, Chartres Cathedral, Royal Portal west façade, right portal, right jamb, three column-figures, c. 1145. Photo: Janet Snyder

1.13 Saint-Bénigne, Dijon, left jamb, c. 1160 (detail). From Dom Urbain Plancher, *Histoire general et particular de Bourgogne* (Dijon, 1739), p. 503. Photo: Janet Snyder

1.14 Notre-Dame du Fort, Etampes, south portal, left jamb, three column-figures, c. 1140. Photo: Janet Snyder

1.15 Saint-Etienne, Bourges Cathedral, south lateral portal, left jamb. Photo: Janet Snyder

1.16 Notre-Dame, Chartres Cathedral, Royal Portal west façade, center portal, left jamb, column-figures 3, 2, 1, c. 1145. Photo: Janet Snyder

1.17 Saint-Julien, Le Mans Cathedral, left jamb, five column-figures, before 1158. Photo: Janet Snyder

1.18 Saint-Ayoul, Provins, left jamb, column-figures, c. 1160. Photo: Janet Snyder

1.19 Saint-Loup de Naud, *trumeau* column-figure: Saint Loup, c. 1160. Photo: Janet Snyder

1.20 *Man column-figure* from the Church of Notre-Dame de Corbeil, west portal, c. 1158. Musée du Louvre, Paris, France. Photo: Erich Lessing/Art Resource, New York

1.21 Saint-Maurice, Angers, left jamb, column-figures 4, 3, 2. Photo: Janet Snyder

1.22 *Head of David* from the Portail Sainte-Anne, Notre-Dame, Paris. Metropolitan Museum of Art, New York, Harris Brisbane Dick Fund, 1938 (38.180)

1.23 Notre-Dame, Chartres Cathedral, Royal Portal west façade, right portal, left jamb (detail): sleeve cuffs, mantle fastenings, c. 1145. Photo: Janet Snyder

1.24 Notre-Dame, Chartres Cathedral, Royal Portal west façade, center portal, right jamb, upper halves of four column-figures, c. 1145. Photo: Janet Snyder

1.25 Rochester Cathedral (Kent), west portal, right jamb, *woman column-figure*:

crown fragment at back of head. Photo: Janet Snyder

1.26 Ivry, *woman column-figure*: belt at natural waist on *bliaut gironé*, no mantle, c. 1155–65. Photo: Janet Snyder

1.27 Saint-Julien, Le Mans Cathedral, right jamb, before 1158. Photo: Janet Snyder

1.28 Abbey Church of Saint-Denis, west façade, right portal, left jamb, column-figures. Antoine Benoist drawings, BN, MS FR 15634, folio 71. Bibliothèque nationale de France

1.29 Saint-Etienne, Bourges Cathedral, south lateral portal, right jamb. Photo: Janet Snyder

1.30 Abbey Church of Saint-Denis, west façade, column-figure CR1. Antoine Benoist drawing, BN, MS FR 15634, folio 50. Bibliothèque nationale de France

1.31 Saint-Maurice, Angers, left jamb, column-figures. Photo: Janet Snyder

1.32 Saint-Maurice, Angers, right jamb, column-figures. Photo: Janet Snyder

1.33 Rochester Cathedral (Kent), west portal, right jamb, *woman column-figure*. Photo: Janet Snyder

1.34 Saint-Maurice, Angers, right jamb 3 (detail): *bliaut* side lacing. Photo: Janet Snyder

1.35 *Enamel Casket*, c. 1180, Limoges, from the court of Aquitaine. The British Museum (M&LA, 1859,0110.1). © Trustees of the British Museum

1.36 Notre-Dame, Chartres Cathedral. Royal Portal west façade, left jamb, left portal 1: belt and waistband; hand. Photo: Janet Snyder

1.37 Notre-Dame, Chartres Cathedral, Royal Portal west façade, right portal,

right jamb 3: deeply pleated hem, mantle on column, pendant belt ends, sleeve tippet, c. 1145. Photo: Janet Snyder

1.38 Notre-Dame, Chartres Cathedral, Royal Portal west façade, center portal, left jamb (detail): feet of column-figures 3, 2, 1, c. 1145. Photo: Janet Snyder

1.39 Saint-Loup de Naud, left jamb, column-figures, c. 1160. Photo: Janet Snyder

1.40 Notre-Dame, Chartres Cathedral, Royal Portal west façade, center portal, left jamb 3: sleeve detail, hips and column, c. 1145. Photo: Janet Snyder

1.41 Notre-Dame, Chartres Cathedral, Royal Portal west façade, center portal, left jamb 3: no knotted belt, no mantle, sleeve understitching, c. 1145. Photo: Janet Snyder

1.42 Notre-Dame, Chartres Cathedral, Royal Portal west façade, center portal, right jamb 3: sleeve border understitching, belt, c. 1145. Photo: Janet Snyder

1.43 Saint-Julien, Le Mans Cathedral, left jamb, column-figures, before 1158. Photo: Janet Snyder

1.44 Notre-Dame, Chartres Cathedral, Royal Portal west façade, center portal, right jamb 3: bulging womb, belt with knot, c. 1145. Photo: Janet Snyder

1.45 *Seal of Agnes of Bar*. Cast no. 26, Département de Sigillographie, Archives nationales, used by permission. Photo: Janet Snyder

1.46 Abbey Church of Saint-Denis, west façade sculpture. From Dom Bernard de Montfaucon, *Monumens des derniers roys merovingiens* (1729), vol. 1, pl. 17

1.47 Abbey Church of Saint-Denis, west façade, right portal, left jamb, column-figure. Antoine Benoist drawing, BN, MS

regal dalmatic, c. 1160. By permission of the Musée de Provins et du Provinois. Photo: Janet Snyder

1.87 Provins, *David*, column-figure found at Saint-Ayoul, now in the Maison Roman: Monarch's dalmatic over Chevalier open-seam *bliaut*, c. 1160. By permission of the Musée de Provins et du Provinois. Photo: Janet Snyder

1.88 *Astrologers Signal the Appearance of a Comet [Halley's Comet], which Portends Misfortune for King Harold II, Bayeux Embroidery* (detail): Harold enthroned without the regal dalmatic. Musée de la Tapisserie, Bayeux, France. Photo: Erich Lessing/Art Resource, New York

1.89 *The Coronation of Harold II; He Receives Sword and Scepter, Bayeux Embroidery* (detail): Harold Godwinson enthroned, wearing the regal dalmatic. Musée de la Tapisserie, Bayeux, France. Photo: Erich Lessing/Art Resource, New York

1.90 Abbey Church of Saint-Denis, west façade, column-figure CR4. Antoine Benoist drawing, BN, MS FR 15634, folio 54. Bibliothèque nationale de France

1.91 Tomb effigy of Geoffroi le Bel (Geoffrey V Plantagenet), shortly after 1151, copper (engraved, chased and gilded), with *vernis brun* and *champlevé* enamel areas in several colors. Le Mans? Cliché Musées du Mans; Conservation: Le Mans, Carré Plantagenêt (Musée d'histoire et d'archéologie du Mans, Inv. 23-1)

1.92 Henry's coronation miniature in the *Gospels of Henry the Lion*, c. 1175–88. From *Das Evangeliar Heinrichs de Löwen*, Wolfenbütel Herzog August Bibliothek, Cod. Guelf, 105 noviss. 2

1.93 Saint-Maurice, Angers, right 1 (detail): upper body, hair, beard. Photo: Janet Snyder

1.94 Saint-Maurice, Angers, right 1 (detail): open center seams at hem. Photo: Janet Snyder

1.95 Saint-Maurice, Angers, right 1 (detail): top of open center seam. Photo: Janet Snyder

1.96 Abbey Church of Saint-Denis, west façade, right portal, left jamb: *Labors of the Months, 'June,'* c. 1137–40: tunic hangs in tree at upper left. Photo: Janet Snyder

1.97 Notre-Dame, Chartres Cathedral, Royal Portal west façade, left portal archivolts: *Labors of the Months, 'July'* and *'April.'* Photo: Janet Snyder

1.98 Abbey Church of Saint-Denis, west façade, right portal, left jamb: *Labors of the Months, 'May,'* c. 1137–40. Photo: Janet Snyder

1.99 Notre-Dame, Chartres Cathedral, Royal Portal west façade, left portal archivolts, *Labors of the Months, 'June'* and *'May.'* Photo: Janet Snyder

1.100 Notre-Dame-en-Vaux at Châlons-sur-Marne, *Personification of Virtue*: Chevalier skirt, shield, chain armor. Photo: Janet Snyder

1.101 Notre-Dame-en-Vaux at Châlons-sur-Marne, *Personification of Virtue* (detail): open seam of Chevalier skirt, chain armor. Photo: Janet Snyder

1.102 *The Lewis Chessmen*, c. 1150–1200, ivory, probably made in Norway. Found on the Isle of Lewis, Outer Hebrides. The British Museum (M&ME 1831, II-1, Ivory Catalogue 78-159). Helmeted Chevaliers on horseback with open-seam Chevalier's *bliauts*; bishop in dalmatic and mitre peaked front and back; king and queen. © Trustees of the British Museum

1.103 *The counterseal of the first seal of Louis VII.* See L.C. Douët d'Arcq, *Inventaire de la collection des sceaux des Archives nationales* (Paris, 1863–68). Cast

67 bis, Département de Sigillographie, Archives Nationales, used by permission. Photo by Janet Snyder

1.104 Saint-Etienne, Bourges Cathedral, south lateral portal, right 1: Chevalier *bliaut* with open center seam at hem. Photo: Janet Snyder

1.105 Saint-Maurice, Angers, left jamb, *column-figure of Chevalier*. Photo: Janet Snyder

1.106 Rochester Cathedral (Kent), west portal, left jamb, *man column-figure*. Photo: Janet Snyder

1.107 Notre-Dame, Paris cathedral, west façade, right portal (Portail Sainte-Anne) (detail): tympanum and upper lintel. Photo: Janet Snyder

1.108 South transept portal, Moutiers-Saint-Jean, c. 1250: two nearly-freestanding column-figures with Chevaliers' open-seam tunics. The Cloisters of the Metropolitan Museum of Art, New York

1.109 Abbey Church of Saint-Denis, west façade, column-figure LL1. Antoine Benoist drawing, BN, MS FR 15634, folio 67. Bibliothèque nationale de France

1.110 Saint-Ours, Loches, left wall of portal, *relief column-figure of Cleric* (before 1168). Photo: Janet Snyder

1.111 Saint-Lazare, Avallon, center portal, right jamb, c. 1155–60. Photo: Janet Snyder

1.112 Saint-Etienne, Bourges Cathedral, south lateral portal, left jamb column-figures: upper bodies. Photo: Janet Snyder

1.113 Notre-Dame, Chartres Cathedral, interior of the west front, left bay (*Passion of Christ*), painted stained glass. Photo: Janet Snyder

1.114 Notre-Dame, Chartres Cathedral, Royal Portal west façade, center portal, left jamb 3, 2, 1: mid-body, c. 1145. Photo: Janet Snyder

1.115 Notre-Dame, Chartres Cathedral, Royal Portal west façade, center portal, left jamb 1, 2: heads and shoulders, c. 1145. Photo: Janet Snyder

1.116 Saint-Loup de Naud, portal, with column-figures and *Majestas Domini* tympanum, c. 1160. Photo: Janet Snyder

1.117 Saint-Loup de Naud, *trumeau* (detail): chasuble point, stole, waffle-pattern dalmatic, with heavy border, c. 1160. Photo: Janet Snyder

1.118 *Abbot of the Abbey of Notre-Dame d'Issoudun*, c. 1160, or 1180–90, limestone, *gisant* from the crypt of the Abbey (detail). Atelier of Sens, according to Neil Stratford. © Musée de l'Hospice Saint-Roch, Issoudun (Inv: 11.54, n.75). Photo: Janet Snyder

1.119 Limoges enamel crosier knob, c. 1160–1200, *champlevé* enamel, gilt. Discovered along with clothing of silk and linen, in 1855, in the tomb of the Abbot of Issoudun. © Musée de l'Hospice Saint-Roch, Issoudun (Inv: 11.986, n.330). Photo: Janet Snyder

1.120 Notre-Dame, Paris cathedral, west façade, Portail Sainte-Anne: side of *trumeau*, Saint Marcel, limestone with traces of polychromy (detail): ecclesiastical dalmatic fringe, c. 1145. Paris, Musée de Cluny – Musée national du Moyen Age (Cl. 18640). Photo: Janet Snyder

1.121 Notre-Dame, Nesle-la-Reposte, portal with six column-figures, c. 1160. From Dom Jean Mabillon, *Annales Ordinis S. Benedicti, II* (Paris, 1703–39), vol. 1, lib. 6, pp. 50–51

1.122 *Henri of Blois*, c. 1150, Mosan enamel plaque. The British Museum

(M&ME 1852, 3–27). © Trustees of the British Museum

1.123 *Seal of Louis VI*, before 1137. See L.C. Douët d'Arcq, *Inventaire de la collection des sceaux des Archives nationales* (Paris, 1863–68). D.35 [No. 36]. Cast no. 66, Département de Sigillographie, Archives nationales, used by permission. Photo by Janet Snyder

1.124 *Seal of Louis VII*, 1147. See L.C. Douët d'Arcq, *Inventaire de la collection des sceaux des Archives nationales* (Paris, 1863–68). No. 37. Cast no. 67, Département de Sigillographie, Archives nationales, used by permission. Photo: Janet Snyder

1.125 *The Lewis Chessmen*, c. 1150–1200, ivory, probably made in Norway. Found on the Isle of Lewis, Outer Hebrides. The British Museum (M&ME 1831, II-1, Ivory Catalogue 78-159). Back view: King with four twisted ropes of hair. © Trustees of the British Museum

1.126 Rochester Cathedral (Kent), west portal, left jamb, *man column-figure* (detail): long coiled hair. Photo: Janet Snyder

1.127 Notre-Dame, Chartres Cathedral, Royal Portal west façade, right portal, right jamb, three column-figures: upper sections, c. 1145. Photo: Janet Snyder

1.128 Saint-Loup de Naud, right jamb column-figures: right hands raised, c. 1160. Photo: Janet Snyder

1.129 Notre-Dame, Chartres Cathedral, Royal Portal west façade, right portal, right jamb 2: open cuff sleeve, armband with cross design, beard, c. 1145. Photo: Janet Snyder

1.130 *The Raising of Jairus's Daughter*, Church of St. Michael and All Angels, Copford (Essex). Photo: Janet Snyder

1.131 Notre-Dame, Chartres Cathedral, interior of the west front, center bay (*Childhood of Christ*), painted stained glass, c. 1150. Photo: Janet Snyder

1.132 Saint-Etienne, Bourges Cathedral, north lateral portal, right column-figure: pin, braid *en trecié*. Photo: Janet Snyder

1.133 Notre-Dame, Chartres Cathedral, Royal Portal west façade, left portal, left jamb 1: hemline; pointed slipper toes, c. 1145. Photo: Janet Snyder

1.134 Notre-Dame, Chartres Cathedral, Royal Portal west façade, center portal, left jamb 2: shoes with inscribed sole seam, c. 1145. Photo: Janet Snyder

1.135 Notre-Dame, Chartres Cathedral, Royal Portal west façade, right portal, left jamb 2: hemline, rucked leggings, boots, c. 1145. Photo: Janet Snyder

1.136 Notre-Dame du Fort, Etampes, northeast chapel column-figure: side and feet. Photo: Janet Snyder

1.137 Saint-Julien, Le Mans Cathedral, left jamb 1: feet of relief column-figure, before 1158. Photo: Janet Snyder

1.138 Saint-Julien, Le Mans Cathedral, right jamb 1: feet of relief column-figure, before 1158. Photo: Janet Snyder

1.139 Notre-Dame, Paris cathedral, west façade, right portal (Portail Sainte-Anne), c. 1155–65. Nineteenth-century reconstruction of right jamb column-figures. Photo: Janet Snyder

1.140 Notre-Dame, Vermenton, west façade, column-figures: L3, L2, L1 (three kings?); *trumeau* (John the Baptist): R1 (Cleric), R2 (woman and child), R3 missing. From Dom Urbain Plancher, *Histoire general et particular de Bourgogne* (Dijon, 1739). Photo: Janet Snyder

1.141 Notre-Dame, Vermenton, west façade, left jamb, column-figures: L3,

Saujon (Charente-Maritime): carved textile patterns. Photo: Janet Snyder

4.23 Linen tunic (alb) worn by Thomas Becket during his exile in Sens, 1164–65, linen, silk, and gold. Musée de Sens, Trésor de la Cathédrale. Photo: Janet Snyder

Appendix B

B.1 Simplified geological map of the Paris Basin, with modern sites indicated. Drawing: Janet Snyder after Annie Blanc and Claude Lorenz, 'Etude géologique des anciennes carrières de Paris,' in P. Marinos and G. Kopukis (eds), *The Engineering Geology of Ancient Works, Monuments and Historical Sites, Preservation and Protection* (Rotterdam, 1968), and *Bulletin d'information géologique Bassin de Paris*, 16 (4) (1979)

B.2 Chartres Cathedral construction stone. Photo: Janet Snyder

B.3 Oise River construction stone from Rhuis. Photo: Janet Snyder

B.4 Bourges Cathedral construction stone. Photo: Janet Snyder

B.5 Geological section of northern France, indicating stone formations and erosion of rivers. Drawing by Janet Snyder after Charles Pomerol, *Geology of France with Twelve Itineraries* (Paris, 1980)

B.6 Schematic illustrating the limestone strata in Parisian quarries. Drawing by Janet Snyder, derived from Annie Blanc and Jean-Pierre Gély, 'Le Lutétien supérieur des anciennes carrières de Paris et de sa banlieue: Essai de corrélations lithostratigraphiques et application a l'archéologie,' in Jacqueline Lorenz, Paul Benoit, and Daniel Obert, *Pierres et carrières, géologie, archéologie, histoire* (Paris, 1997), pp. 175–81

B.7 Comparison of three column-figures with low elbows, hands at center front, right mantle fastening, suggesting a common rough-cut block form. Chartres west portal RR3; Saint-Ayoul (Provins) L3; Saint-Germain-des-Prés R3. Photo: Janet Snyder

B.8 Rochester Cathedral (Kent), west portal. Photo: Janet Snyder

B.9 Diagram of medieval Paris, including the valley of the Bièvre River, Abbey of Sainte-Geneviève, Abbey of Saint-Victor, Notre-Dame cathedral, Abbey of Saint-Germain. From J.G. Bartholomew, *Literary and Historical Atlas of Europe* (1912).

B.10 The 'Porte des Valois,' north transept, Abbey Church of Saint-Denis. Photo: Janet Snyder

B.11 Notre-Dame, Chartres Cathedral, painted stained glass, south aisle (*Architect*) window: 'Construction.' Photo: Janet Snyder

B.12 Notre-Dame, Chartres Cathedral, painted stained glass, south aisle (*Architect*) window: 'Conference.' Photo: Janet Snyder

B.13 Sainte Modeste, Notre-Dame, Chartres Cathedral, north transept west porch, c. 1210–20. Photo: Janet Snyder

PREFACE AND ACKNOWLEDGEMENTS

As the great church portal sculpture programs of the mid-twelfth century were produced by the tremendous optimism not only of those who conceived, designed, and sculpted the limestone but also of a greater community, this book came about due to the optimism and the encouragement of many individuals over many years. Stephen Murray introduced me to the Gothic in the Ile-de-France and to art historical studies at a 1989 National Endowment for the Humanities (NEH) Seminar for College and University Teachers and at Columbia University. I am deeply grateful to him for his advice and faith in my research. I appreciate the warm acceptance into their community that I received from a distinguished group of scholars of medieval art and architecture, especially for their initial enthusiastic responses to my reading of the sculpture and also for their ongoing support. I am indebted to Willibald Sauerländer, who graciously declared it was time to revisit his own reading of Gothic sculpture, and to Whitney Stoddard, who helped me find my way to Romanesque sculpture in France and the familial welcome I felt at Psalmody. William Clark has been a mentor who created time and space to present my research in a Kalamazoo session, provided the introductions that led to my academic appointments and the interest by Ashgate in publishing these ideas, and who graciously and continually offers his wise counsel. Combining roles of teacher, mentor, critic, and friend, Charles Little encouraged me at each stage in the metamorphosis of this research, introduced me to the Limestone Sculpture Provenance Project, and generously undertook important critical readings of earlier versions of this book. Danielle Johnson hosted me in the shadow of the Eiffel Tower, introducing me to important scholars, including Annie Blanc, Marc Viré, Dany Sandron, Michaël Wyss, and Barbara Watkinson, who have given selflessly of their time, expertise, and advice. Professor Anne Prache, the personification of grace, introduced me to the *ymagiers* in Paris (BN, MS FR 15634), and inspired me to aspire to high academic standards. I am indebted to Fabienne Queyroux, a joyful and astute scholar, teacher, and friend, whose guidance made it possible for me to acquire much of the visual evidence from French collections published here. My

thanks go to scholars who have provided critical assessments of my work as well as friendship and encouragement during the long gestation of this publication, including Nancy Wu, Nina Crummy, Laura Gelfand, Michael Davis, Desirée Koslin, Ellen Shortell, Vibeke Olson, James Robinson, and Abby McGehee. I am grateful to many directors, conservators, curators, and registrars of many museums, libraries, and archives for their exceptional cooperation and help with this project.

My research in France was made possible over the years through generous financial assistance from numerous university, foundation, and government sources, beginning with the NEH and Columbia University, and I am grateful to all of them. The understanding of stone laid out in Appendix B would not have been possible without the data collected, analyzed, and maintained by the Limestone Sculpture Provenance Project, Lore Holmes, and Georgia Summers Wright, with support contributed by the Samuel H. Kress Foundation. Original research and initial writing was made possible through the National Endowment for the Humanities Seminar, a Chester Dale fellowship at the Metropolitan Museum of Art, New York, and the patronage of two fellowships from the West Virginia Humanities Council. Support from West Virginia University sustained me through long years of research, writing, and revision, by means of a Senate Research Grant, a semester-long sabbatical leave, The Colonel Eugene Meyers and Florence Meyers Charitable Remainder Unitrust, and the Drs. Paul and Laura Mesaros Foundation. I am grateful to colleagues in the Division of Art and Design and the College of Creative Arts for their encouragement, particularly Kristina Olson, Dean Bernie Schultz, Division Chairs Sergio Soave and Alison Helm, and Beth Royall, Rhonda Reymond, and Ron Aman. My thanks go to Lisa Bridges, who asked the right questions at the right time.

Throughout, I have been compelled to continue to explore this material by the faith of my students at Puget Sound, Iowa, and West Virginia. I am grateful for the affection and optimism of my wonderful family and good friends – especially Ann Rishell, Debby Hatch, Janet Robbins, and Sandra Whaley – who enabled me to believe in myself and so, in this investigation. I owe much to Chloe, who kept me on the edge of my seat, and all to my best collaborator, Jeff Greenham, for his confidence, his infinite patience, and his artistic virtuosity.

Janet Snyder

INTRODUCTION

Bernard of Chartres used to say (c. 1130) that we are like dwarfs on the shoulders of giants, so that we can see more than they, and things at a greater distance, not by virtue of any sharpness of sight on our part, or any physical distinction, but because we are carried high and raised up by their giant size.[1]

A new design formula transformed church façade sculpture programs in northern Europe between the 1130s and the 1170s, revealing the human form with a subtlety that had not characterized northern European sculpture since ancient Roman times. In this formula, over-lifesize high-relief stone images of men and women dressed as courtiers stand along the doorjambs and visually engage with anyone about to enter the portal. While the sculpture programs at Saint-Denis, Etampes, and Chartres were not the first in France to use large standing figures at church doorways, these façade programs established this new design composition formula as a standard.[2] The significance of this use of figural reliefs was new, for patrons of these northern programs employed images of textiles and clothing as signs, expressing and shaping perceived reality (Figs I.1, I.2, 2.2).

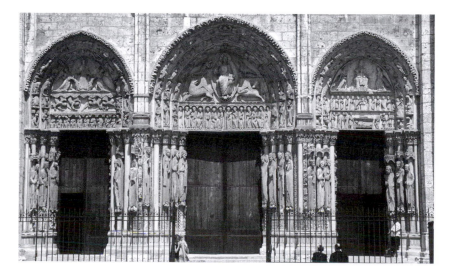

I.1 Notre-Dame, Chartres Cathedral, Royal Portal west façade, c. 1145.

Photo: Janet Snyder

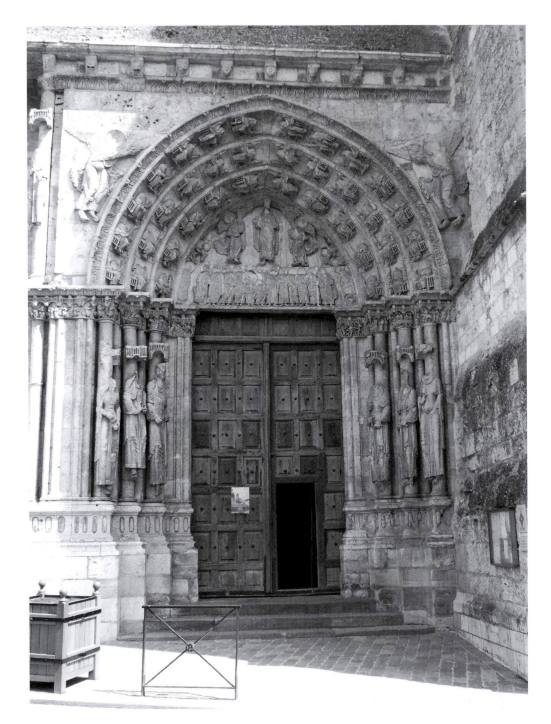

I.2 Notre-Dame du Fort, Etampes, south portal, c. 1140.

Photo: Janet Snyder

In 1989, as a participant in Professor Stephen Murray's National Endowment for the Humanities Summer Seminar for College and University Teachers, *The Gothic in the Ile-de-France*, I was asked to make use of my abilities as a designer for theatre to 'undress' some column-figures on the west façade of Chartres Cathedral. Investigations undertaken over the next twenty years in response to this challenge are described in the following chapters. This examination of twelfth-century limestone sculpture requires, if not a 'sharpness of sight,' then a clear focus upon both the details of sculpture and the contexts that produced them. It stands on a groundwork laid by an interdisciplinary community – the 'giants' who are medieval scholars and scientists. The complex and multivalent programs of church façade sculpture have frustrated comprehensive interpretation. Publications in the scholarly literature have usually placed early gothic column-figure sculpture somewhere along the continuum between European Classical and Renaissance sculpture. This book redefines the study of mid-twelfth-century architectural sculpture by considering social, political, commercial, and scientific perspectives on a limited cadre of church portal sculpture programs that was installed within a very narrow window of time and within a restricted geographic region.

This research was founded upon a suspension of disbelief – that leap of faith that embraces the makers' fabrication of a credible fiction based in observed reality. The represented human beings, cloth, jewelry, and garments could only succeed in conveying powerful ideas if, for their contemporaries, they were recognizable abstractions that corresponded to known realities. Images of human beings carry meaning, yet tantalizing questions remain: why does the mid-twelfth-century sculpture look as it does, different from what came before and what followed, and why were church portal sculpture programs with over-lifesize column-figures installed at this time? The project of this book has been to discover what these images might have signified for twelfth-century visitors, what ideas may have been conveyed with these images, how that communication functioned, and to whom the message was directed. It is not concerned with the evolution of style, the hands of particular artist-masons, or the chronology and the influence of one portal upon another. It seeks to discover what the represented bodies and clothing can reveal about the society that produced them. It is concerned with possible motivations of the patrons of portal programs with column-figures; with the significance of represented ensembles of clothing; with the language of textiles and dress that would have been legible to twelfth-century northern Europeans; with recognizable characteristics of textiles employed in stone sculpture; with the place of production and appropriation of particular materials; with the acquisition, transportation, and fabrication of a particular stone, *liais de Paris*, for sculpture; and with proposing the significance for the use of column-figures as part of mid-twelfth century portal sculpture programs. As the column-figures are the heart of the work, readers are directed to look at specific details of evidence in sculpture and in other twelfth-century media illustrated here and in reality.

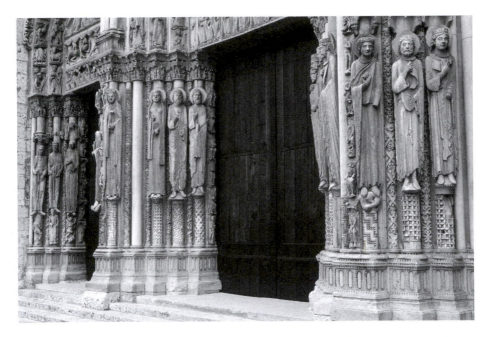

I.3 Notre-Dame, Chartres Cathedral, Royal Portal west façade, left jambs, c. 1145.

Photo: Janet Snyder

I.4 Abbey Church of Saint-Denis, west façade, right portal, right jamb,
Labors of the Month: '*July*,' '*August*,' '*September*,' c. 1137–40.

Photo: Janet Snyder

Why?

Abbot Suger declared in *De Consecratione* that his motivation to refurbish the Abbey church at Saint-Denis was to honor Almighty God and the Holy Martyrs.[3] Few texts have survived from the twelfth century, yet the physical evidence indicates that images were active tools for communication and the shaping of memory.[4] The use of contemporary imagery may have been integrated so completely into ways of thinking that writing down statements concerning its use would have seemed unnecessary. While Suger emphasized elements he perceived as extraordinary – the church doors and the brilliant windows and one old-fashioned mosaic tympanum at Saint-Denis – he failed to mention the ordinary sculpture installation of 1140. The complexity of twelfth-century church portal sculpture programs is astounding: in addition to the column-figures, human beings populate miniature vine scrolls, historiated capitals, friezes, and voussoirs (Figs I.3, I.4, 4.20). The multiple images intensified the observer's participation in the construction of meaning; the gaps that had been left in the narratives could have been completed by the viewer, in a kind of directed meditation.[5]

When? Who? How?

The over-lifesize column-figure sculpture was produced by the artist-masons who were members of the workshops – *chantiers* – charged with preparing all of the masonry and architectural sculpture elements needed to construct these great churches (Fig. I.5). These artist-masons – *ymagiers* – worked in various styles of carving; at Chartres Cathedral, for example, Stoddard recognized the hands of three masters and various assistants at work on the Royal Portal.[6] No precise duplications among the column-figures were fashioned from portal to

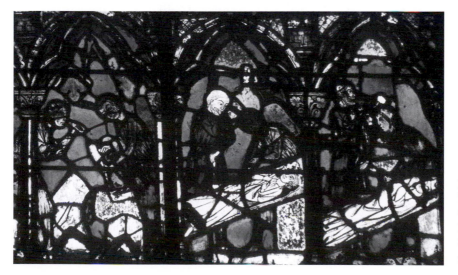

I.5 Notre-Dame, Chartres Cathedral, painted stained glass, c. 1150.

Photo: Janet Snyder

I.6 Saint-
Maurice,
Angers, portal.

Photo: Janet Snyder

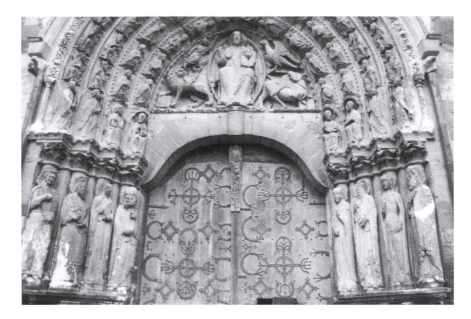

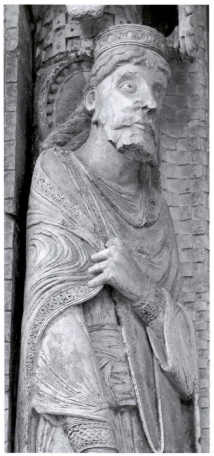

portal, even where a particular *ymagier*'s hand – like 'the Etampes Master' – can be recognized (Figs 1.1, 1.14). The column-figures are not 'portraits.' Their represented clothing paraphrased types of contemporary dress in order to clearly disclose important ideas (Fig. I.6). At the same time, the tremendous skills of the *ymagiers* is evident: much of the contemporary clothing represented in sculpture and painting was depicted with such precision that the garment construction can be discerned and the textiles may be identified hundreds of years after their installation (Figs I.7, I.8, 4.14).

The fully developed design formula featuring column-figures was installed by 1140 in the portals of the Royal Abbey of Saint-Denis and Notre-Dame-du-Fort at Etampes (Figs 2.2, I.2). Before 1150, the same formula had also been installed at the cathedral of Chartres, and then it was incorporated into at least 18 other doorways within 20 years.[7] Just over 150 column-figure sculptures can be assembled to represent the first generation of programs that employed this design formula. This group includes lost sculpture represented in historic drawings and published engravings; column-figures from non-portal contexts; portal sculpture fragments, recognized

I.7 Saint-Etienne, Bourges Cathedral, south lateral portal, left 3: upper body, concealed sleeve.

Photo: Janet Snyder

I.8 Notre-
Dame, Chartres
Cathedral,
Royal Portal
west façade, left
jamb, left portal
1: shoes and
patterned hem.

Photo: Janet Snyder

through scientific analysis; column-figure sculpture held in lapidary and museum collections; modern reconstructions or casts of portal sculpture, and figures that remain at the churches where they were installed. This book's chapters and illustrations integrate detailed descriptions of column-figures with the social, political, and commercial contexts of represented textiles and clothing and with aspects of stone sculpture production and transportation in an effort to propose reasons for the appearance of the bodies and apparel depicted in the sculpture.

The literature

The bibliography exclusively concerned with twelfth-century sculpture that supports this interdisciplinary study assessment is extensive. The interpretation of the iconography has been the central concern of sculpture studies since Montfaucon (1729) identified the crowned figures at Chartres as medieval rulers and queens. His contemporaries Plancher (1739) and Mabillon (1703–39) also published important illustrations of portal installations. Abbé Lebeuf (1754) preferred to name the column-figures as personalities of the Old Testament. As part of his monumental *Dictionnaire raisonné du mobilier français de l'époque carolingienne à la renaissance* (1872), Viollet-le-Duc published interpretations of column-figure sculpture in naturalistic engravings that depict lively men and women. These prints looks suspiciously like his compatriots in fancy dress.

Though Vöge's ground-breaking examination of style (1894) anticipated the direction art historical studies would take in the later twentieth century, Aubert (1941) continued the iconographic focus, refining identifications by

naming each figure as personifying a book of the Old Testament. At mid-century, Katzenellenbogen (1959) published an iconography for Chartres Cathedral, an approach continued by Mâle (1978), Crosby (1987), and Beaulieu (1984). The column-figures are addressed as part of larger considerations of the architecture by Kidson (1958), Branner (1969), and von Simson (1956). The recent publications of Halfren (2001) and Klinkenberger (2008) concur that the column-figures represent the specific biblical heroes, patriarchs, the kings, queens, and high priests of the Old Law, who were the ancestors of Christ. Important redirections were undertaken by Whitney Stoddard and Willibald Sauerländer and most recently by Margo Fassler. Following Vöge's lead and shifting from iconography to the assessment of formal issues, Stoddard (1952) credited the sculpture of the Chartres Royal Portal to individual *ymagiers*. Sauerländer's *Gotische Skulptur in Frankreich, 1140–1270* (1970) defined the sculpture of the period as a body of work, proposed a chronology, foregrounded the sculpture through photographs, and integrated formal and archival evidence. Fassler's *The Virgin of Chartres, Making History though Liturgy and the Arts* (2010) demonstrates how thoroughly the column-figures were integrated with the Chartrain liturgy.

In some ways, archaeological discoveries in the 1960s and 1970s metamorphosed traditional understanding of the physical sculpture. Lost fragments emerged from excavations and secret storage chambers to revise what could be known about sculpture. Fine limestone details, of column-figures from the cloister of Notre-Dame-en-Vaux (Pressouyre and Pressouyre, 1981) and from Notre-Dame of Paris (Giscard d'Estaing, Fleury, and Erlande-Brandenburg, 1977; Erlande-Brandenburg, 1982), and new conservation techniques illuminated and altered the genre. Appendix B discusses revelations enabled by the analyses provided through the Limestone Sculpture Provenance Project (Holmes, Blanc, and Harbottle since the 1980s) that have particularized and authorized specific, once-tentative identifications. The careful stewardship and analyses of Blanc, Lorenz, and Viré (1982 onwards) have illuminated studies of the architectural fabric. The technical analyses of Kimpel and Suckale (1985) have extended and revised ideas about sculpture production. Williamson's *Gothic Sculpture, 1140–1300* (1995) provides an authoritative handbook for 150 years of northern European sculpture. Fabienne Joubert's *La sculpture gothique* (2008) enriches this literature, turning in a fresh direction with its thematic analysis. During the last four decades, the field of gothic sculpture studies has continually expanded through the timely publication of exhibition catalogues, symposia proceedings, *festschrifts* and journal articles, including Gerson (1986), Little (2006), and Joubert, Sandron and Prache (1999).

The habits of medieval thinkers make it likely that designers of these façade programs anticipated that viewers would have been able to comprehend multiple meanings in a design program simultaneously. The potential multivalency of the sculpture negates the modern preference for unique iconographic readings or metaphorical meanings of these church

portal sculpture programs. The chapters in the present study not only direct the reader to the commentary provided by the column-figure sculpture and to contemporaneous visual evidence but also refer to published sources in notes, demonstrating interconnectedness of germane disciplines. Non-limestone evidence evaluated includes archival texts, vernacular literature, seals, extant textile fragments, enamels, and painted and sculpted images in other media (Figs 3.4, 4.2). These chapters integrate exploratory, analytical, scholarly, and scientific interpretations from diverse fields of the physical, visual evidence: social, political, and commercial history, including the historical practices involving the *adventus* ceremonial and the *sacre* in northern France; stone quarrying and transportation; textile manufacture, valuation, and shipping records; the regular appropriation and re-interpretation of the significance of textiles from one culture to another; and the history and reception of images.

Newly considered in the present study of sculpture are the represented clothing and textiles as explanatory elements. Iconographers' interpretations usually have valued the meaning of headgear and the bare feet of 'the beloved,' but the attention given to the figures from chin to ankle have tended to be imprecise.[8] Handicapped by the lack of costume terminology, attempts to identify sculpture have stumbled.[9] No matter which carving traditions or styles of representation were used, much of the contemporary clothing represented in carved and painted sculpture was depicted with such precision that the garment construction can be discerned and the textiles may be identified. An understanding of twelfth-century dress and garment construction has been an important key to understanding what the represented garments were intended to illustrate.[10] Analyses of extant actual garments provide essential facts. Modern archaeological discoveries published by Nockert (1984), Raeder Knudsen (2004), and other NESAT authors (2007) support careful reading of the sculpture. Despite their risk of a kind of circularity, the descriptions produced by historians of costume Boucher (1966) and Harris (1977) of period clothing that are based on images from that period pay attention to appropriations and translations that were made by a contemporary. Explanations of dress founded upon images have been illuminated by the lexicon for named and described costume that was defined by Goddard (1927) from twelfth-century vernacular literature. The assessments of archival documents by Goitein (1967), Muthesius (1993), Sanders (2001), Jacoby (2004, 2005), and Stillman (1976) have joined studies of extant textiles by Martiniani-Reber (1992), Brigitte and Gilles Delluc (2001), Baker (1995), and of archaeological archives by Crowfoot, Pritchard, and Staniland (1992), and by Egan and Pritchard (1991) to produce a credible understanding of the textiles and dress of the twelfth century. In his discussion of the Cappella Palatina (1949), Kitzinger related the mosaic images to historical events. Similarly, the following chapters will relate contemporary political and commercial developments to northern portal sculpture.[11]

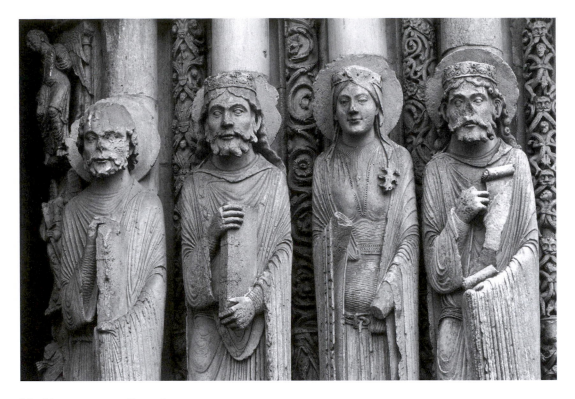

I.9 Notre-
Dame, Chartres
Cathedral, Royal
Portal west
façade, center
portal, right
jamb (detail).

Photo: Janet Snyder

Overview

Dress in northern Europe can be roughly divided into thirty-year terms during
the twelfth century, with each period typified by distinct styles in courtly
costume. The system of communication with large statues in recognizable
clothing employed in the portal programs made use of a language of dress
legible to contemporaries, and its use introduces nuanced significance for the
sculpture. Chapter 1, 'Secret Signals,' describes elements of contemporary
dress as depicted in the column-figure sculpture of mid-twelfth-century portals
(Fig. I.9). Beyond evidence from archival texts and vernacular literature, the
language of dress used in the column-figure sculpture is affirmed in recent
analyses of seals by Bedos-Rezak (2000) (Fig. I.10), of extant textile fragments
by Martiniani-Reber (1992) and Nockert (1984), of painted sculpture by Verret
and Steyaert (2002), and of sculpted images in other media by Neil Stratford
(1997). This language of dress is one that would have been comprehensible
to those to whom the ideas of the portal programs were directed during the
twelfth century. It is known that the images were talked about; and it may
be possible to reconstruct portal design compositions from fragments and
descriptions. However, what was spoken, not what might have been written,
about the sculpture cannot be recovered.[12] The irretrievable loss of the oral
component of the portal programs may be one reason that the significance
of column-figures remains an open question. The assumption that costume

directly *reflects* behavior fails to consider the dynamic character of dress, which develops with social relationships and has the ability to transform them. Chapter 1 articulates the significance of the ensembles that distinguished the ranking members of Frankish society. In its examination of the clothing that appears in the column-figure sculpture, this chapter defines the represented ensembles, distinguishes the status of the wearers, and proposes meanings in the sculpture that would have been apparent to contemporary visitors. In this chapter specific names of ensembles have been proposed – Grande Dame, Norman Lady, Gentlewoman, Elite, Chamberlain, Monarch, Seigneur, Chevalier, Dignitary, Associate, and Clergymen – not to assign jobs to individual column-figures but to furnish the reader with a means to recognize patterns in the design formula and to sharpen the observation of details.

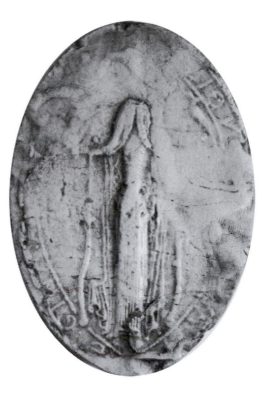

I.10 Eleanor of Aquitaine: Eleanor appears to wear a mantle over a slim Norman *bliaut* in the seal matrix she used to authorize charters in 1153 and 1199, as Queen of England, wife and widow of Henry II. (Cast no. 4, Département de Sigillographie, Archives nationales, used by permission.)

Photo: Janet Snyder

Capetian governance was fragile under Louis VII (r. 1131–37), elected after his *sacre* and subsequently sole monarch at 17. The publications of Bonnefin (1993) and E.A.R. Brown (1992) refined and enriched modern understanding of the *sacre*, and their analyses recognize the specified regalia and costume of the French king. Arranged like courtiers standing in reception lines, column-figure sculpture of church façade compositions appear to reaffirm the support offered by the peers in 1137 for the young King Louis during his escorted tour of the realm. The exploration of the apprehension of images has been illuminated by the analysis and discussion of the historical *adventus* ceremonial at Chartres by Fassler (2007). The publications of Nelson (1992), Koziol (1992, 2002), Evergates (2007), and Bull (2002) revise the traditional political frame for the governance by the Capetians and for their relationship with the magnates of France. The work of Pastoureau (1976) and LoPrete (1999) contribute a rethinking of the social context for the installation of column-figure sculpture.

Chapter 2, 'Structures of Power,' presents interpretations arising from these scholars' work as those interpretations apply to the new design formulas used for portal compositions with column-figures. These compositions reflected the fundamental structures of northern French society during the reign of Louis VII. These sculpted representations of a hierarchical contemporary courtly community may have contributed to the re-ordering of society because appropriate relationships were modeled and expressed through the new design formula. Dated charters issued by Louis VII provide evidence that

the king was in residence, at least briefly, in the locations where the column-figures were installed.[13] It was Thibaut II, Count of Champagne and Blois, who led the newly crowned Louis to receive homage from the peers of France in 1137. Though in the 1140s relations became strained between the king and his liegeman Thibaut II, in the years around 1150, Louis VII arranged for the betrothal of his young daughters to marry the sons of Thibaut – these sons became the counts of Blois and Champagne upon their father's death. In the 1160s, as Alix and Marie assumed their places as countesses and wives, the centers of fashion shifted from Paris to their courts.

The history of commercial exchange during the twelfth century is reviewed in Chapter 3, 'Good Business.' Particular textiles emerged as desirable and exclusive commodities because of the political and commercial exchange of stuffs during the Middle Ages. By the 1140s, the fine textiles represented in column-figure sculpture had become available in northern Europe – for a price. In this chapter, the success is recounted of the system of cyclical markets that were emerging in northern Europe in the later twelfth century. Events such as the fairs of Brie and Champagne were commercially viable and significantly profitable in northern Europe where, usually, nobles could not engage in commerce. The tremendous archival work published by Goitein (1967, 1973) and Jacoby (2004, 2005) disclose the shipping and commercial practices of the twelfth century. The different forms of commercial partnerships of merchants and traders from Italian towns and the establishment of international lines of credit – money used in one locale and repaid in the currency of another – contributed to the success of international trade. Chapter 3 explains sources for dyestuffs and textiles and it lays out the international trade routes for commercial exchange. The appropriation and transformation by northern Europeans of textiles from the Byzantine and Islamic cultures is also discussed. The markets dictated appearances to an extent; further, contact with merchants from the rest of the world through commercial ventures introduced foreign luxuries, ideas, and priorities to the Franks. The appearance of church portal sculpture participated in the construction of meaning, whether the issue concerned the power of the crown, the peace of the realm, the unity of the vassals, or the ineffable luxury and prestige associated with particular exotic textiles and fashions. The clothing and textiles represented in column-figure sculpture contributed to the shaping of changes in the commercial context.

The information provided by extant twelfth-century textiles and decorative arts substantiate the written accounts of trade in textiles and dyestuffs between Western Europeans and the peoples of Egypt, Byzantium, and the Near East. Greek and Islamic textiles, ceramics, ivories, and stucco figures reveal the tremendous importance of fabric as a commodity in the East as well as in the West.[14] Chapter 4, 'Significant Stuff,' presents accounts of these goods, their significances, and textile business and exchange. Contemporary clothing can articulate the values of contemporary society. During the twelfth century, European tailors were able to select from a range of goods acquired from local and from foreign sources as they produced the pleated, fitted, body-revealing

garments preferred by European courtiers. The tailors' choices of particular details of clothing and types of fabric to use for clothes make up the lexicon of the language of dress that was described in Chapter 1. Chapter 4 goes on to address the character of particular textiles' appearance and the visual impression conveyed by that appearance. Comparison with representations and images in Byzantine and Islamic cultures through works selected from exhibition catalogues (Musée du Louvre, *Byzance*, 1992; Evans and Wixom, *The Glory of Byzantium*, 1997; Dodds, *The Art of Medieval Spain*, 1993) demonstrates the appropriation and interpretation of the significance of textiles from one culture to another. The *ymagiers* not only carved the stone but also provided information about fabric pattern and texture in sculpture by painting the stone surface of the sculpture. Contemporary textiles are discussed through the visual evidence, using the 150 column-figures as illustrations, and through comparison with extant fine fragmentary textiles.

Two appendices are provided in support of this assessment of column-figure design. The simple list of column-figures and portals in Appendix A clarifies the location of the column-figures and makes use of the specific names introduced in Chapter 1. Appendix B, 'From Quarry to Cathedral,' describes the exportation of stone from Parisian quarries for use in sculpture, and the barges and the methods used to transport stone to the *chantiers*. The column-figures were made of very fine limestone, often *liais de Paris*, that was requisitioned and transported great distances from the stone sources.[15] Little, Wright, and Johnson directed the Limestone Sculpture Provenance Project (LSPP) in the testing of stone sculpture and in quarries in the Paris Basin. The reports produced by Holmes and Harbottle, leading scientists of the LSPP, have been issued to individual scholars; a number of these results have been brought together in this appendix. The Metropolitan Museum of Art symposium and exhibition *Set in Stone* (Little, 2006) brought the project to the fore of the field. Comparative studies of stone tested by the LSPP reveals that blocks of *liais de Paris* were requisitioned from Parisian quarries and were set *en de lit* when used for the monolithic column-figures.[16] The studies and publications produced by Blanc, Lorenz, Viré, and other geologists of the CNRS of the Parisian and regional quarries have been extensive and thorough. Professor Anne Prache observed that it is likely that *ymagiers* from different *chantiers* met at the quarries where this stone could be found.[17] She suggested that such meetings may have accelerated the spread and influence of designs, especially in the twelfth century as the new design formula permanently altered the appearance of northern French church façades. Masonic interaction and the shipping of roughly finished work may have resulted in the cross-fertilization of design concepts, including the formal standardization practiced in portal construction and the serial production of both sculptural and architectural elements.

This study began with an acceptance of the *ymagier's* abstraction of contemporary cloth and clothing. Since the sculpture supports multiple interpretations, that acceptance evolved to become part of a broader

vision. The goal of this examination has been to introduce a close study of the represented clothing of column-figure sculpture in the light of an understanding of contemporary dress in its original context as a tool for analysis. Much as Kitzinger related the mosaic images in the Capella Palatina to historical events, the following chapters will relate contemporary political and commercial developments to the new design formula for northern portal sculpture.[18]

Notes

1 John of Salisbury (1115/20–1180), *Metalogion*, 1159. His *Metalogion* was a defense of the study of the liberal arts. See Michael Wilks, *The World of John of Salisbury* (Oxford, 1994).

2 Trumeau figures and jamb reliefs decorate doorways at Autun, Vézelay, Moissac, Beaulieu-sur-Dordogne, and Soulliac. 'The construction of the portal, the arrangements of the programme and the interplay of the different sculptors reveal a capacity for a superior synthesis such as we do not find in the so-called Romanesque sculpture of Burgundy, Languedoc and Aquitaine.' Willibald Sauerländer, *Gothic Sculpture in France 1140–1270*, trans. J. Sondheimer (New York, 1972), p. 385.

3 Suger, *De Consecratione*, in *Abbot Suger on the Abbey Church of Saint-Denis and its Art Treasures*, ed. Erwin Panofsky (Princeton, 1946, 1979).

4 'In the Middle Ages … both words and pictures [were] intimately and collaboratively related as devices for composing thoughts and memories … In medieval learned cultures … such a thorough mixing of media, especially the visual and the verbal, was commonplace.' Mary Carruthers and Jan M. Ziolkowski (eds), *The Medieval Craft of Memory, An Anthology of Texts and Pictures* (Philadelphia, 2002), p. 2.

5 'The imagination did not rest in contemplation of one image but constantly played among many, in the repertories of the arts.' Karl Morrison, *History as Visual Art in the Twelfth-Century Renaissance* (Princeton, 1990), p. 102.

6 Whitney Stoddard, *Sculptors of the West Portals of Chartres Cathedral: Their Origins in the Romanesque and Their Role in Chartrain Sculpture Including the West Portals of Saint-Denis and Chartres*, PhD dissertation (Harvard University, 1952).

7 Angers, *Saint-Maurice*; Avalon, *Saint-Lazare*; Bourges, *Saint-Etienne, north portal*; Bourges, *Saint-Etienne, south portal*; Chartres, *Notre-Dame, west façade*; Corbeil, *Notre-Dame*; Dijon, Saint-Bénigne; Etampes, *Notre-Dame-du-Fort*; Ivry-la-Bataille, *Notre-Dame*; Le Mans, *Saint-Julien*; Loches, *(Saint-Ours) Notre-Dame du Château*; Nesle-la-Reposte, *Abbey of Notre-Dame*; Paris, *Notre-Dame, Saint Anne Portal*; Paris, *Saint-Germain-des-Près*; Provins, *Saint-Ayoul*; Provins, *Saint-Thibaut*; Rochester Cathedral, England; Saint-Denis, *Royal Abbey Church, the west portals and the Porte des Valois, the north transept portal*; Saint-Loup de Naud; Vermenton, *Notre-Dame*. Related large figures from this period appear as tomb *gisants*, as cloister sculpture from the Abbey of Saint-Denis and Notre-Dame-en-Vaux at Châlons-sur-Marne, and as individual figures from unknown architectural contexts, such as the figure found at Saint-Ayoul in Provins that is identified as King David. Destroyed portals such as Notre-Dame-en-Vaux and Donnemarie en Montois (Donnemarie-Dontilly), among others, appear to have used the formula as well.

8 Emile Mâle noted the liturgical garb and the 'goose-footed queen' at Saint-Bénigne, but his description of an 'exact' correspondence between the Chartres center right jamb (two dignitaries/chamberlains, a court lady, and a chamberlain) and the Le Mans right jamb (a relief chamberlain, a dignitary/chamberlain, a court lady, and two elites) glosses over significant differences in represented dress. See Emîle Mâle, *Religious Art in France, The Twelfth Century, A Study of the Origins of Medieval Iconography* (Princeton, 1978), p. 391 ff.

9 The neckline decoration of the *bliaut* of a headless man at Saint-Denis was called a *pallium* because of its approximation of an *archiepiscopal pallium*: the broad flat belt of a man dressed like the *Figure of a Nimbed King* from the Saint-Denis cloister has been misread as a woman's accessory (Figs 1.62, 1.68).

10 Katzenellenbogen's identification of a column-figure at Saint-Denis (Fig. 1.28) as Moses is based on a 'shell cap' and an attribute illustrated in Montfaucon's published engraving. Closer comparison of the preparatory drawings for the engravings reveals that the panels held by the column-figure appear to be an architectural elevation rather than tablets of the law. The drawings have been bound in the manuscript, Paris, BN MS FR 15634. The Temple of Solomon immediately springs to mind, an appropriate reference to be used at the portal to the Royal Abbey, especially given Suger's ambitions.

11 '… The boldest innovation in the design of Abbot Suger's new façade of the Abbey Church of Saint Denis, royal burial church and symbolic if not actual seat of power of the French monarchy, was the prominent representation, in the form of column statues, of Biblical kings and queens, who were antecedents not only of Christ but of the French kings as well. The theme was taken over soon afterwards at Chartres on … the Portail Royal.' See Ernst Kitzinger, 'The Mosaics of the Cappella Palatina in Palermo: An Essay on the Choice and Arrangement of Subjects,' *Art Bulletin*, 31 (4) (1949): 291–2.

12 'The problem with oral as opposed to literate cultures of the past is their irretrievability, and it is for this reason that we can no longer apprehend the meaning ….' See Michael Camille, 'Seeing and Reading: Some Visual Implications of Medieval Literacy and Illiteracy,' *Art History*, 8 (1) (March 1985): 37.

13 The evidence for this are the 'Actes' listed in Achille Luchaire, *Etudes sur les actes de Louis VII, Histoire des institutions monarchiques de la France sous les premiers capétiens (Mémoires et documents)* (Paris, 1885).

14 See David Jacoby, 'Genoa, Silk Trade and Silk Manufacture in the Mediterranean Region (ca. 1100–1300),' in *Commercial Exchange Across the Mediterranean: Byzantium, the Crusader Levant, Egypt, and Italy* (Aldershot, 2005), pp. 11–40.

15 The best source for information is available on the website for the Limestone Sculpture Provenance Project: <http://www.medievalart.org/llimestone/index.htm>.

16 William W. Clark, 'Head of an Old Testament King,' in *Set in Stone: The Face in Medieval Sculpture*, ed. Charles T. Little (New York, 2006), pp. 81–2.

17 Dany Sandron, 'Review of 1995 Leeds program,' *Bulletin monumental*, 154 (1) (1996): 80–81.

18 Kitzinger, 'Mosaics of the Cappella Palatina,' 291–2.

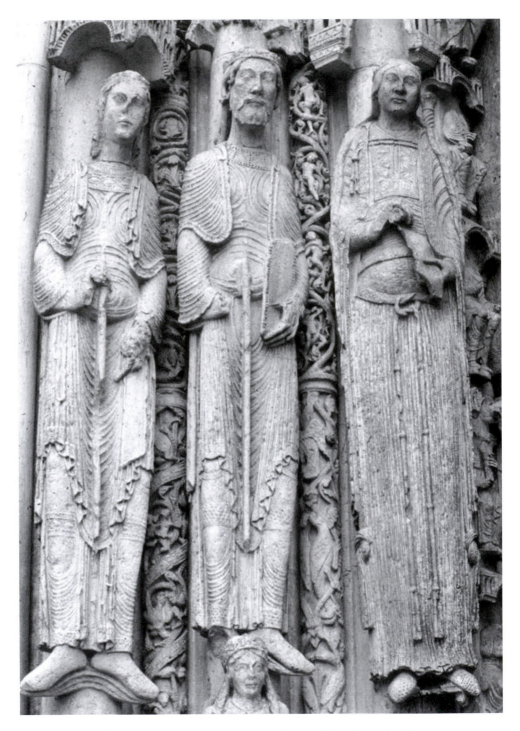

1.1 Notre-Dame, Chartres Cathedral, Royal Portal west façade,
left portal, left jamb, three column-figures, c. 1145.

Photo: Janet Snyder

SECRET SIGNALS: THE MEANING OF CLOTHING IN SCULPTURE

The peace of the political community is an ordered harmony of authority and obedience between citizens … Peace, in its final sense, is the calm that comes in order. Order is an arrangement of like and unlike things whereby each of them is disposed in its proper place.[1]

The words of Augustine in *The City of God* defined peace for its citizens in terms of order. Compositions that used a new design formula for church façade decoration appeared at a time of increasing hope for civil order, regional peace, and economic prosperity among the community of princes. The orderly dress of the men and women of the highest stratum of society in western France distinguishes most of the over-lifesize high-relief stone statues of human figures that were arranged along the main portal jambs of great church façades (Fig. 1.1).[2] Through the appearance of their textiles and clothing in the carved and painted over-lifesize column-figures arranged along the jambs of the main church portals, images of *citizens – like and unlike* – can be identified, each disposed in his *proper place*. *Peace* and *order* are expressed through the arrangement of these citizens in a liminal zone that is neither contained within the sacred space of the church nor completely separated from the church building in the profane world of the town.[3] At times, the processions that moved through the town temporarily expanded the sphere of the church, transforming and sacralizing space.[4] It is possible to investigate separate elements of these column-figures to evaluate how the combined representations of bodies and clothing contribute significance to the multivalence of twelfth-century French sculpture. This chapter takes a close look at the clothing that appears in the column-figure sculpture, defining the represented ensembles, distinguishing the status of the wearers, and proposing meaning that would have been apparent to contemporary visitors.

A language of dress

The column-figures numbering over 150 in this study were not produced by a single sculpture workshop, yet there are details of costume represented in

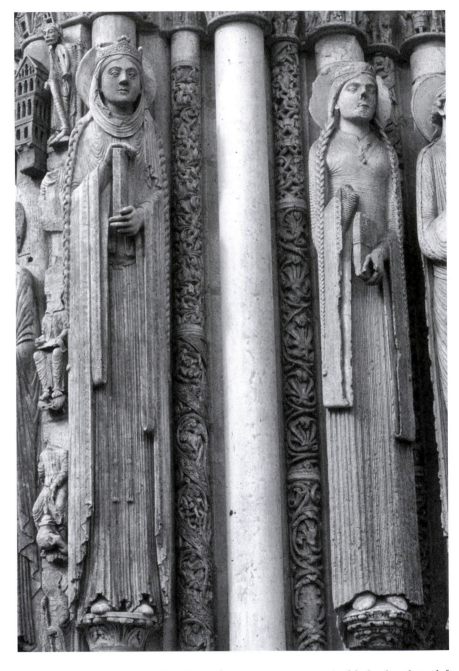

the sculpture that consolidate these figures into a recognizable body of work.[5]
Similar costumes, such as the belted *bliaut gironé* (Fig. 1.2), appeared at each
church. The vertical lines of the clothing reiterate the vertical thrust of columns
and buttresses along the façades. Though the individual figures stand isolated
from each other, they appear to engage visually anyone who approaches
the doorway. The figures' garments were carved with an attention to detail

normally confined to small-scale sculpture, and are strikingly recognizable. During the twelfth century, the usual clothing worn by men and women of the upper ranks in French society was composed of three layers – an undertunic (*chemise*), a belted tunic/gown (*bliaut* or *cote*), and an overgarment (*mantle*) – and these were accessorized with a variety of belts, headgear and footwear.[6] The precision of the stone carving in column-figures reveals garment construction techniques and costume details as if the represented dress were actual clothing (Fig. 1.3).

Though the garments of men and women seem to have been similar, closer examination of the column-figures' clothing reveals that by the 1140s, significant differences were customary between the ensembles of men and of women. Further, the shapes of creases and folds of drapery make it possible to speculate concerning the textiles that were used to make the actual clothes.[7] It is likely that, rather than having intended to produce realistic portraits of actual individuals, *ymagiers* created a meaningful fiction by abstracting and translating reality though the combination of recognizable garment forms and exotic textiles. The sculpted images presented high-status personages in their best clothing, described through a known language of dress. This chapter's parsing of the meaning of the vocabulary used in this language attempts to unlock the intended significance of the representation. With acceptance of an artistic fiction that is legible only because of its use of an intelligible language of dress, it is possible to propose the *raison d'être* for vestiary details included in the sculpture.

1.3 Notre-Dame, Chartres Cathedral, Royal Portal west façade, left jamb, left portal 1: mid-body, hair.

Photo: Janet Snyder

The lexicon used in column-figure sculpture to communicate ideas concerning propriety, hierarchy, and order through dress was put to use in other northern European visual media. Manuscript illustrations, proto-portraits on personal seals, paintings, embroideries, and other decorative arts share the common vocabulary. Examples in other media illustrate the wider system of communication effected with this language. The hierarchy of dress was applied in a twelfth-century ivory game piece to narrate a critical scene from the story of Apollonius of Tyre (Fig. 1.4).[8] Making their escape from Tyre, Apollonius and his wife undertook a sea voyage during which she seemed to die in childbirth. The ivory carving captures the moment when superstitious sailors – in simple tunics with tight forearms – frightened by a terrible storm, are lowering her sealed coffin into the raging sea, under the direction of the helmsman – in a wide-sleeved loose

1.4 *Game Piece
with Episode
from the Life of
Apollonius of Tyre*,
c. 1170, walrus
ivory, Rhenish,
Cologne, c. 1170.
The Metropolitan
Museum of
Art, New York
(1996.224).

bliaut. Apollonius, the only figure in the game piece relief wearing a *bliaut* with a mantle fastened on his right shoulder, raises his hand to his brow in a gesture of the grief that is to trouble him until the legend's denouement. On a twelfth-century bronze 'Hansa' bowl, textile cues reveal the status of Cadmus, King of Thebes (Fig. 4.2).[9] Similar textile cues were employed in other media: in a contemporaneous manuscript illustration, the conquered enemies of the victorious *Humility* are marked with *ṭirāz* bands.[10] Just as, through features of their clothing, the participants in these ancient stories could be identified by contemporaries during the twelfth century, the status and rank of column-figure sculptures can be discovered by modern observers through an analysis of their represented dress. Among the column-figures, clear characteristics point to categories of high-status persons. The scarcity of written documentation from the twelfth century for the appearance of high-status persons handicaps description of their appearance, elevating the value of phenomenological evidence.[11]

Since there are multiple meanings for terms that define courtly persons and their stations within contemporary social structure, this chapter employs words for persons of rank that were currently in use during the twelfth century. Nouns that might seem to modern readers to provide appropriate vocabulary may not have been in use during the twelfth century or may have had different connotations. For example, the term 'Chevalier' is used here to describe someone who would have been wealthy enough to own a horse and be equipped to ride it, though that person might not have met all the requirements to be called a knight.[12] Since the close examination of represented dress is the goal, the nomenclature was selected to facilitate a discussion about that representation. *Le nouveau petit Robert* has been consulted for the lexicon.[13]

1.5 Saint-
Maurice, Angers,
right 3 (detail):
bliaut and
chemise hems.

Photo: Janet Snyder

The ensemble: 1, the chemise

The chemise, a floor-length, roomy undergarment with long narrow and rucked sleeves, was

the undergarment worn by both genders next to the skin.[14] On many column-figures, the chemise can be seen where it emerges around the edges of men's and women's garments. At Angers Cathedral, the chemise is visible in sculpture at the neckline, on forearms, and at the hem, below a lifted overgown (Fig. 1.5). The neck opening may not always be visible on column-figures, especially since the necklines of many figures were concealed with mantles draped across the chest and fastened on one shoulder. The shaped opening at the neck of this shirt appears to have a vertical slit at center-front (seen in the neckline of a garment hung in a tree, Fig. 1.96). The significance of the chemise has to do with propriety: an appropriate ensemble for any courtly person rightly included the chemise. A pin closing the chemise can be seen at the base of women's throats at Notre-Dame-en-Vaux (Figs 1.6, 1.7), Chartres Cathedral (Fig. 1.127), and Bourges Cathedral North (Fig. 1.54). Lower-status persons and figures considered 'Associates,' like stoic philosophers, might appear in the chemise without an overtunic (Figs 1.35/Pl. 1, the musician; and I.4, harvesters).

The ensemble: 2, the tunic and accessories

Three variations of a simple women's gown can be distinguished among the column-figures: the Grande Dame or Matron wears an ample tunic, the *cote*, cinched at the natural waist (Figs 1.8, 1.9); the Norman lady's gown is a torso-hugging, one-piece *bliaut* with a flared skirt (Figs 1.6, 1.7, 1.32, 1.33); the Courtly Lady or Gentlewoman's *bliaut gironé* features a separate skirt and bodice (Figs 1.10, 1.11, 1.36, 1.46, 4.17, 4.18).[15] It seems appropriate to recognize the distinction between the regional affiliations of women that can be discerned in ladies' gowns represented at the cathedrals of Chartres, Angers, and Rochester (compare Fig. 1.2 with women in Figs 1.32 and 1.33).

Even more strongly than the woman's gowns, the distinct arrangements of the elements of a man's ensemble appear to express the courtly rank of the wearer. For that reason, the forms of masculine

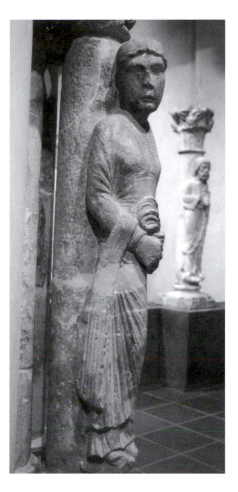

1.6 Notre-Dame-en-Vaux at Châlons-sur-Marne, *Young Woman column-figure*.

Photo: Janet Snyder

1.7 Notre-Dame-en-Vaux at Châlons-sur-Marne, *Young Woman*: upper body.

Photo: Janet Snyder

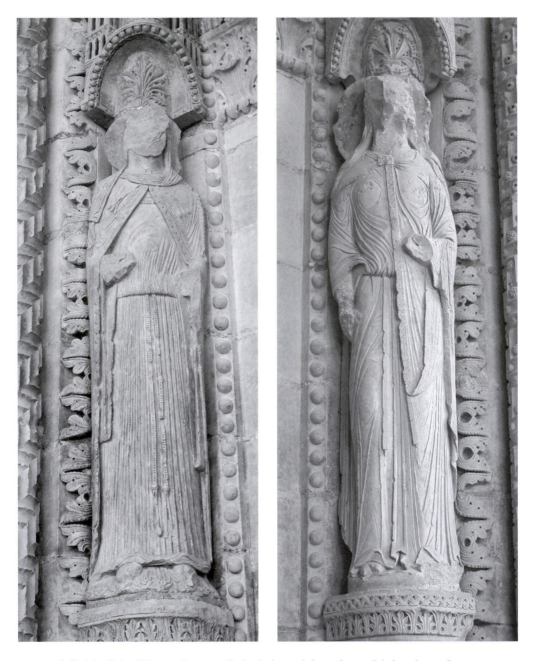

(*left*) 1.8 Saint-Etienne, Bourges Cathedral, north lateral portal, left, column-figure.

(*right*) 1.9 Saint-Etienne, Bourges Cathedral, north lateral portal, right, column-figure.

Photos: Janet Snyder

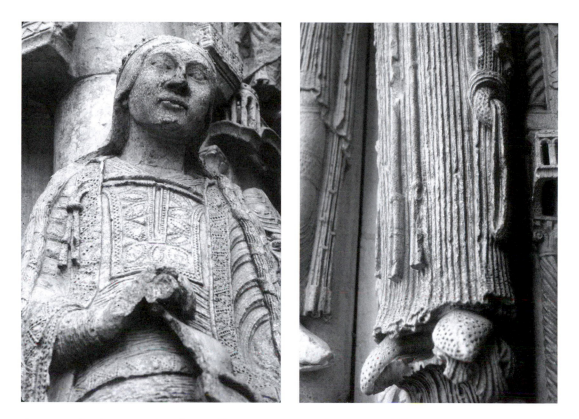

dress can be designated with specific words: Elite, Chamberlain, Monarch, Seigneur, Chevalier, Dignitary, Associate, and Clergyman. Although it appears that the *ymagiers* abstracted and translated reality by combining recognizable forms with exotic textiles in their stone representations, the resulting fictive garb was meaningful. The Elite *bliaut* skirt hangs in loose vertical folds from waist to the feet (Fig. 1.69). The hem of the Chamberlain's *bliaut* appears to have been draped diagonally from the side hem up towards the opposite hip, exposing the undertunic (Fig. 1.12). The unpleated regal dalmatic, open on both sides of a tunic that falls to just below the knees, partially conceals the Monarch's *bliaut*; a heavily textured border decorates the dalmatic hem (Fig. 1.13). In this period, the territorial magnates, the Seigneurs, imitated the rituals and governance of the king, but did not try to usurp the anointed one. The narrow, pleated and belted gown of the Seigneur reflects the regal model, with a *bliaut* hem that terminates just below knee level, revealing an ankle-length undertunic (Fig. 1.14). The seams of the Chevalier's *bliaut* skirt were left unsewn at the center in front and in back from hem to hip level (Fig. 1.15). Some Monarch column-figures appear in the Chevalier's *bliaut* since the king acted as the First Warrior in defense of the realm, the Church, and the poor (Figs 1.13, 1.80, 1.87). Further, a number of column-figure men in various *bliauts* stand out because they are Dignitaries. Dignitaries can be identified

(*left*)
1.10 Notre-Dame, Chartres Cathedral, Royal Portal west façade, left jamb, left portal 1: upper body.

Photo: Janet Snyder

(*right*)
1.11 Notre-Dame, Chartres Cathedral, Royal Portal west façade, left jamb, left portal 1 (detail): belt ends, shoes, left sleeve tippet knot.

Photo: Janet Snyder

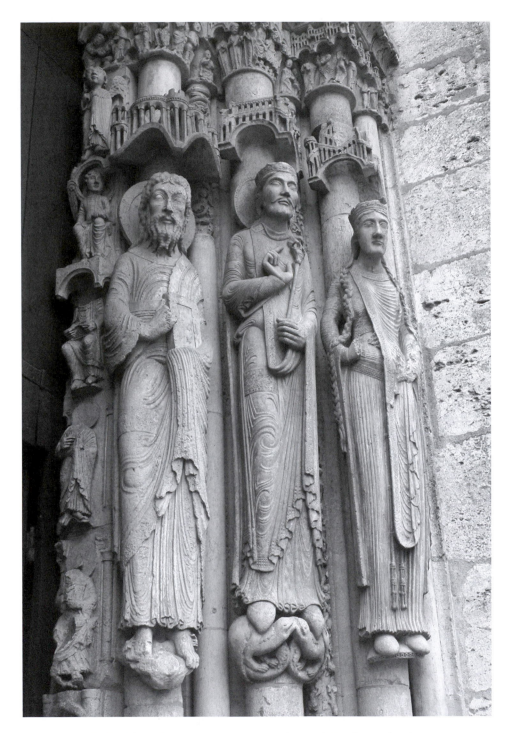

1.12 Notre-Dame, Chartres Cathedral, Royal Portal west façade,
right portal, right jamb, three column-figures, c. 1145.

Photo: Janet Snyder

1.13 Saint-Bénigne, Dijon, left jamb, c. 1160 (detail). From Dom Urbain Plancher, *Histoire general et particular de Bourgogne* (Dijon, 1739), p. 503.

Photo: Janet Snyder

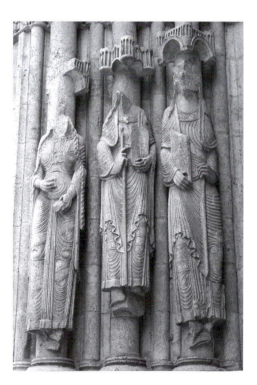

1.14 Notre-Dame du Fort, Etampes, south portal, left jamb, three column-figures, c. 1140.

Photo: Janet Snyder

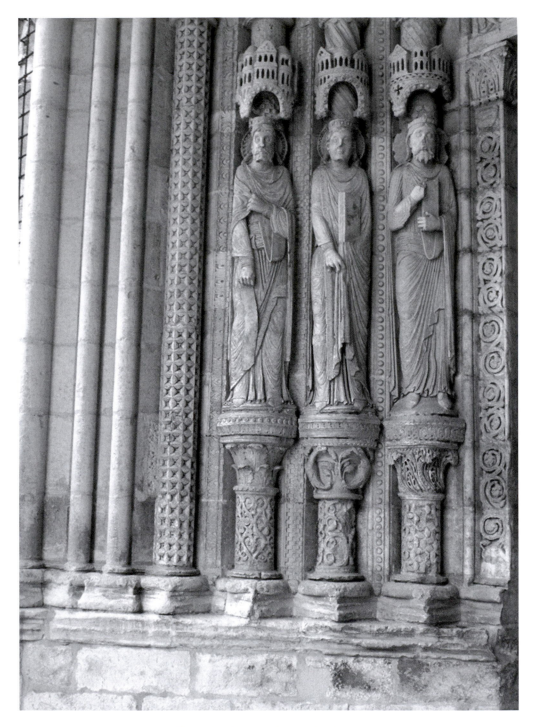

1.15 Saint-Etienne, Bourges Cathedral,
south lateral portal, left jamb.

Photo: Janet Snyder

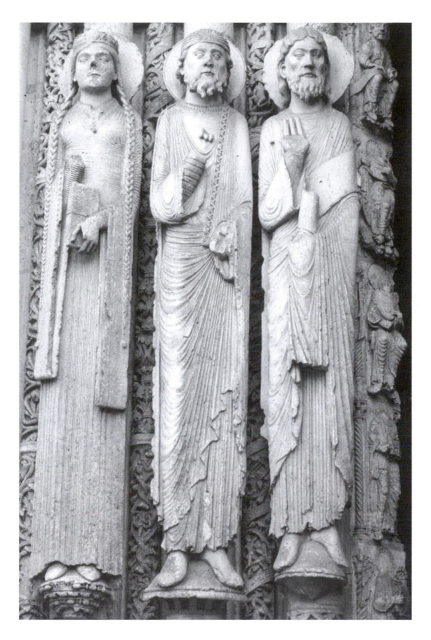

because their garb also includes the civil *pallium*, an additional length of wide fine fabric secured around the waist so that it conforms to the hip and torso, seemingly arranged in a fashion descended from the ancient Roman citizen's garb (Figs 1.16, 1.115). The dress of a few barefooted men appears to imitate that of ancient philosophers. As in images of ancient philosophers, the mantles of those who might be called the Associates of Christ are wrapped rather than fastened (Figs 1.17, 1.18, 1.43, 1.64). Clerical garb is considered under its own heading (Fig. 1.19).

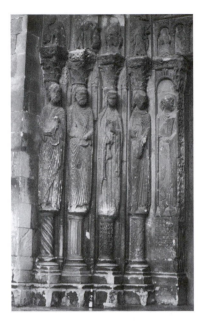

1.17　Saint-Julien, Le Mans Cathedral, left jamb, five column-figures, before 1158.

Photo: Janet Snyder

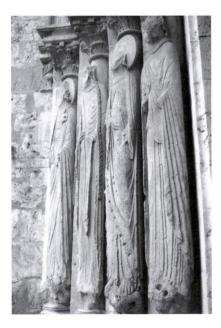

1.18　Saint-Ayoul, Provins, left jamb, column-figures, c. 1160.

Photo: Janet Snyder

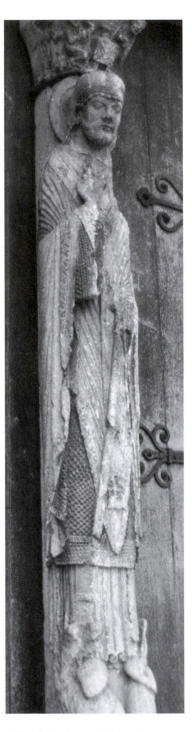

1.19　Saint-Loup de Naud, *trumeau* column-figure: Saint Loup, c. 1160.

Photo: Janet Snyder

Scholars have frequently considered headgear to be the determining identifier that signals vocation in medieval sculpture (Fig. 1.20). Though many column-figures have lost their heads, the remaining fragments may provide clues to identity (Figs 1.21, 1.22). Most of the extant column-figures appear to have been fitted with any one of a variety of headdresses and few remained bare-headed (Figs 1.23, 1.111). In some instances, a ribbon of gold, a *cercle*, appears to hold the hair in place, as at Angers Cathedral (Figs 1.10, 1.93). Crowns may or may not signify royal status; the typical form of a crown was a metal band of moderate width decorated with large lozenge- or geometrically shaped gems held in raised bezels, like those at Saint-Denis and Chartres Cathedral (Figs 1.53, 1.24).[16] Raised above the rim of the crown, cut or wrought points or *fleurons* frequently embellished this band, like the one that Harold wears in the Bayeux Embroidery (Figs 1.88, 1.89).[17] Remnants of such points are visible on the figure at Rochester Cathedral (Fig. 1.25). At Rochester, and also at Ivry (Fig. 1.26) and Bourges (Fig. 1.8), such decoration provides clear evidence for a crown having been originally part of the damaged figure's head.[18] Although the profile of a crown like the one worn by men at Angers and at Saint-Ayoul (Figs 1.31, 1.50) can be described as a narrow section of an inverted truncated cone, wider at the top, resembling the Byzantine *stemma*, European crowns were worn without the Byzantine pendants. Many of these European crowns appear to rest easily on the hair, just above the fullest circumference of the head, while others seem to compress the head (Fig. 1.22). A number of men's crowns appear to be slightly larger hats, combining the *stemma* form with a flat hat, as seen at Saint-Denis, at Angers Cathedral, and next to the low-relief jamb figure at Le Mans Cathedral (Figs 2.3, 1.21, 1.27).

Besides crowns, *cercles*, and circlets, two significant types of hats appear to be worn by column-figure personages. A domed hat with decreasing, ridged circles arranged concentrically around the head appears at Saint-Denis (Fig. 1.28) and at Bourges Cathedral (Fig. 1.29). A hemispherical hat in the form of a half-melon, with wedges flaring out from center-

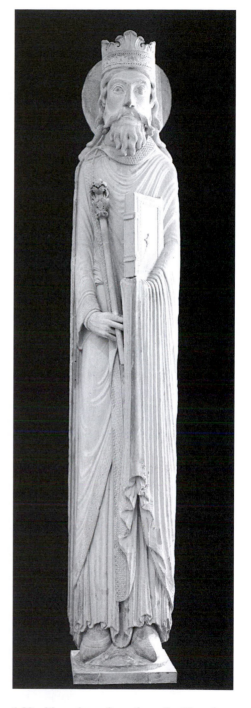

1.20 *Man column-figure* from the Church of Notre-Dame de Corbeil, west portal, c. 1158. Musée du Louvre, Paris, France.

Photo: Erich Lessing/Art Resource, New York

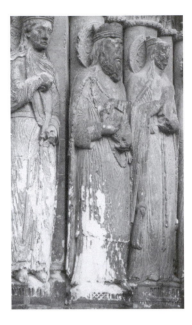

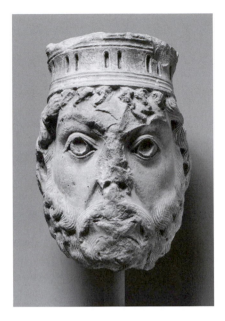

1.21 Saint-Maurice, Angers, left jamb, column-figures 4, 3, 2.

Photo: Janet Snyder

1.22 *Head of David* from the Portail Sainte-Anne, Notre-Dame, Paris. Metropolitan Museum of Art, New York, Harris Brisbane Dick Fund, 1938 (38.180).

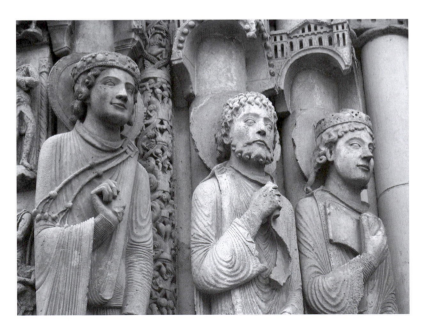

1.23 Notre-Dame, Chartres Cathedral, Royal Portal west façade, right portal, left jamb (detail): sleeve cuffs, mantle fastenings, c. 1145.

Photo: Janet Snyder

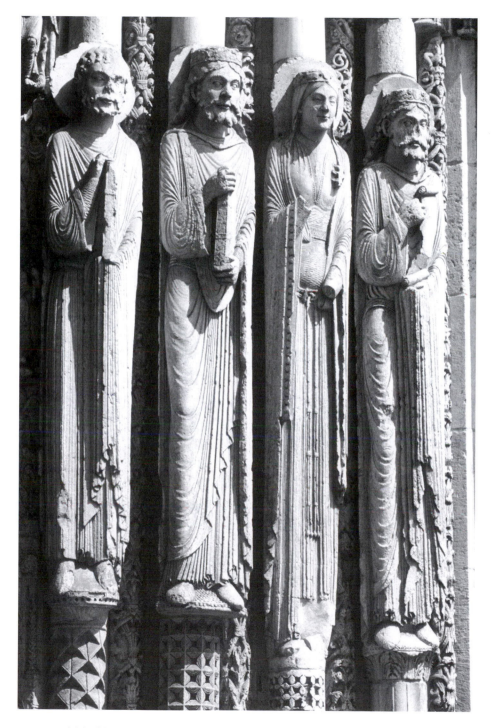

1.24 Notre-Dame, Chartres Cathedral, Royal Portal west façade, center
portal, right jamb, upper halves of four column-figures, c. 1145.

Photo: Janet Snyder

1.25 Rochester Cathedral (Kent), west portal, right jamb, *woman column-figure*: crown fragment at back of head.

Photo: Janet Snyder

1.26 Ivry, *woman column-figure*: belt at natural waist on *bliaut gironé*, no mantle, c. 1155–65.

Photo: Janet Snyder

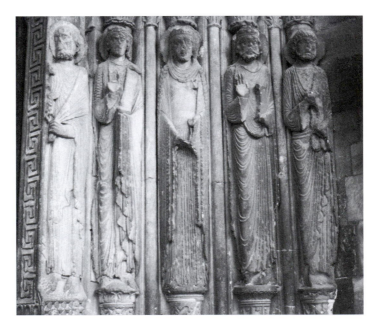

1.27 Saint-Julien, Le Mans Cathedral, right jamb, before 1158.

Photo: Janet Snyder

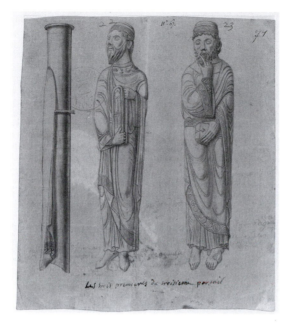

1.28 Abbey Church of Saint-Denis, west façade, right portal, left jamb, column-figures. Antoine Benoist drawings, BN, MS FR 15634, folio 71. Bibliothèque nationale de France.

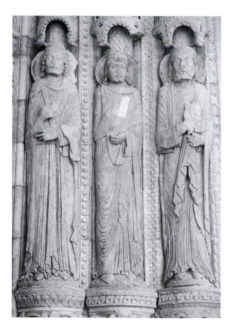

1.29 Saint-Etienne, Bourges Cathedral, south lateral portal, right jamb.

Photo: Janet Snyder

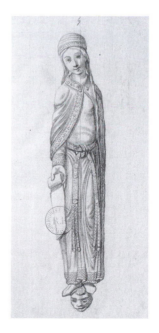

1.30 Abbey Church of Saint-Denis, west façade, column-figure CR1. Antoine Benoist drawing, BN, MS FR 15634, folio 50. Bibliothèque nationale de France.

front and compressing again at center-back, also appears at Saint-Denis (Figs 1.28, 1.109, 2.3) and at Bourges Cathedral (Fig. 1.29). Men appear with this 'half-melon' at Chartres Cathedral (Figs 1.16, 1.114), but it appears worn by both genders at Saint-Denis (Fig. 1.30).

The ensembles of women

Grande Dame/Matron

The *cote*, the one-piece *bliaut*, and the *bliaut gironé* signal women's place in society. Around 1100 in northern Europe, a woman's everyday dress had been the *cotte* or *cote*, a simple, moderately loose, mid-calf-length tunic with long sleeves, belted at the natural waist. Illustrating the conservative style of a matron, this simple tunic belted at the natural waist barely reveals the curves of a woman's body. It is this garment, complete with the pendant sleeve tippets characterizing the gowns of all elite women, that appears to be worn by the women in the *Bayeux Embroidery*.[19] Among column-figure women, one Grande Dame in a *cote* appears at Angers Cathedral (Figs 1.31, 1.21, 4.19/Pl. 18), and another appeared at the Portail Sainte-Anne at Notre-Dame of Paris.[20] Very similar to the *cote* were the *chainse* or *cainsil*, gowns that were more than a chemise, but less than a *bliaut*, differing primarily from the *cote* in their fabrication in white linen.[21] Since it was an everyday gown, it is unlikely that the *chainse* would have been illustrated among the high-status women in portal sculpture.

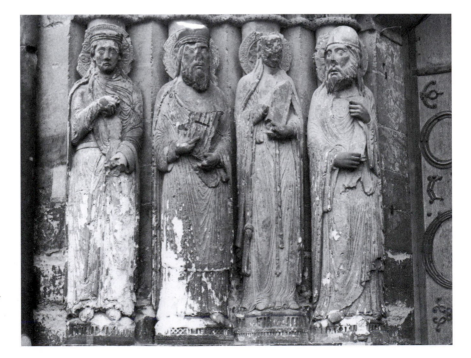

1.31 Saint-Maurice, Angers, left jamb, column-figures.

Photo: Janet Snyder

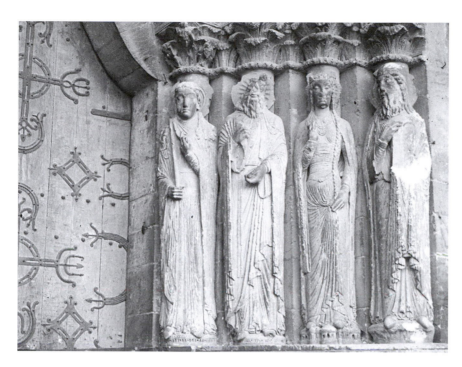

1.32 Saint-Maurice, Angers, right jamb, column-figures.

Photo: Janet Snyder

NORMAN LADY

The early years of the twelfth century were characterized by a transition in feminine silhouette towards a slimmer form, as the conservative *cote* was replaced as the women's courtly dress by a cinched and form-revealing gown.[22] The fit distinguishes the women's gowns represented on the right jambs at Angers, Saint-Denis, and Rochester Cathedral (Figs 1.32, 1.30, 1.33). Each of these one-piece *bliauts* has a closely fitting bodice, an ankle-length flared skirt, and very long, comparatively loose sleeve cuffs. In these column-figures, no evident seam was sculpted at the join of the bodice and skirt, apparently indicating that this gown would have been cut from neckline to ankle out of a single length of cloth. The drapery described in stone carving suggests the bias drapery and the slight flare of the skirt would have been caused by the insertion of triangular wedges of fabric (gores),[23] with the narrow point of the gore at the hip and the wider part at the hem. The appellation 'Norman' seems to suit this one-piece *bliaut* since among surviving mid-twelfth-century sculpture it appears primarily in extant sculpture at churches north and west of Paris. A round neck opening allowed the *bliaut* to be slipped

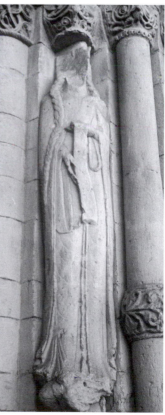

1.33 Rochester Cathedral (Kent), west portal, right jamb, *woman column-figure.*

Photo: Janet Snyder

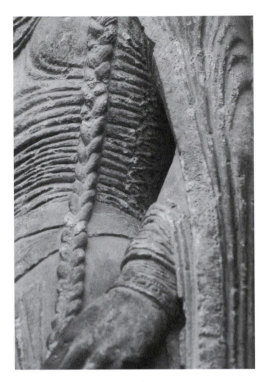

1.34 Saint-Maurice, Angers, right jamb 3 (detail): *bliaut* side lacing.

Photo: Janet Snyder

on over the head, and laces cinched the slim bodice snugly around the torso (Fig. 1.34). Only at Angers Cathedral was the lacing along the left side of the column-figure illustrated, giving form to the poetic description in Marie de France's *Lanval* which specified this side closure as well as colors, horse, and hunting animals:[24]

… They were about to give their judgment when through the city came riding a girl on horseback: there was none more beautiful in the world. She rode a white charger, who carried her handsomely and smoothly: he was well apportioned in the neck and head, no finer beast in the world. The horse's trappings were rich; under heaven there was no count or king who could have afforded them all without selling or mortgaging lands. The young girl was dressed in this fashion: in a chemise and a tunic that revealed both her sides since the lacing was on each side. Her body was elegant, her hips slim, her neck whiter than snow on a branch, her eyes bright, her face white, a beautiful mouth, a well-set nose, dark eyebrows and an elegant forehead, her hair curly and rather blond; golden wire does not shine like her hair in the light. Her mantle, which she had wrapped around her, was dark purple, and its edges were beautifully tailored. On her wrist she held a sparrow hawk, a greyhound followed her …

At Angers Cathedral, the one-piece *bliaut* appears to have been secured with a thin, straplike belt at the natural waistline. A Limoges enameled casket ascribed to the court of Aquitaine illustrates the colorful patterned textiles and graceful movements of such a Norman *bliaut* (Fig. 1.35/Pl. 1).[25]

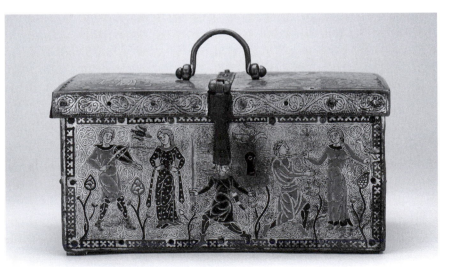

1.35 *Enamel Casket*, c. 1180, Limoges, from the court of Aquitaine. The British Museum (M&LA, 1859,0110.1). © Trustees of the British Museum.

Contemporaneous wall paintings of women at Montmorillon in western France and at Copford Church in Essex further locate this *bliaut* in French-speaking areas outside north-central France (Fig. 1.130).[26]

GENTLEWOMAN/COURTLY LADY

By the 1130s, gentlewomen in northern French courts appeared wearing a startling new fashion, the *bliaut giroté*, made in two pieces. This gown characterizes church portal sculpture programs from 1140 until the late 1160s, and 21 of the 28 women column-figures for which there is good evidence among the northern church portal programs are carved as if wearing this fashionable gown (Fig. 1.1). The Lady's *bliaut giroté* had a closely fitted bodice, rucked or pleated vertically, with a separately constructed skirt that was finely pleated horizontally into a fitted, low waistband (Fig. 1.36). The great quantity of the fine textile used for a skirt can be seen in a hem at Chartres Cathedral since deep pleats were indicated in the sculpted fabric (Figs 1.37, 1.38). Apparently, the tailor took advantage of the long dimension of the woven cloth to produce the skirt's circumference, taking the selvages into the waistband and the hem (Figs I.8, 1.11). The long warp threads of the skirt fabric run in the same direction as the selvages. Shorter weft/woof yarns extend across the width of the fabric. The warp direction was used horizontally in the skirts of the *bliaut giroté*, allowing the weft yarns to be arranged carefully in narrow vertical pleats that were custom-fitted around the hips and set into a waistband. Pleats that would fall practically parallel to each other were created as the tailor delicately tucked the stuff, joining the skirt to a lowered waistband (Figs 1.1, 1.36, 1.60, 4.17). Archaeological finds in contemporaneous West Scandinavian burial sites have been identified as the northern equivalent of the skirts worn by twelfth-century women column-figures.[27]

1.36 Notre-Dame, Chartres Cathedral. Royal Portal west façade, left jamb, left portal 1: belt and waistband; hand.

Photo: Janet Snyder

1.37 Notre-Dame, Chartres Cathedral, Royal Portal west façade, right portal, right jamb 3: deeply pleated hem, mantle on column, pendant belt ends, sleeve tippet, c. 1145.

Photo: Janet Snyder

1.38 Notre-Dame, Chartres Cathedral, Royal Portal west façade, center portal, left jamb (detail): feet of column-figures 3, 2, 1, c. 1145.

Photo: Janet Snyder

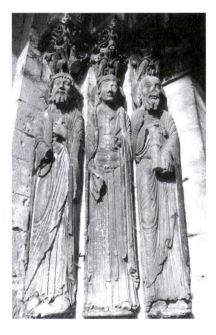

1.39 Saint-Loup de Naud, left jamb, column-figures, c. 1160.

Photo: Janet Snyder

1.40 Notre-Dame, Chartres Cathedral, Royal Portal west façade, center portal, left jamb 3: sleeve detail, hips and column, c. 1145.

Photo: Janet Snyder

Many art historians had considered the regular, parallel folds in twelfth-century sculpture to be an artistic convention until the discovery of these contemporaneous finely pleated fabrics showed that the *ymagiers* had been depicting a genuine style of costume. The bodice sleeves of the *bliaut gironé* terminate at the elbow or on the forearm (Figs 1.39, 1.24, 1.42, 1.44, 4.8) but their freely hanging pendant cuffs are so long that some appear to have been knotted as if to prevent their dragging underfoot (Figs 1.1, 1.11); others flare from the elbow crease, with the broad cuffs folded back upon themselves (Fig. 1.40). The *ymagiers* carefully illustrated how these pendant cuffs were secured with strong understitching (Figs 1.41, 1.42, 1.44, 4.8).

THE SIGNIFICANCE OF THE BELT

A doubly wrapped belt, the *ceinture*, distinguishes many twelfth-century ensembles of women (Fig. 1.36). At 13 church doorways the carvers indicated that the ensemble of most women in the *bliaut gironé* included the doubly wrapped *ceinture*. Each column-figure's *ceinture* was secured with a unique knot (Fig. 1.42). The center of this doubly wrapped *ceinture* was placed above the waist, over the diaphragm in front; it crossed around behind the lower back and then returned to be fastened in front with the decorative knot, low over the pelvic bone (Fig. 4.8). Below the knot, the ends of the belt appear to be weighted and decorated with knots, cords, baubles or fringe, and fall nearly to the ankles (Figs 1.43, 1.1, 1.12, 1.14, 1.26, 1.30, 1.37, 1.49, 1.50, 1.121, 4.18).[28]

The intricacy and variety in the forms of women's *ceinture* fastenings command attention. It is likely that the regular patterned surface of the doubly wrapped *ceinture* could have been produced by the technique of tablet-weaving and combined the belt ends with tubular or bundled cords.[29] If tablet-woven of fine materials like soft leather or silk yarn, *ceinture*s might have been decorated further, appliquéed or embroidered with precious gold or silver thread and set with pearls.[30] The doubly wrapped belt represented in most of the column-figure women sculptures emphasizes the rounded lower abdomen,

1.41 Notre-Dame, Chartres Cathedral, Royal Portal west façade, center portal, left jamb 3: no knotted belt, no mantle, sleeve understitching, c. 1145.

Photo: Janet Snyder

1.42 Notre-Dame, Chartres Cathedral, Royal Portal west façade, center portal, right jamb 3: sleeve border understitching, belt, c. 1145.

Photo: Janet Snyder

1.43 Saint-
Julien, Le Mans
Cathedral,
left jamb,
column-figures,
before 1158.

Photo: Janet Snyder

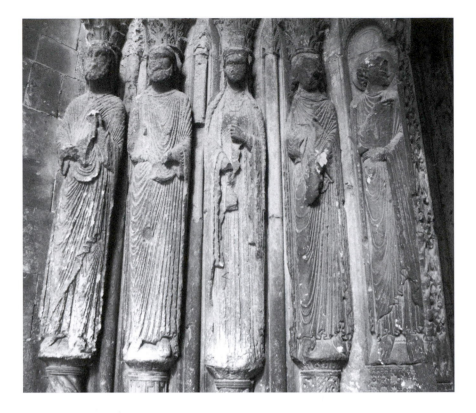

typical of the mature female form (Figs 1.44, 4.17, 4.18). The emphasis on the woman's womb that is framed by this belt endows this accessory with power; in column-figure sculpture, even when the knot might have been concealed by drapery, the long, pendant ends were sculpted, calling attention to this feature (Fig. 1.37). Apparently this arrangement functioned as part of the vestiary language, conveying information about rank, marital status, and fertility.

That this complex belt, doubly wrapped and knotted to emphasize the womb, was a significant part of a courtly woman's dress is confirmed by proto-portraits on seals like those of Ida, Countess of Nevers, or of Agnès, Countess of Bar (Fig. 1.45).[31] A belt figures

1.44 Notre-Dame, Chartres Cathedral, Royal Portal west façade, center portal, right jamb 3: bulging womb, belt with knot, c. 1145.

Photo: Janet Snyder

significantly in the plots of *Eliduc* and *Lanval*, late-twelfth-century *lais* by Marie de France.[32] Column-figures with doubly wrapped *ceintures* include four of the five women column-figures at Chartres Cathedral (Figs 1.1, 1.2, 1.12, 1.42, 1.44), and women at Saint-Denis (Figs 1.46, 1.30), Notre-Dame du Fort at Etampes (Fig. 1.14), Nesle-le-Reposte (Fig. 1.121), Saint-Ayoul (Figs 1.50, 1.57), the Portail Sainte-Anne at Notre-Dame of Paris (Fig. 1.48), Saint-Germain-des-Prés (Fig. 1.59), Saint-Loup de Naud (Fig. 4.8), Le Mans (Fig. 1.43), Notre-Dame of Corbeil (Fig. 1.49), and Saint-Thibaut (Fig. 1.60). If two women column-figures stand on the jambs of a doorway, only one woman is represented as if wearing a *ceinture* with pendant ends, except at the center portal at Chartres Cathedral where there are three women, where the only one of those three without a belt also appears without a mantle (Figs 1.2, 1.41).[33]

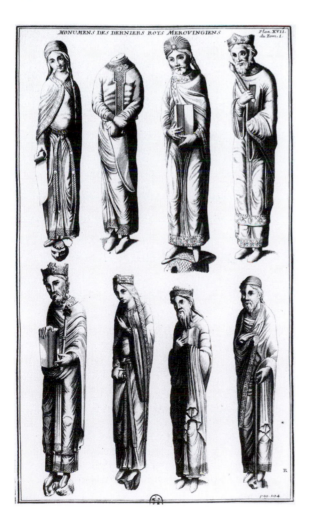

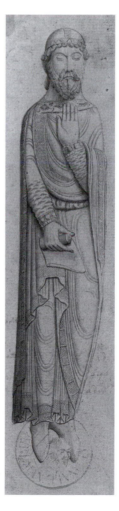

(*top*) 1.45 *Seal of Agnes of Bar*. Cast no. 26, Département de Sigillographie, Archives nationales, used by permission.

Photo: Janet Snyder

(*left*) 1.46 Abbey Church of Saint-Denis, west façade sculpture. From Dom Bernard de Montfaucon, *Monumens des derniers roys merovingiens* (1729), vol. 1, pl. 17.

(*right*) 1.47 Abbey Church of Saint-Denis, west façade, right portal, left jamb, column-figure. Antoine Benoist drawing, BN, MS FR 15634, folio 70. Bibliothèque nationale de France.

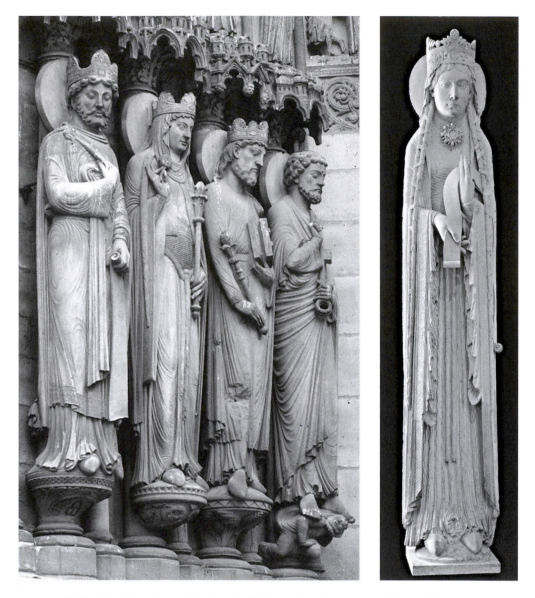

(*left*) 1.48 Notre-Dame, Paris cathedral, west façade, right portal (Portail Sainte-Anne), c. 1155–65. Nineteenth-century reconstruction of left jamb column-figures.

Photo: Janet Snyder

(*right*) 1.49 *Woman column-figure* from the Church of Notre-Dame de Corbeil, west portal, c. 1158. Musée du Louvre, Paris.

Photo: Erich Lessing/Art Resource, New York

VEILS AND LADIES' COIFFURES

Neither within nor entirely outside the church, women column-figures in the transitional, liminal zone of the church portals were depicted with many different kinds of hairstyles and headdresses. About one-third of the women shown in mid-twelfth-century painting and sculpture appear with no veil. Although a mantle could function as a headcovering, the supposition that women were never without a veil must be tempered.[34] Chaplets, *cercles*, and coronets appear to have been worn directly on the hair, without a veil (Figs 1.10, 1.127). Alternatively, these might be used to secure the *voile*, a small nearly-square rectangular cloth that rests on the crown of the head, falling as far as the shoulders, as seen on the woman from Corbeil (Fig. 1.49) and at Chartres Cathedral (Fig. 4.6).[35] In this period, women's veils would have been made of the finest soft linen or silk fabric and might have been trimmed with delicate embroidery or pearled borders. The long rectangle of fine fabric worn on the top of the head and draped across the throat, the *guimple*, was always represented in conjunction with a crown. It appears at Chartres Cathedral with the long ends arranged in a circle around the face (Fig. 1.2), and as a scarf circling women's throats at Bourges (Fig. 1.54/Pl. 3), Notre-Dame du Fort at Etampes (Fig. 1.77), Ivry (Fig. 1.55), Le Mans (Fig. 1.27), and Saint-Ayoul (Fig. 1.50).[36] It is unusual when the veil virtually conceals a woman's hair, as it does on one figure at Chartres (Fig. 4.6).

No female column-figure appears with loose hair. The majority of column-figure women appear to have their hair arranged in extraordinarily long plaits, some extending to the level of their knees (Figs 1.51, 1.52, 1.32, 1.49). The hair appears to have been divided into two tresses by a center part (the *grève*) from forehead to nape.[37] It is possible to see this division on the back of the extant head of a crowned woman from Saint-Denis (Fig. 1.53) and the young woman from Notre-Dame-en-Vaux (Fig. 1.56).[38] In some depictions, the *ymagiers* arranged the long, heavy

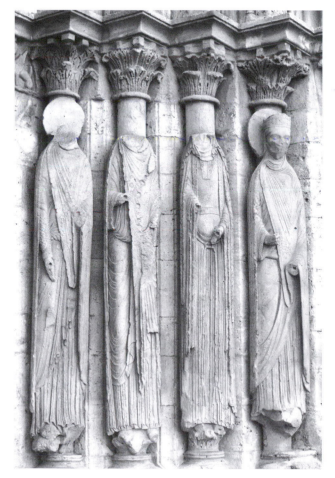

1.50 Saint-Ayoul, Provins, right jamb, column-figures, c. 1160.

Photo: Janet Snyder

1.51 Saint-
Germain-des-
Prés, west
façade, left jamb
column-figures,
c. 1163 (detail).
From Dom
Jean Mabillon,
*Annales Ordinis
S. Benedicti, II*
(Paris, 1703–39),
vol. 1, lib. 6,
n. 69, p. 169.

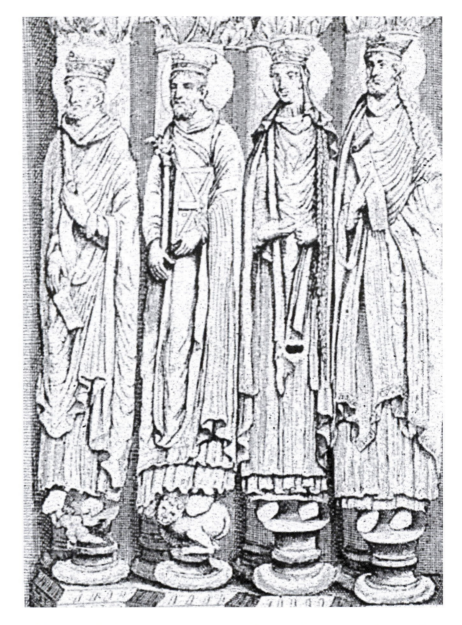

braids *en trecié* of many women column-figures along the outside profile of
their arms (Fig. 1.2).[39] This horizontal expansion of the figure appears to take
advantage of the greater width of the diagonal dimension of the limestone
block.[40] Simple braids *en trecié* were regularly depicted with a ball or tassels
pendant from the bound-up tip of the braid, visually extending the length
of the hair: these can be seen at Chartres (Fig. 1.40), and on the left jamb at
Bourges (Figs 1.54/Pl. 3, 1.8). Braids *en trecié* appear at Angers (Fig. 1.34),
Chartres (Figs 1.2, 1.40, 1.69), Etampes (Fig. 1.77), Ivry (Fig. 1.55), Le Mans
(Fig. 1.27), and Rochester (Fig. 1.33).

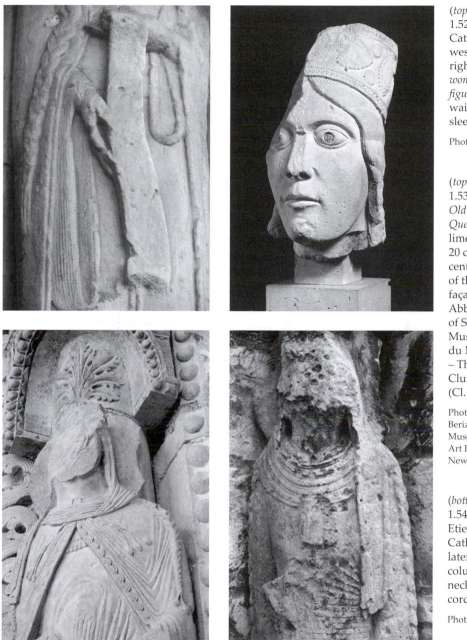

(top left)
1.52 Rochester Cathedral (Kent), west portal, right jamb, *woman column-figure* (detail): waistband, sleeve, hair.

Photo: Janet Snyder

(top right)
1.53 *Head of an Old Testament Queen*, c. 1140, limestone, 32 × 20 cm, from the center portal of the west façade of the Abbey Church of Saint-Denis. Musée national du Moyen Age – Thermes de Cluny, Paris (Cl. 23250).

Photo: Jean-Gilles Berizzi. Réunion des Musées Nationaux/ Art Resource, New York

(bottom left)
1.54 Saint-Etienne, Bourges Cathedral, north lateral portal, left column-figure: neckline, braid, cord and tassels.

Photo: Janet Snyder

(bottom right)
1.55 Ivry, *woman column-figure*, c. 1155–65: hair, *guimple*.

Photo: Janet Snyder

The extreme length of the braids depicted in female column-figure sculpture strains credulity. The preferred represented fashion in the sculpted hairstyles seems to substantiate concerns expressed in contemporary sermons that urged women not to purchase hair (of dead women) with which to supplement their natural hair. Archaeological finds in London verify that tresses of silk, flax, or wool were also used to supplement human hair.[41] The

(left)
1.56 Notre-
Dame-en-Vaux
at Châlons-
sur-Marne,
Young Woman,
hair encased in
fabric tube.

Photo: Janet Snyder

(right)
1.57 Saint-
Ayoul, Provins,
right jamb 3:
finished carving,
c. 1160.

Photo: Janet Snyder

young woman in the cloister of Notre-Dame-en-Vaux at Châlons-sur-Marne (Fig. 1.56) illustrates an arrangement in which the hair is enclosed in a tube of fabric that could have been filled with padding or artificial hair and bound with ribbon to conceal the actual length of the woman's hair.[42] One means of avoiding the shortening of the natural length of hair that occurs with the folding and crimping characteristic in traditional braiding is to divide each of the tresses into two sections to be intertwined with ribbons, exploiting to the fullest extent the natural length of the hair. Commonly among the column-figure women, the hair was shown dressed with the tresses carved as if not braided but hanging straight, like bundles of cords, with ribbons delicately twined around (Fig. 1.53) and into the hair (Fig. 1.57, 4.17), or with ribbons of various widths wrapped in an x-pattern around the bundled cords, as at Notre-Dame de Corbeil (Fig. 1.49). Beribboned tresses *en galonné* appear at Bourges (Fig. 1.58), Chartres (Fig. 1.3), Etampes (Fig. 1.14), Nesle-la-Reposte (Fig. 1.121), Saint-Loup (Fig. 4.8), Saint-Germain (Fig. 1.59), and Saint-Thibaut (Fig. 1.60).[43]

As will be discussed in Chapter 3, 'Good Business,' in the 1160s, the fairs of Champagne and Brie emerged as centers of mercantile exchange in northern

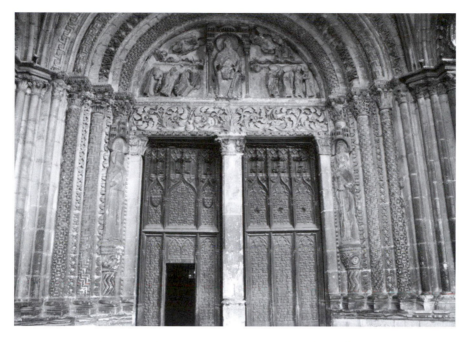

1.58 Saint-Etienne, Bourges Cathedral, north lateral portal.

Photo: Janet Snyder

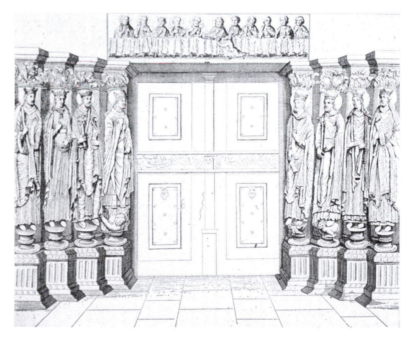

1.59 Saint-Germain-des-Prés, west façade with column-figures, c. 1163. From Dom Jean
Mabillon, *Annales Ordinis S. Benedicti, II* (Paris, 1703–39), vol. 1, lib. 6, n. 69, p. 169.

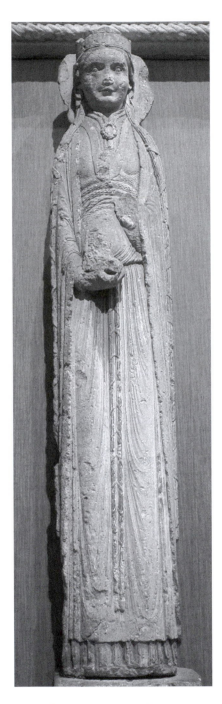

Europe. During this decade, as the daughters of Louis VII, Marie and Alix, assumed their status at the centers of their husbands' courts in Champagne and Blois respectively, a significant fashion shift occurred in northern Europe, and this is reflected in the style of dress depicted in the seal of Marie de Champagne, Countess of Champagne (Fig. 1.61).[44] While the mid-twelfth-century's courtly pendant sleeves were retained during this fashion shift, the textiles represented in sculpture appear to have been replaced. The softening of the silhouette makes clothing appear to have been made of the more substantial cloth traded at the fairs: wool (*escarlet*, *fustian*) and heavier silks (*samite*, *cendal*, and *damask*). As will be discussed in Chapter 4, 'Significant Stuff,' by the end of the century women's dress was illustrated draped in the broader folds characteristic of substantial northern textiles.

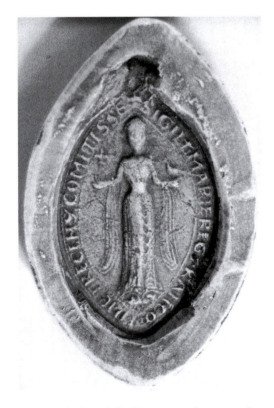

1.60 *Column-figure of a haloed queen*, limestone, from Saint-Thibaut, Provins. Glencairn Foundation. Bryn Athyn, Pennsylvania (09.SP.103).

Photo: Janet Snyder

1.61 *Seal of Marie de Champagne* , Countess of Champagne (daughter of Louis VII). The same matrix was used in 1184 and 1193. Cast no. 523B, Département de Sigillographie, Archives nationales, used by permission.

Photo: Janet Snyder

The ensembles of men

Among the column-figures can be discovered the characteristic styles of clothing worn by men who participated in the complex structure of social networks, military fellowships, courts attached to lords and princes, and as independent peers of the realm, and so on. Like the dress of women, masculine costume reflected a tendency toward slimness in the early twelfth century, though apparently men's garments did not require a comparable delicacy in tailoring.[45] Similarly to women's dress, the male chemise undergarment can be discerned in column-figure sculpture. It appears along the forearms, variously rucked, crumpled, or pushed up, and occasionally can be seen at the necklines (Figs 1.23, 1.24, 1.129).

In manuscript illuminations, in painted stained glass, and in ivory or metalwork figures, men's clothing is regularly illustrated with a center-front neck opening that has a vertical slit, like that of the kneeling king in the tympanum of the Portail Sainte-Anne (Fig. 1.107). In contrast to those examples, among men column-figures this center-front neck closure is rarely seen. The center-front neck opening can be observed frequently in the clothing of women, with the singular depiction on a man's neckline at Le Mans Cathedral (Fig. 1.43). Only visible when the mantle is not fastened, the neckline of the male *bliaut* was usually a high, curved opening at the base of the throat, closed imperceptibly with an overlap or along the shoulder (Figs 1.62, 1.29).[46] For the 33 male column-figures whose mantles are not fastened, most necklines were carved as wide ovals like those of the Dignitaries at Saint-Loup de Naud (Figs 1.63, 1.39) and Rochester Cathedral (Fig. 1.126). When conspicuous, the neckband may appear to be decorated with an applied band of embroidered or jeweled decoration (Fig. 1.92/Pl. 7) that could be depicted in sculpture (Figs 1.64, 1.65) by means of carved three-dimensional forms that suggest ornamental pearls, jewels, and embroidery in patterns much like the forms characteristic of extant *ṭirāz* textiles or tablet-woven bands (Figs 1.1, 1.115, 2.4).[47] Usually the upper section of a man's overtunic was cut with greater fullness than the bodice of a women's *cote* or *bliaut* might have been, so that the man's *bliaut* appears to blouse loosely over a cinch at the natural waistline (Figs 1.69, 1.23). Open mantles and oval neck openings continued

1.62 Abbey Church of Saint-Denis, west façade, column-figure CR2. Antoine Benoist drawing, BN, MS FR 15634, folio 58. Bibliothèque nationale de France.

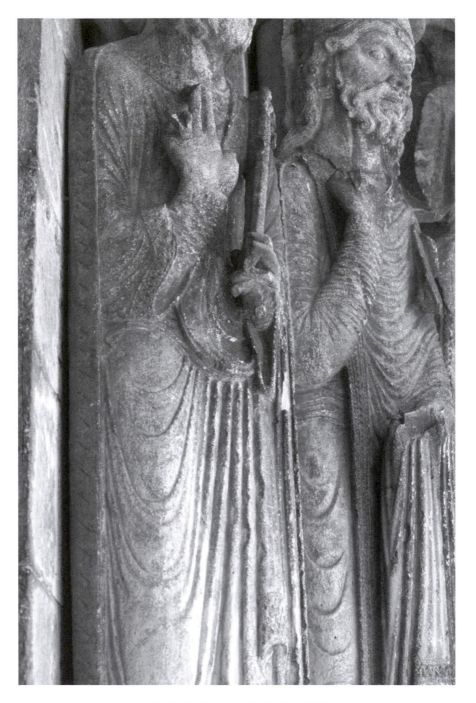

1.63 Saint-Loup de Naud, right jamb,
c. 1160 (detail): R1 holds single key.

Photo: Janet Snyder

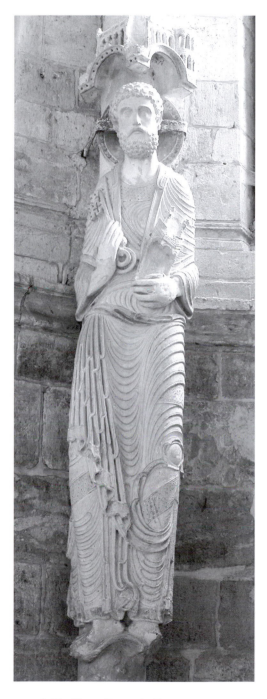

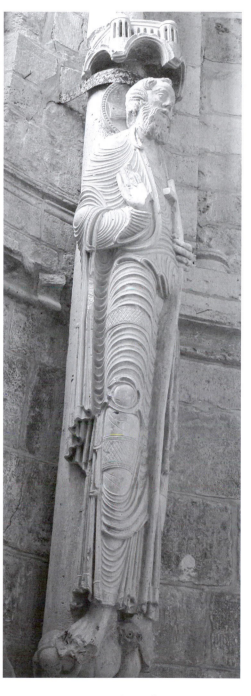

1.64 Notre-Dame du Fort, Etampes,
interior chapel: northwest column-
figure holding keys in Seigneurial *bliaut*
with diagonal *ṭirāz* bands, c. 1160.

Photo: Janet Snyder

1.65 Notre-Dame du Fort,
Etampes, interior chapel: southeast
column-figure holding cross-staff,
ṭirāz on thigh, c. 1140.

Photo: Janet Snyder

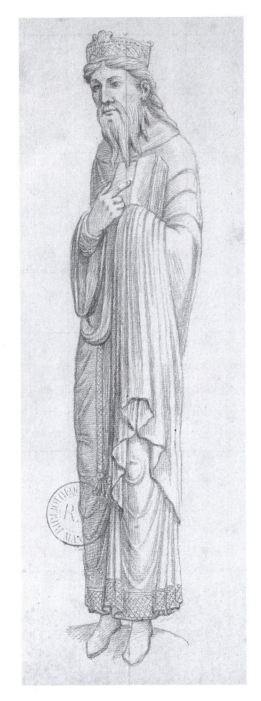

to be depicted into the later 1160s when, with the viability of Philippe Dieu-Donné, men's dress manifested the shifts in the form and materials then current in women's clothing, with less-fitted *bliauts* appearing to have been produced using substantial northern fabrics.

Ceintures with long pendant ends appear not only on most of the column-figure women but also on men at Saint-Denis (Fig. 1.66/Pl. 4) and Saint-Germain-des-Prés (Fig. 1.51). Men's belts with pendant and tasseled ends were depicted on the lifesize 'Wolfram' bronze candlestick at Erfurt Cathedral, where pendant belt ends that hang to the figure's knees were inscribed with text,[48] and also on the jamb relief Chevalier at Kilpeck, Herefordshire (Fig. 1.67). Tassels decorate the pendant belt ends of the cloister figure from Saint-Denis now at the

1.66 Abbey Church of Saint-Denis, west façade, column-figure CL3. Antoine Benoist drawing, BN, MS FR 15634, folio 55. Bibliothèque nationale de France.

1.67 Kilpeck (Herefordshire), Norman village church, portal, left jamb relief figure: chevalier's open-seam tunic, knotted belt with pendant ends, helmet.

Photo: Janet Snyder

Metropolitan Museum, resembling those of a column-figure at Saint-Denis (Figs 1.68, 1.66/ Pl. 4).[49] The broad sash of the cloister figure formally resembles the textile cummerbunds of Islamic costumes, and also the girdle form of the civil *pallium*.[50] This broad sash on the cloister figure seems to conceal a belt whose pendant, tasseled ends signal a buckled or knotted fastening.[51] It is likely that perceived anomalies in the clothing of the cloister figure reflect a modern misreading of the significance of the belt and the civil *pallium*.[52]

ELITE

By the 1130s, the simplest style of *bliaut* appears to have been the garment of an Elite, one of the 'chosen few,' part of the group of persons who were considered better than others, and who served as remarkable leaders in their communities.[53] Some of the column-figures designated Elite through this *bliaut* hold attributes identifying them as disciples; their ensembles will be discussed below as Associates (Fig. 1.12 left). Many Elite column-figure men are marked as Dignitaries as well (Fig. 1.16 center). The ubiquitous Elite *bliaut* (Figs 1.69, 1.17, 1.39) features a bodice bloused loosely over the belt cinched at the natural waistline; loose, non-fitted sleeves extending along the forearms to near the wrist; and a skirt hanging in soft folds around the legs to the ankles. Not at all form-revealing, the sleeves of this loose tunic generally display relatively wide wrist openings. A band of embroidered or appliquéd decoration may trim the lower edge (Fig. 1.62). Although some hems were carved to fall in a jagged outline of pleats above each foot (Fig. 1.111), the lower hem of the Elite *bliaut* usually appears to hang relatively horizontally.

In the 1140s, before their installations as ranking clergymen, two younger brothers of Louis VII employed seals with proto-portraits that showed images of themselves dressed in the Elite *bliaut* and mantle (Figs 1.70, 1.71). One

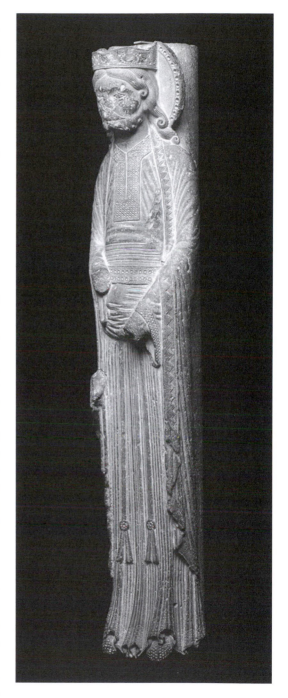

1.68 Cloister figure of a nimbed king, c. 1145–55, from the Abbey Church of Saint-Denis: Elite *bliaut* with mantle, girdle-*pallium*, pendant belt ends fall to mid-calf, with tassels. The Metropolitan Museum of Art, New York (20.157).

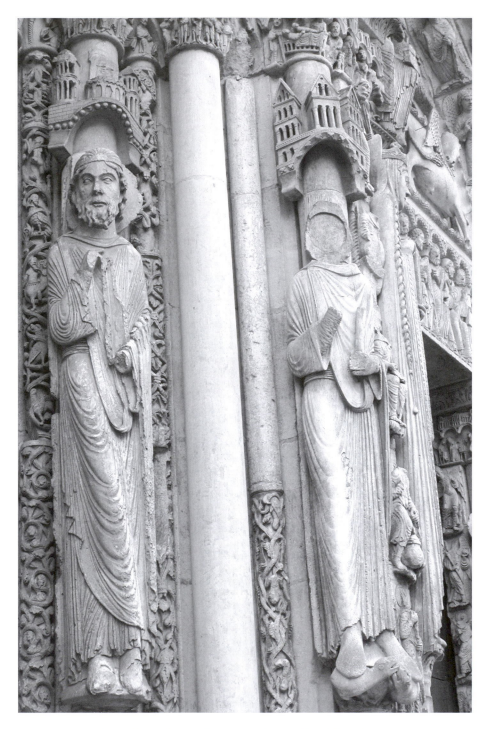

1.69 Notre-Dame, Chartres Cathedral, Royal Portal west
façade, left portal, right jamb, column-figures.

Photo: Janet Snyder

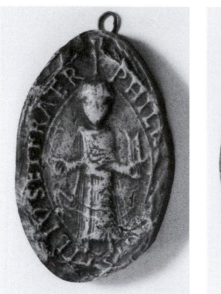
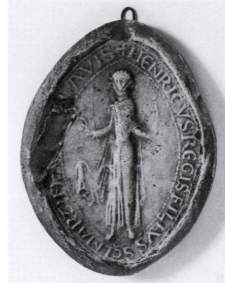

(*left*) 1.70 *Seal of Philippe de France* (brother of Louis VII), 1140s. See L.C. Douët d'Arcq, *Inventaire de la collection des sceaux des Archives nationales* (Paris, 1863–68). no. 9181. Cast, Département de Sigillographie, Archives nationales, used by permission.

Photo: Janet Snyder

impression of the seal of Henri de France (1121–75), who was tonsured in 1134, can be dated c. 1146 because of the charter to which it was appended.[54] Though he resigned his ecclesiastical appointments to become a Cistercian, in 1148 Henri was elected bishop of Beauvais and then, in 1162, archbishop of Reims. Philippe de France (1132–61) succeeded to the ecclesiastical positions his brother has resigned 1146–47, and sealed with this seal through 1152. In the twelfth-century *Moralia in Job* from Cîteaux, the image of Job before his misfortunes is presented wearing the Elite *bliaut*.[55]

(*right*) 1.71 *Seal of Henri de France* (brother of Louis VII), 1146. See L.C. Douët d'Arcq, *Inventaire de la collection des sceaux des Archives nationales* (Paris, 1863–68). no. 7615. Cast, Département de Sigillographie, Archives nationales, used by permission.

Photo: Janet Snyder

CHAMBERLAIN/GENTLEMAN

By the end of the eleventh century, a court gentleman serving the king in his private rooms was known as a chamberlain.[56] Second in number only to Elite men among the courtiers represented among the column-figures, the Chamberlain's *bliaut* appears in the composition of most portals (Figs 1.72, 1.12, 1.50). In the Chamberlain clothing arrangement, the left side of the long *bliaut* skirt appears to have been lifted and tucked into the left side of the waist cinch, so that the hem draped diagonally from his right ankle to his left hip (Fig. 1.29 center). The carved fabric appears to fall in a cascade of bias pleats across his legs, revealing the lower part of his chemise. This diagonal skirt drapery can be seen on male column-figures at Bourges Cathedral, Chartres Cathedral, and Notre-Dame de Corbeil (Figs 1.72, 1.24, 1.20). At Bourges (Figs 1.73, 1.74/Pl. 5) and Chartres (Figs 1.75, 1.1, 4.1), a broad, horizontal band of foliate and geometric decoration has been incorporated into the woven fabric of the draped skirt, arranged to embrace thighs and calves in the *bliauts* of Chamberlains and Seigneurs. It is likely that this band was intended to indicate high-value textiles – it either represented a *ṭirāz* or had been visually derived

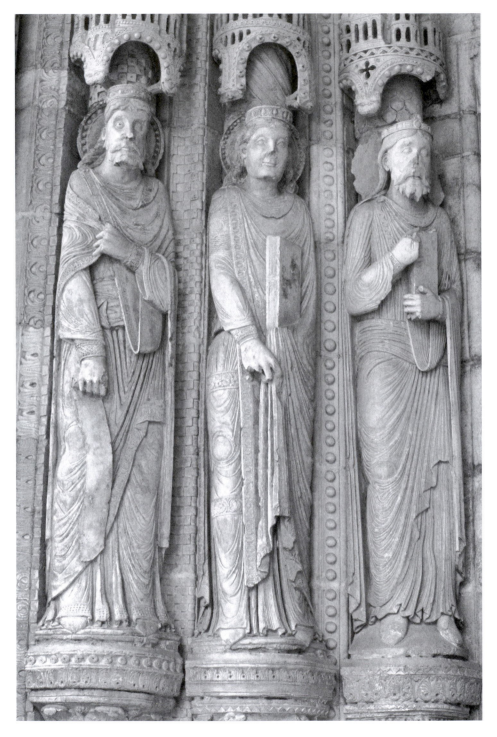

1.72 Saint-Etienne, Bourges Cathedral, south lateral portal, left column-figures.

Photo: Janet Snyder

1.73 Saint-Etienne, Bourges Cathedral,
south lateral portal, left 2:
mid-body *ṭirāz* band.

Photo: Janet Snyder

1.74 Saint-Etienne, Bourges
Cathedral, south lateral portal, left
2: below-knee body, *ṭirāz* band.

Photo: Janet Snyder

1.75 Notre-Dame, Chartres Cathedral,
Royal Portal west façade, right portal,
right jamb 1: *ṭirāz* band, c. 1145.

Photo: Janet Snyder

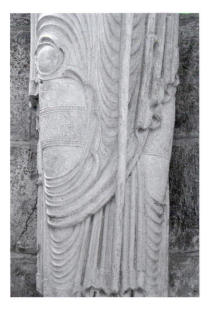

1.76 Notre-Dame du Fort, Etampes:
detail of *ṭirāz* bands in skirt of
southeast column-figure.

Photo: Janet Snyder

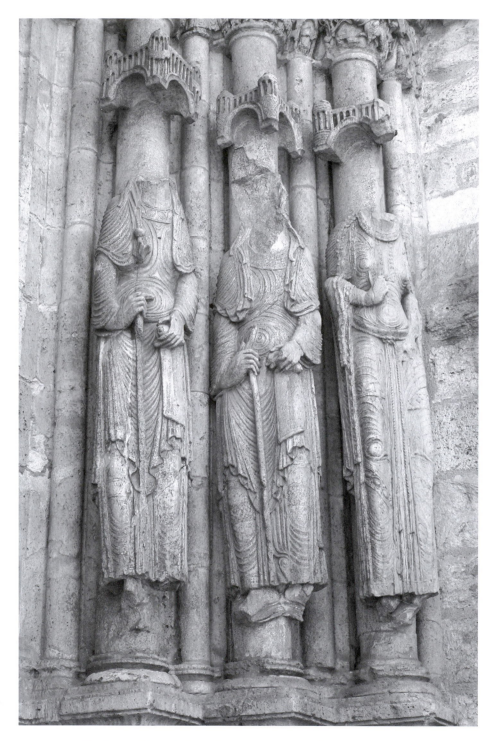

1.77 Notre-Dame du Fort, Etampes, south portal, right jamb, c. 1140.

Photo: Janet Snyder

from the inserted tapestry bands of *ṭirāz* (Fig. 1.76; Fig. 1.107, Herod's right arm).[57] While these bands have three-dimensional relief in some sculptures, elsewhere, on other column-figures, such bands were carved as flat surfaces and would have been enlivened by painted designs (Figs 1.77, 1.78, 1.65).

MONARCH/KING

An important and exclusive garment, the regal *dalmatic*, distinguishes the Monarch.[58] The regal dalmatic was represented in sculpture and painting as a narrow but not form-fitting tunic finished with a heavy band of decoration at the hem.[59] Falling to below the knees but shorter than the *bliaut*, it is a formal, prince's ceremonial garment derived from Roman dress[60] that signifies the *sacre* of the monarch in the same way that the tonsure marks those in religious orders and the ecclesiastical dalmatic signifies the elevation of a religious (Fig. 1.79).[61] Constructed of flat, unpleated panels of fine cloth attached at the shoulders and sometimes belted at the natural waistline, the regal dalmatic was worn superimposed over the *bliaut* and chemise, affirming the monarch's consecration as Vicar of Christ. A flat front panel distinguishes the regal dalmatic from the loosely bloused Elite *bliaut* and the Seigneurial *bliaut*. The open seams arranged along the sides differentiate the regal dalmatic (Fig. 1.80) from the Chevalier's *bliaut* with its open center front and back seams (Fig. 1.94). This regal dalmatic designated the special status of an anointed Monarch in column-figures at Angers Cathedral (Fig. 1.21), Saint-Bénigne de Dijon (Figs 1.81, 1.13), Notre-Dame, Paris Cathedral (Figs 1.82, 1.48, 1.139), Saint-Germain-des-Prés (Fig. 1.51), Saint-Denis west (Fig. 2.4), the Porte des Valois (Figs 1.83, 1.84, 1.85), and Vermenton (Figs 1.140, 1.145).[62] While a significant number of the column-figures were represented wearing crowns, only 16 wear this dalmatic. The Frankish notion that the king was the first among warriors was realized when an ensemble includes both the regal dalmatic as well as the Chevalier's *bliaut*: at Saint-Bénigne de Dijon (Fig. 1.13), in the cloister of Notre-Dame-en-Vaux at Châlons-sur-Marne (Figs 1.79, 1.80), and the *David*[63] found in excavations at Saint-Ayoul (Figs 1.86, 1.87). In these figures with open side seams in the dalmatic and open center seams in the *bliaut*, function seems trumped by semiotic value. This arrangement articulates the multiple roles of a consecrated king, God's anointed one.[64]

Clothing enabled contemporary viewers of visual images like the column-figures to distinguish between the consecrated king in his sacred capacity and a pretender or minor lord. Two representations of Harold Godwinson on the *Bayeux Embroidery* illustrate this point. In the first, Harold is seated on

1.78 Saint-Ayoul, Provins, left jamb 3: penultimate carving, c. 1160.

Photo: Janet Snyder

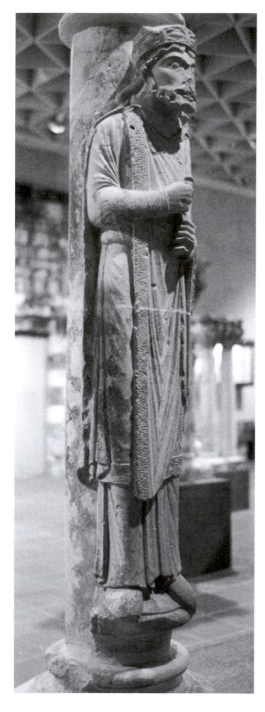

1.80 Notre-Dame-en-Vaux at Châlons-
sur-Marne, Monarch (detail): side
opening of regal dalmatic.

Photo: Janet Snyder

1.79 Notre-Dame-en-Vaux at Châlons-sur-
Marne, *cloister Monarch*: regal dalmatic,
chevalier skirt, long curls.

Photo: Janet Snyder

1.81 Saint-Bénigne, Dijon, right jamb
(detail), c. 1160. From Dom Urbain
Plancher, *Histoire general et particular
de* Bourgogne (Dijon, 1739), p. 503.

 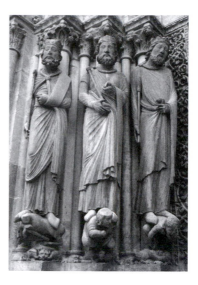

(*left*) 1.82 Notre-Dame, Paris cathedral, west façade, Portail Sainte-Anne, column-figure fragment with dalmatic border, c. 1155–65. Paris, Musée de Cluny – Musée national du Moyen Age.

(*right*) 1.83 Abbey Church of Saint-Denis, the 'Porte des Valois' (north transept portal), left jamb column-figures, sculpture c. 1140.

Photos: Janet Snyder

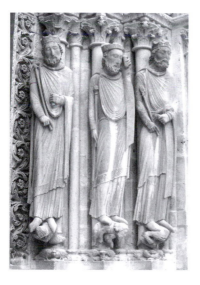

(*left*) 1.84 Abbey Church of Saint-Denis, the 'Porte des Valois' (north transept portal), right jamb column-figures, sculpture c. 1140.

(*right*) 1.85 Abbey Church of Saint-Denis, the 'Porte des Valois' (north transept portal), right jamb 1 (detail): regal dalmatic hem border.

Photos: Janet Snyder

(*left*) 1.86
Provins, *David*,
column-figure
found at Saint-
Ayoul, now in the
Maison Roman:
side view, open
side seam of regal
dalmatic, c. 1160.
By permission
of the Musée
de Provins et
du Provinois.

Photo: Janet Snyder

(*right*) 1.87
Provins, *David*,
column-figure
found at Saint-
Ayoul, now in the
Maison Roman:
Monarch's
dalmatic over
Chevalier open-
seam *bliaut*,
c. 1160. By
permission of the
Musée de Provins
et du Provinois.

Photo: Janet Snyder

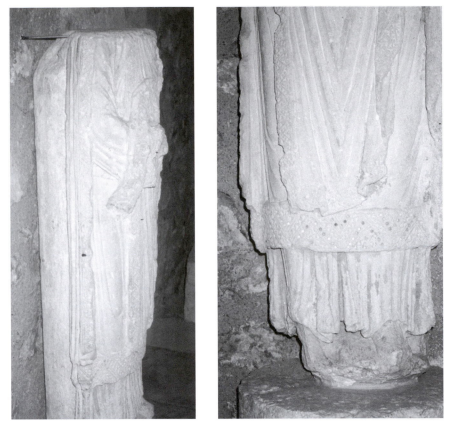

the throne beneath Halley's Comet, taken to be a harbinger of bad fortune, and he is dressed in a *bliaut* and mantle (Fig. 1.88). In the second, at his consecration, Harold, having seated himself on the English throne – therefore considered a pretender by the Normans – has dressed in the ceremonial dalmatic over a *bliaut*, and he is in possession of the other symbols of regal authority, the orb, scepter, crown, and mantle (Fig. 1.89). The designers of column-figure programs and of the *Bayeux Embroidery* communicated using a common vestiary language.

SEIGNEUR

The Seigneurs were princes, lords of their own domains, who were depended upon by others (Fig. 1.1).[65] The Seigneurial *bliaut* reflects the regal model, with a hem that terminates just below the knees, exposing an additional ankle-length undertunic or the chemise (Figs 1.14, 1.64, 1.65). In some column-figures, this *bliaut*'s hem was carved as if it were longer at the sides and center than it was over the legs. Prominent applied or *ṭirāz* border bands can be seen on the hem of this closed *bliaut* at Saint-Denis (Fig. 1.90) and segments of *ṭirāz* in the *bliaut* and chemise skirts on figures of two men at Chartres (Fig. 1.1).[66] Illustrated on the enamel funeral effigy of Geoffroi V, le Bel, Duke of Normandy, the

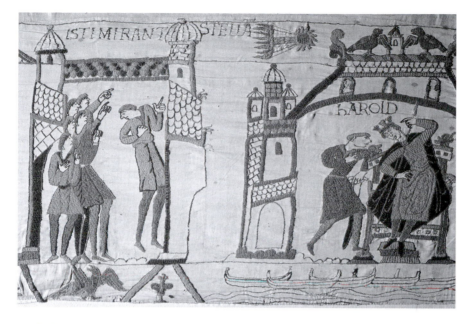

1.88 *Astrologers Signal the Appearance of a Comet [Halley's Comet], which Portends Misfortune for King Harold II, Bayeux Embroidery* (detail): Harold enthroned without the regal dalmatic. Musée de la Tapisserie, Bayeux, France.

Photo: Erich Lessing/Art Resource, New York

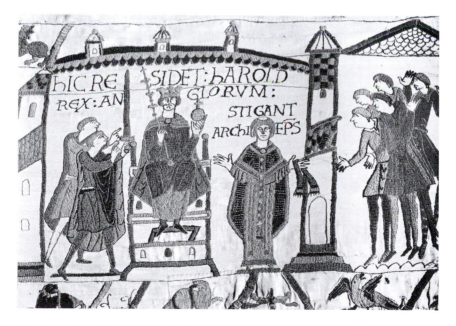

1.89 *The Coronation of Harold II; He Receives Sword and Scepter, Bayeux Embroidery* (detail): Harold Godwinson enthroned, wearing the regal dalmatic. Musée de la Tapisserie, Bayeux, France.

Photo: Erich Lessing/Art Resource, New York

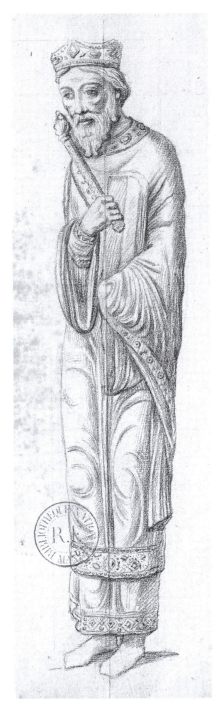

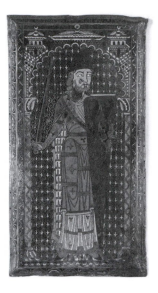

1.91 Tomb effigy of Geoffroi le Bel (Geoffrey V Plantagenet), shortly after 1151, copper (engraved, chased and gilded), with *vernis brun* and *champlevé* enamel areas in several colors. Le Mans? Cliché Musées du Mans; Conservation: Le Mans, Carré Plantagenêt (Musée d'histoire et d'archéologie du Mans, Inv. 23-1).

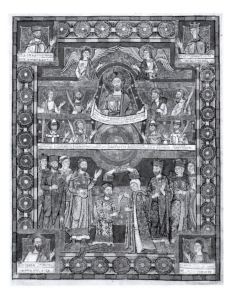

1.90 Abbey Church of Saint-Denis, west façade, column-figure CR4. Antoine Benoist drawing, BN, MS FR 15634, folio 54. Bibliothèque nationale de France.

1.92 Henry's coronation miniature in the *Gospels of Henry the Lion*, c. 1175–88. From *Das Evangeliar Heinrichs de Löwen*, Wolfenbütel Herzog August Bibliothek, Cod. Guelf, 105 noviss. 2.

loosely belted Seigneurial tunic falls to the level of his knees, with diagonal stripes of *ṭirāz* tapestry decorating the skirt (Fig. 1.91/Pl. 6).[67] From this enamel, known to have been made just after 1151, it may be possible to understand that this *bliaut* designates ranking magnates of the king who were his liegeman. The manuscript illuminator illustrated Seigneurs in these costumes as witnesses at the wedding/coronation of Henry the Lion and Matilda of England (Fig. 1.92/Pl. 7).[68]

1.93 Saint-Maurice, Angers, right 1 (detail): upper body, hair, beard.

CHEVALIER

Chevaliers – the Norman and continental warriors called *milites* in Latin[69] – and the Peace of God – a movement instituted by the bishops to resist the violence of these armed men – appeared at the same time in documents in the 980s.[70] In the twelfth century, the term *nobility* cannot be applied to individuals since such a designation – based as it is upon inherited rank and status – was still in its formative stages. Chevaliers might or might not have been 'noble.'[71] In the present discussion of represented clothing in column-figure sculpture, the term 'Chevalier' will used to designate individuals who had the wherewithal and stature to possess, arm, and ride horses.

The Chevalier's horsemanship and status were signaled through the form of his *bliaut* (Figs 1.93, 1.94, 1.95/Pl. 8). Beneath the protection afforded by his chain-armor a mounted warrior wore a long *bliaut* and chemise with skirt open from hem to hip in front and back in the same way as his chain-armor *hauberk* would have been.[72] This Chevalier's gown provided the wearer the freedom of movement required to straddle a horse. This costume was an indicator of social rank and wealth as well as power: the Monarch and his princes (the Seigneurs), held responsibility for defense, and therefore had the right to bear arms. This right to fight – in defense and in just causes – extended to the Chevaliers who were authorized by these lords. Each Chevalier was required to maintain a certain status and to support number of retainers and several horses.[73] In practice, many Chevaliers served Seigneurs, by whom they were given their weapons and horses.

1.94 Saint-Maurice, Angers, right 1 (detail): open center seams at hem.

1.95 Saint-Maurice, Angers, right 1 (detail): top of open center seam.

Photos: Janet Snyder

Certainly there could be no confusion on the ground about the social and economic chasm between the small closed elite of castle-holding families and the knights who held fiefs from them. But whether they were substantial castle lords, middling allodial

1.96 Abbey Church of Saint-Denis, west façade, right portal, left jamb: *Labors of the Months,* 'June,' c. 1137–40: tunic hangs in tree at upper left.

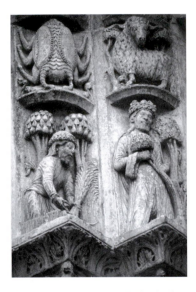

1.97 Notre-Dame, Chartres Cathedral, Royal Portal west façade, left portal archivolts: *Labors of the Months,* 'July' and 'April.'

1.98 Abbey Church of Saint-Denis, west façade, right portal, left jamb: *Labors of the Months,* 'May,' c. 1137–40.

Photos: Janet Snyder

proprietors, or simply stipendiary knights who served in the retinues and garrisons of their lords, they all held property or revenue in fief tenure. The pre-1150 charters are consistent in describing those fiefholders as a diverse and stratified class of proprietors that belies any starkly drawn contrast between barons and knights.[74]

During the first two-thirds of the twelfth century, the gradual stratification of society took place in France is revealed in represented clothing. Social hierarchy was expressed in the conventional representations employed in the *Labors of the Months* at Saint-Denis and at Chartres Cathedral (Figs 1.96, 1.97, 1.98, 1.99). A natural authority was believed to characterize the upper strata of society, including a kind of superior knowledge that was made visible in the portal sculpture program: this would include knowledge concerning the pruning of plants (*April*, Fig. 1.97) or skill in hunting with falcons (*May*, Figs 1.98, 1.99).[75] The nobility of the personifications in *April* and *May* was clearly articulated because their Chevalier *bliaut* skirts have open center seams. *Dignité* defined by appearance in these personifications contrasts with quotidian workers like the field hands in short shirt-gowns (*cotterons*) who appear in the *June*, *July*, and *August* Labors (Figs 1.99, 1.97, 1.96, I.4). These tableaux introduce temporal narratives into sculpture: the tunic of *June* has been removed in the heat of the day, and has been hung in the tree on the left (Fig. 1.96). Except for the Champenois, who were exempt, an elite man's *noblesse* might be degraded were he to exert himself in physical labor to earn a living.[76]

The functional nature of the Chevalier's *bliaut* clearly differentiates this horseman from other courtiers.[77] In column-figures at Saint-Bénigne and the cloister figures from Saint-Ayoul and Notre-Dame-en-Vaux, when the regal dalmatic was depicted as being worn over the Chevalier's *bliaut*, it asserted the king's rank as first among warriors (Figs 1.13, 1.79, 1.87). The Chevalier's *bliaut* and hauberk appear in personifications of *Virtue* in the sculpture in the archivolts of a

west portal at Laon Cathedral and in the cloister of Notre-Dame-en-Vaux at Châlons-sur-Marne (Figs 1.100, 1.101).[78]

Images in seals, in manuscripts like the twelfth-century *Moralia in Job* from Cîteaux, or of knights among the *Lewis Chessmen*, conform to modern expectations of the Chevalier's costume since each warrior has a horse, a weapon and a shield (Fig. 1.102).[79] A conventional depiction of a horseman-in-arms typified later twelfth-century sigilligraphic proto-portraits of male lords, but the

counterseal of the first seal of Louis VII (1141) depicts the king as a mounted Chevalier with the skirt panels of his chain-armor *hauberk* divided on each side of the horse (fig. 1.103).[80] On an elephant ivory rook, c. 1150, now in the collection of the Louvre, the skirts of the Chevaliers graze the earth beneath their horses' hooves.[81]

Though statues of mounted horsemen appear on church façades in western France, the composition of portals with column-figures excludes horses, making it seem unlikely that Chevaliers might be found among the ranks of the column-figures.[82] However, *ymagiers* ingeniously used very subtle vestiary cues for column-figure Chevaliers at Bourges Cathedral (Figs 1.104, 1.29), Angers Cathedral (Figs 1.105, 1.21, 1.31, 1.93, 1.94, 1.95/Pl. 8), Chartres Cathedral (Figs 1.16, 1.134, 4.7), St-Ayoul, Provins (Fig. 1.50),

1.99 Notre-Dame, Chartres Cathedral, Royal Portal west façade, left portal archivolts, *Labors of the Months*, 'June' and 'May.'

Photo: Janet Snyder

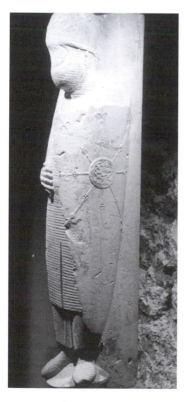

(*left*) 1.100 Notre-Dame-en-Vaux at Châlons-sur-Marne, Personification of Virtue: Chevalier skirt, shield, chain armor.

Photo: Janet Snyder

(*right*) 1.101 Notre-Dame-en-Vaux at Châlons-sur-Marne, Personification of Virtue (detail): open seam of Chevalier skirt, chain armor.

Photo: Janet Snyder

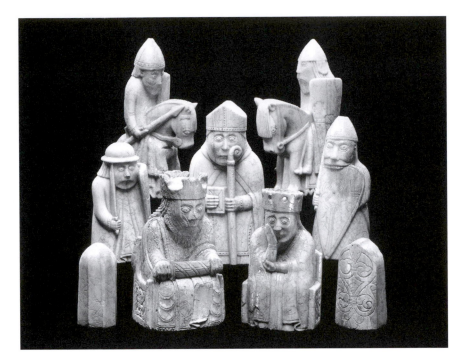

1.102 *The Lewis Chessmen*, c. 1150–1200, ivory, probably made in Norway. Found on the Isle of Lewis, Outer Hebrides. The British Museum (M&ME 1831, II-1, Ivory Catalogue 78-159). Helmeted Chevaliers on horseback with open-seam Chevalier's *bliauts*; bishop in dalmatic and mitre peaked front and back; king and queen. © Trustees of the British Museum.

1.103 *The counterseal of the first seal of Louis VII (1141).* See L.C. Douët d'Arcq, *Inventaire de la collection des sceaux des Archives nationales* (Paris, 1863–68). Cast 67 bis, Département de Sigillographie, Archives Nationales, used by permission.

Photo by Janet Snyder

Rochester Cathedral (Fig. 1.106), Saint-Bénigne de Dijon (Fig. 1.13), Vermenton (Figs 1.141, 1.142) and the cloister personification from Notre-Dame-en-Vaux (Figs 1.100, 1.101). The functional character of a Chevalier's skirt is difficult to recognize in a standing figure since the skirt seams appear to be closed when the sides of the fabric panels hang parallel. *Ymagiers* therefore used a kind of shorthand to indicate the Chevaliers, with the open center seam conveying status (Figs 1.93, 1.94, 1.95/Pl. 8). Though the open seam between halves of the skirt is at times barely discernible, elsewhere it was clearly illustrated, with the lower corners of the open seam carved so that they appear to hang slightly open, folding back upon themselves, as at Chartres (Fig. 1.38) and at Bourges (Fig. 1.104) and on Philippe de France's seal (Fig. 1.70). The Chevalier status at Angers is more apparent because three-dimensional edges border the open skirt panels (Figs 1.21 left, 1.32). The conventional representation of the Chevalier was followed at Kilpeck in Herefordshire, where the widely open seam of the skirts of the knights on the left jamb has been misread as indicating loose trousers (Fig. 1.67).[83]

The mobility allowed by the unsewn seam is demonstrated on the tympanum of the Portail Sainte-Anne at Notre-Dame, Paris. The drapery of the bordered panel of the *bliaut* skirt, open in the center to the hip, enables that first warrior, the king, to genuflect at the edge of the tympanum (Fig. 1.107). This convention of communicating status through the depiction of a Chevalier was also employed in bronze sculpture, including the 'Wolfram' candlestick, c. 1180. The open seam distinguished two crowned men as Chevaliers on the transept jambs at Moutiers-Saint-Jean, when they were installed in the mid-thirteenth century. The open seams of the skirts of these two standing figures – now installed in the Cloisters Collection of the Metropolitan Museum of Art – are especially visible on the undersides of lower edges at center front (Fig. 1.108).[84]

Actual belts and baldrics would have contributed to the real security of draped clothing worn by an active courtier. The various arrangements of belts illustrated in sculpture seem to be primarily related to rank, derived from a man's roles as a chevalier, a cleric, or courtier, rather than serving a practical function. The waist cinch of the male column-figure's costume is most often concealed by the drapery of the bodice of his *bliaut*, by

1.104 Saint-Etienne, Bourges Cathedral, south lateral portal, right 1: Chevalier *bliaut* with open center seam at hem.

Photo: Janet Snyder

1.105 Saint-Maurice, Angers, left jamb, *column-figure of Chevalier*.

Photo: Janet Snyder

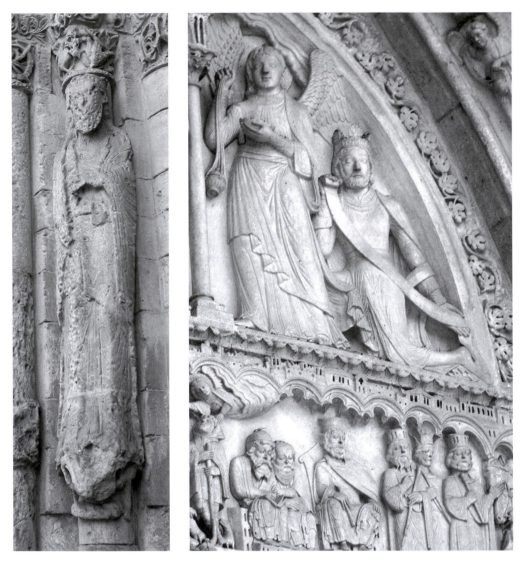

(*left*) 1.106 Rochester Cathedral (Kent), west portal, left jamb, *man column-figure.*

(*right*) 1.107 Notre-Dame, Paris cathedral, west façade, right portal
(Portail Sainte-Anne) (detail): tympanum and upper lintel.

Photos: Janet Snyder

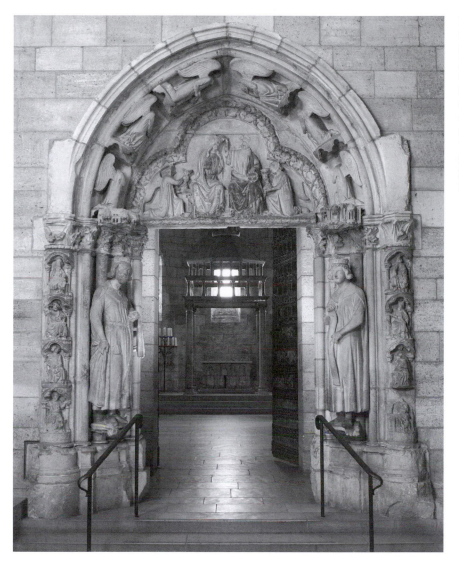

1.108 South transept portal, Moutiers-Saint-Jean, c. 1250: two nearly-freestanding column-figures with Chevaliers' open-seam tunics. The Cloisters of the Metropolitan Museum of Art, New York.

the mantle fastened across his body, or by attributes held by the column-figure.[85] In the image on his tomb effigy plaque, Geoffroi le Bel appears with a belt at his natural waist, and an additional shoulder strap, a baldric, crosses to carry his *bouclier* (Fig. 1.91/Pl. 6). This shoulder strap, used to support the chevalier's heavy shield, appears in twelfth-century seals, a detail also evident on the *Personification of Virtue* at Notre-Dame-en-Vaux, where the sword scabbard was secured with the belt at the natural waist (Figs 1.31, 1.32, 1.93, 1.105). On the left jamb at Angers, the Chevalier's pendant belt hangs nearly to the ankle while on the right jamb the Chevalier's belt buckles at the waist.

The wide and flat, decorated band that belts a man from the right portal at Saint-Denis (Fig. 1.28) is similar to illustrations of the Islamic belt in

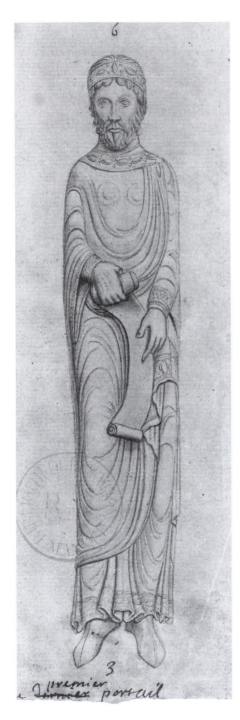

1.109 Abbey Church of Saint-Denis, west façade, column-figure LL1. Antoine Benoist drawing, BN, MS FR 15634, folio 67. Bibliothèque nationale de France.

manuscripts. A Chamberlain at Angers has a belt fastened at the natural waist with two pendant ends hanging asymmetrically over his right thigh to his knees (Fig. 1.21). These belts with pendant ends seem to have been an indicator used to convey a man's social standing. Among the voussoirs illustrating the Labors of the Month on the Chartres west façade left portal, the Seigneur who prunes the vines in *April* wears the tasseled *ceinture* (Fig. 1.97). The broad belt with hanging tabs worn by the fisherman in the capital at Saujon has been referred to as the 'belt of strength' (Fig. 4.22).

DIGNITARIES GRANTED THE PALLIUM

The Dignitary holds an eminent rank in the hierarchy of officials, having been vested with this distinction or status.[86] Twenty-four Dignitaries can be recognized among the Elite, Seigneurs, Chamberlains, and Chevaliers, distinguished in each case by an additional significant item of clothing. A length of fine cloth, worn in addition to the mantle and the *bliaut*, appears to signify the award of power and status in both secular and religious spheres.[87] *Pallium* was the term used for a very precious silk textile of great width that had been presented to important visitors to Constantinople since the fifth century, making this the best word to designate the Dignitary's wide sash in column-figure sculpture (Fig. 1.68).[88] In documents relating to the fairs of Champagne and in Suger's writings, the term *pallium* (or *pallia*) refers to silk stuffs.[89] The expense of such fine, large textiles, even when they might have been available, would have limited their use to the upper echelon of society.[90]

In the West, a civil *pallium* might have served a function similar to that of the archiepiscopal *pallium*, signifying official status and authority.[91] The archbishop's insignia, a narrow strip of pure white wool, rests on top of liturgical vestments as two Y-forms joined on the shoulders, with the hanging foot falling in center-front, as at Saint-Ours at Loches (Fig. 1.110).[92] Parallel to the use of the archiepiscopal *pallium*, the civil *pallium* appears to signify an authority conceded to the wearer in his domain and its appearance may signify the pageantry associated with rituals like the *adventus*.

Though the secular insignia may be less known or easily recognized than the religious vestment, the role of the civil *pallium* in identifying powerful members of the court is significant, for it distinguishes ranking men from lesser personages. The civil *pallium* might appear to be similar in form to the *loros*, the jeweled stole of the Byzantine Emperor.[93] This large, fine textile could be artfully arranged as a wide girdle much as the Byzantine *loros*; it belonged to and signified rank. Conventionally, it was worn by the emperor, empress, magistrates, and the eparch.[94]

Among the column-figures, the civil *pallium* was represented in two versions: it was either the girdle *pallium*, thickly bunched around the waist as at Avallon (Fig. 1.111), or it was the swathed *pallium*, draped from hem to hip as at Chartres Cathedral (Fig. 1.16). The girdle *pallium*, bunched into a sash, appears to be a narrower strip of cloth than the wide, swathed *pallium* but more ample than a broad, flat belt. The grandiose bunching around the torso supports the civil *pallium*'s ceremonial function in that this extraneous garment affirms the nobility associated with the principle of *largesse*.[95] Further, its sash-like quality resembles the textile sashes of Islamic costumes like those represented on each of the Metropolitan Museum's Islamic stucco princely figures (Fig. 4.10/Pl. 15). The Islamic figures have sashes knotted low around their waists in the center-front with pendant tabs hanging to mid-thigh, a similarity that connects column-figure Dignitaries in the girdle *pallium* with Near Eastern contexts. The girdle *pallium* can be identified at Bourges Cathedral south (Fig. 1.112), at Chartres Cathedral (Fig. 1.69), at the Porte des Valois at Saint-Denis (Fig. 1.83), at Le Mans Cathedral (Figs 1.27, 1.43), and at Saint-Loup de Naud (Figs 1.63, 1.128).

The swathed *pallium* is arranged with the width of the rectangle draped more loosely around the body, so that the short-dimension edge crosses the leg diagonally from ankle to hip, draped in front of the skirt of the *bliaut*. Easily confused with the arrangement of the *bliaut* that identifies the Chamberlain, it seems likely that the rectangle of fabric might have been folded so that the diagonal from corner to corner could be pulled snugly across the bias of the cloth, around the man's waist and hips. It is easily seen in the twelfth-century painted

1.110 Saint-Ours, Loches, left wall of portal, *relief column-figure of a Cleric* (before 1168).

1.111 Saint-Lazare, Avallon, center portal, right jamb, c. 1155–60.

Photos: Janet Snyder

1.112 Saint-
Etienne, Bourges
Cathedral,
south lateral
portal, left jamb
column-figures:
upper bodies.

Photo: Janet Snyder

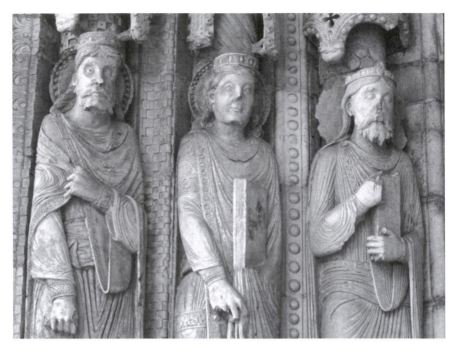

1.112 Saint-
Etienne, Bourges
Cathedral,
south lateral
portal, left jamb
column-figures:
upper bodies.

Photo: Janet Snyder

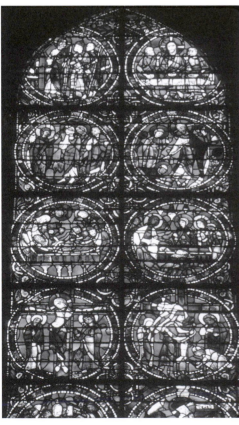

stained glass at Chartres because it was illustrated with contrasting hues of glass: it appears on John in the *Crucifixion* section and on Christ in the *Nolo me tangere* scene (Fig. 1.113/Pl. 9).

The swathed *pallium* appears at Chartres Cathedral (Figs 1.114, 1.24), Saint-Germain-des-Prés (Fig. 1.59), Saint-Loup de Naud (Figs 1.39, 1.63), Saint-Denis (Fig. 1.109), and Rochester Cathedral (Figs B.8, 1.106). This swathed *pallium* is particularly noticeable on the center portal at Chartres Cathedral, distinct from the *bliaut* and also from the mantle: its carved border embraces the right shoulder, runs downward along the outside of the upper arm to the elbow, and then is bound tightly around the waist (Figs 1.115, 1.16, 1.114). The edges of the mantle clearly hang along the column-figure's right side, straight down to the ankles at Chartres and also at Saint-Bénigne (Fig. 4.20). The civil *pallium* seems to emphasize a Dignitary's social or political status at the same

1.113 Notre-Dame, Chartres Cathedral, interior of the west front, left bay (*Passion of Christ*), painted stained glass.

Photo: Janet Snyder

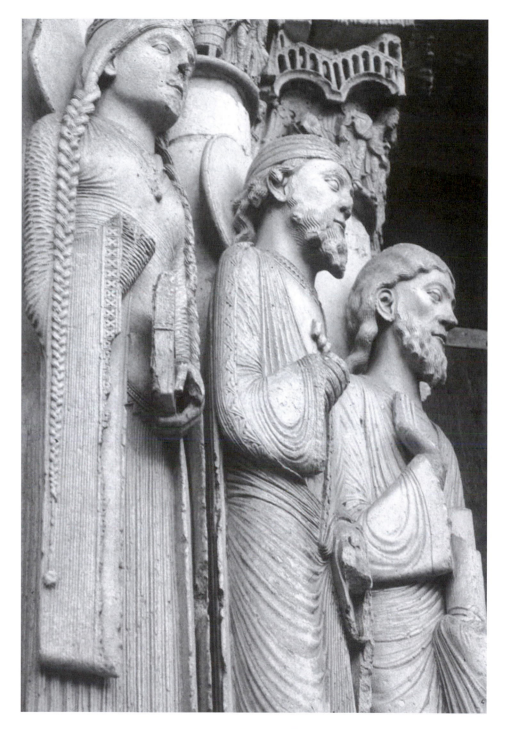

1.114　Notre-Dame, Chartres Cathedral, Royal Portal west façade,
center portal, left jamb 3, 2, 1: mid-body, c. 1145.

Photo: Janet Snyder

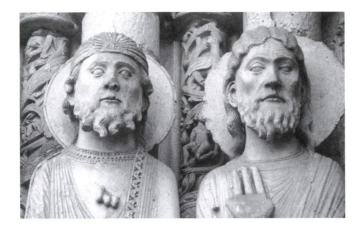

1.115 Notre-Dame, Chartres Cathedral, Royal Portal west façade, center portal, left jamb 1, 2: heads and shoulders, c. 1145.

Photo: Janet Snyder

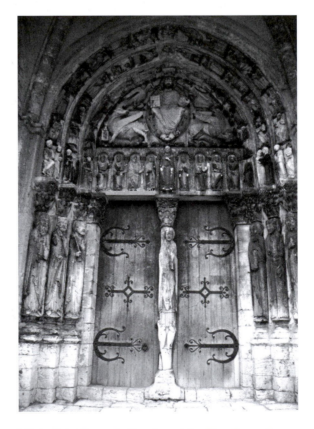

1.116 Saint-Loup de Naud, portal, with column-figures and *Majestas Domini* tympanum, c. 1160.

Photo: Janet Snyder

time as it stresses the corporeality of the figure. While the original polychromy was legible, a sharp identification of the separate layers of clothing would have been clearly apparent.

At Saint-Loup de Naud, the key-bearing Saint Peter on the right jamb and a balding, book-clasping Saint Paul on the left jamb are depicted wearing versions of the *pallium* (Figs 1.116, 1.39, 1.63, 1.128). In representing these personages who symbolized the Universal Church in recognizable and appropriate twelfth-century clothing that signified the award of power, the makers of column-figures married belief with contemporary perception. Among the column-figures, those depicted wearing civil *pallia* can be sorted almost evenly among those who are bareheaded, those wearing jeweled crowns, and those wearing melon-shaped bonnets. This use of *pallia* demonstrates how critical it is to assess a figure's entire ensemble when reading portal program iconography. Though modern art historians have cited headgear depicted on high-ranking men in readings of column-figure personages, hats which serve as signifiers for modern viewers reveal less about identity than customary clothing.

1.117 Saint-Loup de Naud, *trumeau* (detail): chasuble point, stole, waffle-pattern dalmatic, with heavy border, c. 1160.

Photo: Janet Snyder

CHURCHMEN AND DISCIPLES/ASSOCIATES OF CHRIST

The Clergy were ministers of various ranks in the episcopal hierarchy.[96] The rank and status of participants in most religious establishments can be discerned through their clothing. These participants who served as chaplains, scribes and advisors at court or worked in churches and in monasteries were either in major orders – bishop-priests, deacons, and subdeacons admitted to Holy Orders by ordination – or they were in minor orders. The most recognizable ensembles of the Clergy are those worn for the celebration of the liturgy. Liturgical vestments appear to clothe column-figures on the *trumeaux* (mullion supporting the lintel) of Saint-Loup de Naud (Figs 1.117, 1.19, 2.6), Notre-Dame of Paris (Figs 1.120/Pl. 10, 2.7), and Saint-Bénigne (Fig. 4.21); on the jambs at Nesle-la-Reposte (Fig. 1.121), Saint-Ours of Loches (Fig.

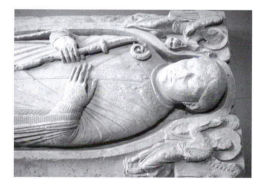

1.118 *Abbot of the Abbey of Notre-Dame d'Issoudun*, c. 1160, or 1180–90, limestone, *gisant* from the crypt of the Abbey (detail). Atelier of Sens, according to Neil Stratford. © Musée de l'Hospice Saint-Roch, Issoudun (Inv: 11.54, n.75).

Photo: Janet Snyder

1.110), Saint-Germain-des-Prés (Fig. 1.59), and Saint-Bénigne (Fig. 1.81); figures from the cloister at Notre-Dame-en-Vaux; and in contemporaneous tomb effigy relief sculptures now in Provins, Reims, and Issoudun (Figs 1.118, 1.119).[97]

In column-figure sculpture, often a personage's status in society and governance appears to have taken priority in determining the appearance of costume over their rank within the clerical hierarchy. Attributes and visual

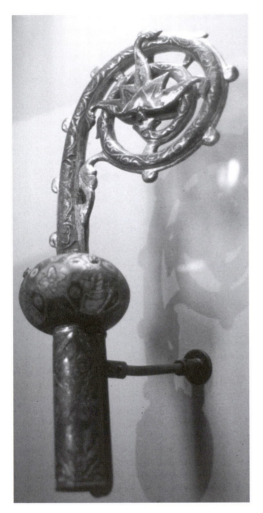

1.119 Limoges
enamel crosier
knob, c. 1160–
1200, *champlevé*
enamel, gilt.
Discovered along
with clothing of
silk and linen, in
1855, in the tomb
of the Abbot
of Issoudun.
© Musée de
l'Hospice
Saint-Roch,
Issoudun (Inv:
11.986, n.330).

Photo: Janet Snyder

cues identify column-figures as Disciples and Associates – Saint Peter's keys or Saint Paul's balding pate at Le Mans Cathedral (Figs 1.43, 1.27) – and these Associates of Christ appear draped rather than attired in garments. Exceptionally, a Cleric in episcopal garb was depicted opposite a column-figure bearing the key attribute of Saint Peter – at Nesle-la-Reposte and at Loches – indicating that these clerical column-figures may have been intended to personify Saint Paul.[98] Otherwise, unless known to have been ordained religious persons in historic times, like Saint Loup or Saint Germain (Figs 2.6, 1.19, 1.117, 1.59), the clothing of close Associates of the Redeemer may appear to have been appropriated from antique images of philosophers. Other images associated by scholars with Old Testament personages appear in dress indistinguishable from clothing worn by the twelfth-century close associates of the monarch. In uniting the garb of ranking courtiers with sacred personages, the language of dress infers the significant integration of secular and sacred in twelfth-century thought. 'Bishops and abbots were by definition an elite of cadets.'[99] Louis VII had preceded his younger brothers in clerical studies at Saint-Denis before the sudden death of their eldest brother elevated him to kingship (Fig. 1.124, 1.70, 1.71).

Many of the parts of the linen and silk liturgical costume that became fixed in the twelfth century can be recognized on column-figures at Saint-Loup (Figs 1.19, 1.117), Saint-Bénigne (Figs 1.81, 4.21), Saint-Germain-des-Prés (Fig. 1.59), and Loches (Fig. 1.110).[100] The *alb* and the archiepiscopal dalmatic appear in column-figure sculpture at Saint-Bénigne (Fig. 1.81).[101] The wide decorated border decorating the lower hem of the alb tunic used by Thomas Becket during his exile in Sens (Fig. 4.23) is similar to the *parement* featured prominently on the fragment from the Portail Sainte-Anne in Paris now in the Museé Cluny (Fig. 1.120/Pl. 10). The *amice* and *stole* were carefully rendered by the eighteenth-century engravers of Saint-Bénigne (Figs 1.81, 4.21), Nesle-la-Reposte (Fig. 1.121), and Saint-Germain-des-Prés (Fig. 1.59).[102] The lower ends of similar liturgical stoles can be seen carved in relief on column-figures at Loches, Saint-Loup de Naud, and Portail Sainte-Anne, terminating just above ankle level.[103] At Nesle-la-Reposte the celebrant of the Mass can be recognized since the *maniple* hangs over his left forearm.[104] Like most column-figure Clerics, he appears in a celebrant's *chasuble*[105] and his small collar may be the *superhumeral*.[106]

1.120 Notre-Dame, Paris cathedral, west façade, Portail Sainte-Anne: side of *trumeau*,
Saint Marcel, limestone with traces of polychromy (detail): ecclesiastical dalmatic
fringe, c. 1145. Paris, Musée de Cluny – Musée national du Moyen Age (Cl. 18640).

Photo: Janet Snyder

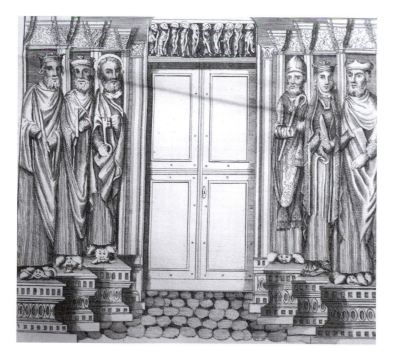

1.121 Notre-Dame, Nesle-la-Reposte, portal with six column-figures, c. 1160. From Dom
Jean Mabillon, Annales Ordinis S. Benedicti, II (Paris, 1703–39), vol. 1, lib. 6, pp. 50–51.

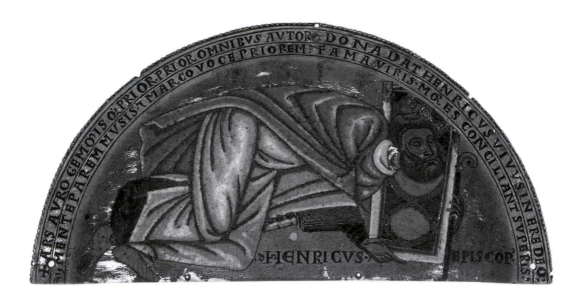

1.122 *Henri of Blois*, c. 1150, Mosan enamel plaque. The British Museum (M&ME 1852, 3–27). © Trustees of the British Museum.

The Y-shaped archiepiscopal *pallium*, made of white lambswool, appears superimposed on the chasuble of Saint Loup, with a sculpted cross on the hanging foot (Fig. 1.19, 2.6).[107] The Clerical dress of stone column-figures conforms to vestments represented on a Mosan *champlevé* enamel plaque of Henri of Blois (1129–71), Bishop of Winchester, brother of Stephen I (Fig. 1.122/Pl. 11).[108] Henri appears in an ecclesiastical dalmatic, grasping a crosier and the portable altar donated by him. In the twelfth century, the ecclesiastical dalmatic visible on column-figures at Saint-Germain-des-Prés, Saint-Bénigne, and at Saint-Loup de Naud (Fig. 1.117) was a privilege reserved for bishops.[109] The ecclesiastical dalmatic, a tunic with short sleeves that was worn underneath the chasuble, was open up the sides like the regal dalmatic donned by the king of the French after his anointing, over his *bliaut* and under his mantle, to signify his sacerdotal role.

In sculpture, a rounded half-melon hat was depicted as worn by men otherwise dressed as bishops, as seen at Saint-Bénigne de Dijon (Figs 1.13, 4.21). During the middle third of the twelfth century the *mitre* achieved its form as the characteristic bishop's hat, with two flat *pans* – pointed upright panels – and two hanging strips, the *fanons* (Fig. 1.59).[110] At Loches, the fanons can be distinguished hanging on each shoulder from the now-missing head, indicating that it must have borne a mitre (Fig. 1.110). A more rounded hat with soft pans and hanging fanons appears in sculpture at Saint-Loup de Naud (Fig. 1.19). The originals of episcopal mitres, like the one at Saint-Germain-des-Prés (Fig. 1.59), would have been made of silk textile with embroidery, perhaps in *opus anglicanum*. Irregularities in episcopal headgear would be resolved by the end of the twelfth century as mitres became formally standardized, with peaked pans in front and back.[111]

STYLES OF MEN'S HAIR AND BEARDS

A tremendous range of men's hairstyles was represented in column-figure sculpture. Parallels in manuscripts, painted stained glass, and smaller sculpted depictions, and also in the *Bayeux Embroidery* confirm the significance of hair and beard styles as indicators of rank and station for men. It is certainly possible that the fashion for long hair responded to contemporary interest in regaining the ancient glory associated with the Merovingians (Figs 1.123, 1.124). However, the variety in beards and hairstyles indicates more complex significances for early twelfth-century men's hairstyles. Column-figure men's hair varied in length from very short ringlets to coiling locks extending to mid-back (Figs I.7, 1.29, 1.111). Long hair tumbles in individual curls on the shoulders of Chevaliers at Angers Cathedral (Figs 1.21, 1.93), recalling a fashion of the 'long-haired kings' described by Gregory of Tours and critiqued in manuscript images.[112] The seals of Louis VI and Louis VII differ in that long individual curls coil on the shoulders of Louis VII (Figs 1.123, 1.124).[113] At Easter in 1105, Serlo, Bishop of Séez, preached against men with long hair and used scissors to cut the tresses of the king and his magnates.

... In April 1105 Henry [I] landed in Normandy to begin the conquest of the duchy from his brother, Robert Curthose. Easter he celebrated in a small church crammed with the chests and tools of peasants who had gathered them there for safety. Serlo, bishop of Séez, delivered the sermon. Using the peasants' humble possessions to recall a godly ruler's obligation to protect the weak, the bishop spoke of Henry's high purpose and contrasted it to the excesses of Curthose's court, with its whores, jesters, and drunkenness, a maelstrom of godless lasciviousness symbolized for the bishop in the chivalric custom of wearing long hair. The bishop asked that the king set an example for his barons, and upon Henry's agreement took scissors and cut first his hair, then that of all his magnates, who confirmed their resolve by crushing their fallen locks into the ground ...[114]

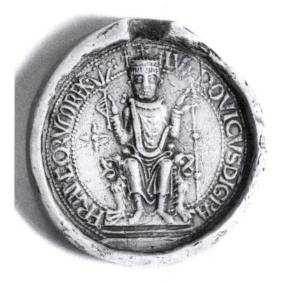

1.123 *Seal of Louis VI*, before 1137. See L.C. Douët d'Arcq, *Inventaire de la collection des sceaux des Archives nationales* (Paris, 1863–68). D.35 [No. 36]. Cast no. 66, Département de Sigillographie, Archives nationales, used by permission.

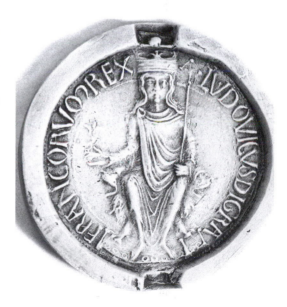

1.124 *Seal of Louis VII*, 1147. See L.C. Douët d'Arcq, *Inventaire de la collection des sceaux des Archives nationales* (Paris, 1863–68). No. 37. Cast no. 67, Département de Sigillographie, Archives nationales, used by permission.

Photos: Janet Snyder

1.125 *The Lewis Chessmen*, c. 1150–1200, ivory, probably made in Norway. Found on the Isle of Lewis, Outer Hebrides. The British Museum (M&ME 1831, II-1, Ivory Catalogue 78-159). Back view: King with four twisted ropes of hair. © Trustees of the British Museum.

1.126 Rochester Cathedral (Kent), west portal, left jamb, *man column-figure* (detail): long coiled hair.

Photo: Janet Snyder

In contrast, the mid-twelfth-century illustration in the *Bible of Stephen Harding* show four long individual curls resting along the shoulders of the figure of *David in Majesty*, the Old Testament anointed hero-king with whom medieval kings were often compared (Fig. 3.4). The Monarch in the Cloister at Notre-Dame-en-Vaux (Fig. 1.79) and five of the eight kings among the set of twelfth-century ivories known as the *Lewis Chessmen* have great ropes of hair hanging in four long locks on their shoulders (Fig. 1.125).[115] Similar hairstyles distinguish men at Bourges (Figs I.7, 1.72, 4.4), Rochester Cathedral (Fig. 1.126), Saint-Denis (Fig. 1.66/Pl. 4), and Notre-Dame de Corbeil (Fig. 1.20). Their locations in the place of honor, on the right hand of Christ in the tympanum above the door, seems to point to an elevated status for each of these longhairs. A receding hairline is an attribute that identifies Saint Paul, a figure that could be paired with a column-figure identified by attributes of curly hair and large keys as Saint Peter: at Saint-Loup de Naud (Figs 1.128, 1.39, 1.116), and in low-relief at Le Mans (Figs 1.27, 1.43).

While many of the male column-figures appear to wear crowns, much headgear – frequently the entire head – has been damaged or lost, and the idea of kingship must be deciphered from their clothing and the hairstyle arranged in corkscrew coils on the shoulders of extant sculpture. A single long curl was illustrated in the engraving of a Monarch at Saint-Germain-des-Prés, where a Dignitary appears with a single braid (Fig. 1.51). Both monarchs on the left jamb of Saint-Bénigne and the bishop on the *trumeau* have long hair (Figs 1.13, 4.21). Courtiers at Saint-Loup de Naud (Fig. 1.63) and at Chartres (Figs 1.16, 1.97, 1.127, 4.6) and Bourges (Fig. 1.112) also have longer hair, as does the striding man at Saujon (Fig. 4.22).

The hirsute column-figure men dominate portal compositions though there are some column-figure men that appear to have smooth, freshly barbered faces: Angers (Fig. 1.93), Bourges (Fig. 1.29), and Chartres (Fig. 1.23). Similarly bearded men appear in similar locations at different portals. A roughly carved texture provides

one figure at Angers with the appearance of a very short-stubble beard. The smooth face at Bourges appears originally to have had painted whiskers (Fig. 4.4). More commonly, the beard may have been sculpted as if neatly barbered, as at Chartres (Figs 1.127, 1.129), carved as a mass of curly knots as on the *trumeau* at Saint-Loup (Fig. 2.6) or at Etampes (Fig. 1.64), or stylized, much like a sunburst (Fig. 1.23). A beard may be combed and divided into curls or corkscrews along the jawline, as at Saint-Loup de Naud (Fig. 1.63) or Chartres (Fig. 1.127), or it may extend over the chest in thick, snaky locks, as at Saint-Denis (Fig. 1.66/Pl. 4) and at Saint-Loup de Naud (Fig. 1.128). Just as Roman imperial portraits copied the hairstyle of Augustus, these styles may have brought to mind the characteristic styles of specific magnates like Charles the Bald.[116] Generally, it seems that mustaches were carved in proportion with the beard, though some men appear to have 'handlebar' mustaches that extend to the jawline of a relatively short beard, as at Le Mans (Fig. 1.27) and Bourges (Figs I.7, 1.112). At the Porte des Valois, florid mustaches with excessively curled ends and small but curly beards appear on all six crowned men (Figs 1.83, 1.84). During the twelfth century, courtly men illustrated through column-figure sculpture appear to have worn mustaches only in combination with beards.

The ensemble: 3, the mantle

An outer wrap has been a regular part of the attire of men and women since ancient times. The mantle, a floor-length, sleeveless, semi-circular outer cloak, completed the ensemble worn by ranking men and women in France, in a fashion that remained in use until the end of the fourteenth century.[117] It is such an essential part of the costumes of both men and women column-figures that every non-clerical column-figure appears cloaked in a mantle, with only three exceptions: at Ivry, at Saint-Denis, and Chartres

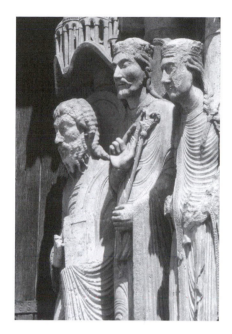

1.127 Notre-Dame, Chartres Cathedral, Royal Portal west façade, right portal, right jamb, three column-figures: upper sections, c. 1145.

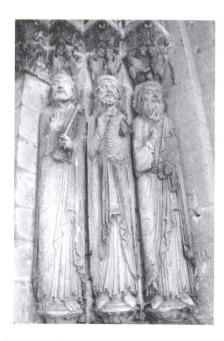

1.128 Saint-Loup de Naud, right jamb column-figures: right hands raised, c. 1160.

Photos: Janet Snyder

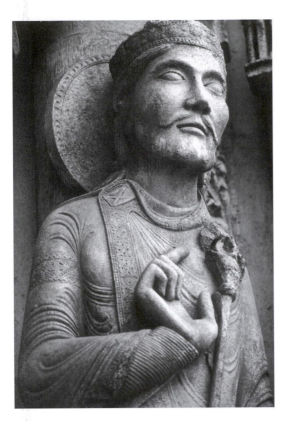

1.129 Notre-Dame, Chartres Cathedral, Royal Portal west façade, right portal, right jamb 2: open cuff sleeve, armband with cross design, beard, c. 1145.

Photo: Janet Snyder

Cathedral (Figs 1.26, 1.62, 1.2 respectively). Under the Merovingians, this traditional outer garment had been reserved for the wardrobe of the elite.[118] In portal sculpture, some column-figures are depicted with the mantle covering their hands, as if being used to shield sacred attributes from profane touch – books, scrolls, and gifts – like the man from Notre-Dame de Corbeil (Fig. 1.20). The mantles of both men and women might have been made from imported silk textiles or from northern woolen or worsted cloth. The *Linceul de saint Remi*, held in the Musée Saint-Remi in Reims, a single piece of silk fabric 230 cm wide by 190 cm long, confirms that the seamless cloaks as large as those represented in column-figure sculpture might have been fabricated from single pieces of silk fabrics.

Displayed asymmetrically on most column-figure sculptures, the normal arrangement appears to have been that mantles were secured on the right shoulder by a pin or by metal clasps with cords or ribbons, as they appear to be on the men at Bourges (Fig. 1.112).[119] Decorative pins close mantles on figures at Bourges (Fig. 1.58), and at the Porte des Valois (Figs 1.83, 1.84). At Chartres Cathedral (Figs 1.23, 1.129) and at Saint-Ayoul (Fig. 1.18), a circular or bar *fermail* appears to fasten overlapping edges of mantles.

Closure on the right shoulder leaves the right arm unencumbered, facilitating writing, the handling of a sword, or managing the reins of a horse. A few male figures' mantles close at center front, as at the Porte des Valois (Fig. 1.84), while many mantles appear to be unfastened, as at Etampes (Fig. 1.14), Chartres (Figs 1.16, 1.115), and Bourges (Fig. 1.29 right). Although the mantles of some column-figure women close on the right shoulder (Fig. 1.12), the mantles of many others were arranged without fastening to rest symmetrically on both shoulders, as at Chartres, Le Mans, Saint-Thibaut, and Rochester Cathedral (Figs 4.6, 1.43, 1.60, 1.33 respectively); or they are fastened at center front, as at Saint-Denis (Figs 1.30, 1.46).[120] The functional character of a right-shoulder fastening of the mantle is illustrated in both the enamel funeral effigy of Geoffroi le Bel, Duke of Normandy and father of King Henry II of England, who brandishes his sword in his right hand (Fig. 1.91/ Pl. 6), and the engraving of Cadmus of Thebes, who is pictured working at his writing desk on the 'Hansa' basin (Fig. 4.2).

The remains of the original painting on some sculptures indicate mantles might have been lined, in the manner of the mantle on the Plantagenet enamel,

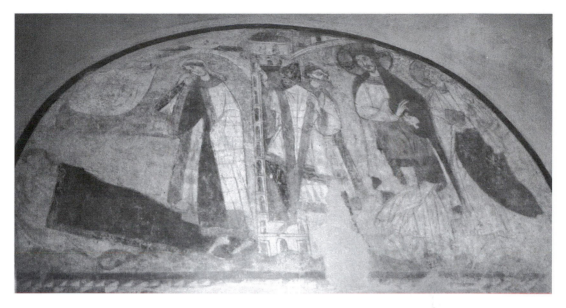

1.130 *The Raising of Jairus's Daughter*, Church of St. Michael and All Angels, Copford (Essex).

Photo: Janet Snyder

with skins or furs.[121] A figure at Chartres wears a mantle with a kind of collar falling over the shoulders and back (Fig. 1.3): the mantle of the Empress Matilda of England (d. 1167) in the *Gospels of Henry the Lion* was depicted with a pattern that indicates it was lined with vair (Fig. 1.92/Pl. 7).[122] In the twelfth-century wall painting of *The Raising of Jairus's Daughter*, at Copford Church, the vair-lined mantles of Jairus, 'one of the synagogue rulers,' and his wife mark them as wealthy citizens appealing to Christ for a miracle (Fig. 1.130).[123] This sartorial clue may also provide some political subtext regarding an astonished high-ranking fallen-away believer who might be persuaded to return to the faith, something that might have served the local Anglo-Saxon viewers of the painting as well as any conquering Norman who might have visited Saint Michael and All Angels. In the early twelfth-century mural decoration of St Botolph's, in Hardham, infidel fighters were depicted as Normans carrying shields like the ones carried by the invaders at Hastings a few years earlier.[124]

The uncommon left-shoulder fastenings that can be seen at Chartres Cathedral (Fig. 1.23) also appeared at Saint-Denis (Fig. 1.109) and Angers (second figure from left in Fig. 1.32). The significance for left closings might be deduced from contemporary paintings: a mid-twelfth-century manuscript, the *Bible of Saint-Martial*, illustrates the Thessalonians in left-fastening mantles.[125] The *Jesse* relief on the façade of Notre-Dame du Grande of Poitiers includes a mantle fastened on the left.[126] These left-shoulder mantle closures were depicted on the painted stained-glass Magi of the center lancet of the Chartres Cathedral west façade (Fig. 1.131/Pl. 12). It is likely that the eight left-handed column-figures were intended to indicate elders like Jesse, who anticipated the coming of Christ, or foreigners, like the Thessalonians and the Wise Men, who recognized the Messiah.

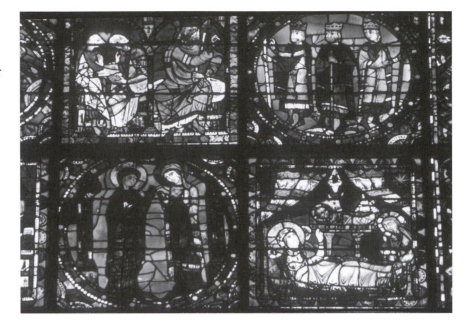

1.131 Notre-Dame, Chartres Cathedral, interior of the west front, center bay (*Childhood of Christ*), painted stained glass, c. 1150.

Photo: Janet Snyder

One's status as articulated through the conspicuous consumption of luxury materials can be expressed with jewelry, though *fermails* with raised jewels or sculpted patterned designs could be depicted in stone as closures for the mantle (Fig. 1.39, 1.49, 1.60).[127] Since these brooches appear on column-figure women installed in the region east of Paris (Notre-Dame at Corbeil, Saint-Thibaut, and Saint-Loup de Naud), they may have had specific meaning. These big pins resemble reliquaries and may have been suspended on a cord

like a necklace.[128] Possibly, this design element could have been intended to indicate the wearer had traveled as a pilgrim; it might have signaled the exalted status of the owner of such a possession. The flat kite-shaped pin of a matron's mantle (Fig. 1.132/Pl. 13) contrasts with more typical buttonlike closures (Figs I.7, 1.27, 1.30, 1.39, 1.83, 1.84, 1.129, 1.130, 1.131/Pl. 12). The *ymagiers* combined sculpted pins and cords for mantle fasteners, and showed a tremendous variety of *tassels* with *attaches* represented in sculpture as being worn by both women and men, as can be seen at Chartres Cathedral (Figs 1.10, 1.23), Angers Cathedral (Figs 1.21, 1.31, 1.93), Bourges Cathedral (Fig. 1.29), and Avallon (Fig. 1.111). Sculpted diagonal, swirling

1.132 Saint-Etienne, Bourges Cathedral, North lateral portal, right column-figure: pin, braid *en trecié*.

Photo: Janet Snyder

cords pull the observer's attention to certain figures; these dancing lines across the sculpture at Angers introduce implied movement to the static portal composition (Figs 1.21, 1.105).

Further significances may be deduced when the mantles appear to be unfastened and column-figures appear with bare feet. Though nearly all column-figures were represented as if wearing shoes – slippers, shoes, or ankle-boots (Figs 1.133, 1.134, 1.135, 1.69) – the toes of a select few are naked (Figs 1.136, 1.137, 1.138). Reminiscent of classical garments, the mantles of 36 column-figures were sculpted to appear to be wrapped and draped around the shoulders and torso, with no fastenings. The wrapped, grasped outer garments are carried much as an ancient Roman citizen might have fashionably draped the *umbo* of his *toga* over his arm or shoulder. Some of these wraps appear to be rectangular *pallia* rather than semicircular mantles, causing the column-figures to appear clothed in costumes copied from sculptures of ancient philosophers. A number of these column-figures appear with sandals or no foot coverings at all, much as the apostles Peter and Paul appeared in smaller reliefs on the jambs of the Galilee porch at Vézelay. There are bare toes visible at Chartres (Fig. 1.12), Etampes (Fig. 1.136), Le Mans (Fig. 1.137), Notre-Dame in Paris (Fig. 1.139), and Saint-Loup (Fig. 1.128). When this loosely draped outer wrap is not fastened and is combined with unshod feet in the image, the type recalls Stoic philosophers. For this reason, these figures, otherwise dressed in the garb of the Elite or Chamberlains, have been designated in Appendix A as 'Associates with bare feet.' More often than not, these figures stand on each side of the doorway, and half of them appear to hold attributes like the keys of Saint Peter – coincidences which validate the theory that the dress of the Associates may signal that these figures represent evangelists, prophets, or disciples. It seems probable that these figures participate in the long tradition recognized in the twelfth century that Peter and Paul represented the communities that comprise the Universal Church.[129]

1.133 Notre-Dame, Chartres Cathedral, Royal Portal west façade, left portal, left jamb 1: hemline; pointed slipper toes, c. 1145.

1.134 Notre-Dame, Chartres Cathedral, Royal Portal west façade, center portal, left jamb 2: shoes with inscribed sole seam, c. 1145.

1.135 Notre-Dame, Chartres Cathedral, Royal Portal west façade, right portal, left jamb 2: hemline, rucked leggings, boots, c. 1145.

Photos: Janet Snyder

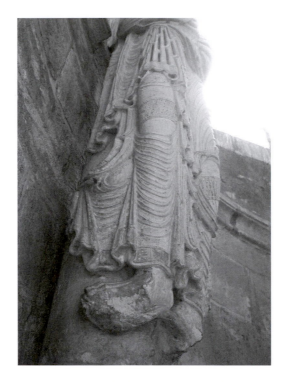

1.136 Notre-Dame du Fort, Etampes, northeast chapel
column-figure: side and feet.

Photo: Janet Snyder

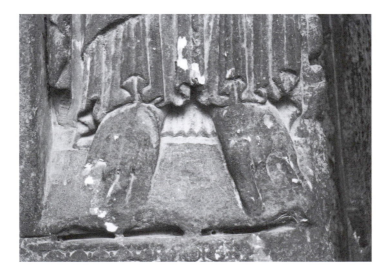

1.137 Saint-Julien, Le Mans Cathedral, left jamb 1:
feet of relief column-figure, before 1158.

Photo: Janet Snyder

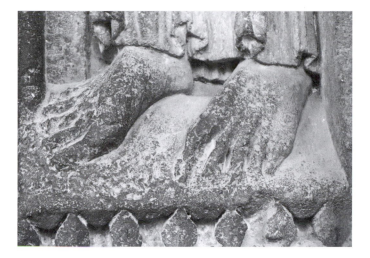

1.138 Saint-Julien, Le Mans Cathedral, right jamb 1:
feet of relief column-figure, before 1158.

Photo: Janet Snyder

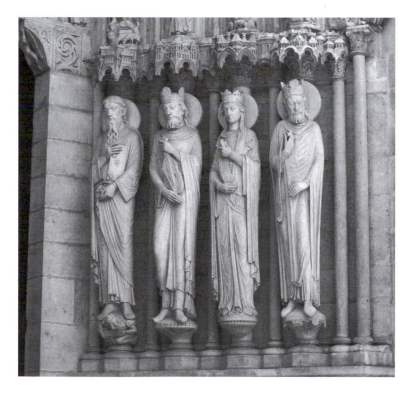

1.139 Notre-Dame, Paris cathedral, west façade, right portal (Portail Sainte-Anne),
c. 1155–65. Nineteenth-century reconstruction of right jamb column-figures.

Photo: Janet Snyder

New significances

The designs that were used for church portal programs became more complex in the last third of the twelfth century. Unlike the portal designs installed c. 1140–60 that featured individuals, later compositions combined pairs and groups into meaningful assemblages. In the transitional 1160s, changes in appearance were the result of complex interactions. At Vermenton, the roles of individual column-figures may be recognized as participating in an interactive tableau but the intended narrative may have differed from the one that Plancher's engraver presented several centuries after its installation (Fig. 1.140). If there were indeed, three crowned men on the left jamb depicting the Magi, it seems odd that only one of these has fastened his mantle on the left like other foreigners. The center

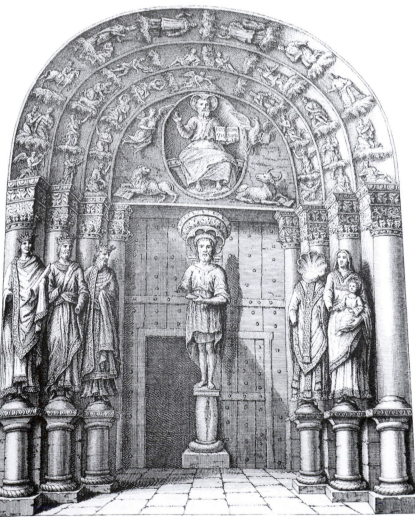

1.140 Notre-Dame, Vermenton, west façade, column-figures: L3, L2, L1 (three kings?); *trumeau* (John the Baptist): R1 (Cleric), R2 (woman and child), R3 missing. From Dom Urbain Plancher, *Histoire general et particular de Bourgogne* (Dijon, 1739).

Photo: Janet Snyder

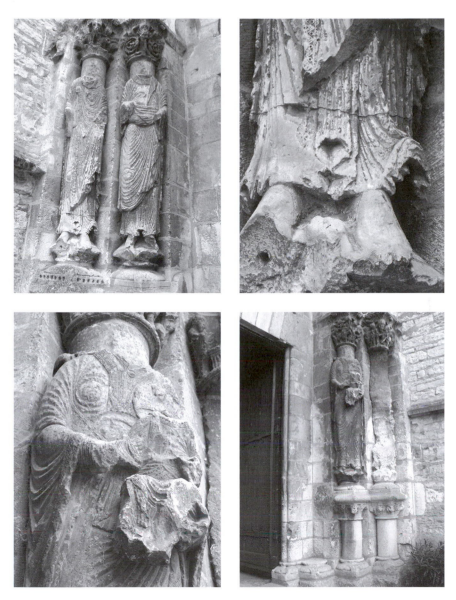

(*top left*) 1.141 Notre-Dame, Vermenton, west façade, left jamb, column-figures: L3, Chevalier; L2 portrays round neckline and mantle wrapped like girdle, c. 1160–70.

(*top right*) 1.142 Notre-Dame, Vermenton, west façade, left jamb, fragment of column-figure. L3 (detail): Chevalier hem with open center seam, c.1160–70.

(*bottom left*) 1.143 Notre-Dame, Vermenton, west façade, right jamb, column-figure: cote and mantle; wide trumpet sleeve; breast emphasized; child's crossed nimbus, c. 1160–70.

(*bottom right*) 1.144 Notre-Dame, Vermenton, west façade, right jamb, c. 1160–70.

Photos: Janet Snyder

column-figure more closely resembles an Associate, while the outside figure wears the Chevalier's open-seam *bliaut* (Figs 1.141, 1.142). The extraordinary costume of John the Baptist on the *trumeau* indicated in the Plancher illustration, the Cleric's head framed by a shell, and the Mother and Child are unique among twelfth-century images (Fig. 1.143, 1.144). Despite subsequent damage to the Vermenton portal, remains of the regal dalmatic of the Monarch (Fig. 1.145) indicates the portal deserves a fresh assessment.

The fictive textiles and unusual decorative garment details of column-figure sculpture correspond to preferred features of twelfth-century Frankish

courtly dress that conveyed meaning. The free translation of the language of textiles and dress expressed in column-figure sculpture demonstrates the fluidity of meaning for clothing during the period. The language of dress provides a key to unlocking the code of represented clothing in twelfth-century portal designs with column-figures and to the discovery of further significances of portal compositions. The Grande Dame, the Norman Lady, and the Gentlewoman stand shoulder to shoulder with courtiers who can be identified according to their ranks and roles. While clothes may not 'make the man,' understanding the lexicon legible in the twelfth century opens a new path for the investigation of political and social rank and roles in the Capetian courts and this understanding provides access to the more complex layers of meaning of column-figure sculpture in twelfth-century northern Europe.

1.145
Notre-Dame, Vermenton, west façade, right jamb fragment: open-seam side of dalmatic with heavy border band, c. 1160–70.

Photo: Janet Snyder

Notes

1 Saint Augustine, *The City of God*, trans. Gerald Walsh et al. (New York, 1958), XIX, 13, p. 456.

2 'Rank' refers to one's place in a social group relative to other social groups; 'status' indicates 'personal attributes (including birth) that condition one's relations to other individuals, whether those within the same social rank or those in another.' See Kimberly A. LoPrete, 'Adèla of Blois: Familial Alliances and Female Lordship,' in Theodore Evergates (ed.), *Aristocratic Women in Medieval France* (Philadelphia, 1999), p. 33.

The social structure under leaders during the Middle Ages eventually came to be recognized with inherited status, but during the twelfth century systems of hierarchy and liege–lord relationships were still being worked out. For this reason, in this chapter the term 'elite' is used to refer to the members of the upper echelons of the community. Though elsewhere 'nobility' may have been used to refer to this group, the term seems inappropriate for the twelfth century. The concept of 'noblesse' is discussed below in relation to the exceptional status of Champenois leaders.

3 Victor Turner and Edith Turner, *Image and Pilgrimage in Christian Culture, Anthropological Perspectives* (New York, 1978), p. 2.

4 Nicholas Howe (ed.), *Ceremonial Culture in Pre-Modern Europe* (Notre Dame IN, 2007): p. 5.

5 The sculpture was produced in the church-side *chantiers* (workshops or construction areas) that prepared the building fabric. The word *ymagier* is used to differentiate the stoneworkers who produced images, specialists who would be called sculptors in later periods. The work of the sculptor was not recognized as a distinct art or craft in twelfth-century Europe.

6 Jules Quicherat, *Histoire du costume en France depuis les temps les plus reculés jusqu'à la fin du XVIII^e siècle* (Paris, 1875, 1877); Eugène-Emmanuel Viollet-le-Duc, *Dictionnaire raisonné du mobilier française du Moyen-age* (Paris, 1872), vol. 4; Eunice R. Goddard, *Women's Costume in French Texts of the Eleventh and Twelfth Centuries* (Baltimore and Paris, 1927); Jennifer M. Harris, *The Development of Romanesque-Byzantine Elements in French and English Dress 1050–1130* (Manchester University, 1977); François B. Boucher, *20,000 Years of Costume, The History of Costume and Personal Adornment* (New York, 1965); idem, *Histoire du costume en occident de l'antiquité à nos jours* (Paris, 1983); Janet E. Snyder, *Clothing as Communication: A Study of Clothing and Textiles in Northern French Early Gothic Sculpture* (PhD dissertation, Columbia University, 1996).

7 Chapter 4, 'Significant Stuff,' below, discusses textiles in detail.

8 *Game Piece with Episode from the Life of Apollonius of Tyre*, c. 1170, walrus ivory, Rhenish, Cologne, 0.2 × 5.6 × 1.6 cm; Purchase, Stark and Michael Ward Gift, Joseph Pulitzer Bequest, and Pfeiffer and Dodge Funds, 1996; The Metropolitan Museum of Art (1996.224). For the story, see Philip H. Goepp, 'The Narrative Material of Apollonius of Tyre,' *ELH* [*English Literary History*], 5 (2) (June 1938): 150–72.

9 *Bronze ('Hansa') Bowl engraved with Mythological Scenes*, twelfth century, probably German, found in June 1824 in the river Severn between Tewkesbury and Gloucester. In the center, King Cadmus of Thebes, inventor of the Greek alphabet, sits on a throne in a snug *bliaut* and mantle; medallions show the birth and Labors of Hercules (The British Museum M&LA 1921, 3–25, 1/).

10 See the skirt of *Pride* and the upper arm of Holofernes in the Drawing of *Victory of Humility, stabbing Pride, in the center, flanked by Jael and Judith*, at the beginning of epistle IV.2; South Germany, The British Library, Arundel 44, fol. 34v. The image is available on line at: <http://www.bl.uk/catalogues/illuminatedmanuscripts/record.asp?MSID=7952&CollID=20&NStart=44>.

11 'Apart from, or in the absence of, written documents, the phenomenological evidence is primary ….' See David Freedberg, *The Power of Images* (Chicago, 1989), p. 20.

12 Each mounted warrior may or may not have been dubbed a knight as defined by scholars of post-twelfth-century England; in other words, he experienced the requisite apprenticeship, tests, ceremonies, and rituals. See Rachel Dressler, *Of Armor and Men in Medieval England: The Chivalric Rhetoric of Three English Knights' Effigies* (Aldershot, 2004); and Peter Coss, *The Knight in Medieval England 1000–1400* (Conshohocken PA, 1996).

13 *Le nouveau petit Robert* (Paris, 1996).

14 Quicherat, *Histoire du costume en France*, p. 163. The chemise was made from fine linen. The structure of woven linen causes the linen fabric to crease in dimples with pointed rather than curved crease ends. 'Rucked' describes the appearance of sleeves that had been smocked on the inside of the garment.

15 '*Chemise* … – XII^e; base lat. *Camisa* … a garment covering the torso, often worn next to the skin … ancient undergarment,' *Le nouveau petit Robert*, p. 356.

'*Cote* … 1080.' Side, rib. '*Cotte* … – 1155 … Ancient … tunic,' ibid., pp. 483–4.

'*Bliaud*, … var. *Bliaut – blialt* 1080 … a long tunic worn by men and women during the Middle Ages,' ibid., p. 232. '*Bliaut*, Vêtement des deux sexes en usage du XI^e à la fin du XIII^e siècle. Le bliaut des femmes est une tunique serrée au

buste et à la taille, lacée sur les côtes, fermée sur la poitrine par un bouton ou une agrafe et munice d'une *ceinture* dont les jeunes filles, etc. …. Vers 1230 il disparaît sur les sceaux on le rencontre encore ailleurs jusqu'à la fin du XIIIe siècle, mais alors il est definitivement remplacé par le surcot.' See Victor Gay, *Glossaire archéologique du moyen âge et de la renaissance*, reviewed and completed by Henri Stein, illustrations directed by Marcel Aubert (Paris, 1887, 1928), p. 161.

'With reference to clothing, *cors* means the bodice of a *bliaut* …,' Goddard, *Women's Costume in French Texts*, p. 102.

'*Giron* … – gerun 1140 … *Gironné/e*, adj – *v.* 1530; *de giron* … the part of a garment from the belt to the knees,' *Le nouveau petit Robert*, p. 1019. '*La gironée* is the skirt of a dress as distinguished from the bodice or *cors* …,' Goddard, *Women's Costume in French Texts*, p. 131.

16 'Very often it was set with jewels, in which case it is practically a crown, though not always used as the insignia of royalty …,' Goddard, *Women's Costumes in French Texts*, pp. 66–7. See also Camille Enlart, *Manuel d'archéologie française depuis les temps Mérovingiens jusqu'à la Renaissance*, vol. 3, *Le costume* (Paris, 1916), p. 178.

17 For crowns, see plates 12, 14, 15, and 17 in Ronald W. Lightbown, *Mediaeval European Jewellery with a Catalogue of the Collection in the Victoria and Albert Museum* (London, 1992).

18 The upper rim of the crown might undulate above the large jewels set into the band, or the crown appears divided into quarters, with the rim rising in peaks at front, back, and sides (Fig. 1.121).

19 For the *Bayeux Embroidery* ('*Tapestry*'), see Martin Foys, *The Bayeux Tapestry on CD-ROM* (Scholarly Digital Editions (CD-ROM), 8 November 2002). See also Wolfgang Grape, *The Bayeux Tapestry, Monument to a Norman Triumph*, trans. David Britt (Munich and New York, 1994), pp. 107, 122, and 143. Tippets are described in Goddard, *Women's Costumes in French Texts*, p. 15.

20 The waist cinch is unclear in the Paris figure. Understanding of this detail is distorted through the lens of the eighteenth-century illustration and nineteenth-century reproduction (Fig. 1.139) of the column-figure that has been reduced to a fragment in the Musée national du Moyen Age, Thermes et Hôtel de Cluny.

21 Boucher calls the *chainse* a long tunic of fine linen with long sleeves and gathered wrists, generally finely pleated, and always white. See Boucher, *20,000 Years of Costume*, p. 427.

22 Goddard, *Women's Costume in French Texts*, p. 16.

23 The narrow point of a gore is illustrated in Fig. 4.5.

24 Marie de France, *Lanval*, lines 547–74. '… the approximate period of her literary activities is 1160–1215 … the *lais* have been dated 1155–1170 ….' See Marie de France, *The Lais of Marie de France*, trans. Robert Hanning and Joan Ferrante (Durham NC, 1978), pp. 1 and 7.

25 *Enamel Casket*, c. 1180, from the court of Aquitaine, Limoges, France, 1. 21.1 × w. 15.6 × h. 11 cm; The British Museum (M&ME 1859,0110.1). See <www.thebritishmuseum.ac.uk/explore/highlights/hightlight_objects/pe_mal/e/enamel_casket.aspx> (accessed 1 August 2007). See also Neil Stratford, *Catalogue of the Medieval Enamels in the British Museum*, vol. 2, *Northern Romanesque Enamel* (London, 1993), nos 1, 2.

26 Montmorillon (Vienne) in Notre Dame, *The Mystic Marriage of S. Catherine*. Paul
 Mantz, *La peinture française du IX^e siècle à la fin du XVI^e* (Paris, 1897), p. 107. *The
 Raising of Jairus's Daughter*, Church of St. Michael and All Angels, Copford, Essex
 can be seen at <http://www.paintedchurch.org/copfjair.htm>.

27 These archaeological textile fragments from Gamla Lödöse, on the Göta älv
 River are discussed in greater detail in Chapter 4, 'Significant Stuff.' See
 Margareta Nockert, 'Medeltida dräkt i bild och verklighet,' in *Den Ljusa
 Medeltiden* (Stockholm, 1984), pp. 191–6.

28 'The *ceinture* is a belt worn with the dress … From the texts we have further
 evidence as to the materials, which were of silk or similar fabrics embroidered in
 gold, and of *orfrois*,' Goddard, *Women's Costumes in French Texts*, p. 63. (See also
 Judith in Arundel 44, fol. 34v, as in note 10 above.)

29 'Tablet-weaving is a technique of combining warp and weft, characterized by
 the use of flat tablets … for the production of the shed,' Peter Collingwood,
 The Technique of Tablet Weaving (New York, 1982), p. 8. See also Sigrid Müller-
 Christensen, 'Examples of Mediaeval Tablet-Woven Bands,' in Victoria Gervers
 (ed.), *Studies in History in Memory of Harold B. Burnham* (Toronto, 1977), pp.
 232–7. See examples of tablet-weaving with patterns similar to carved examples
 in Lise Raeder Knudsen, 'Brocaded Tablet-Woven Bands: Same Appearance,
 Different Weaving Technique, Hørning, Hvilehøj and Mammen,' in Frances
 Pritchard and John Peter Wild (eds), *Northern Archaeological Textiles* (Oxford,
 2005), pp. 36–41.

 For *ceinture* materials, see Goddard, *Women's Costumes in French Texts*, p. 63. For
 orfrois, '… embroidery done in gold thread,' see idem, p. 178. See *Le nouveau petit
 Robert*, p. 1546, '*Orfroi … orfreis*, 1150 … Rich cloth embroidered with gold or
 silver for liturgical vestments.'

30 'Pictorial or sculptural representations tell us relatively little … always
 in mediaeval jewellery pearls form a secondary pattern of their own …,'
 Lightbown, *Mediaeval European Jewellery*, pp. 101–2.

31 Agnes, Countess of Bar, wife of Renaud, Count of Bar, 1171 (Champagne 26).
 Ida, Countess of Nevers, wife of Guillaume III (1151–61), died at the earliest
 in 1178. 'Dame debout, de face, robe ajustée à la taille, à manches pendantes,
 très longues; des deux bras écartés, la main droite tenant une fleur (PL
 XI). SIGILLUM IDE DE NIVERNIS COMITISSE. vers 1180.' See A. Coulin,
 *Inventaire de la Champagne, recueillis dans les depots d'archives musées et collections
 particulières des departments de la Arne, de l'Aube, de la Haute-Marne et des
 Ardennes*, MS no. 113.

32 Marie de France, *Eliduc* (line 380), *Lanval* (line 724) (see note 24).

33 The original column-figure CL5 is in the crypt at Chartres Cathedral, while
 the cast installed on the cathedral façade of a column-figure left jamb of the
 center portal at Chartres has a restored *ceinture* knot (Figs 1.2, 2.5). The cast
 of the original sculpture, now in the Musée national des monuments français
 (Trocadéro), reveals the original *ceinture*; the knot and waistband had been
 destroyed before the modern restoration.

34 The supposition arises since entry into a church was allowed only if a woman's
 head were covered. Enlart stated that mantles were used in Carolingian times as
 veils, because women were only admitted to churches with covered heads. 'Les
 manteaux ont les formes déjà usitées à l'époque carolingienne: le voile se pose sur
 la tête, et il est d'un grand usage, car les femmes ne sont admises à l'église que la
 tête couverte,' Enlart, *Manuel d'archéologie*, p. 33.

'… [T]oaille, is also found towards the end of the twelfth century as a headress,' Goddard, *Women's Costume in French Texts*, p. 213.

35 At court, women held the veil in place with a crown or *cercle*; in other situations, women are shown with the long veil wrapped and knotted around the head as a *coife*. Ibid., p. 99.

36 Ibid., p. 221. 'The *guimple* was a kind of woman's headdress, consisting of a piece of linen or silk wound around the head and neck in such a way that it could be drawn over the face,' ibid., p. 137.

37 The *grève* is defined by Gay (*Glossaire archéologique*) as a parting in the hair. See Goddard, *Women's Costume in French Texts*, p. 136.

38 *Queen of Sheba*, center portal, Abbey Church of Saint Denis; Musée national du Moyen Age, Thermes et Hôtel de Cluny, Paris (Cl. 23250). See Charles Little (ed.), *Set in Stone: The Face in Medieval Sculpture* (New York, 2006). See also Alain Erlande-Brandenburg, 'Une tête de prophète provenant de l'abbatiale de Saint-Denis portail de droite de la façade occidentale,' *Comptes rendus de l'Académie des Inscriptions et Belles-Lettres* (Paris, July–October 1992): 515–42.

39 When arranged *en trecié*, three sections of hair were plaited without ribbons entwined.

40 This layout and carving technique is discussed further in Appendix B, 'From Quarry to Cathedral.'

41 *Plaited Hair-Piece with Silk Tablet-Woven Filet* (no. 1450). 'The use of false hair was not a new departure in fourteenth-century England. Long plaits worn down the back, sometimes almost to the ground in the twelfth century, often required the artful addition of extra hair, and from regulations issued by a church in Florence in the early fourteenth century, it appears that plaits of flax, wool, cotton or silk were sometimes substituted for hair.' See Geoff Egan and Frances Pritchard, *Dress Accessories c. 1150–c. 1450* (London, 1991), pp. 292–3.

42 The *jeune femme* from the cloister of Notre-Dame-en-Vaux, c. 1170. See Sylvia Pressouyre and Léon Pressouyre, *The Cloister of Notre-Dame-en-Vaux at Châlons-sur-Marne*, trans. Danielle V. Johnson (Nancy, 1981), #34, p. 59.

43 *En galonné*: made with the aid of a ribbon. Goddard, *Women's Costumes in French Texts*, p. 125.

44 See William Provost, 'Marie de Champagne,' in Katharina M. Wilson and Nadia Margolis (eds), *Women in the Middle Ages: An Encyclopedia* (Westport CT, 2004), vol. 2, pp. 596–9.

45 See Charles Oursel, *Miniatures cisterciennes* (Macon, 1960). See, for example, the *Falconer* in the initial Q, Dijon, Bibliothèque municipale, MS 173, fol. 174.

46 For techniques of decoration, see the cabochon jewels attached to the *chasuble attachée au nom de Saint Ladislas Ier Arpád, roi de Hongrie* (1077–95) in Riggisberg. Mechthild Flury-Lemberg, *Au sujet de quatre vêtements sacerdotaux au Moyen-Age et de leur conservation* (Bern, 1987), p. 19.

47 The word *ṭirāz* can refer to the tapestry-woven or embroidered inscription band worked as part of a textile, or to the garment bearing the band, or to the workshop where the cloth was woven or ornamented. See Lisa Golombek and Veronika Gervers, '*Ṭirāz* Fabrics in the Royal Ontario Museum,' in Veronica Gervers (ed.), *Studies in History in Memory of Harold B. Burnham* (Toronto, 1977), pp. 82–93. See further discussion of *ṭirāz* in Chapter 4, 'Significant Stuff.'

48 'Wolfram' candlestick, c. 1180, St. Mary's Cathedral, Erfurt Cathedral, Thuringia, Germany. See Marcel Durliat, *L'art roman* (Paris, 1982), p. 551.

49 *Column Figure of a Nimbed King*, c. 1150–70, limestone, French, h. 115 cm. Columnar statue made in Saint-Denis, from the Cloister of the Abbey of Saint Denis. Now in The Metropolitan Museum of Art, Purchase 1920, Joseph Pulitzer Bequest (20.157). See the drawing in Paris: BN, Fr. MS 15634, fol. 46.

Paris: BN, MS FR 15634 folio 55. Drawing before 1728. Engravings published in Dom Bernard de Montfaucon, *Les monumens de monarchie françoise, qui comprennent l'histoire de France* (Paris, 1729), vol. 1, pl. 17.

50 The civil *pallium* will be discussed below.

51 See Charles T. Little, 'Column Figure of a Nimbed King, from the Old Cloister,' in Paula Gerson (ed.), *The Royal Abbey of Saint-Denis in the Time of Abbot Suger (1122–1151)* (New York, 1981), pp. 45–6. Little referred to this as the 'tasseled girdle.' See also V.K. Ostoia, 'A Statue from Saint-Denis,' *Metropolitan Museum of Art Bulletin*, 13 (10) (June 1955): 298–304.

52 The engraver of the 1728 drawings of Saint-Denis column-figures deleted the puzzling tassels on a male costume prior to the publication of Montfaucon's *Monumens de monarchie françoise* in 1729 (see vol. 1, pl. 17); the tassels of the second figure from the door on the right jamb at Saint-Germain-des-Prés were minimized and obscured by the engraver, compounding the errors in art historians' readings. See ibid., vol. 1, pl. 7, for engravings of Saint-Germain-des-Prés. See also Dom Jean Mabillon, *Annales Ordinis S. Benedicti, 2* (Paris, 1703–39), vol. 1, book 6, n. 69, p. 169.

53 '… *choix* – XIIe …,' *Le nouveau petit Robert*, p. 733.

54 Louis Claude Douët d'Arcq, *Inventaire de la collection des sceaux des Archives nationale* (Paris, 1863–68). The dating of these seals is precise: Henri de France, c. 1146, Douët d'Arcq no. 7615; Philippe de France, 1137–52, Douët d'Arcq no. 9181. See also Foundation for Medieval Genealogy, http://fmg.ac/Projects/MedLands/CAPET.htm#_Toc154137004.

55 Dijon, Bibliothèque municipale, MS 168, fol. 7 (1100–30).

56 '*Chambellan* … fin XIe …' Gentleman of the court charged with service of the chamber of the sovereign. See *Le nouveau petit Robert*, p. 338.

57 The *ṭirāz* workshops and their products are discussed in Chapter 4, 'Significant Stuff.'

58 '*Roi … rei* – Xe; lat. *rex* …' The head of state who accedes to power for life by hereditary means or, more rarely, is elected. See '… *monarque, prince, souverain* …' in *Le nouveau petit Robert*, p. 1995.

59 The fragment of a column-figure from Portail Sainte-Anne at Notre-Dame in Paris that was found in 1977 includes a complex border decoration for a regal dalmatic (Fig. 1.82; compare with nineteenth-century column-figure in Fig. 1.48).

60 The dalmatic is a Roman outer garment with short sleeves decorated with *clavi* under which was worn the *tunica romain*, a long gown with narrow sleeves. The *clavus* is a broad fabric stripe extending from the front hem over each shoulder to the back hem. See Elisabeth Piltz, *Le costume officiel des dignitaires byzantins à l'époque paléologue* [*Costume of the Byzantine Court Officials in the Paleologue Era*] (Uppsala, 1994), p. 10. See also Quicherat, *Histoire du costume en France*, p. 161.

61 No. 81 in the cloister at Châlons-sur-Marne. See Pressouyre and Pressouyre, *The Cloister of Notre-Dame-en-Vaux*, p. 81 and figures 15–16. See also Léon Pressouyre, 'Réflexions sur la sculpture du XIIème siècle en Champagne,' *Gesta*, 9 (2) (1970): 24.

62 The identity of the Vermenton fragment in Plancher's figure 188, already missing in the 1730s when he published the engraving, can be made by means of the open side seam and broad border, all that remains of the column-figure's regal dalmatic. See Dom Urbain Plancher, *Histoire générale et particulière de Bourgogne* (Dijon, 1739; repr. Paris, 1974).

63 According to the Musée de Provins et du Provinois, the inscription identifies the figure as David.

64 See discussion of the *sacre* in Chapter 2, 'Structures of Power.'

65 '… v. 1205; *seignur* 1080; lat. *Senior* … The master, in the system of feudal relations. … Maître. → prince …,' *Le nouveau petit Robert*, p. 2064.

66 Bands of tapestry were set into woven textiles (Figs 4.11, 4.12) produced by the weaving and embroidery workshops, known as *Dar al-Ṭirāz* or *Dar al-Kiswa*, found in Islamic urban centers in the Mediterranean basin from Afghanistan to Spain from the seventh century until about the thirteenth century. See discussion of *ṭirāz* in Chapter 4, 'Significant Stuff.'

67 The tomb effigy of Geoffroi V le Bel (Plantagenet), copper (engraved, chased, and gilded) with *vernis brun* and *champlevé* (raised) areas of lapis and lavender blue, turquoise, dark and medium green, semi-translucent dark green, yellow, golden yellow, pinkish white, and white; shortly after 1151, Le Mans (?), Musée de Tessé, Le Mans (Inv. 23-1). Illustrated in *Enamels of Limoges, 1100–1350* (New York, 1996), pp. 98–9.

68 Henry married Matilda of England, daughter of Henry II and Eleanor in 1168. See Henry's coronation miniature in the *Gospels of Henry the Lion* (c. 1175–78). *Das Evangeliar Heinrichs de Löwen*, Wolfenbütel Herzog August Bibliothek, Cod. Guelf, 105 noviss. 2.

69 Coss, *The Knight in Medieval England*, pp. 5–7. See also Constance B. Bouchard, 'Rural Economy and Society,' in Marcus Bull (ed.), *France in the Central Middle Ages: 900–1200* (Oxford and New York, 2002), pp. 79–80: 'The word *miles* itself, simply meaning soldier, went back to the Roman empire, but it had fallen out of use until it was revived in the final decades of the tenth century with a new meaning: a fighter on horseback. *Caballarius*, meaning someone on horseback, was even more specific.'

70 On the Peace of God see Bouchard, 'Rural Economy and Society,' p. 78.

71 '*Noble* … fin XI[e]; lat. *Nobilis* … One who commands respect and admiration by his distinction, his natural authority,' *Le nouveau petit Robert*, p. 1490. After 1165 the term 'chevalier' was used for members of *Chevalerie*, a religious-military institution with religious character which was to become part of the feudal *noblesse*.

72 He might also have worn a tunic as padding underneath that heavy garment. See Quicherat, *Histoire du costume en France*, p. 149. The *Bayeux Embroidery* illustrates chain-armor and open-seam skirts (Fig. 1.89, where the isolated figure under the word 'mirant' wears the latter). See also Foys, *The Bayeux Tapestry on CD-Rom*.

73 John van Engen, 'Sacred Sanctions for Lordship,' in Thomas N. Bisson (ed.),
 Cultures of Power: Lordship, Status, and Process in Twelfth-Century Europe
 (Philadelphia, 1995), pp. 214–17.

74 Theodore Evergates, *The Aristocracy in the County of Champagne, 1100–1300*
 (Philadelphia, 1999), p. 14.

75 At Chartres, *May* is at the same time a chevalier and a falconer, exercising 'the
 sport of kings,' while at Saint-Denis the chevalier in a chain tunic holds a pennant
 on his lance. In the tiny compositions of the Chartres archivolt, the *ymagier*
 provided further key information about the scene when he illustrated the man's
 braies (leggings) exposed by the open front seam of the chevalier's *bliaut*.

76 See Chapter 3, 'Good Business,' for a discussion of the degradation of one's
 noblesse that was associated with participating in commerce and the developing
 economy.

77 '… *chevalier* 1080 …. A feudal seigneur who possessed a sufficiently important fief
 that enabled him to own and ride a horse. The Chevalier may be a member of a
 Chevaleric (religious, military, c. 1165) order,' *Le nouveau petit Robert*, pp. 361–2.

78 *Personification of Virtues as Knights*, #52–55, the Cloister of Notre-Dame-en-Vaux
 at Châlons-sur-Marne. See Pressouyre and Pressouyre, *The Cloister of Notre-
 Dame-en-Vaux*, pp. 94–101.

79 *Falconer* in the initial Q *Incipit*, Book 35, Gregory the Great, *Moralia in Job*, in
 Dijon, Bibliothèque municipale, MS 173, fol. 174. *The Lewis Chessmen*, c. 1150–
 1200; British Museum (M&ME 1831, 11–1, Ivory Catalogue 78–159).

80 The counterseal (on the reverse) of the first seal of Louis VII, attached to a
 confirmation by Louis le Jeune, of a donation made by a Salomon, doctor, to
 the canons of Viel-Étampes, Paris 1141. Archives nationales, Département des
 seaux, 67 bis, Douët d'Arcq 36 bis, p. 271. The remaining inscription is 'et Duc
 Aquitanorum.' Another early seal is 'Gui, sire de Chevreuse, vers 1140 (St 3039),'
 Archives nationales, illustrated in Françoise Gaspari, *Le XII^e siècle, Mutations et
 renouveau en France dans la première moitié du XII^e siècle* (Paris, 1994), pp. 99–100.

81 *Elephant Ivory Rook: The Fall of Man; Knights in Combat*, c. 1150, ivory with traces
 of gilding, French(?), h. 6.4 cm; Louvre, Paris (OA 3297). Neil Stratford, *The Lewis
 Chessman and the Enigma of the Hoard* (London, 1997), illus. 40, p. 32.

82 See Linda Seidel, *Songs of Glory, The Romanesque Façades of Aquitaine* (Chicago, 1981).

83 The church was built in 1134. See Malcolm Thurlby, *The Herefordshire School of
 Romanesque Sculpture* (Little Logaston, Woonton Hereford, 1999), p. 45.

84 *Doorway from Moutiers-Saint-Jean*, c. 1250, white oolitic limestone with traces
 of polychromy, Burgundy; The Cloisters Collection, 1932 (32.147); The
 Metropolitan Museum of Art.

85 Though in Arundel 44, fol. 34v., *Pride* has no sword illustrated, the *bouclier* of
 Pride signals he once carried a sword in his engagement in the battle he has lost
 to *Humility*. See note 10 above.

86 'Dignitaire,' *Le nouveau petit Robert*, p. 645.

87 *Pallium* and *pallia* are the terms used in inventories of treasuries for large pieces
 of silk fabric and during the twelfth century in the Pipe Rolls in England to
 record very large lengths of silk fabric acquired by Queen Eleanor and her
 daughters. 'A *pallium* is also listed occasionally, again as a kind of mantle
 but whose form we cannot define with any certainty and in these accounts it

appears only as part of a lady's wardrobe. One is purchased in 1177–78 for the young Henry's wife (24 Henry II, p. 128) and several for Queen Eleanor between 1177 and 1179 (25 Henry II, p 125).' See Harris, *The Development of Romanesque-Byzantine Elements*, pp. 147–9. See also Thelma Thomas, *Textiles from Medieval Egypt AD 300–1300* (Pittsburgh, 1990), p. 16.

88 Agnes Geijer, *A History of Textile Art, a Selective Account* (New York, 1979), p. 130. The Latin word *pallium* signifed a rectangular woolen covering, inferring the Greek *himation* as opposed to the Roman *toga*. See also Gay, *Glossaire archéologique*, p. 196. See also Archibald Lewis, 'Byzantium as an Integral Part of European Christendom: Political and Military Factors, 568–1204 AD,' in *The Sea and Medieval Civilizations*, 14 (London, 1978), p. 5.

89 Suger, 'De Rebus In Administratione Sua Gestis,' I, p. 40, line 11; XXXIV A, 'Ordinatio AD MCXLo. vel MCXLIo. confirmata,' in Erwin Panofsky (ed. and trans.), *Abbot Suger on the Abbey Church of Saint Denis and its Art Treasures* (Princeton, 1946, 1979), p. 80, line 6; p. 126, lines 28–34.

90 'Le coût de la soie, du brocart et de la pourpre limitait leur usage à une clientèle restreinte: la noblesse.' See Etienne Sabbe, 'L'importation des tissus orientaux en Europe occidentale du haut Moyen Age IXe–Xe siècle,' *Revue belge de philologie et d'histoire* (July–December 1935): 1284. For recent reappraisal of the exclusive nature of silk, see David Jacoby, 'Silk Economics and Cross-Cultural Artistic Interaction: Byzantium, the Muslim World, and the Christian West,' *Dumbarton Oaks Papers*, vol. 58 (2004), pp. 197–240.

91 See A.W. Pugin, *Glossary of Ecclesiastical Ornament and Costume, compiled from Ancient Authorities and Examples* (London, 1846), p. 189.

92 Since at least the fourth century, the archiepiscopal *pallium* indicated ecclesiastical rank, symbolic of *plenitudo pontificalis officii*; the pope conferred the *pallium* to authorize the metropolitan prerogatives of the archbishop. The archiepiscopal *pallium* could be worn only on Great Feasts and in one's own diocese. See <http://www.catholic.org/encyclopedia/vieww.php?id=8917> (accessed 12 October 2008).

93 'The *loros*, a heavy, gold embroidered, gem-encrusted scarf probably derived from consular *trabea*, is generally worn on all Feast Days after the religious ceremony for the return to the palace.' See Adèle La Barre Starensier, *An Art Historical Study of the Byzantine Silk Industry* (PhD dissertation, Columbia University, 1982), p. 196. See Boucher, *20,000 Years of Costume*, p. 176, illustration 306: *Coronation of Roger II*, mosaic in La Martorana, Palermo, mid-twelfth century.

 The angels wear the *loros* in the Spanish twelfth-century *Fresco* attributed to the 'Pedret Master,' from San Juan de Tredos, c. 1130, Spanish (Catalonian); The Cloisters Collection, The Metropolitan Museum of Art (50.180a). See Peter Barnet and Nancy Y. Wu, *The Cloisters: Medieval Art and Architecture* (New York, 2005).

 The diagonal sash/stole worn by R2 at Etampes (Fig. 1.14) is similar to the stole worn by *Bernard, archidiacre de Paris, 1143–1157*, figure 324 in Germain Demay, *Le costume de guerre et d'apparat d'aprés les sceaux du Moyen-Age* (Paris, 1875), p. 278.

94 The Eparch or Prefect of the City is the Lord Mayor of Constantinople; dress of the Eparch comprises 'a tunic, mantle, laced shoes, and *loros*. He is the only non-royal, non-magisterial person to wear the *loros*.' See Starensier, *An Art Historical Study*, p. 208. Like the *loros*, this *pallium* derived from a long band of cloth

signifying the Roman consul's authority of office, the *trabea*: see Viollet-le-Duc, *Dictionnaire raisonné*, vol. 4, p. 100. Charles the Bald wore the *loros* pinned on his right shoulder like a rectangular mantle.

95 '*Largesse* ... – XII ...,' *Le nouveau petit Robert*, p. 126. This virtue reveals a predisposition for generosity, nobility, goodness, magnanimity, etc.

96 '*Clerc* ... Xᵉ... (→ *clergé*). One who has entered into the ecclesiastic state by having received the tonsure,' *Le nouveau petit Robert*, p. 390.

97 In addition to garments of silk and linen found in the *gisant* tomb, a Limoges *champlevé* enamel crosier knob, c. 1165–1200, was discovered in 1855 in a crypt chapel of the Abbey of Notre-Dame, Issoudun.

98 'There was a long tradition by the early twelfth century of seeing these two Apostles as the leaders and, indeed, as the personifications of Christianity's two constituent communities.' For the beginnings of this tradition, in the milieu of fourth-century Rome, see J.M. Huskinson, *Concordia Apostolorum: Christian Propaganda at Rome in the Fourth and Fifth Centuries: A Study in Early Christian Iconography and Iconology* (Oxford, 1982), p. 148; Herbert L. Kessler, '*Caput et Speculum Omnium Ecclesiarum*: Old Saint Peter's and Church Decoration in Medieval Latium,' in William Tronzo (ed.), *Italian Church Decoration in the Middle Ages and Early Renaissance*, Villa Spelman Colloquia (Bologna, 1989), vol. 1, pp. 119–46; and Herbert L. Kessler, 'The Meeting of Peter and Paul in Rome: An Emblematic Narrative of Spiritual Brotherhood,' *Dumbarton Oaks Papers*, 41 (1987), pp. 265–75. For further discussion of the twelfth-century significance of Peter and Paul, see Peter Low, '"You Who Were Once Far Off": Enlivening Scripture in the Main Portal at Vézelay,' *The Art Bulletin*, 85 (3) (September 2003): 474–5.

99 'Cadets' is a term referring to the younger brothers who did not inherit. See Theodore Evergates, 'Nobles and Knights in Twelfth-Century France,' in Bisson (ed.), *Cultures of Power*, pp. 18–19.

100 Quicherat, *Histoire du costume en France*, p. 168.

101 The alb, a long white linen shirt, considered sacred because of its contact with the skin, was cinched at the waist with a cord referred to as the girdle. Colored and embroidered bands of silk textile, *parement*, might be appliquéed at the hem in front and back of the alb.

102 The priest wore the amice (from *amictus*), an oblong of fine linen, with a standing collar of colored silk fabric tied over his shoulders.

103 The stole, a long strip of silk fabric with a rectangle of linen at the center, was worn over the celebrant's neck and shoulders, crossed in front of the chest and held in place by the girdle cinching the waist, with the long fringed stole ends hanging down in front of his skirt. The stole was an essential part of the priest's clothing when administering the sacraments.

104 When celebrating the Mass, the priest hung a shorter strip of linen trimmed in silk ribbon, the maniple, over his left arm.

105 The chasuble (*casula*, *planeta*), the outer garment worn by the celebrant of the Mass, was made of the most luxurious fabrics available, usually silk. It was usually decorated with a contrasting vertical strip of silk, the *clavus* (if embroidered, an *orphrey*), at center-front and center-back. See *The Fermo Chasuble*, c. 1116, said to have been worn by Thomas Becket, illustrated in Marie Schuette and Sigrid Müller-Christensen, *A Pictorial History of Embroidery*, trans. Donald King (New York, 1963), p. 300, illus. 57–9.

106 The superhumeral, a wide jeweled collar considered to be related to the ephod of the Jewish high priest, was worn over the bishop's shoulders on top of the chasuble. See Quicherat, *Histoire du costume en France*, p. 173.

107 The archiepiscopal *pallium* is always worn on top of and independent of the chasuble, though in visual representations the *clavus* is easily confounded with the archiepiscopal *pallium*. In modern use, the *pallium* is limited to the pope and archbishops, but was usual for bishops during the Middle Ages. See Joseph Braun, 'Pallium,' in *The Catholic Encyclopedia*, 11 (New York, 1911), available at: <http://www.newadvent.org/cathen/11427a.htm> (accessed 27 June 2009).

108 Mosan enamel plaque, Henri of Blois, c. 1150, h. 9 × w. 17.8 cm; now in the British Museum (M&ME 1852, 3-27, 1), available at <www.the britishmuseum. ac.uk/explore/highlights/highlight_image.aspx> (accessed 1 August 2007). See also Stratford, *Medieval Enamels*, nos 1, 2.

109 A. Bonnefin, *Le sacre royal dans l'histoire de France, permanence d'une valeur fondamentale* (Paris, 1993), p. 8. Among the Romans, the dalmatic was an outergarment with short sleeves decorated with *clavi* under which was worn the *tunica romain*, a long gown with narrow sleeves. See Piltz, *Le costume officiel*, p. 10. See also Quicherat, *Histoire du costume en France*, pp. 161 and 173. The form of the ecclesiastical dalmatic contrasts with the form of the regal dalmatic discussed above.

110 For the earlier form of the mitre, with pans over the ears, see 'Hugues III, archevéque de Rouen, en 1153 (D6362),' Archives nationales, illustrated in Gaspari, *Le XII^e siècle*, pp. 100 and 102. Boucher, *20,000 Years of Costume*, p. 187: 'Only the two-horned mitre was completely transformed at the end of the twelfth century to take on its present form, with the horns at back and front.' See also Enlart, *Manuel d'archéologie*, pp. 310–17; Quicherat, *Histoire du costume en France*, p. 174; and Schuette and Müller-Christensen, *Pictorial History of Embroidery*, cat. nos 95/96, *Mitre from England*, late twelfth-century, in the Bayerisches Nationalmuseum, Munich (T.17).

 See *Yellow Silk Austrian (?) Mitre from the Convent of Neustift*, The Metropolitan Museum of Art (46.156.31). Of Sicilian workmanship, this mitre was said to have belonged to Bishop Hartmann of Brixen, 1140–64.

111 Quicherat, *Histoire du costume en France*, pp. 174–5. See *Mitre given to Kloster Seligental by Duchess Ludmilla* (c. 1170–1240). 'It is of English work of the period 1180–1210, on white silk twill with scenes of the martyrdom of Saints Thomas and Stephen in underside couching in silver-gilt thread,' Bayerische Nationalmuseum, Munich, in Kay Staniland, *Embroiderers* (London, 1991), p. 9.

112 Gregory of Tours, *A History of the Franks* [electronic resource: ACLS e-book], trans. Ernest Brehaut (New York, 1969), Book II, Ch. 9, p. 31. The hairstyle is discussed in Bonnie Effros, 'Appearance and Ideology: Creating Distinctions between Clerics and Lay Persons in Early Medieval Gaul,' in D.G. Koslin and J.E. Snyder (eds), *Encountering Medieval Textiles and Dress: Objects, Texts, Images* (Basingstoke and New York, 2002), p. 14. As in note 10, above. The British Library, Arundel 44, fol. 34v. See note 10 also for website address.

113 Douët d'Arcq, *Inventaire, Louis VI*, no. 35; *Louis VII*, no. 37 (1147).

114 Orderic Vitalis, *The Ecclesiastical History of Orderic Vitalis*, ed. and trans. Marjorie Chibnall (Oxford, 1978), vol. 6, Book 11, Ch. 2, pp. 62–9), with Chibnall's discussion at p. 66, n 1.

115 Other kings in the series have more than four curls. *The Lewis Chessmen*, c.
 1150–1200, ivory, probably made in Norway, found on the Isle of Lewis, Outer
 Hebrides, Scotland; max. h. 10.2 cm; now in the British Museum (M&ME 1831,
 11–1, Ivory Catalogue 78–159; eleven are in the National Museums of Scotland).
 For illustrations of six of the eight kings, see Stratford, *The Lewis Chessman*,
 plates 6–11. The hairstyles of the other kings differ slightly, with shoulder-length
 hair or five or six ropes of hair.

116 *Presentation of the Bible to Charles the Bald*, the Vivian Bible, Bibliothèque
 nationale, Paris (MS lat. 1, fol. 423r) c.845.

117 '… *mantel* 980 …,' *Le nouveau petit Robert*, p. 1347. See also Gay, *Glossaire
 archéologique*, p. 111: '… *manteau*: Vêtement de dessus, taillé en rotonde, sans
 manches, parfois fendu à un ou deux côtes, et le plus souvent retenu par
 une agrafe sur le devant. Il fut longtemps l'apanage exclusif des princes, des
 personnages de marque et des grands officiers.'

118 Viollet-le-Duc, *Dictionnaire raisonné*, vol. 4, p. 100.

119 'The *afiche* is a brooch … synonymous with *fermail* and *nosche*, and like them was
 worn usually at the neck,' Goddard, *Women's Costume in French Texts*, p. 24. 'The
 tassels were metal ornaments placed on the front edge of the *mantle*, at the height
 of the shoulders, like a modern clasp, except that, instead of being provided
 with a hook for fastening, ribbons (*ataches*) were run through them, which, when
 tied, held the mantle in place,' ibid., p. 209.

 '… Kings and emperors are sometimes depicted in the eleventh and twelfth
 centuries with a cloak draped over the left side of the body and fastened in
 antique fashion on the right shoulder by a brooch that is usually either round or
 lozenge-shaped, forms whose popularity for brooch clasps persisted as late as
 the fourteenth century…,' Lightbown, *Medieval European Jewellery*, p. 105.

120 Pastoureau declares that women's *manteaux* are fastened center-front, unlike
 men's which close on the shoulder; this is not always true for men or women
 column-figures. See Michel Pastoureau, *La vie quotidienne en France et en
 Angleterre au temps des chevaliers de la table ronde (XII–XIII siècles)* (Paris, 1976),
 p. 99.

121 See Anna Muthesius, 'The Byzantine Silk Industry: Lopez and Beyond,' *Journal
 of Medieval History*, 19 (1–2) (March/June 1993): 54. See also Marielle Martiniani-
 Reber, 'Les textiles IXe–XIIe siècle,' in *Byzance, L'art byzantin dans les collections
 publiques français*, Musée du Louvre (Paris, 1992), Catalogue entries no. 280–89;
 pp. 374–80.

122 See note 67.

123 Mark 5:21–43; Matthew 9:18–26; Luke 8:40–56.

124 Roger Rosewell, *Medieval Wall Painting* (Woodbridge, 2008), p. 27.

125 'St. Paul, St. Sylvanus, and Timothy teaching the Thessalonians,' *Bible of Saint-
 Martial de Limoges*, c. 1130; Bib. Nat., lat. 82, fol. 254 v, illustrated in Joan Evans,
 Dress in Mediaeval France (Oxford, 1952), pl. 4B.

126 Marie-Thérèse Camus and Claude Andrault-Schmitt (eds), *Notre-Dame-la-Grande
 de Poitiers* (Paris, 2002), fig. 323, p. 257.

127 See large mantle pins in figure 180 in *The Bible of Stephen Harding*, Dijon,
 Bibliothèque municipale (Dijon 641) m. 14, fol. 13v. Large pins also appear in
 London, British Library, Arundel 44, fol. 34v.

128 'The well-known statue of a queen from Corbeil ... shows the figure wearing a large circular brooch ... probably meant to be understood as stitched to the material...,' Lightbown, *Medieval European Jewellery*, p. 102.

129 See Huskinson, note 97 above.

STRUCTURES OF POWER:
THE SUPPORT OF THE PEERS

Innocentius igitur papa viii kalendas Nouembris filium
regis regem consecrauit.[1]

In a nation reeling after the death of its young co-king, the consecration of
Louis VII by Pope Innocent before his election by the peers of France was
shocking, even though this *sacre* served to maintain peace and stability in the
nation. Just 11 years later, the installation of 20 over-lifesize stone column-
figures at Saint-Denis expressed ideals of order, peace, and stability in stone,
irrevocably altering the appearance of church portal program design in
northern Europe. Just as the second son of Louis VI was permanently changed
from an ordinary prince into the King of the Franks through unction at his
sacre, so the brilliant new design formula that featured high-relief sculpture
arranged along the jambs like courtiers in reception lines permanently
transformed the perceived significance of church portal sculpture programs
through its representation of textiles and clothing that combined signals about
commercial, political, religious, and temporal power.[2]

Located in the liminal zone where the sacred space of the church
transitions into the profane world of the town, the painted, nearly three-
dimensional, sculpted human forms must have had a tremendous impact on
those participating in processions, whether liturgical or informal, through
the portal and into the sacred space of the church. The sculpture program
would have been perceived intellectually and verbally at the same time that
it was recognized physically and viscerally. The habits of mind employed
in twelfth-century intellectual circles engaged the world simultaneously
on different levels, in discrete systems that combined for profound results.
For these thinkers, traditionally sacred symbols had four levels of meaning:
the physical, the allegorical, the moral or tropological, and the salvational/
eschatological – Madeline Caviness has described these:

A sculpture of the Virgin and Child may have been widely recognized as Mary
and Jesus … a highly educated person of the time could distinguish an immediate
physical signification (the historical Mary and Jesus), an allegorical one (she is the

Seat of Wisdom that had been associated with King Solomon), a moral or tropological level (she is the life-giving Church), and an association with eternal salvation such as that she will be crowned by Christ in heaven and mediate his judgment at the end of time.[3]

This traditional multivalence of images supports a reconsideration of twelfth-century column-figure sculpture. A close examination of the recognizable forms in these compositions reveals that much more is available in the images than has been attributed to them in the past. When these idealized abstractions of contemporary courtly dress are evaluated in their historical, sociopolitical contexts, other significances for column-figures in mid-twelfth century compositions emerge. To some degree these sculpture programs are at war: the design formula employed in the mid-twelfth-century portals unites them, yet in details each individual portal is unique, so that the significance of the column-figures may never be finally resolved. The understanding of architectural 'copies' during the Middle Ages based on the selective transfer of the elements of architecture proposed by Krautheimer in the 1940s pertains in these portal programs.[4] While mid-twelfth-century sculpture programs installed across northern France have been proposed as a chronological series of lesser reproductions of the west façades of Saint-Denis and Chartres,[5] in fact, as an aggregation, these installations articulate both the independence and the unity of the patrons and artist-masons who produced them.

What could have caused this portal design with column-figures to have taken precedence over other design formulae of the period? Although the design first appeared in the Ile-de-France, this composition was repeated more often in the domains of the peers of France than in the royal principality. The majority of the sculpture in this study was installed in territories of the lords of Burgundy, Aquitaine, Anjou, Blois, Brittany, Vermandois, Nevers, and Troyes/Champagne (Fig. 2.1).[6] The consensual and dynamic relationships of the king with a group of magnates who can be called the seigneurs of France were evolving in the twelfth century, during the reigns of Louis VI and Louis VII. This chapter's examination of these relationships will help to explain, in part, the appearance of these column-figure compositions. It will show how two features of the portals with column-figures – the courtly dress of the column-figures and their arrangement along the jambs as if in reception lines – function as keys to unlocking aspects of the mystery behind the introduction of this portal design formula (Fig. I.3).

Several stores of knowledge and experience shared by the primary community of viewers of these portal programs made their visual vocabulary comprehensible. While it is likely that the programs' images and composition might have been unintelligible for an observer unfamiliar with the Christian scriptures or medieval typology, the same might be true for persons unacquainted with ancient Roman traditions for representing human

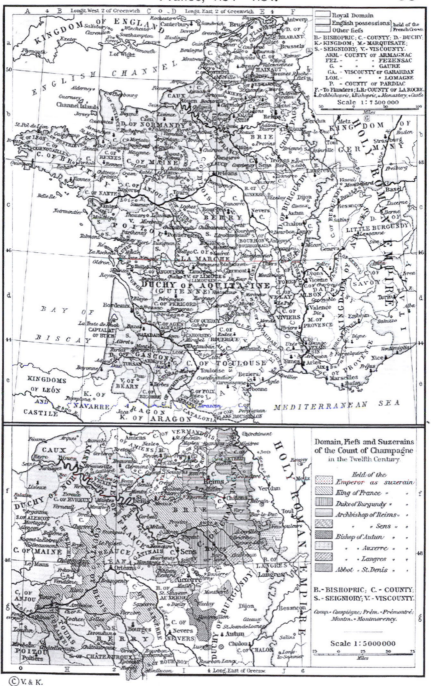

2.1 Map of France, 1154–84. From William R. Shepherd,
Historical Atlas (New York, 1929), p. 69.

beings in sculpture,[7] with the forms and materials of twelfth-century dress, or with the conventional relationships between and the codes of conduct practiced by various ranks of Frankish society. The combination in column-figure compositions of human figures, of contemporary dress, of formal representations of physical gestures, and of cultural or religious rituals would have catalyzed viewers, bringing to mind events that could reverberate in memory. As Patrick Geary has observed, the act of remembering not only preserved history, but it also 'changed the very nature of what would be preserved.'[8] The history of scholarly readings addressing these sculpture programs has influenced which ideas have been investigated and consequently 'preserved' through scholars' primary focus on theological/eschatological/Christian scriptural meaning. The political culture of the region during the early twelfth century introduces alternative readings for the portal sculpture programs, as would the consideration of modern theories concerning the hierarchies of jurisdiction.

Structured memory

Some of the best written documentation for the period comes from accounts such as the *Ecclesiastical History*[9] by Orderic Vitalis, the anonymous *Chronicle of Morigny*[10] and the various writings of Abbot Suger.[11] These texts cannot be taken literally, since these authors organized and revised memories to suit their purposes. The unabashed bias of the writers is inherent in their work. It was essential to these writers for a symmetry between heaven and earth to be expressed in their histories.[12] Abbot of Saint-Denis from 1122 to 1151, Suger was also a royal councilor and advisor, regent and writer who chronicled the history of the kingdom and the abbey. Elizabeth Brown has described him as being '… adept at employing, exploiting, and sometimes creating evidence to serve France and Saint-Denis.'[13] Like the other authors, Suger organized and shaped his own record of events to serve his purposes, and his account strains modern credulity at times, as when he cited divine intervention for the location of 12 massive timbers and 'marble' columns for Saint-Denis.[14] As in histories by other writers, in Suger's work

> … memory intersects with myth and the past acquires a functional quality as the source of legitimacy for activity in the present … At the very least, therefore, any study concerned with the process of remembering the past must also concern itself with the attitudes and motivations of those who were doing the remembering … The ecclesiastical literati … tended to have a distinctive viewpoint, formed, among other things, by their professional training, corporate patriotism, and loyalty to specific patrons or programs.[15]

The column-figure compositions represented and addressed the literati of the twelfth century in several ways. Suger's distinctive viewpoint was shaped by his training, his character, his patriotism, and his loyalty to Saint-Denis, and

these emerge in his account of the life of Louis VI. Suger shaped the context of what was to be remembered when he recalled the old alliance that, 350 years before, had been established against the oppressors and enemies of the Christian Church by Pope Stephen II and the Frankish King Pippin at Saint-Denis.[16] In Suger's *Vie de Louis VI, Le Gros*, the idea of a French self-assurance had been secured in 1107, through the meeting between Pope Paschal II and Philippe I and his heir, Louis VI, at the Abbey of Saint-Denis. Suger informed not only the present (1140s) but also the future of France under Louis VII and the status of the Abbey of Saint-Denis. This connection established the model for early Capetian ritual as that of the ninth-century Carolingians, displacing that of the Holy Roman Empire.[17] The association in the sculpture composition of people in contemporary dress with supernatural beings articulated a connection between the contemporary French and legendary ancestors. The façade of the abbey church was the appropriate venue for the visible, physical expression of this association, since legend held that the basilica of Saint-Denis had been consecrated by Christ Himself.[18] Thus parts of Carolingian royal theory were revived when a new formula for portal sculpture design was installed under Suger's abbacy at Saint-Denis: the theoretical association with Christ that had authorized the Carolingian kings was invoked in the design formula that assembled column-figures beneath Christological reliefs in the tympanums. The represented clothing of the column-figures articulates an association of contemporary Capetian courtiers with Christ at Saint-Denis.

Order

The new church portal composition with column-figures functions as a text about the relationship between the territorial magnates and the king of the French.[19] At the beginning of the twelfth century, alliances between the king and the seigneurs of France were regularly reconfigured, to adjust the balance of power, less between friends or enemies than between enemies or enemies-of-my-enemies. The subtext for these power alliances was the threat of anarchy resulting from instability at times of transition. The king and the territorial seigneurs had immediate experience with the insurrections, rebellions, and terrible civil wars that had erupted during the hundred years preceding the appearance of the new portal designs in northern France. Koziol succinctly summarized periods of civil unrest during the century:

… in Normandy, during the minority of William the Conqueror (1035–1047) and after the deaths of William Rufus (d. 1100) and Henry I (d. 1135); in Anjou, when Fulk le Réchin expelled his brother from the county (1068); in Flanders after the death of Baldwin VI, when Robert the Frisian usurped the county from an under-age nephew (1071), and again after the murder of Charles the Good left the county without any clear successor by patrilineal right (1127).[20]

A fear of this sort of anarchy may have served as one fundamental motivation for the introduction in the 1130s of the design for church portals with column-figures. The hieratic character of this composition laid out a structure for society and a solution to the risks of anarchy. The image of reception lines along the doorjambs, balanced visually between the simplicity of the threshold and the ordered complexity of the sculpted upper zone, established the symmetry between heaven and earth so important in contemporary thought (Figs 4.7, 1.97). The idealized contemporary garments that were represented compounded the layers of meaning in church portal compositions.

The primary community of viewers acknowledged that divine intervention had touched the Capetians. Before 1114 some believed not only that Louis VI had been born heir to the throne but also that his birth had been attended by miraculous elements.[21] Even his name alluded to a kind of Carolingian royalty, assigning probable Carolingian descent to Louis.[22] Although his father Philippe I had repudiated his mother, Bertha of Holland, and had eloped with Bertrada of Montfort, it was Louis whom the peers of the realm recognized as the heir of Philippe I. As a young man, Louis VI was active in the defense of France. In 1098, he led the forces of the Vexin in defensive warfare against William Rufus of England but, apparently because of disputes with his father, Louis retired from the campaign. In May 1098, he was knighted at Abbeville by Gui I, Count of Ponthieu.[23] After this, he was reconciled with the king, and before the end of 1100 he held the title *rex designatus*.[24] Before his death, Philippe I apparently had presented Louis to an assembly of bishops and nobles and had had them 'elect' him as heir.

Louis remained king-designate and was not consecrated during his father's lifetime, though he carried out major responsibilities in the government and the defense of the realm. Louis could not be *rex* until transformed through *sacre*.[25] Consecration was still urgently needed to overcome baronial opposition when he succeeded to the throne in 1108. After the death of Philippe I, Bertrada tried to replace Louis with her son, Philippe of Mantes. Louis' supporters rushed him to Orléans for the *sacre* and coronation by the Archbishop of Sens.[26] This disorder around Louis VI's accession to the throne in 1108 was symptomatic of the difficulties the Capetians faced as legitimate monarchs of the French. The use of a premature *sacre* and/or *couronnement* strengthened the successive right of the heir-apparent; the disorder he had experienced was probably one of the reasons that Louis VI carried out the premature *sacre* of two of his own sons, crowning each as co-king.[27]

For the hard-won (if relative) peace and the well-being of France, the stability of the Capetian line was essential. Louis VI had governed from the saddle until incapacitated by his great weight and poor health. Though his father's consort had failed in her attempt to replace him with her son in 1108, some 20 years later Louis VI avoided potential crises with these

premature *sacres*. His eldest, Philippe, was elected and consecrated co-king in 1129, but in 1131 he died following a fall from a horse.[28] Though stunned by this loss of his son and successor, at the urging of the royal advisors Louis acted on behalf of the realm to consolidate the government. To secure the succession within the Capetian line, and to avoid armed conflict among the peers, Louis VI quickly proceeded with the consecration of the 11-year-old Louis le Jeune in Reims 12 days after Philippe's death.[29] Since Pope Innocent II was meeting in council at Reims in October 1137, it was the pontiff rather than the Archbishop of Reims who anointed Louis VII with the oil from the *sainte ampoule*.

Support of the sovereign

The portal program established at Saint-Denis departed from previous church façade sculpture programs in the way sculpture was arranged horizontally, unifying the three doorways of the west façade, and in the tremendous variety and the character of the sculpture assemblage. Images from quite different sources can be combined to express something new.[30] It seems that the person – perhaps Abbot Suger[31] – who oversaw the creation of the façade decoration program at Saint-Denis used images to influence current political reality, at once reshaping and expressing what was to be remembered. Probably conceived during the period 1131–37, while Louis le Jeune shared the throne as co-king with Louis VI, this church portal composition with column-figures appears to have been introduced as a part of a campaign to assert Capetian sovereignty. Two important dates are associated with the appearance of column-figures as part of a new formula for church façade decoration in northern France: 9 June 1140, when the expanded western *massif* at the Royal Abbey of Saint-Denis was dedicated; and 11 June 1144, the date of the dedication of the rebuilt choir of the abbey church (Fig. 2.2). These dedications were gatherings of political and religious seigneurs, in which the peers of the realm would have processed through the portals of the Abbey of Saint-Denis that were decorated with column-figures. These seigneurs must have carried away with them the tremendous impression of that experience.[32]

The French monarch had been given the appellation 'most Christian king' after opposing his neighbors and siding with the pope in the Investiture Controversy.[33] Henry I of England and Henry V, the Holy Roman Emperor, tried to control investiture in their domains, and were excommunicated until they accepted the pope's control. It was in apparent revenge for Louis VI's opposition in the Investiture Controversy that Henry V led forces toward France in 1124, ostensibly with the intention of increasing his possessions in the Lorraine.[34] In response to this menacing action by Henry V, Louis VI raised the town militias and called up the troops of his seigneurs. The watershed event that took place in late summer 1124 at Saint-Denis

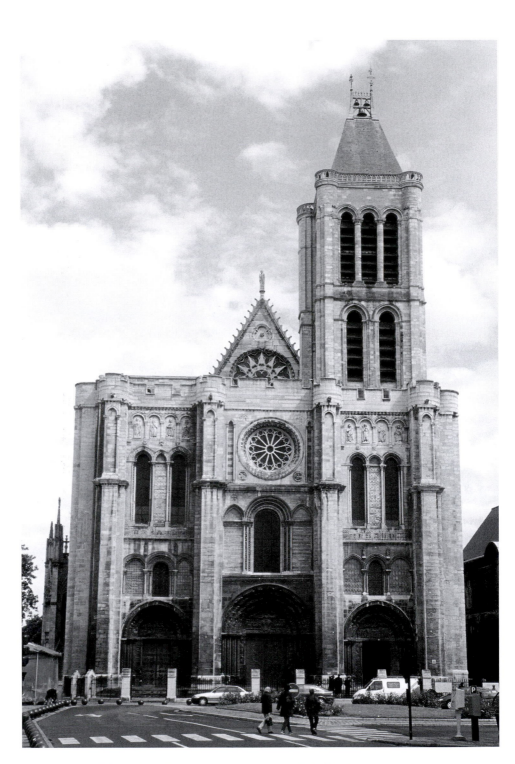

2.2 Abbey Church (now cathedral) of Saint-Denis, west façade.

Photo: Janet Snyder

united the peers of France as a viable defensive community.[35] The political meaning for the installation of a portal composition containing images of the contemporary elite derives from this incident. When Louis VI went to the Royal Abbey of Saint-Denis, he called for 'the whole of France' – *tota Francia* – to follow.[36] According to Suger, Louis galvanized the peers when he spoke; he united the Church and the seigneurs with his pledges of funds and treasures to support their patron saint, and he took up the oriflamme, that standard of the Norman Vexin held at Saint-Denis – it was believed that the oriflamme had belonged to Charlemagne. The princes who participated in the meeting at Saint-Denis subsequently brought thousands of mounted warriors and infantry to Reims, ready for battle.[37] In response to his call on *tota Francia*, the 'diverse peoples' of Aquitaine, Anjou, Brittany, Burgundy, Flanders, and Champagne followed Louis VI. The lords of these domains perceived themselves as staunchly independent princes who were peers of the king. The response of the people reveals the increased prestige of the king in the sight of his peers, for this federation was perceived to be not Frankish but 'of the French.'[38] The design for an assemblage of column-figures that was installed across the façade of Saint-Denis by 1140 recalled this powerful incident.

The defense embodied in the response of the seigneurs and their people to the call of the king was not just of the land but of the prerogatives of the king. Since the mid-tenth century, with the division of Charlemagne's domain among his sons, actual power in northern Europe had been scattered among minor lords. With the incident at Saint-Denis in 1124, the kingdom of the Franks was reunited as an entity. Though acting as the leader of a group of peers, through his pledge to the abbey and his seigneurs, Louis VI served on their behalf as the servant of Saint Denis. The preservation of the realm came before the protection of the poor. With the account he wrote about this meeting a quarter-century later in *Le Vie de Louis VI, le Gros*, Suger manipulated the collective memory of this unifying event. One level of meaning for the portal sculpture at Saint-Denis might have been another such manipulation in which the newly constituted kingdom of the French recreated at Saint-Denis was not merely described, it was set in stone. Even if it is not possible to declare that 'France' in the modern sense was 'born' in 1124, the series of events at Saint-Denis prepared the way for the gradual transformation that took place during the twelfth century, from an association of peers under Louis VI to the kingdom of the divinely sanctioned Philippe-Auguste, with the result that 'something actually existed in 1200 which had not been there in 900.'[39]

Along the same lines, the column-figure sculpture used in the new design formula of the new west entrance to Saint-Denis (dedicated 1140) also manipulated perceived truth. According to Suger, the king united 'the whole of France' against its opponents in 1124; the knowledge of these French preparations caused the Imperial troops to reconsider the invasion.[40] According to the Benoist drawings and Montfaucon's engravings of the Saint-Denis sculpture, while six of the 20 column-figure men along the jambs of the

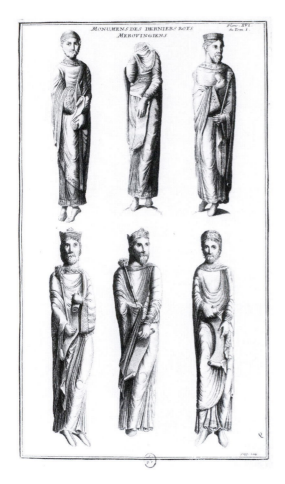

2.3 Abbey
Church of
Saint-Denis,
west façade
sculpture. From
Dom Bernard
de Montfaucon,
*Monumens des
derniers roys
merovingiens*
(1729), vol.
1, pl. 16.

west portals appeared to wear crowns, only one column-figure was carved as if wearing an ensemble belonging to the newly crowned monarch (Figs 2.3, 1.46 – see upper right figure in the latter).[41] It seems more than coincidental that Suger had named six diverse peoples (of Burgundy, Flanders, Aquitaine, Brittany, Anjou, and Troyes/Champagne) in his account of the ground-breaking assembly of 1124. After the confrontation had been defused, the bishops invoked the Peace of God and the Truce of God to quiet the battle fervor of the warriors who were prepared but did not have the opportunity to fight. True to his word, Louis VI returned to Saint-Denis to give thanks for a success which was recorded by Suger as a great, unified victory, for '… maintaining peace is the special responsibility of kings and bishops, God's chosen agents on earth.'[42] Louis made good on the gifts and treasure he had promised to Saint Denis; these supported the remodeling of the basilica that was dedicated more than 14 years later.

The multivalence of the design that employed rows of column-figures in contemporary dress on French church portals is complex: the column-figures describe the support of a community of the French unified by Louis VI; they project the idea of the parallel unification of all people in a Christian world that was implied by the success of the First Crusade; and they represent personages from the Old Testament in the guise of recognizable ranks of courtiers. It may have occurred to Suger to use artwork to convey political ideas after traveling to Rome as an ambassador for Louis VI in 1118 and 1123, for in Rome he would have had the opportunity to see large depictions of individuals in contemporary dress portrayed in artwork in sacred settings, like the mid-seventh-century mosaics in the Oratory of San Venanzio in the Baptistery for San Giovanni in Laterano.

Transformation

The ensemble belonging to the newly crowned monarch expresses an important transformation. During the Middle Ages, the installation of kings in France and England involved a religious consecration – the *sacre*. As the act of consecration suggests, the king of the French was in part a lay person and

partially religious. As part of the rituals associated with his consecration, the king disrobed to wear only a chemise made of white silk cloth so he could be anointed on his head, shoulders and breast.[43] After the unction at the altar, the king was vested in the royal costume: over his chemise he put on a tunic, a dalmatic and the royal mantle fastened by a *fermail* on his right shoulder (Fig. 1.79).[44] At the *sacre*, the new clothes assumed by the king revealed his altered state and signaled his competence to direct the political affairs of his people.[45] The term 'ordo' can be used to describe a liturgical calendar that specifies the various parts of ceremony and liturgy. The *ordo* associated with the elevation of the French kings was revised several times during the Middle Ages, including in the 1130s, during the reign of Louis VII.[46] Brown's study showed that the 1130s *ordo* for the *sacre* specifies a ceremonial that broke with the *ordo* prepared by Hincmar for the *sacres* of Charles the Bald in 848, and of Louis II in 877.[47] The regal dalmatic was not called by name in an *ordo* until the coronation *ordines* of the fourteenth century, but this part of the costume was described in the manuscript of the 1250 *ordo*.[48]

In twelfth-century church portal and cloister sculpture the regal dalmatic is represented. This confirms a documentary value for the column-figures. Although it has become apparent that the column-figure sculpture documents the royal ensemble at mid-century, when that ensemble was not recorded in written sources, the sculpture does more than document; it describes and expresses the influences which shaped the French notion of the monarchy. In addition to carrying a royal scepter the king wears the knight's *bliaut* – in Frankish tradition the sovereign is the head of a clan of warriors; he also wears the dalmatic of the subdeacon – according to Church doctrine the monarch functions as a member of the clerical hierarchy – and he holds a banderole or a codex, representing the written law of the Gallo-Romans (Fig. 1.81). Only a few of the male column-figures are dressed in precisely this royal ensemble: the court dress of a Monarch at his *sacre* appears at Angers (Figs 1.21, 1.31), Saint-Bénigne of Dijon (Figs 1.13, 1.81), Notre-Dame of Paris Fig. 1.82), Saint-Germain-des-Prés (Figs 1.51), Vermenton (Figs 1.141, 1.142, 1.145), and Saint-Denis (including the Porte des Valois) (Figs 1.83, 1.84).[49] That the Capetians self-consciously performed their religious function is documented in the twelfth and thirteenth centuries: Louis VI asked to be dressed as monk for his death and was interred in his religious vestments; before the battle of Bouvines Philippe-Auguste blessed his soldiers; Louis IX regularly dressed himself in a dalmatic.[50]

The appearance of good government

The monarch occupied a position at the pinnacle of a hierarchical society that was defining itself throughout the twelfth century. Named in charters by Louis VI as his *familiaris* and *amicus*, Suger continued as close advisor to the crown after the death of Louis VI during the first ten years of the reign

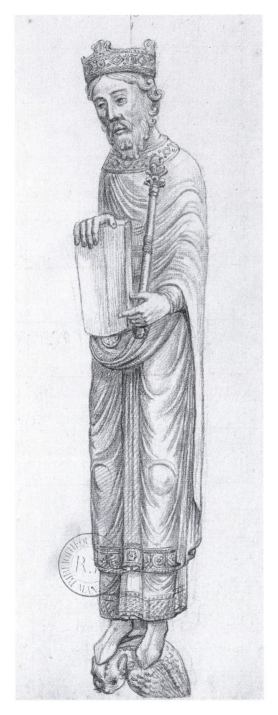

2.4 Abbey Church of Saint-Denis, west façade, column-figure CL1. Antoine Benoist drawing, BN, MS FR 15634, folio 62. Bibliothèque nationale de France.

of Louis VII.[51] Structurally, the composition with column-figures installed during Suger's abbacy at Saint-Denis can be understood as both reflecting and influencing the relationship between the king and the seigneurs as that relationship evolved during the twelfth century (Figs 1.28, 1.30, 1.62, 1.90, 1.109). The distinctive costumes of precious silk textiles and finely woven linen cloth with silk tapestry insertions or silk embroidery depicted as clothing the column-figures caused them to appear as if elegantly garbed in contemporary courtly fashions (Figs 2.4, 1.66/Pl. 4, 1.68, 1.85, 1.98). As discussed in Chapter 1, 'Secret Signals,' and Chapter 4, 'Significant Stuff,' aspects of the represented garments and textiles appear to have been appropriated from distant lands and the holy regions associated with Christ. The use in sculpture of contemporary courtly clothing made of these exotic stuffs articulated the status of people who wore it. Living men and women were exalted when, dressed in the same clothing as that represented in column-figure sculpture, they appeared to be affiliated with the divine image in the tympanum, with Christ and other personages from the Holy Land (Fig. 1.12).[52] An understanding of the originating contexts for the column-figure sculpture may facilitate comprehension of reasons for the representation of the actual clothing of the elite of northern French society – courtly ladies, landowners, chevaliers, dukes, powerful castellans, bishops, and kings – in outfitting the column-figures.[53]

The fundamental structures of northern French society during the reign of Louis VII are reflected in these portal compositions. It has been customary among scholars to characterize the government of France under the Capetians as weak and ineffective, with most power having been usurped by the seigneurs of the realm, until the conquests of Philippe-Auguste after 1200.[54] Alternative analyses presented by revisionist historians suggest that the theory of Capetian weakness arose because inordinate attention has been given to particular rulers.[55] These scholars

have found it useful, instead, to focus on the political culture rather than on the king.

In the first third of the twelfth century, policing unruly local magnates had been the concern of governance under Louis VI. By the end of the century, as the structure of the institutional monarchy had become fairly well established under Philippe-Auguste, this concern shifted. Between these two periods, during the mid-twelfth-century reign of Louis VII – when the first generation of column-figures was installed – theoretical or actual hierarchies of jurisdiction appear to have existed, not only between the ruler and those who owed him homage, but also in ecclesiastical provinces, in the relationships of monastic mother-houses and daughter-houses and their possessions, and within Anglo-Norman domains.[56] It seems likely that the sculpted representation of the hierarchical contemporary courtly community may have contributed to the re-ordering of society through these representations because models of appropriate relations were presented there. The patterns of identifiable ensembles within individual portals listed in Appendix A may further illustrate social hierarchies within and between discrete communities.

Reflection of identity

Not intended to be individual portraits in the modern sense, the crowned figures among the sculpture might have been intended to recall Old Testament kings such as David, to whom the king was compared after the unction during the *sacre*,[57] or Solomon, the builder of the Temple of Jerusalem (Figs 1.24, 1.106).[58] Stoddard observed, 'Louis VII was praised because "from the time he was anointed as king, he had followed the humility of David, the wisdom of Solomon and the patience of Job."'[59] The symbolism of the royalty of Israel influenced French conceptions of kingship and shaped the extended system of rulership (Figs 1.86, 1.87).

The language of dress current during the twelfth century in northern Europe signals responsibilities, since courtiers can be identified through clothing.[60] Recognizable garments reveal the reciprocal duties among citizenry, particular responsibilities being associated with governance and rank in society, and with the particular relationships between sovereign and subject. The location of the column-figures in courtly dress within the framework of the portal, at the threshold of sacred space and in close proximity to the divine image in the tympanum, affirms the rightness of peace and order pursued through temporal political culture. The represented assembly was at once sacred and secular (Fig. 4.20).

The obligations of his magnates to the king, the nation, and to the discrete communities of their domains morphed the status of courtiers from profane to holy. The representation of sacred persons in the garb of the contemporary French elite would have further associated members of that elite with the prestige of biblical models.

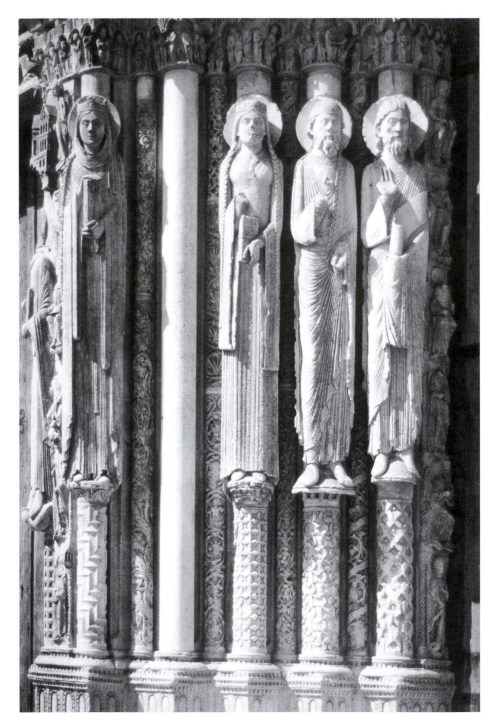

2.5 Notre-Dame, Chartres Cathedral, Royal Portal west façade,
center portal, left jamb, four column-figures, c. 1145.

Photo: Janet Snyder

The presupposition was that whether a castellan's power derived from delegation, agreement, or simple brute force, it remained mere power. In contrast, the rule of the great princes represented legitimate and legitimating authority, established by God and modeled on God's qualities of rulership. The princes therefore fulfilled a divine ministry, with all the responsibilities attendant on those who ruled by the grace of God to govern justly; to maintain the peace; to protect the defenceless …[61]

In the late eleventh and early twelfth centuries the territorial magnates imitated the rituals and governance of the king. These seigneurs presided over open-air peace councils, and worked with the ecclesiastical authorities to establish the Peace of God and the subsequent Truce of God to reduce violence in the region.[62] Documents describe the seigneurs in monarchial terms as princes. Though the seigneurs were not anointed like the king, and they did not seek to depose the anointed king, they were installed with formal liturgical rites that echoed the investitures of new kings and they were buried in dynastic necropoles. In imitating the rituals of the king, the seigneurs elevated their own authority over their own subjects through association with the rituals they imitated, without diminishing the king's authority.[63] This association through imitation provides an additional basis for locating programs with column-figures in the domains of the peers: as the seigneurs elevated themselves by imitating the king's behavior, so they, too, would have appeared to possess a great stature and authority when figures dressed in their own, contemporary courtly dress appeared on the jambs of church portals (Fig. 2.5).

Adventus[64]

The *sacre* of the monarch was substantially transformative. His metamorphosis from ordinary to sacred seems to have taken place within the ritual as a result of having been anointed with holy chrism as a new king.[65] The anointing of a king was constitutive, in that the divine grace transmitted through that act permanently altered the status of the individual, and it was dynamic, in that it transformed the *electus* into a *rex*.[66] This unction during the *sacre* by holy chrism permanently metamorphosed the king's person from an ordinary mortal into a being of higher status, the anointed one of God.[67] In token of this 'christomimesis' every solemn entry of a king into a city of his dominions involved an *adventus*, a formal, choreographed, religious procession conceived in imitation of Christ's entry into Jerusalem before the Passion.[68]

During the Carolingian and Ottonian periods, the king's authority derived from divine authority '… the king as *vicarius Christi* was an important part of royal theory …'[69] In the ninth century, the act of anointing was regarded as adding a supernatural element to the function of kingship. The king, while not ordained like a priest, had a quasi-ecclesiastical role in that he was charged with the duty of guiding his subjects to salvation, and in this he acted as the image or type of Christ.[70] When Carolingian kings visited their episcopal cities and the royal monasteries, they were greeted with an elaborate liturgical

reception.[71] Three centuries later, this authorization was made visible through the new portal composition. Iconographically, a portal like the one at Bourges or the Royal Portal at Chartres is about the entrances of Christ, and the Royal Portal is also, by extension, about the entrance and welcoming of God's 'christus,' the anointed king (Figs 1.15, 1.29).[72] Records of the Parisian entry celebrations from the thirteenth century are relatively continuous and complete, noting the processional routes, order of participants, and sequence of events.[73]

The new portal sculpture composition with column-figures of the 1140s appears to have been taken from political culture. Early imperial reliefs of *adventus* scenes in Rome depict standing figures.[74] Twelfth-century column-figures stand along the jambs and the compositions make further use of physical gesture. The eyes and bodies of these jamb figures turn their attention to the person entering the church, with the visual focus of each column-figure directed toward a visitor whose path of approach falls in the center of the portal (Figs I.1, I.2, 4.20, 1.59, 1.121). In 1771, the column-figures at Saint-Denis were sawn away from the attached columns behind them, a removal that left the columns intact so they could be resurfaced to suit eighteenth-century taste. Neatly removed – first from their columns and then from their bodies – and preserved like relics, the heads from Saint-Denis retain some trace of the column, not at the center backs of the heads but somewhat around their circumference, marking the original relationship of figure to column (Fig. 1.53).[75] The disposition of the finished column-figures along the steps of the portal jamb varies according to each column-figure's focus of attention, so that each column-figure was uniquely carved and placed as part of the façade composition. This arrangement of members of the elite appropriately posed in a position to receive important visitors reproduces an arrangement like the part of the *adventus* ceremonial during which the ruler was welcomed as he traveled through the kingdom (Figs 1.29, 1.72). This welcome was symbolized by the depicted *adventus,* a ceremonial that included the exchange of promises and gifts.[76] 'When the king, count, or other leader came to a church or monastery, he and his entourage had to be ceremonially received; to refuse this reception was to deny allegiance.'[77]

The portal location of the column-figures is significant: in more than one description of an *adventus* ritual, the cathedral doors remained closed until after the prince had sworn to honor the 'good, old rights' and privileges of the community (Fig. 1.16).[78] An important part of this exchange of promises involved the prince giving his hand to a representative of the community. 'It was not the inferior who had to give his hand to his superior; rather, the person who promised something gave his hand to those to whom he promised.'[79] Those who welcomed the king 'became his bodyguards at the entrance into the popular sphere; in the streets of the city the king received the shouts of joy and viewed the pageants presented by those whose liberties he had recognized.'[80] This reference to recognized, older customs informs modern readings of gestures and clothing in the sculpture, for it presumes a

2.6 Saint-Loup de Naud, *trumeau* (detail): alb, diamond-pattern amice, raised right hand, c. 1160.

Photo: Janet Snyder

twelfth-century understanding of oral and physical expressions in addition to written texts. Although many hands are missing from the column-figures, few of their right elbows are bent to allow hands to have been raised, and most of those hands seem to have connected with the book, staff, or banderole held at the center of the body. If the raised right hand indicates a pledge or an oath, it seems the emphasis on this gesture shifted in the years after c. 1152. Events of 1151–52 include the deaths of Suger and Thibaut II of Blois-Champagne and the divorce of Eleanor and Louis VII. Only six of the extant column-figures installed before 1152 appear to raise a right hand (Fig. 1.65).[81]

The majority of the column-figures with free, raised right hands are situated beneath the tympanum, at the feet of Christ: on the *trumeaux* of the *Grand Portail* at Avallon, Notre-Dame of Paris, and Saint-Loup de Naud (Figs 2.6, 1.19). Others stand in the position of honor on the left jambs (that is, on the right hand of Christ in the tympanum): in the center and right portals at Chartres (Figs 1.16, 1.23); two men at Saint-Benigne de Dijon (Fig. 4.20); the woman at Ivry (Fig. 1.26); the Cleric at Loches (Fig. 1.110); and two figures at Saint-Germain-des-Prés (Fig. 1.59).[82] The column-figures with free, raised right hands appear on the right jambs at Chartres (Fig. 1.69, 1.129); at Saint-Loup de Naud (Fig. 1.128); and at Le Mans Cathedral (Fig. 1.27). It may be that the gesture of Christ as the *Majestas Domini* in the tympanum above French column-figures signifies more than the Lord's beneficence and the Word of God as spoken through the Gospels – it expresses the promise of salvation by the divine representative.[83] This personification of Christ also expresses the reciprocal obligations of the lord and of the people, given in exchange

for the promise of the king of the French to act in the defense of the Church against the infidels and the defense of the whole country against invaders. Under such a reading, the portal program with column-figures, particularly a 'Royal Portal,' seems to project a reminder of regal duties as well as a promise of fealty to the arriving visitor. 'The idea that members of the House of Judah should stand in the temple gates and proclaim is central to the portal sculpture of the west façade of Chartres cathedral.'[84]

The community participating in the medieval *adventus* received the prince at the entrance – to their town, to their political sphere – for the exchange of promises and, holding banners, led him to the church through streets flanked by citizens.

Kings might make their way through the streets of towns and cities, as royal banners preceded them, and be greeted at monasteries with special hymns praising their virtues and lineage. ... the *adventus* of an early-medieval king might be followed by other events that highlighted the accomplishments of the host or the generosity of the royal visitor.[85]

Eighty-five of the column-figures studied hold banderoles or books (Fig. 4.6). Scholars have cited the name of Solomon on a banderole at Chartres that was still legible in the nineteenth century as support for the interpretation that column-figures of the Royal Portal represent Old Testament patriarchs and ancestors of Christ. Though the inscription might not have been the original, such an inscription might have recalled a practice of displaying banners in *adventus* processions that were decorated with biblical references extolling the wisdom or lineage of the royal visitor. These banners could have injected literal, that is, textual, meaning into the composition, expanding the multivalence of the sculpture programs, and articulating the voice of the community.

Fundamental principles

Michel Bur compared the peers' relationship with the king to the legendary assembly of knights of the Round Table.[86] The territorial magnates – princes, seigneurs, peers – had the prerogative to elect the king: only they could bestow their consent to rule. The seigneurs and the king perceived themselves as peers. These magnates ruled their territories in imitation of royal privileges and prerogatives. The priority for the seigneurs was not to have a strong king, but to have a just king. They recognized that there could be only one King of the Franks, and that the king ruled only because he had their consent. During the reigns of Philippe I and Louis VI, the relationship of the king with the peers was unstable. Under Philippe I, power was transmitted exclusively by the association by the king of his eldest son to the throne as *rex designatus*, an association contingent upon the consent of the seigneurs of France.

Essential features of west Frankish political culture can be discerned in the forms of church portal design. The first fundamental principle of west

Frankish political culture, the right of territorial magnates to be honored by a king as they would honor him, is expressed through the arrangement of column-figures in lines along the jambs. These reception lines demonstrate the reciprocated esteem embodied in the exchange of promises in the *adventus* ceremonial and in the concept of fief-holding. Another key principle was the right of these territorial magnates to act with viceregal authority. Their authority was not simply derived from the king, it also emerged from the hierarchy of jurisdictions. It was based '… on a divinely-ordained order that sanctioned the power of kings and magnates alike.'[87] The lines of column-figure men and women in contemporary dress expressed this authority and order, sanctioned by God.

First described in the eleventh century, fief-holding represented sets of reciprocal obligations of each party to the other rather than levels in a pyramidal structure.[88] The practice of fief-holding presented a new dimension in the long-standing relationship of loyalty and clientage between the most powerful princes and those who attended them.[89] Fiefs were granted for a lifetime, in contrast to the temporary, precarial grants that had been made by Carolingian kings. Two men of comparable status could exchange fiefs and oaths of homage in order to cement a peace. One was not limited to a single status in either receiving or granting fiefs; individuals might hold much of their land as fiefs at the same time as they owned other land outright, in *allodium*. Holding their land only from God, some seigneurs remained entirely independent, as these column-figures, individually isolated, interact with the visitor but not with each other. In practice, the kings of the Franks did not try to attempt to persuade the great dukes and counts that they were royal vassals until well into the twelfth century.[90] Even after each had accepted their roles in this relationship, the king, though first among peers, did not impose a government on the princes who were his vassals.

Distinguished from the other princes by his dignity and consecration, the King of the Franks stood alone primarily because of the greater responsibilities he held. The king was charged not only with the defense of the whole country against invaders – as in the 1124 call upon all of France to follow him – but also with the defense of the Church and the poor. Many ecclesiastics ranked as lords of secular domains and could have influenced the inclusion of the contemporary dress of poor laborers in archivolts and jamb reliefs (Figs I.4, 1.96, 1.97, 1.98, 1.99) and clerical costumes in reliefs and metalwork (2.7, 1.116, 1.122/Pl. 11) as well as column-figures. The character of the first generation of portal designs with column-figures certifies the rectitude of the hierarchy of jurisdictions. The collective appreciation of monumental cycles meant that the façade design formula with column-figure sculpture participated in shaping social relationships.[91] These installations affirmed support for the elected monarch with assemblages of courtiers, repeating the welcome and homage embodied in an *adventus* ceremonial. The portal sculpture came to function as a text expressing important concepts that had been accepted and had entered the collective memory of the French.[92]

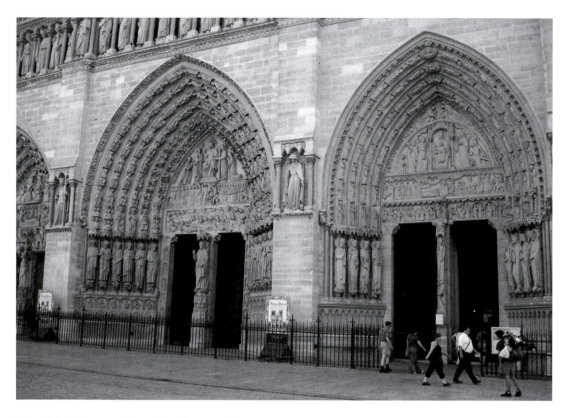

2.7 Notre-Dame, Paris cathedral, west façade, right portal (Portail Sainte-Anne), c. 1155–65.

Photo: Janet Snyder

Re-ordered memories

At the time that the young Philippe, co-king since 1127, had been killed, the outlook was bleak for stability, peace, and order in the realm, since dysentery was progressively disabling Louis VI. Thus, the hurried consecration of Louis VII in 1131 can be understood as an act intended to assure the maintenance of peace and a stable government for all. At the same time, this consecration threatened the fundamental principles of west Frankish political culture and risked a destabilization of the crown's relationships with the peers. A number of the magnates were displeased, since for the first time there had not been even a pro-forma election before the *sacre*, nor an acclamation by the great lords.[93] Although a belated election did take place after the *sacre*, the consecration of Louis le Jeune as co-king with his father was a gross affront to political culture in the kingdom.

The stability of the system had been threatened by this unprecedented deviation from essential seigneurial approval, even though the belief that he had been transformed through the unction of the *sacre* protected Louis le Jeune as king. The emergence of the new portal design with column-figures in north central France appears to have responded to this peril, for this visualization re-ordered memory and reshaped the perceived history of events. Expressed through the invention of this design formula that

included column-figures, the support for the young monarch emerged as an especially valuable part of a larger campaign to affirm Capetian sovereignty in the domains of the peers. If, indeed, the design mirrored a royal *adventus*, then the composition created the impression that the seigneurs had exercised their electoral right, bestowed their consent to rule, and affirmed the political culture of the Franks. During Suger's regency of 1147–49, when Louis VII was absent from France, in 1148 there was an attempt to revise the king's choice of successor, this time with Robert of Dreux.[94] It cannot be an accident that the majority of the column-figure compositions at churches outside the domain of the King of the French were installed after return of Louis VII from participation in the Second Crusade, visually validating fundamental concepts of Frankish political culture.

Louis le Jeune had shared the throne as co-king with Louis VI for six years, 1131 to 1137. Possibly, the affirmation of royal authority embodied in the new design formula was formulated during those six years. Neither Abbot Suger, the royal advisor since 1127,[95] nor the young co-king were with Louis VI at the time of his death on 1 August 1137, for Louis had sent Suger to accompany Louis le Jeune to the west prior to the marriage of Louis and Eleanor of Aquitaine.[96] In 1137, one of the most powerful territorial seigneurs was Thibaut II of Champagne. At first a guardian and guide for the young king following the death of his father, Thibaut II escorted Louis VII on a tour of the domain to receive homage, where they certainly would have been received by vassals with formal ceremonies welcoming the monarch, *adventus* rituals.[97] Within five years of this very visible sponsorship, the highly principled Thibaut II and the young husband of Eleanor of Aquitaine had a falling out over difficulties in one of the cities in her control. The disagreement between Thibaut and Louis seems also to have led to the withdrawal of Suger from court to the Abbey of Saint-Denis, at the time that the construction of the new west façade was nearly complete.

The column-figures placed along church portal jambs set the king's election in stone, in the most public place. Through its composition, the portal design with column-figures concretized the conceit that Louis VII, first among peers and chief defender of the Church, was the elected, legitimate heir to the throne of France. An image of the *adventus* ceremonial is invoked: hieratically arranged column-figures flank the divine image in the tympanum; they appear to be wearing significant elements of courtly dress, gathered and arranged for a ceremony of reception. This arrangement articulated the peers in relation to their king as his magnates; they appear, not as rivals for royal power, but each in his proper place (Fig. I.3). This representation had been shaped to express an idea, a reality of great significance.

In 1142–44, relations between Thibaut II of Champagne and Louis VII deteriorated further; the two were never fully reconciled before Thibaut's death.[98] Good relations between seigneur and king were significantly

damaged for a decade, a rift somewhat concealed by Henri le Libéral's standing-in for his father in the Second Crusade. These serious disruptions in relations did not, however, void the formal relationship between the king and the count. After the *conduit des foires* had been violated in 1148, Thibaut II appealed for justice more than once to the king, through Suger as regent.[99] With these appeals, Thibaut acknowledged the king's role in preserving peace and distributing justice for all. With this acknowledgement, Thibaut confirmed his participation in the community of princes. Count Thibaut's sons Thibaut and Henri le Libéral[100] married the daughters of Louis, and his daughter Adèle would become Louis's third wife and the mother of Philippe II. The delicate stability of the system that had been maintained throughout the period was made tangible in the column-figures. After Henri and Thibaut had succeeded their father, the new design of church portals was employed extensively outside the royal domain, a use that signaled at once the hierarchy of jurisdiction in France: these peers of the realm were independent within their own lands and they remained loyal supporters of their sovereign.

In 1159, at the time that Henry II of England upset the peace in the south with a plan to attack Toulouse, in several situations the peers expressed their understanding of their relationship to the king. Although Henry II owed fealty as Duke of Normandy to Louis VII, during this campaign, Henry harassed the king and Louis' allies. His commitment required that, on principle, Henry could not directly attack his king. Declaring that an attack on Toulouse would be an attack against all of France, Raimond V of Toulouse requested Louis VII's help. Using terms that recalled the classic image of the *corpus regni* – in which the monarch is the head of the body and the peers represent its members – Louis VII obtained letters that agreed to peace from Raymond Trencavel, Viscount of Béziers, and Viscountess Ermengard of Narbonne.[101] In the thirteenth century this theory would come to be termed the *corpus mysticum*.[102]

Form as content

Modern apprehension of the relationship of the king with the seigneurs of France clarifies a context for the appearance of these column-figure compositions. The monarch serves to center and ground the realm. The arrangement of column-figures along the jambs as witnesses to the entry in the *adventus* ceremonial informs a reading of the new portal design formula with column-figures. These representations – dressed as contemporary courtiers, clerics, and local leaders – were carved and composed to look like the men and women who would have participated in significant rituals, and the limited number of column-figures in these compositions corresponds to the practice of having individuals act on behalf of large numbers of citizens.[103] The authority of the anointed king – and in places like Angers, Le Mans,

or Loches, the seigneurs who imitated his regal behavior – derives from his function as the imitator of Christ. 'The royal progress through the realm was thus made a "sacral procession"...'[104]

For about thirty years in the middle of the twelfth century, the column-figures represented the community of the elite assembled as if in reception lines. In the mid-twelfth century, the column-figures articulated the political ideal that the king had been properly elected and consecrated and their arrangement continues to eternally affirm the election of Louis VII. The perception by contemporaries of the legitimacy of the monarch influenced reality in the collective memory. Indeed, from 1140 until about 1170, it appears that the makers of sculpture programs both responded to and shaped reality. Just as cathedral architecture was irrevocably transformed by the unified space of the choir of the Royal Abbey Church of Saint-Denis, so, too, were the façades of great churches across northern Europe conceptually transformed by a new formula for portal sculpture design that fundamentally affirmed the unique political culture of the Franks. The success of this sculpted formula in stabilizing the government of the realm meant that the portal design established in the 1140s did not prevail during the last third of the century. The portal composition at Senlis Cathedral exemplifies another innovative alternative, a type of composition in which column-figures were in composed groups that participated in narrative or thematic sculpture programs (Fig. 2.8). In this thread, column-figures were depicted in the generic dress of philosophers rather in contemporary courtly dress.

2.8 Senlis Cathedral, west portal, c. 1165–70.

Photo: Janet Snyder

The portal design established in the 1140s participated in the political culture, creating the appearance that the seigneurs had exercised their electoral right, bestowed their consent to rule, and affirmed the political culture of the Franks. It seems that already in the fourteenth century, the identity of the column-figures seems to have been uncertain, and by the seventeenth century Montfaucon and Plancher published illustrations of the column-figures as the kings, founders, and ancient saints of the region.[105] Once the political culture of the Franks had been transformed and the stability of the monarchy ensured, the visual expression of that political culture could also be transformed.

Notes

1 'Pope Innocent therefore consecrated the king's son as king on 25 October
 [1129],' Orderic Vitalis, *The Ecclesiastical History of Orderic Vitalis*, ed. and trans.
 Marjorie Chibnall (Oxford, 1978), vol. 6, Book 13, Ch. 2, p. 422.

2 Angers, *Saint-Maurice*; Avalon, *Saint-Lazare*; Bourges, *Saint-Etienne, north portal*;
 Bourges, *Saint-Etienne, south portal*; Chartres, *Notre-Dame, west façade*; Corbeil,
 Notre-Dame; Dijon, *Saint-Bénigne*; Etampes, *Notre-Dame-du-Fort*; Ivry-la-Bataille,
 Notre-Dame; Le Mans, *Saint-Julien*; Loches, *(Saint-Ours) Notre-Dame du Château*;
 Nesle-la-Reposte, *Abbey of Notre-Dame*; Paris, *Saint Anne Portal*, Notre-Dame;
 Paris, *Saint-Germain-des-Près*; Provins, *Saint-Ayoul*; Provins, *Saint-Thibaut*;
 Rochester Cathedral, England; Saint-Denis, *Royal Abbey Church, the west portals
 and the Porte des Valois, the north transept portal*; Saint-Loup de Naud; Vermenton,
 Notre-Dame. Related large figures from this period appear as tomb *gisants*, in
 cloister sculpture from the Abbey of Saint-Denis and Notre-Dame-en-Vaux
 at Châlons-sur-Marne, and as individual figures from unknown architectural
 contexts, such as the figure found at Saint-Ayoul in Provins and identified
 as King David, the Psalmist. Destroyed portals at Notre-Dame-en-Vaux and
 Donnemarie-en-Montois, among others, appear to have used the formula as well.

3 Madeline Harrison Caviness, 'Reception of Images by Medieval Viewers,' in
 Conrad Rudolph (ed.), *A Companion to Medieval Art: Romanesque and Gothic in
 Northern Europe* (Oxford, 2006), p. 71.

4 Richard Krautheimer, 'Introduction to an "Iconography of Mediaeval
 Architecture,"' *Journal of the Warburg and Courtauld Institutes*, 5 (1942): 13.

5 Anne Claire Doherty, *Burgundian Sculpture in the Middle of the Twelfth Century: Its
 Relationship to Sculpture in the Ile-de-France and Neighboring Provinces* (dissertation,
 University of Wisconsin-Madison, 1980), p. 118.

6 Angers (Anjou); Avallon (Burgundy); Bourges (royal, and the archbishop was
 primate of Aquitaine); Chartres (Blois; a royal episcopate); Corbeil (Corbeil/
 royal); Dijon (Burgundy); Etampes (royal); Ivry (Dreux, between Ile-de-France
 and Normandy); Le Mans (Maine); Loches (Touraine; the archbishop of
 nearby Tours was Primate of Brittany); Nesle-la-Reposte (Champagne); Paris
 (royal); Provins (Troyes/Champagne); Rochester Cathedral, England (Henry
 II, Duke of Normandy, Kent); Saint-Denis, Royal Abbey (royal); Vermenton
 (Burgundy or Nevers). Chartres Cathedral, in the county of Blois, was a royal
 episcopate. See map. no. 30, 'North-Western France in the Eleventh Century,'
 in *The Cambridge Medieval History*, vol. 3, eds H.M. Gwatkin, J.P. Whitney, J.R.
 Tanner, and C.W. Previté-Orton (Cambridge, 1922); map no. 55, 'The Dominions
 of Henry II, Plantagenet,' in ibid., vol. 5, eds J.R. Tanner, C.W. Previté-Orton,
 and Z.N. Brooke (Cambridge, 1929); map no. 55, 'The Dominions of Henry II,
 Plantagenet,' and map no. 57, 'Ecclesiastical Divisions of Europe Circa 1250,' in
 ibid., vol. 6, eds J.R. Tanner, C.W. Previté-Orton, and Z.N. Brooke (Cambridge,
 1929).

7 Once major Roman outposts, cities like Paris, Sens, and Reims retain
 amphitheaters, memorials, and arches decorated with figural sculpture. See the
 Porte de Mars in Reims.

8 Patrick Geary, *Phantoms of Remembrance: Memory and Oblivion at the End of the
 First Millennium* (Princeton, 1994), p. 177.

9 Orderic Vitalis, *Ecclesiastical History*, 6 vols (Oxford, 1978).

10 *Chronique de Morigny* (1095–1152), ed. Léon Mirot (2nd edn, Paris, 1909).

11 See Erwin Panofsky (ed. and trans.), *Abbot Suger on the Abbey Church of Saint Denis and its Art Treasures* (Princeton, 1946, 1979). For the life of Louis VI, see Suger, *Vie de Louis VI le Gros*, ed. and trans. Henri Waquet (Paris, 1964); and Suger, [*Vie de Louis VI, Le Gros*] *The Deeds of Louis the Fat*, trans. R. Cusimano and J. Moorhead (Washington DC, 1992).

12 Geoffrey Koziol, *Begging Pardon and Favor, Ritual and Political Order in Early Medieval France* (Ithaca and London, 1992), p. 145.

13 E.A.R. Brown, *'Franks, Burgundians and Aquitainians' and the Royal Coronation Ceremony in France*, Transactions of the American Philosophical Society, fol. 82, part 7 (Philadelphia, 1992), p. 13.

14 Panofsky, *Abbot Suger on the Abbey Church of Saint-Denis*: see columns, p. 91; timbers, p. 97.

15 David A. Warner, 'Ritual and Memory in the Ottonian Reich: The Ceremony of *Adventus*,' *Speculum*, 76 (2) (April 2001): 256 and 258–9.

16 Bernd Schneidmüller, 'Constructing Identities of Medieval France: Constructing the Medieval Nation,' in Marcus Bull (ed.), *France in the Central Middle Ages: 900–1200* (Oxford and New York, 2002), p. 37.

17 Schneidmüller, *Karolingische Tradition*, pp. 69–76 and 175–83, cited in Koziol, *Begging Pardon and Favor*, p. 168.

18 Saint-Denis had been '… built about 475 by St. Geneviève and dedicated, according to legend, by Christ himself in 636.' See Kenneth J. Conant, *Carolingian and Romanesque Architecture, 800 to 1200* (London, 1978), p. 43.

19 The regional distinction *France* is used for convenience, glissaded with the more accurate term for the population, the *Franks*: 'From the tenth century, the standard title was "king of the Franks" (*rex Francorum*); from Louis IX, the monarch was commonly known as king of France.' See John E. Morby, *Dynasties of the World* (Oxford, 2002), p. 79.

20 Geoffrey Koziol, 'Political Culture,' in Marcus Bull (ed.), *France in the Central Middle Ages 900–1200* (Oxford and New York, 2002), pp. 55–6.

21 A.W. Lewis, *Royal Succession in Capetian France: Studies on Familial Order and the State* (Cambridge MA, 1981), pp. 50–51. See also Achille Luchaire, *Louis VI le Gros, annales de sa vie et de son règne (1081–1137)* (Paris, 1890; repr. Brussels, 1964), pp. xi–xii. Some believed the birth of Louis VI was miraculous, since Arnulf, the abbot who said he would intervene on behalf of the sterile Bertha of Holland, sent Thibaut I, Count of Champagne, to tell the queen she was pregnant before she had announced it. Saint Arnulf is said to have directed the choice of the name Louis. The new heir's name was to be Louis Thibaut.

22 Louis was born in 1081 or 1082; see Suger, *The Deeds of Louis the Fat*, p. 170, n. 1. The name 'Louis' is a pronunciation of 'Clovis,' which would resonate with the Merovingians, too. See Michel Bur, *Suger, Abbé de Saint-Denis, Regent de France* (Paris, 1991), p. 33.

23 See no. 7, Abbeville, 24 May 1098, in Luchaire, *Louis VI*, p. 6.

24 In 1101–1102, Louis was referred to as *le roi désigné* as in no. 20, Reims, 23 May 1102; see Luchaire, *Louis VI*, p. 12. See also no. 8, 17, 22, etc., in Luchaire, *Louis VI*, pp. 6, 10, 13; and discussion pp. 289–93.

25 *Le sacre* combines the rites of consecration, anointing, and coronation. Its rank as a sacrament and its role in conferring legitimacy on the French king were under debate in the twelfth century.

'Le sacre est en quelque sorte la consécration d'un pouvoir par un rite – l'onction – qui confère à celui la reçoit un supplément de légitimité et donc de puissance dont les attributs sont remis ensuite lors du couronnement,' Archives nationales, *Le sacre à propos d'un millénaire 987–1987* (Paris, 1987), p. 13.

26 Phillippe of Mantes was the son of Bertrada's marriage with Fulk le Réchin, whom she had left. See no. 57, Orléans, 3 August 1108, in Luchaire, *Louis VI*, pp. 30–31. For discussion of the *ordo* see Brown, *Franks, Burgundians and Aquitainians*, pp. 41–2.

27 Ralph E. Giesey, 'Two Inaugural Aspects of French Royal Ceremonials,' in János M. Bak (ed.), *Coronations: Medieval and Early Modern Monarchic Ritual* (Berkeley, 1990); available at: <http://ark.cdlib.org/ark:/13030/ft367nb2f3/>, p. 37 (accessed 6 June 2007).

28 Philippe was elected and crowned on 14 April 1129. See Orderic Vitalis, *Ecclesiastical History*, vol. 6, Book 12, Ch. 48, iv. 497, pp. 390–91. The fatal accident occurred on 13 October 1131. It is described by Suger, *The Deeds of Louis the Fat*, pp. 149–50. (For an online translation of Suger's *Life of King Louis the Fat*, see the *Medieval Sourcebook*, at <http://www.fordham.edu/halsall/basis/suger-louisthe fat.html>, Ch. 32.) See also Luchaire, *Louis VI*, no. 474.

29 Orderic Vitalis, *Ecclesiastical History*, vol. 6, Book 13, Ch. 12, v. 27, pp. 422–3. Louis VII was anointed and crowned at Reims Cathedral during the council convened by Innocent on 25 October 1131. See Luchaire, *Louis VI*, no. 476, pp. 220–21.

30 Paula Lieber Gerson, 'Suger as Iconographer: The Central Portal of the West Façade of Saint-Denis,' in *Abbot Suger and Saint-Denis, A Symposium* (New York, 1986), p. 194.

31 'The whole decorative scheme, planned by Suger himself – possibly inspired by the writings of the great exegete Hugh of Saint-Victor ….' See Paul Williamson, *Gothic Sculpture 1140–1300* (New Haven and London, 1995), p. 12. On Hugh of Saint-Victor, see Conrad Rudolph, *Artistic Change at St-Denis: Abbot Suger's Program and the Early Twelfth-Century Controversy over Art* (Princeton, 1990), pp. 32–47.

32 The liminal experience of the portal is described in Janet Snyder, 'Bodies Revealed and Concealed in Twelfth-Century French Sculpture,' in Laura Gelfand and Sarah Blick (eds), *Push Me, Pull You: Art and Devotional Interaction in Late Medieval and Early Modern Europe* (Brussels, 2011).

33 The Investiture Controversy refers to the '… struggle for control of the Church through the power to invest the higher clergy with their ring of office and pastoral staff during the liturgy ….' See Allan Doig, *Liturgy and Architecture from the Early Church to the Middle Ages* (Aldershot, 2008), p. 171.

34 See Marcel Pacaut, *Louis VII et son royaume* (Paris, 1964), p. 43. See also Bur, *Suger*, p. 27.

35 For a document relating the event, see #348 '*Août 3 (après), 1124*, Saint-Denis, Paris, Archives nationales, K. 22, no. 4 – *Cop.* Archives nationales, LL. 1157 (cartul. de St.-Denis), fo. 348,' and '#349 – *Juillet 25 – août* Reims.' Luchaire, *Louis VI*, p. 160.

Suger infers that the crowns of the dead kings belong to the Martyrs at Saint-Denis. '... Before their most holy bodies, he would lay down the crown and the kingdom, and profess the monastic way of life. He would exchange crown for crown' See Suger, *The Deeds of Louis the Fat*, p. 153.

36 Though the Bishop of Rouen had a claim upon the Vexin, the king was the Count of the Vexin, and theoretically he held it in fief from Saint-Denis. See Bur, *Suger*, pp. 115–16.

See Luchaire, *Louis VI*, p. 160, document #348: '*Août 3 (après)*. Saint-Denis, Paris, Louis VI notifie que, sur le bruit de l'entrée des Allemands en France, il s'est rendu à Saint-Denis avec les grands du royaume. Là, en présence de l'abbé Suger, son fidèle conseiller, il a pris sur l'autel des saints l'étendard qu'il avait le droit de porter comme comte du Vexin et vassal de l'abbaye. Il fait don à ladite abbaye: 1o. de la voirie et de la justice sur la villa de Saint-Denis, depuis la Seine, à l'endroit dit Moulin de Baiard, jusqu'au commencement de la ville d'Aubervillers, limites qu'il a lui-même déterminées; 2o. des revenus de la foire du Lendit, créé pour la célébration des saintes reliques, du clou et de la couronne du Seigneur.' *Original*: Archives nationales, K. 22, no. 4 – *Cop.* Archives nationales, LL. 1157 (cartulary de St.-Denis), fol. 348. The charter is dated in 1124, '18th year of the reign, tenth with queen Adélaïde; undersigned by Etienne, *sénéchal*; Gilbert, *bouteiller*; Hugue, *connétable*; given by the hand of d'Etienne, *chancelier*' See also p. 160, document #349, *Juillet 25–août*, Reims.

37 Thibaut II of Blois-Champagne joined the princes of Aquitaine, Anjou, Brittany, Burgundy, and Flanders. See Suger, *The Deeds of Louis the Fat*, pp. 128–30.

38 'Of the French' refers to the community named in the *Song of Roland*, the epic tale of the battle of Roncevaux, c. 1100. Though partial to the people of royal France, rather than proposing a narrow kind of nationalism, the poet, inspired by the ideal of the crusades, intended to exalt all the people grouped under the banner of Charlemagne. See R. Bossaut, L. Pichard, and G. Raynaud de Lage, *Dictionnaire des lettres françaises, Le Moyen Age* (Paris, 1964), p. 1300.

39 Bull, *France in the Central Middle Ages*, p. 1.

40 Suger, *The Deeds of Louis the Fat*, p. 131.

41 See description in Chapter 1, under the heading 'The ensemble: 2, the tunic.' Montfaucon's 1729 engravings are reproduced in Willibald Sauerländer, *Gothic Sculpture in France 1140–1270*, trans. J. Sondheimer (New York, 1972), figs 1, 2, 3, pp. 62–3.

42 Koziol, *Begging Pardon and Favor*, p. 146.

43 J.-P. Bayard and P. de la Perrière, *Les rites magiques de la royauté* (Paris, 1982), p. 157.

44 See the royal costume descriptions in P.E. Schramm, *Kaiser, Könige und Päpste, Gesammelte Aufsätze zur Geschichte des Mittlealters* (Stuttgart, 1969), vol. 3, pp. 547–52.

45 Bayard and de la Perrière, *Les rites magiques*, p. 162.

46 'The ordo of lat. 14192, I believe, was prepared in the first weeks of June 1137 for the coronation in Bordeaux, and perhaps for the ceremony in Poitiers as well,' Brown, *Franks, Burgundians and Aquitainians*, p. 37. (See BN, Lat. 14192, fols 73r–83v.)

47 A. Bonnefin, *Le sacre royal dans l'histoire de France, permanence d'une valeur fondamentale* (Paris, 1993), pp. 5–6.

48 Paris, Bibliothèque national, MS lat. 1246. See Henri, Comte de Paris, with Gaston Ducheta-Suchaux, *Les rois de France et le sacre* (Paris, 1996), pp. 150–51.

49 The regal dalmatic is discussed in Janet Snyder, 'The Regal Significance of the Dalmatic: The Robes of *le sacre* Represented in Sculpture of Northern Mid-Twelfth-Century France,' in Stuart Gordon (ed.), *Robes and Honor, The Medieval World of Investiture* (New York, 2001), pp. 291–304. The location among the column-figures of Monarchs is noted below in Appendix A.

50 Bonnefin, *Le sacre royal*, p. 8.

51 Eric Bournazel, 'Suger and the Capetians,' in Gerson (ed.), *Abbot Suger and Saint-Denis*, p. 58.

52 What is represented becomes present: see David Freedberg, *The Power of Images* (Chicago, 1989), pp. 28–30.

53 As Evergates has demonstrated, women held titles and offices, controlled property and income, and exercised power. Theodore Evergates, *The Aristocracy in the County of Champagne, 1100–1300* (Philadelphia, 2007), pp. 87–9.

54 The heir of Louis VII, a son born late in his father's life, Philip II Augustus or Philippe Auguste, was called *Philippe Dieudonné*, 'God-given,' when he was born on 21 August 1165. He was King of France from 1180 to 14 July 1223.

55 Koziol, 'Political Culture,' p 58. See also Evergates, *Aristocracy in Champagne*.

56 Andrew W. Lewis, 'Suger's Views on Kingship,' in Gerson (ed.), *Abbot Suger and Saint-Denis*, p. 50.

57 After anointing [the king's] hands with oil, the archbishop compares the anointed king to David's unction by Samuel. '… après l'onction des mains, l'archevêque compare le roi et son onction à David oint par Samuel.' See Henri, Comte de Paris, *Les rois de France*, p. 144.

 The English word 'consecration' can be used for convenience, though the French term *le sacre* is the more accurate one in this context for the rite ('the eighth sacrament') which, combining consecration, anointing and coronation, has the power to confer legitimacy on the French king. Archives nationales, *Le Sacre*, p. 13.

58 Bayard and de la Perrière, *Les rites magiques*, p. 162.

59 'Katzenellenbogen interprets the large jamb statues as combining qualities of kingship and priesthood: *Regnum* and *Sacerdotium*.' See Whitney S. Stoddard, 'Review, *The Sculptural Programs of Chartres Cathedral … by Adolf Katzenellenbogen,' Speculum*, 35 (4) (October 1960): 614.

60 The specific ensembles and the vocabulary used for the language of dress are described and discussed in Chapter 1, 'Secret Signals.'

61 Koziol, 'Political Culture,' p. 53.

62 Councils included the Council of Lillebonne (1080) and the Council of Rouen (1096). On the Peace of God and the Truce of God, see H.E.J. Cowdrey, 'The Peace and Truce of God in the Eleventh Century,' in *Popes, Monks and Crusaders* (London, 1984), pp. 42–67.

63 'Chants known as *laudes* ('praises') were composed for the dukes of Normandy and the counts of Flanders.' In the same way that the entry of the king was celebrated with a liturgical procession chanting hymns, the entry of a count

into one of his cities was welcomed with an *adventus*. See Koziol, 'Political Culture,' p. 54.

64 'A classic *adventus* has three major components: (1) a gathering and arranging of those who will receive the person or persons coming; (2) the coming in itself, which commonly features some sort of procession; and (3) a ceremony of reception by prominent persons, who will then escort the one received to a destination for vows' See Margot Fassler, '*Adventus* at Chartres. Ritual Models for Major Processions,' in Nicholas Howe (ed.), *Ceremonial Culture in Pre-Modern Europe* (Notre Dame IN, 2007), pp. 13–14.

65 'The unction, a ceremony of Biblical origin, was particularly important. The king was anointed on the head and various parts of his body and was entitled to the Chrism, a mixture of oil and balsam. By right of this he could claim all the privileges of a bishop. Further popular belief maintained that the Chrism in the coronation vial at Rheims had been brought to Saint Remy by a dove for the baptism of Clovis' See Charles Petit-Dutaillis, *The Feudal Monarchy in France and England from the Tenth to the Thirteenth Century* [*La monarchie féodale en France et en Angleterre 10e–13e siècles*], trans. E.D. Hunt (New York, 1964), p. 23. See also Janet L. Nelson, *Politics and Ritual in Early Medieval Europe* (London and Ronceverte WV, 1986), p. 275.

66 Nelson, *Politics and Ritual*, p. 270.

67 Arnold van Gennep, *Rites of Passage*, trans. M.B. Vizedom and G.L. Caffee (Chicago, 1960), p. 110. See also Bayard and de la Perrière, *Les rites magiques*, p. 156.

68 Koziol, 'Political Culture,' pp. 44–5. See also Fassler, '*Adventus* at Chartres,' pp. 13–14.

69 Susan Twyman, *Papal Ceremonial at Rome in the Twelfth Century* (London, 2002), p. 12. See P. Willmes, *Der Herrscher-Adventus im Kloster des Frühmittelalters*, Münstersche Mittelalter-Schriften 22 (Munich, 1976), pp. 52–90; and Ernst H. Kantorowicz, 'The "King's Advent" and Enigmatic Panels in the Doors of S. Sabina,' *Art Bulletin*, 26 (1944): 209–10.

70 Walter Ullmann, *The Carolingian Renaissance and the Idea of Kingship* (London, 1969), pp. 95 and 109.

71 For the itinerary of Charles the Bald, see Janet L. Nelson, 'Charles the Bald in Town and Countryside,' in *Church in Town and Countryside*, Studies in Church History 16 (Oxford, 1979), pp. 103–18.

72 See Margot Fassler, 'Liturgy and Sacred History in the Twelfth-Century Tympana at Chartres,' *The Art Bulletin*, 75 (3) (September 1993): 499–520.

73 Lawrence M. Bryant, 'The Medieval Entry Ceremony at Paris,' in János M. Bak (ed.), *Medieval and Early Modern Monarchic Ritual* (Berkeley, Los Angeles and Oxford, 1990), p. 88.

74 Gunilla Åkerström-Hougen, 'Adventus travels North, A Note on the Iconography of some Scandinavian Gold Bracteates,' in J. Rasmus Brandt and Olaf Steen (eds), *Imperial Art as Christian Art – Christian Art as Imperial Art: Expression and Meaning in Art and Architecture from Constantine to Justinian, Acta Ad Archaeologiam et Artium Historiam Pertinentia*, 15/1 (Rome, 2001), p. 229.

75 The heads decapitated in the eighteenth century from the jambs of Saint-Denis confirm this position: the sides, not the backs of the heads show the saw-marks

where the stone had been attached to the jamb colonettes. See Xavier Dectot, 'Beheaded We Stand: The Heads of Saint-Denis and the Problem of Eighteenth-Century Prerevolutionary Vandalism,' in *Facing the Middle Ages*, symposium, 14 October 2006, The Metropolitan Museum of Art, New York.

76 Subsequent descriptions of the gesture of oath-taking specify swearing with two fingers raised followed by 'hand-pressing,' in which the prince made physical contact with the people. In the scene of oath-taking to Emperor Henry VII in 1311 (r. 1308–13) illustrated by Bojcov, those who swear lift their right hands with two fingers raised. The prince responded with a promise to the people. See Mikhail A. Bojcov, 'How One Archbishop of Trier Perambulated his Lands,' in Björn Weiler and Simon MacLean (eds), *Representations of Power in Medieval Germany 800–1500*, International Medieval Research 16 (Turnhout, 2006), p. 331.

77 Margot Fassler, *The Virgin of Chartres, Making History through Liturgy and the Arts* (New Haven and London, 2010), p. 58.

78 'After the citizens had performed their duty as subjects, it was the turn of the prince to give his promises to respect the old privileges and freedoms of the community. … his obligation to respect the *good old* customs ….' See Bojcov, 'One Archbishop,' p. 326.

79 Ibid., p. 334.

80 Bryant, 'The Medieval Entry Ceremony at Paris,' p. 98.

81 The exceptions include three column-figures on the left jamb of the center portal and two on the right jamb of the right portal at Chartres Cathedral and the column-figure holding a cross at Etampes.

82 The gesture of the Saint-Germain-des-Prés column-figures appears to be the single raised index finger. 'This, one of the most pervasive of all twelfth-century schemata, has its roots in the classical tradition of picturing the rhetorical *declamatio*, which Early Christian artists had adapted from images of the pagan philosopher … The pointing index finger was a universal sign of acoustical performance, the speaking subject ….' See Michael Camille, 'Seeing and Reading: Some Visual Implications of Medieval Literacy and Illiteracy,' *Art History*, 8 (1) (March 1985): 27–8.

83 Of the two images of Christ on the doors of Santa Sabina in Rome, it is the scene of Christ between Peter and Paul rather than at the *Parousia* in which Jesus raises his right hand with two fingers extended. See Hugo Brandenburg, *Ancient Churches of Rome from the Fourth to the Seventh Century* (Turnhout, 2005), illustrations, pp. 302–3. See also Kantorowicz, 'The "King's Advent,"' 207–31.

84 Fassler, *The Virgin of Chartres*, p. 57.

85 Warner, 'Ritual and Memory,' p. 261.

86 Michel Bur, *La formation du Comté du Champagne, v. 950 – v. 1150* (Nancy, 1977), p. 282.

87 Koziol, 'Political Culture,' p. 50.

88 '… at its most basic level, a fief (*foedum, casamentum*) designated property, revenue, or rights held in restrictive tenure. A fief could not be alienated, encumbered, or otherwise diminished without the consent of the person from whom it was held.' See Evergates, *Aristocracy in Champagne*, p. 64.

89 'Land grants called *precaria* were granted in return for military service. The use of church lands to support warriors in the king's service contributed to

the growth of *precaria* in the eighth century. Late historians assimilated such grants to "fief," an assumption now under some suspicion. Nevertheless, even with[out] assuming a[n] evolved "feudal" system, there is evidence that land was distributed, or appropriated by the fighting classes, and that distinctions between private and public jurisdiction collapsed.' See Paul Halsall, 'Fiefs and Jurisdiction,' *The Medieval Sourcebook* (1996), available at <http://www/fordham.edu/halsall//source/feud-fief2.htmml> (accessed 3 October 2008).

90 Constance B. Bouchard, 'Rural Economy and Society,' in Marcel Bull (ed.), *France in the Central Middle Ages: 900–1200* (Oxford and New York, 2002), pp. 81–2.

91 'The group … would have perceived these works of art, not in terms of individual response, but as a choric or mass one.' See Camille, 'Seeing and Reading,' pp. 32–3.

92 '… personal experience migrates into the collective memory and is refracted back again.' See Michael G. Kenny, 'A Place for Memory: The Interface between Individual and Collective History,' *Comparative Studies in Society and History*, 41 (3) (July 1999): 421 ff.

93 Archives nationales, *Le sacre*, p. 16.

94 Lewis, *Royal Succession in Capetian France*, p. 13.

95 'Suger … had been raised in the abbey of Saint-Denis. He and the future King Louis VI had attended the abbey school together and Suger became Louis's closest counselor and advisor after the fall of Stephen Garlande in 1127.' See Elizabeth M. Hallam, *Capetian France 987–1328* (London and New York, 1980), p. 174. See also Suger, *La geste de Louis VI et autres oeuvres*, introd. Michel Bur (Paris, 1994), Ch. 10, p. 168.

96 Brown, *Franks, Burgundians and Aquitainians*, p. 13. William of Aquitaine had asked Louis VI to serve as Eleanor's guardian. Louis joined their domains and found a queen for the young king with their marriage and Eleanor's coronation in 1137.

97 'Simply stated, the entry ceremony consisted of processions out of a city to greet a ruler and a procession into the city by the ruler after the greeting.' See Bryant, 'The Medieval Entry Ceremony at Paris.'

98 In another dispute, Louis and Thibaut went to war in 1142–44. Louis occupied Vitry and withdrew only after a thousand Champagnois died in a church burned at his command. In 1145, to partially atone for this massacre, the king departed for the Second Crusade.

99 Through this important safeguard, travelers were guaranteed safe passage to and from the fairs of Champagne. Louis VII was absent from the kingdom, participating in the Second Crusade.

100 Felix Bourquelot, *Etudes sur les foires de Champagne, sur la nature, l'étendue et les régles du commerce qui s'y faisait aux XII, XIII, et XIV siècles* (Paris and Provins, 1839–40), vol. 1, p. 66. Henri governed the province from 1152 to 1180. 'Henri le Libéral in particular furthered the cultural and economic development of his country. Troyes and Provins, where he resided, were adorned with magnificent new castles, and more than a dozen hospitals were built during his reign. He ordered the draining of the swamps around Troyes and the construction of canals, along which a flourishing trade began to develop. Fully alive to the importance of the fairs, he furthered them in

every way he could' See also H. Wescher, 'The Cloth Trade and the Fairs of Champagne,' *Ciba Review*, 65 (March 1948): 2366.

101 Yves Sassier, *Louis VII* (Paris, 1991), pp. 364–5.

102 Ernst H. Kantorowicz, *The King's Two Bodies, A Study in Mediaeval Political Theology* (Princeton, 1957), p. 206.

103 Bojcov, 'One Archbishop,' p. 326.

104 Twyman, *Papal Ceremonial*, pp. 11–12.

105 Stefan Albrecht, personal communication, 12 April 2007 in conversation: at the Society of Architectural Historians, Pittsburgh, Prof. Albrecht cited the 1410 dispute between Saint-Denis and Notre-Dame, Paris, about who held the true relic of Saint Denis. Notre-Dame canons claimed their fourteenth-century column-figures showed Saint Denis holding his cranium as validating their possession of the true relic, since they held the top of his head. The monks of Saint-Denis claimed to hold the entire head. See also Dom Bernard de Montfaucon, *Les monuments de monarchie française, qui comprennent l'histoire de France* (Paris, 1729); and Dom Urbain Plancher, *Histoire générale et particulière de Bourgogne* (Dijon 1739, repr. Paris, 1974).

3

GOOD BUSINESS:
COMMERCE IN THE NORTH

And since we are convinced that it is useful and becoming not to hide but to proclaim Divine benefactions, we have destined … that increase in textiles [*palliorum*] which the Hand Divine has granted to this sacred church in the time of our administration …[1]

In *De administratione*, Suger took credit for the accumulation by the Royal Abbey of Saint-Denis of gold, silver, most precious gems, and excellent textiles: '… *auri, argenti et pretiosissemarum gemmarum, necnon et optimorum palliorum repositione* …'[2] His choice to rank fine fabrics alongside gold, gems, and ornaments, confirms the valuation of textiles by political and religious leaders who required prestigious luxuries either for themselves, to underscore their status in society, or to give to one another as suitably impressive gifts (Fig. 1.49).[3] When they were represented in mid-twelfth-century column-figures, fine exotic fabrics and furs could convey information about status, luxury, and prestige. For northern Europeans, the fabrics imported from the Mediterranean basin and the Levant were valuable and meaningful for quite a number of reasons: the inherent beauty of these stuffs, their color and fiber content, their rarity in a particular community, the differences between these textiles from locally produced goods, the places of their origin, and the difficulties associated with the transportation of these materials. When, in the 1160s and 1170s, a shift occurred in the significance of textiles and the value placed upon particular shapes of clothing and types of fabrics, the appearance of textiles and costumes represented on the column-figures of church façade programs changed at the same time (Figs 3.1, 3.2, 3.3). This chapter concerns itself with the exclusive nature of particular textiles that appear represented in sculpture, with the transportation of cloth during this period, and with issues pertaining to the economy and commercial exchange of stuffs traded during the Middle Ages.

The intersection of permanent changes in government and its infrastructure with fundamental economic developments during the twelfth century created circumstances that contributed to the various meanings inherent in specific textiles. One justification for the isolation of a group of northern French

3.1 Saint-Eliphe, Rampillon, left jamb, thirteenth century.

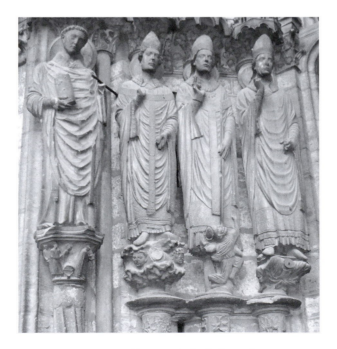

3.2 Notre-Dame, Chartres Cathedral, south transept,
east porch, left jamb, c. 1235 and c. 1210–20.

Photos: Janet Snyder

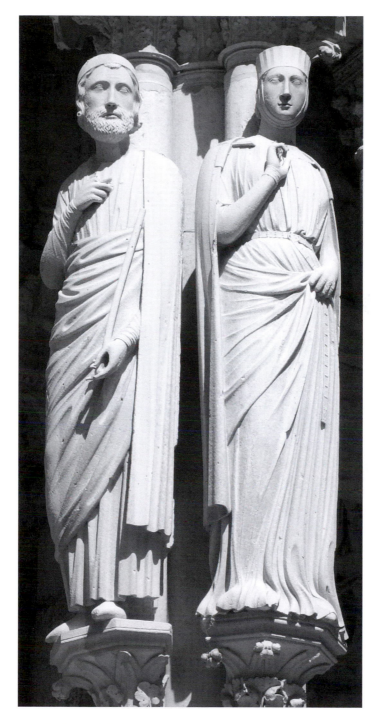

3.3 Notre-Dame, Chartres Cathedral, north transept porch,
column-figures, c. 1220–30.

Photo: Janet Snyder

portal sculpture programs in the history of meaning conveyed through three-dimensional images springs from this intersection between state and business. Beginning in the 1160s, a decade of relative stability, the fairs of Champagne and Brie became centers of mercantile activity in northern Europe. Technological advances, institutional changes in France and developments in international trade contributed to the commercial success of the fairs.

Access to silk

Although Egeria's travels in the fourth century testify to the long history of European pilgrimages to the Holy Land,[4] the twelfth century witnessed a marked increase in the number of Europeans who returned from journeys to the Middle East. The impact made by these returning travelers produced a broadening of horizons that not only popularized a world of luxury and sensation for the West, but also increased Europeans' fluency in a language of dress that was articulated through Eastern textiles and clothing. Alternate significances might have been communicated through the use of this language, depending upon location, participants, and context. Describing his visit to Constantinople in the late twelfth century, the Spanish traveler Benjamin of Tudela said the people looked like princes, dressed in silk, purple and gold.[5] His assessment is important, for it reveals as much about Benjamin's understanding of the appearance of princes as it tells about the residents of Constantinople, and it testifies to the common twelfth-century European habit of communication based upon appearances.

The significance and the controlled use of silk in Byzantium were stressed in the regulations of the *Book of the Eparch*.[6] The plain costumes of foreigners were supposed to distinguish them from the Byzantine citizens but mid-grade and less expensive fabrics were actually available for purchase by strangers, so the distinction was a matter of degree and quality.[7] Historically, it has been a scholarly trope that all imperial silk had been produced in imperial workshops. However, David Jacoby has demonstrated that the demand for high-grade silk was actually so great that the imperial workshops could not meet it and also that medium- and low-grade silk was more available than previously had been thought.[8] By the tenth century, the demand for silk was so great that the Byzantines found they needed to import silk into Constantinople from Syria.[9] Even when using advanced techniques to study fabrics, modern textile historians have difficulty determining the precise origin of Syrian/Byzantine fabrics of the same type. It is even likely that there were Syrian products that may have been superior to many of the silk fabrics produced in Byzantine workshops.

Varying qualities of stuffs were produced for the multiple uses for silk textiles. Heavyweight silks like the *cendal* and *samite* fabrics that have been preserved in church treasuries and museums were not the only types of fabrics made in the twelfth century (Figs 4.11, 4.12, 4.15/Pl. 16, 4.16/Pl.

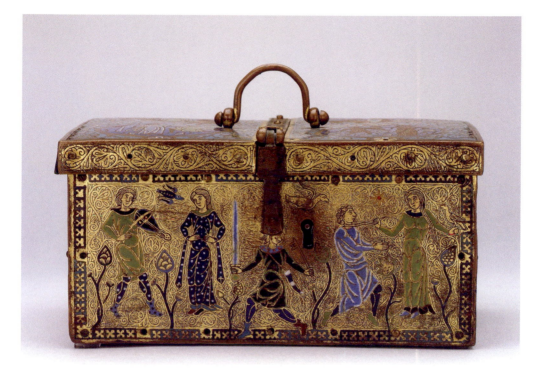

1 *Enamel Casket,* c. 1180, Limoges, from the court of Aquitaine.
The British Museum (M&LA, 1859,0110.1). © Trustees of the British Museum.

2 Abbey Church of Saint-Denis, west façade, right portal, left jamb, column-figure. Antoine Benoist drawing, BN, MS FR 15634, folio 70. Bibliothèque nationale de France.

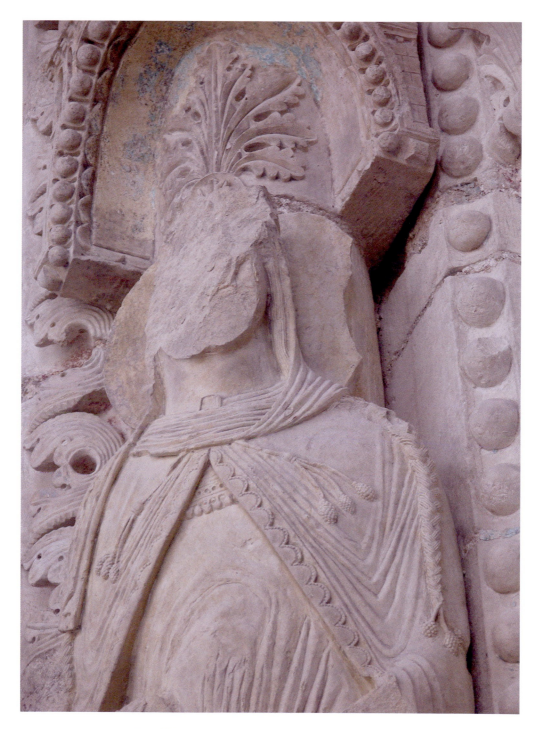

3 Saint-Etienne, Bourges Cathedral, north lateral portal, left
column-figure: neckline, braid, cord and tassels.

Photo: Janet Snyder.

4 Abbey Church of Saint-Denis, west façade, column-figure CL3.
Antoine Benoist drawing, BN, MS FR 15634, folio 55.
Bibliothèque nationale de France.

5 Saint-Etienne, Bourges Cathedral, south lateral portal,
left 2: below-knee body, *ṭirāz* band.

Photo: Janet Snyder

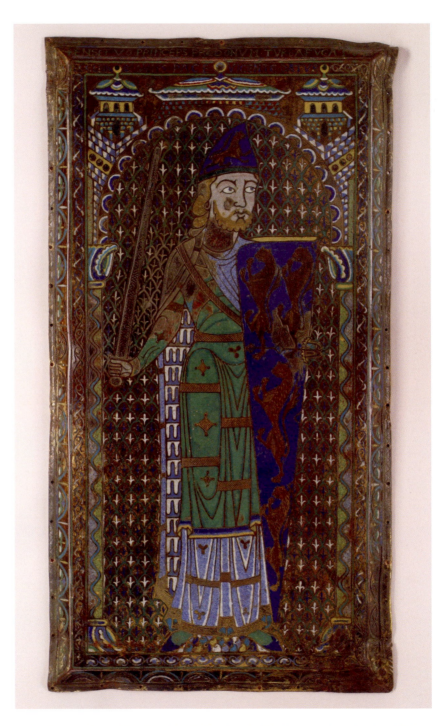

6 Tomb effigy of Geoffroi le Bel (Geoffrey V Plantagenet), shortly after 1151,
copper (engraved, chased and gilded), *vernis brun*, *champlevé* enamel areas in
various colors. Le Mans? Cliché Musées du Mans; Conservation: Le Mans, Carré
Plantagenêt (Musée d'histoire et d'archéologie du Mans, Inv. 23-1).

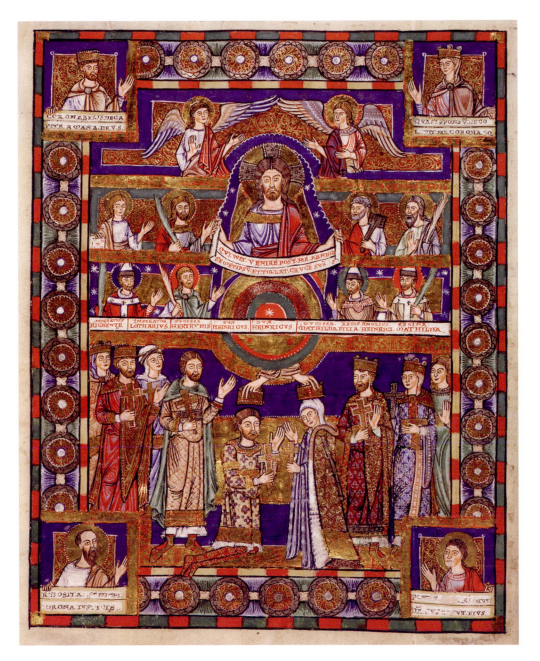

7 Henry's coronation miniature in the *Gospels of Henry the Lion*, c. 1175–88. From *Das Evangeliar Heinrichs de Löwen*, Wolfenbütel Herzog August Bibliothek, Cod. Guelf, 105 noviss. 2.

8 Saint-Maurice, Angers, right 1 (detail): top of open center seam.

Photo: Janet Snyder

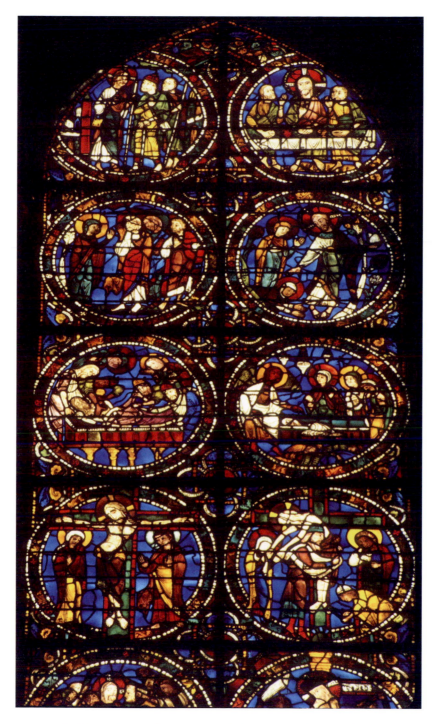

9 Notre-Dame, Chartres Cathedral, interior of the west front,
left bay (*Passion of Christ*), painted stained glass.

Photo: Janet Snyder

10 Notre-Dame, Paris cathedral, west façade, Portail Sainte-Anne: side of *trumeau*,
Saint Marcel, limestone with traces of polychromy (detail): ecclesiastical dalmatic
fringe, c. 1145. Paris, Musée de Cluny – Musée national du Moyen Age (Cl. 18640).

Photo: Janet Snyder

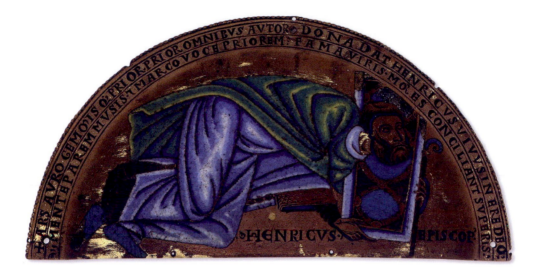

11 *Henri of Blois*, c. 1150, Mosan enamel plaque. The British Museum
(M&ME 1852, 3-27). © Trustees of the British Museum.

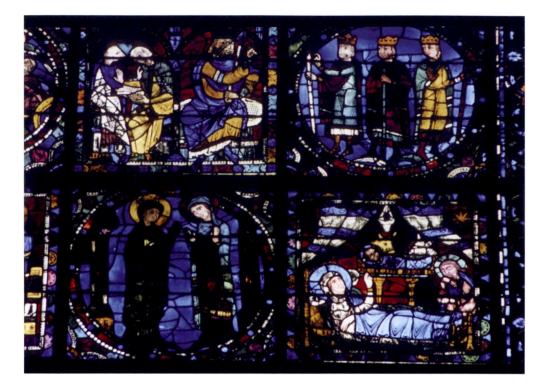

12 Notre-Dame, Chartres Cathedral, interior of the west front, center
 bay (*Childhood of Christ*), painted stained glass, c. 1150.

Photo: Janet Snyder

13 Saint-Etienne, Bourges Cathedral, north lateral portal,
right column-figure: pin, braid *en trecié*.

Photo: Janet Snyder

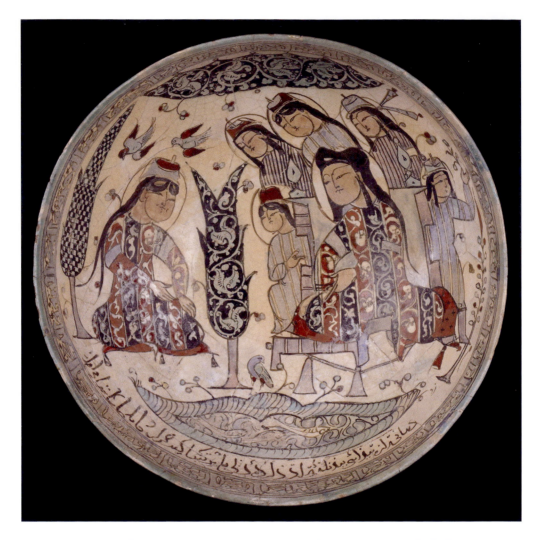

14 Fritware bowl, painted with an enthroned ruler and his attendants, 1187 CE, Iran. Signed by Abu Zayd. Inv. 19,451,017.26. © The Trustees of the British Museum/Art Resource, NY.

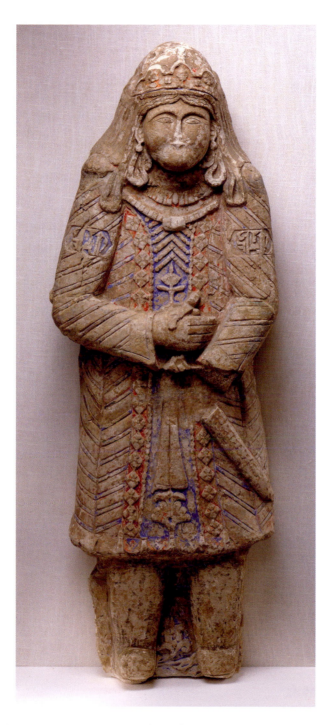

15 *Royal Figure with Winged Crown*, eleventh century, stucco, free-formed, incised, painted, gilt, h. 119.4 cm. Iran or Afghanistan. The Metropolitan Museum of Art, New York (57.51.18), Cora Timken Burnett Collection of Persian Miniatures and Other Persian Art Objects, Bequest of Cora Timken Burnett, 1956.

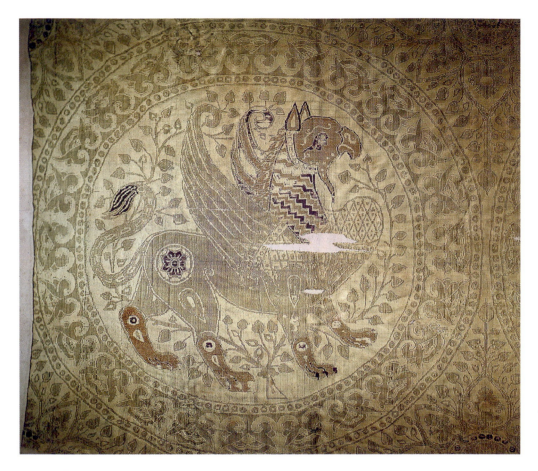

16 Textile fragment from the *Reliquary Shroud of St. Sivard*, twelfth century, Byzantine, silk
with gold thread, h. 89 cm × w. 136 cm. Treasury of the Cathedral of Sens, inv. no. B.8.

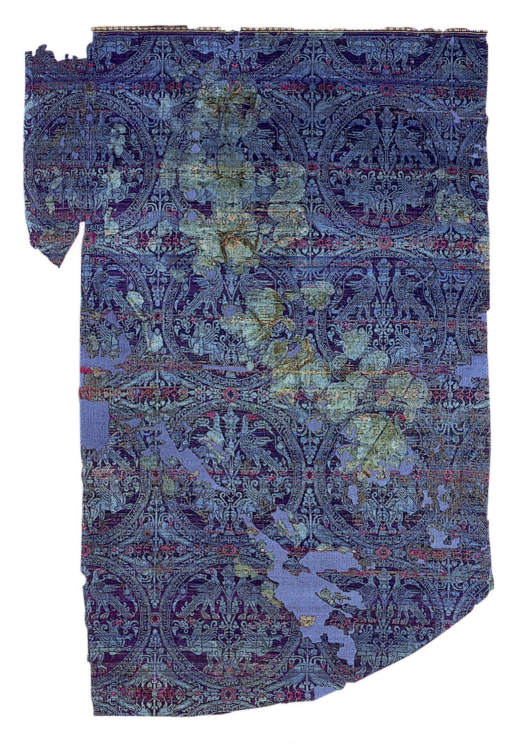

17 Large fragment of the *Second Shroud of St. Potentien*, twelfth century, Byzantine, silk samite, h. 145 cm × l. 97 cm. Treasury of the Cathedral of Sens, inv. no. B.7.

18 Saint-Maurice, Angers, left jamb 2 (detail):
pendant baubles, sleeve knot, mantle.

Photo: Janet Snyder

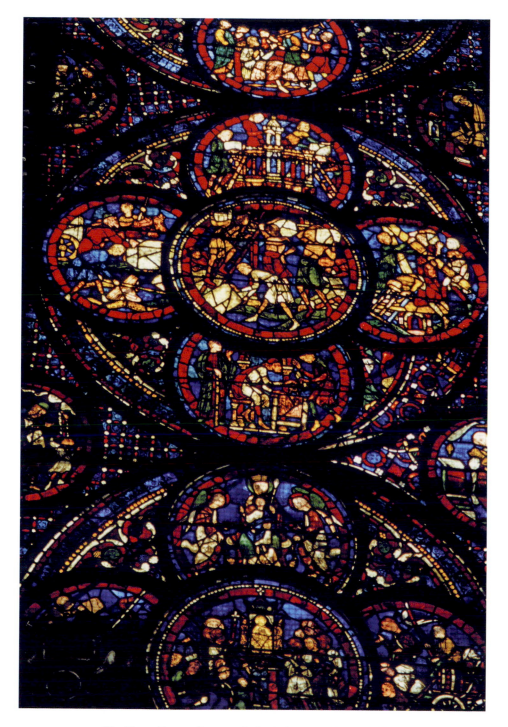

19 Notre-Dame, Chartres Cathedral, painted stained glass,
south aisle (*Architect*) window: '*Construction*.'

Photo: Janet Snyder

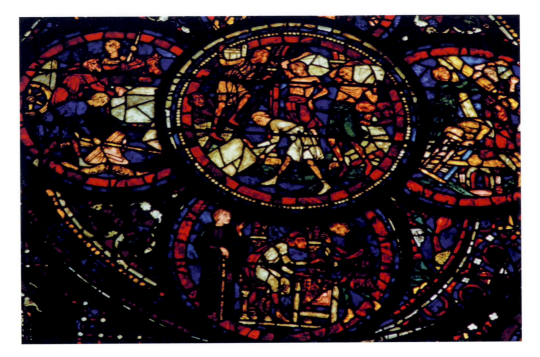

20 Notre-Dame, Chartres Cathedral, painted stained glass,
south aisle (*Architect*) window: '*Conference.*'

Photo: Janet Snyder

17). Fabrics of lower quality that had a shorter span of life generally have not survived.[10] Twelfth-century sources suggest there was a substantial commercial movement of Byzantine silk wares, for though trade in imperial silks was strictly controlled within Byzantium, there were no serious obstacles in the empire to the purchase or sale of silk textiles that were less expensive than imperial silk or in the export of these goods to other countries.[11] While the unavailability of imperial quality silk from Byzantine imperial workshops is well documented, less expensive silks of various qualities from private workshops were authorized for trade. Further, trade controls were lax at times, and private trade was considerable.[12] The trade routes used to transport all these goods were well established and the inventory of even a middle-class Mediterranean household might include the luxury of a pure floss silk dress and several half-silk dresses.[13]

Trade records

An extraordinary resource for the understanding of commerce during the Middle Ages, the materials stored in the Old Cairo/Fustat *geniza*[14] provide documentation of trade and cultural exchange dealing with the kinds of textiles and clothing that are represented in twelfth-century column-figure sculpture in northern France. European trade with ports around the Mediterranean had continued despite the Muslim conquest of Sicily (827) and the ninth-century invasion of Italy, but trade with Constantinople and Alexandria dropped dramatically until a successful Byzantine counter-offensive reclaimed mainland Italy in 915. Since Muslim fleets dominated the Mediterranean, maritime trade in this period was very risky. Following the First Crusade, 1095–99, commercial traffic accelerated.

At the end of the nineteenth century a storage room, or *geniza*, of the Ben Ezra Synagogue in the twin city of Cairo/Fustat was found to be filled with documents.[15] In order to preserve them from desecration, discarded writings on which the name of God was or might have been written by the Jewish community were deposited in their *geniza*. Most of the documents stored in a *geniza* had been produced by the associated synagogue, but unlike other *genizas*, a tremendous quantity of purely secular writings was preserved in the Cairo/Fustat *geniza*, such as personal letters and business records, including commercial shipping logs from the twelfth century.[16] Analysis of the materials preserved in this *geniza* has helped to explain how the fine stuffs represented in northern European column-figure sculpture might have been acquired. These documents show that Egyptian Jewish merchants had been trading with northern Europe since at least the ninth century, with the Egyptian port of Alexandria serving as the international exchange center of silk with commerce from Sicily, Iraq, Tunisia, and Spain, and that textiles and 'spices' were prime commodities of this trade network during the eleventh and twelfth centuries.[17]

The merchants from Old Cairo dealt with Syrian silks, Egyptian linens and *fustians*,[18] and they shipped dyestuffs, cotton fibers, and flax. Dyestuffs and mordants were included in the category of 'spices,' while silk and flax were by far the most commonly shipped fibers.[19] The Jewish overseas traders handled great quantities of dyeing materials coming from practically all parts of the trading world: the Far East, India, Yemen, Egypt, Palestine, Syria, Tunisia and Morocco.[20] In the eleventh and twelfth centuries Egyptian venture-traders sent goods to Europe via sea routes, not only dealing in Egyptian fabric and raw materials but also in spices and textiles from the Asian subcontinent. As the capital of Egypt, Cairo/Fustat formed the terminus and distribution center for the trade from the two large areas of medieval maritime commerce, the Mediterranean and the India trade. The trade records indicate that threads, fabrics, and clothing exceeded all other categories of commerce, in both general and luxury goods.

Syria, locus of the Crusader kingdoms, produced and freely traded quantities of brilliantly colored silk and *mulham* textiles.[21] For example, the Fustat *geniza* documents include records from around 1100 from Nahray bin Nissim, a wholesale merchant of high standing. He shipped silk fabrics from Spain and Sicily and also other fabrics – ranging from European or Syrian cotton to North African felt – and all kinds of finished goods and textiles, from garments to bedcovers. Though his greatest volume of business was in flax that he exported from Egypt to Tunisia and Sicily, silk was his second substantial trade.

As research by Jacoby and Goitein has shown, in 1140 and 1144, Venetian marine shippers were handling silks between Corinth, the closest port to Thebes, and the Egyptian port of Alexandria.[22] The records kept by Jewish traders who went to China and India by sea indicate that their primary trade carried threads, fabrics, and clothing. The prices of silks in these records demonstrate that the fabrics traded were of varying qualities; the heavyweight silk relic wrappings that have survived in European treasuries would have been among the most expensive, highest quality and heaviest-weight textiles. The specific role silk played in the finances of the Fatimid period (909–1171) in Egypt was much like that played by stocks and bonds in twentieth-century society. The primary source for fine textiles was the *ṭirāz* (Figs 4.11, 4.12).[23] Silk was traded in pounds and ounces, flax in hundred-pounds and in bales containing 350 through 600 pounds. The quantities handled required that only professional merchants specializing in this branch of trade considered undertaking these commercial ventures. The Fatimid treasury controlled the sale and required stamps to transport the bales of fabric.[24]

Twelfth-century records of Mediterranean trade document that not only the Egyptian but also the Italian merchants were involved in shipping the kinds of fine linen and silk fabrics represented in column-figure sculpture (Figs 1.2, 2.5, 1.16, 1.115). Genoese commercial and colonial ventures in the Levant began with the First Crusade.[25] Contracts of the 1130s note how highly the Genoese valued silk textiles manufactured in Andros, *cendal* and *samite*.[26] Genoese

traders had established traffic with Syria by 1154; their lucrative trade was well established by 1175, when the bilateral *societas* was replaced by the unilateral *commenda* or *accomendatio* as the dominant form of partnership.[27] The trade partnerships of these merchant-venturers set the foundation for international commercial relations. In a *societas*, the investment, risk, and profit were shared equally by the investor and factor; in the *accomendatio*, the investor carried a heavier burden of capital investment and risk than the factor and therefore the investor received the greater proportion of profit. Both the Venetians and the Genoese wanted to have commercial control of the Mediterranean trade and to establish colonies in the Levant.[28] Their political bases made the activities of the citizen-merchants of these Italian city-states fundamentally very different: the Venetians subordinated individual enterprises to the welfare of the Republic while the Genoese, whose commune was disturbed constantly by internal strife, were able to function first as individuals. As a result, the Genoese excelled individually as businessmen and collectively as traders, and they formed superior commercial organizations during the twelfth century.

Sources of fabrics and dyestuffs

While Fatamid Egypt *ṭirāz* produced fine linen cloth with inserted silk tapestry bands,[29] the *ṭirāz* of Islamic Spain made their region a leading silk producer as well. The silkworks of southeast Spain that had been established between the seventh and tenth centuries produced some excellent copies of Byzantine imperial silks and other Levantine silks that could barely be distinguished from the originals.[30] The pattern and motifs of the early Iberian *ṭirāz* correspond to those employed by the Baghdad and Cairo courts.[31] The *Burgo de Osma Silk*, for example, is one of a distinctive group of Islamic Andalusian textiles believed to have been made in deliberate imitation of Baghdad silks.[32] The popularity of Eastern textiles in Europe at the beginning of the twelfth century produced the demand that resulted in these goods being copied in Iberian workshops.

Sericulture in Sicily was second only to that of Spain in the Mediterranean basin. Sicily exported raw materials to be manufactured into cloth in North Africa and Egypt, supporting the entire Fatimid silk industry.[33] Together with inscribed *ṭirāz*, these workshops produced enormous quantities of finished cloth. Northern European courtly consumers were able to have greater access to *ṭirāz* silks following the mid-eleventh-century Norman conquest and occupation of Sicily. Although there had been a silk industry in Sicily before the Norman invasion, very high quality silk textiles were not produced on the island until after 1147. Fine fabrics were appreciated in Sicily and their use prior to 1147 for royal garments in known through inscriptions such as the jewel-encrusted silk *Mantle of Roger II*,[34] a cloak that this ruler wore for audiences when he received guests. Contemporaneous Sicilian mosaics illustrate Roger – in La Martorana in Palermo – and his

grandson William – at Monreale Cathedral – each crowned by Christ while clothed in the *loros* and *stemma* of the Byzantine emperor.

Roger II ameliorated the quality of his Palermo silkworks with the addition of the silkworkers whom his forces abducted from Thebes, Athens, and Corinth following the sack in 1146 by his forces of these Byzantine manufacturing centers.[35] Despite the efforts of the Byzantine imperial government under the Comnènes, these silkworkers were never repatriated following peace negotiations.

Appropriation changed meaning

The Byzantines themselves understood a language involving a vocabulary of high-grade silk textiles and significant colors produced by special dyestuffs. This language described essential principles of Byzantine social hierarchy and conveyed social signals for the Byzantines, though it was not necessarily comprehensible elsewhere.[36] For example, murex dyes, acquired through the processing of vast quantities of now-extinct shellfish, produced the imperial purple, and therefore were absolutely restricted to imperial silks. Gifts of silk *pallia* given to foreigners, however, might have been colored with non-murex dyes. Nonetheless, the European recipients of these gifts perceived the materials, motifs, and inscriptions as endowing export silks with imperial prestige. It was less important to the Europeans that the gifted stuffs had been produced at a lower production cost for the Byzantines, and that these stuffs were less valuable – to the Byzantines – since they did not meet the Byzantines' standards for imperial quality.[37] European appropriation of these goods involved in a translation into the equivalent of a local dialect of dress understood in northern Europe.

Similar to transactions elsewhere during the twelfth century, in the Islamic world silk transactions also took the form of the exchange of gifts, the granting of robes of honor, and trade.[38] Unlike the rulers of other large empires, the governments in Islamic countries did not monopolize or restrict trade in silk, though they indulged in the lavish consumption of silk and other luxuries. Sometimes the caliphs and sultans required that the best silks be reserved for themselves, so these goods would not have been available through traders. The demand from the rulers was so great that whenever traders had difficulty in selling their stock on the international market, they always were able to count on selling it to the government.[39]

Decorative details

As with the silk trade, merchants responded to European courtiers' desire for more rare and exotic materials. A vogue for furs contributed to the development of commerce in animal pelts. As represented in sculpture, the

long mantle of the European courtier, that signifier of rank and authority, appears to have been made in various materials, ranging from northern woolen cloth to imported silk. Frequently, the mantle provided the locus for the expression of wealth and status in the language of dress, articulating demonstrable conspicuous consumption. This can be seen illustrated in the texture of the lining of the mantle of the *February* Labor of the Month at Chartres Cathedral or in the borders of a dalmatic on the *trumeau* figure of Saint Marcel at Notre-Dame in Paris, where little tufts of fur appear to have been exaggerated in the portal sculpture (Fig. 1.120/Pl. 10). The expansion of the fur trade following the First Crusade made luxurious furs more available to France, with imports arriving from Siberia, Armenia, Norway and Germany: marten, beaver, sable, bear, and the greatly prized ermine and vair.[40] Mantles were described in secular literature having been as lined with local pelts of fox, squirrel, rabbit, lamb, or with vair/miniver/gros vair of Asian luxury furs.[41] By mid-century, red and white fox pelts from the borders of the Caspian Sea, and from Armenia and Siberia, were acquired through the Russian trade routes.[42]

Very little twelfth-century exterior stone sculpture retains its original paint, though descriptions[43] and manuscript illustrations or polychromed wooden sculpture report that the appearance of the colors and patterns of the actual textiles were brilliant. '[T]he medieval man, like tropical singing birds, liked ... green, red, and intense yellow, and, above all, intricate nuances with all kinds of "glitter," "gloss," iridescence, stripes, waves, and patterns ...'[44] It was possible to represent such effects on the stone surfaces of column-figure sculpture (Fig. I.7). Drilled holes may have been filled with contrasting pastilles, dimensional paste, or decorative additions of glass or stones (Fig. I.8).[45] It is likely that fur was represented in sculpture through painted depictions on smooth surfaces lining mantles, dalmatics, and pelisses, in the way that vair was painted on the mantle lining of the *Falconer* in the *Moralia in Job* in Dijon,[46] and on the lining of the Christ Child's mantle in the thirteenth-century Spanish *Virgin and Child*, now in The Cloisters collection of the Metropolitan Museum of Art.[47] Vair-lined mantles are worn by the enthroned David (Fig. 3.4) and by the king observing the scene of *Hebrews in the Fiery Furnace* (both in the *Bible of Stephen Harding*), and by the tomb effigy of Geoffroi le Bel (Fig. 1.91/Pl. 6).[48] Painted vair lines the mantles of Jairus and his wife in the twelfth-century wall painting of *The Raising of Jairus's Daughter*, at Saint Michael and All Angels Church, Copford, Essex (Fig. 1.130).[49]

Matilda of England was depicted wearing a vair-lined mantle in the full-page miniature of her coronation beside her husband, Henry the Lion, Duke of Brunswick (Fig. 1.92/Pl. 7).[50] The mantles of the earthly court appear to have been made of gold and patterned silk textiles; a textile patterned in large circles clothes Empress Richenza, similar to the extant Byzantine silks that often have been described as furnishing fabrics (Figs 4.15/Pl. 16, 4.16/Pl. 17). No jewelry can be seen on the men, but the mantles of the Empress

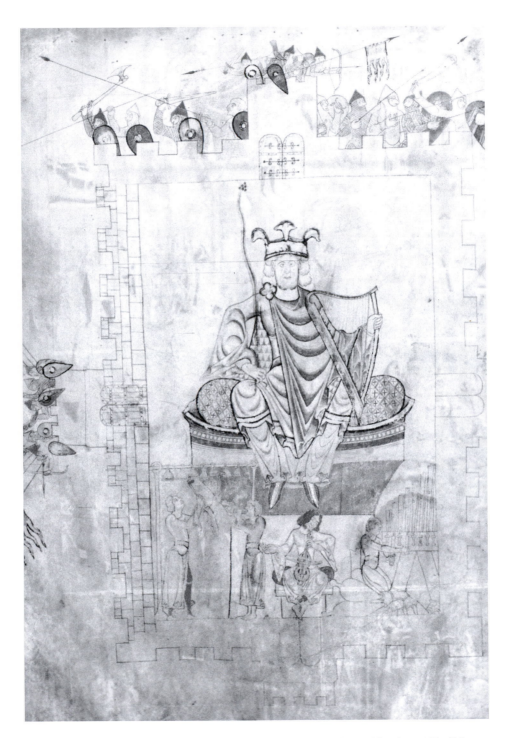

3.4 *David in Majesty*, from *The Bible known as the Stephen Harding Bible*, after 1109, Abbey of Cîteaux. Dijon, Bibliothèque municipale de Dijon (Dijon 641), MS 14, folio 13v.

Photo: E. Juvin

Richenza (d. 1141) and the Empress Matilda (d. 1167) appear to have been fastened at the breast by large circular gold brooches or *fermails* much like the one illustrated in sculpture on the woman from at Corbeil (Fig. 1.49).[51]

Changing emphases

In the mid-twelfth century, Italians added large-scale production of silk textiles on the mainland to their shipping business. While some specialized silk textiles had been made in Lucca, Genoa, and Venice during the eleventh century, on the mainland, Lucca was the first Italian town to initiate industrial production of silk fabrics.[52] It was not long before Venice, Genoa, Milan and other towns of northern Italy followed the Luccan pioneers in commercial production.[53] This changed point of origin was only one of the reasons for a change in the meaning of silk textiles within the language of dress for northern Europeans.[54] Italy was more familiar territory for northern Europeans and once it had been generally recognized that silk was being produced in Italy rather than in the region associated with the Holy Land, a subtle shift in its significance took place for northern Europeans. When, in the late twelfth century, the availability in the north of silk cloth increased because it had been made and handled by neighboring Italians, its price fluctuated and its meaning was altered in the language of dress. Increasingly, international trade enabled the northern Europeans to subscribe to the attitude of the Fustat merchants: '... travel around the Mediterranean was considered to be within one's own precincts and never beyond reach.'[55]

The changing commercial value of silk cloth was indicated in church portal sculpture as different fabrics were represented: exclusivity was no longer signaled by all types of imported textiles. The column-figure sculptures of northern European portals installed between c. 1165 and c. 1210 – at Senlis or on the transept portals of Chartres (Figs 2.8, 3.2, 3.3) – reveal substantially more than a stylistic difference in the carving or the use of a decorative surface motif. Not only is the cut of the garment new but the drapery of the cloth also makes it appear to represent the use of a different material. These textiles look like the more substantial European fine woolen or linen textiles (Fig. 3.1).

This shift in form and represented textiles in monumental sculpture parallels the expansion of the centers of commercial exchange known collectively as the fairs of Champagne and Brie. Merchants came from distant regions for fairs – large organized gatherings at the market towns that took place at regularly spaced intervals.[56] While portal sculpture programs installed before c. 1165 in market towns like Provins featured slender personages wearing closely fitted costumes of delicate imported textiles (Figs 1.18, 1.50, 1.57, 1.60, 1.78, 1.86, 1.87), after 1170 these gave way to more substantial and more corporeal figures in expansive robes represented at thirteenth-century church portal sculpture like the nearby Saint-Eliphe at Rampillon (Fig. 3.1), Auxerre (Fig. 4.9), or the transepts of Chartres Cathedral (Figs 3.2, 3.3).

The market economy and the fairs

A demographic expansion at the end of the eleventh century and the beginning of the twelfth meant that more and finer textiles could be produced in the Lowlands, Flanders, and England. With more and improved products to move, the producers and merchants in these northern lands were not restricted to sales at local markets, and they looked to the fairs of Champagne and Brie for wider outlets for their industrial products. Even at the beginning of the twelfth century, when the fairs were still largely local agricultural markets, the presence of foreign tradesmen at the fairs in northern France is documented. The best known and most important of the medieval fair cycles was one of six fairs held in four towns on a rotating basis throughout the year in Champagne. The counts of Champagne were rewarded for their active promotion of this system of cyclical markets with substantial profits, putting the northern European economy in their control in the late twelfth century.

These rewards were possible because of an extraordinary exception to the accepted behavior of the upper stratum of society, one that had a direct impact on the success of these fairs. In northern France and in England, tradition required that the income of 'nobles' must result from their superior status as landowners and, further, that *noblesse* was inherited through the male line.[57] That is, impoverished nobility could not engage in work or trade without risking a diminution of their rank in society. However, according to the 'customs of Troyes' – Troyes was the seat of the Count of Champagne – the nobles could engage in commerce without degrading their *qualité*. The customs of Troyes arose because the elite men of this region had been decimated in a battle of the Frankish civil war of 841.[58] Under these customs, in Champagne, the children of a commoner father and a noble mother were ennobled, and this deviation from the norm produced an atypical attitude towards business transactions, one that freed high-status members of Champenois society to engage in commerce, more like nobles in Italy and in Provence. Because the sources of their profits arose not from the land itself but from commercial transactions in the county, the income of the Counts of Champagne differed from that of the other French magnates.

Coincidences in the twelfth century of technological improvements, geographic location, and the development of road systems also appear to have contributed to the ascendency of the fairs of Champagne and Brie, though the primary force driving these international markets was the will of the counts of Champagne. Though there is evidence of the existence of fairs in northern France since the fifth century, tradition holds that the cycle of fairs in Champagne was founded by Count Henri le Libéral, son-in-law of Louis VII.[59] In fact, cartulary evidence shows that it was both Henri I (r. 1152–81) and his father Thibaut II – le Grand – (r. 1125–52) who worked to establish the location of the six fairs in the four towns of Troyes, Provins (Fig. 2.1), Bar-sur-Aube and Lagny. At mid-century, these two assured the cyclic organization

of the markets. Further, it is possible to trace the counts' assurance of safe travel, the *conduit des foires*, their ownership of the toll roads, the rights to traverse, the stall-rents, cartage, mintage, etc., for Coulommiers, Epernay, Meaux, Crépy, Rebaix, Méry, Pont, Saint-Pathus, Bar-sur-Seine, Trilbardou, etc., to the twelfth century. At the beginning of his government, Thibaut II removed the Fair of Saint-Martin of Provins from its old location and in 1137 he replaced it and assigned new regulations.[60] Before 1141, Thibaut II set up the regulations for the fair of May in Provins, reissuing an *instrumentum de constitutione nundinarum maii* which had been burned some years earlier in a fire.[61] He also issued the franchise of the fair of Lagny. Subsequently, actions of Henri I continued this active management of the fairs in the county.

By 1179 revenues were available in several ways from the fairs: profit on the goods sold; taxes on goods sold; rents from merchants' use of ground space for stalls (*tonlieux*[62]) and house-rents of buildings; and taxes on the money-changers' tables. The Count of Champagne held lands in fief from lay and ecclesiastical lords; only one quarter of his fiefs were held from the king.[63] It was common in Champagne for fiefs to consist of revenue rather than revenue-producing land. On occasion, the count waived rents for favored individuals or institutions: in 1161, Henri gave up the rents on the grounds of the abbey in favor of the monks of Saint-Jacques of Provins.[64] House-rents produced two kinds of income for the count and for owners of allodial (freely owned) properties: for some houses of which they were the proprietors, the count and the owners received the rental price directly; for the others held in fief, they were entitled to a fixed rental price.[65] The fief-holders were paid from these revenues and contemporary charters indicate that churches and monasteries received very large incomes from the ground-rents and the market fees of the cyclical fairs.

The exercise of money-changing provided another source of revenue for the counts of Champagne, some monasteries, and, later, for the kings of France.[66] The authorization of the creation of the offices of money-changers belonged to the count; the tables of exchange were given in fief; they might be rented or sold, and the tenant who signed for each table set aside some rather considerable taxes on every exchange. One charter of privileges accorded by Henri le Libéral in 1154 to the Church of Saint-Ayoul of Provins assigned a rent of 40 sous to the religious that had previously been received by the count from the fairs on the tables of the *monnayeurs* – *in tabulis monetariorum* – who appear to be money-changers.[67] The portal sculpture at Saint-Ayoul was installed between 1154 and 1164 (Figs 1.18, 1.50). In 1165, Henri gave a table as money-changer in Troyes in fief to a Master Norman from Esigné, adding that this table grew to be worth 100 sous per year, 50 for the Fair of Saint-John, and 50 for Saint-Remi, which Norman assigned in endowment to his wife Mathilde. In 1179 Henri made a gift to the Hôtel-Dieu of Provins, five sous of revenue on each change table, payable during the fairs of May.[68] The jobs of banker, changer, and purveyor of loans with interest were jobs performed by classes of individuals who were designated

by the names *Lombards* (particularly traders from Asti), *Caorsins* (Italians based in Cahors) and *Juifs* (Jews).[69] The rates of interest were officially fixed. Although later, 20 per cent was fixed as the top limit, no more than 15 per cent was allowed at the fairs of Champagne.[70]

Reciprocal benefits

The influence upon the larger culture of the fairs and the goods exchanged in them appears to have influenced the appearance of column-figure sculpture. When an image is presented as publicly as the column-figures were, what is represented can become highly desirable.[71] The economic context provides some reasons that religious institutions might have responded to commercial pressures as they produced church portal sculpture designs. Ecclesiastical establishments would have profited from the growth and the success of the fairs, receiving concessions taken from rents and the licensing rights on houses for warehousing, as well as income from selling goods during the fairs. The ecclesiastical foundations were the only owners of significant property in Champagne, and they constructed *quartiers* entirely to lodge the merchants engaged at the fairs. Important fortifications were built around these towns, insuring the security of goods, merchants, and customers.[72]

Henri le Libéral modified the rules of the Fair of May twice. In 1164, at a critical juncture in the social organization, he enacted the major regulations for the Fair of May.[73] Henri's betrothal to the elder daughter of Louis VII and Eleanor had taken place in relation to his participation in the Second Crusade. With her marriage in 1164, Countess Marie assumed her place at the center of Henri's court, having spent her educative years at the Champenois convent of Saint-Pierre-d'Avenay.[74] At about the same time, a shift began to appear in the fashionable stuffs depicted in church portal sculpture.[75] In his revised regulations for the Fair of May, Henri established the boundaries of the fair and specified the distribution of revenues, assigning house rents to himself and to the Hôtel-Dieu, and to the chapters of Saint-Jacques and Saint-Quirace. Much of the revenues collected as rents, taxes, and duties during the fairs were disbursed from money-fiefs or fief-rents. Of the fairs of May of Provins, half the price of the rental of houses went to the Count of Champagne, except for those of the Hôtel-Dieu. The count reserved this benefice for himself in the regulatory charter of 1165, declaring there that it was given by the inhabitants of Provins themselves.

The counts of Champagne also were producers of finely finished woolens and linens. These textiles of Champagne and those of Flanders were staples sold at their fairs, along with silk textiles and other luxury goods that had been imported from Italy and the East. In the twelfth century, the biggest sales at the fairs of Bar and of Provins were of the locally produced *futaines* (fustians).[76] By an act of 1163, Count Henri gave the house where *futaines* were sold for the fairs of Saint-Martin to Habran, brother of Pierre Bursaud,

and went on to stipulate that no other house could sell *futaines* before that one was full.[77] The count remained active in the promotion of commerce: in 1179, he approved the donation by Pierre de Langres to the Maison-Dieu of Bar-sur-Aube, of a third of the *tonlieu* of *futaines* and half of the other two thirds. Henri went on to give all rights that he owned on this *tonlieu* to the brothers.[78]

Since the fairs were mutually beneficial to the ecclesiastical foundations, the towns, the counts, and the merchants, it seems likely that the patrons of church portal sculpture might promote the most profitable stuffs like *futaines*. Images of fashionable clothing would have made a permanent impression on visitors to churches with column-figure sculpture on their façades like Saint-Ayoul and Saint-Thibaut in the Fair town of Provins (Figs 1.18, 1.50, 1.60). Just as the Church appears to have contributed to the shaping of popular opinion by contributing its prestige in support of the king in the 1140s and 1150s, after the 1160s it appears that the Church may have benefited from revising the appearance of sculpture to encourage spending on local goods in the profitable fairs.

Some of the institutional changes were instigated through commercial contacts. The influence of not only foreign goods but foreign attitudes and cultural practices was evident in northern Europe. In Mediterranean society a learned middle-class merchant, a rather common phenomenon, ranked as high as a rich and powerful supplier of the court.[79] In both Judaism and Islam, scholarship conferred social prestige. In the twelfth century, southern literary traditions and Arabic learning shifted attitudes in the north. The status in Europe of literature and literary persons was upgraded by association with prestigious persons who dressed in the same luxurious costumes as the column-figures. Conversely, conservative northern European attitudes reflected ancient tradition. One tradition had been passed down from the Romans who, like the Greeks before them, viewed commerce with condescension.[80] Trade was specifically prohibited to members of the senatorial class. This attitude that noble persons could not engage in commerce – unlike the nobility in Champagne – precisely pinpoints the reason that the agency of the counts of Champagne in promoting the fairs was so exceptional. What has been called the commercial revolution in Europe altered the value and meaning of textiles for contemporaries at the same time that the social status of dealers and notaries rose, especially the status of the literate merchants who supplied luxuries. These shifts were articulated in the language of dress represented in monumental art (Figs 2.8, 3.1, 3.3).

Shipping and credit

While the Genoese and Venetian maritime trade and Egyptian merchant-venturers transported the luxury textiles from the East to the West, they

were not the only exporters who made the long haul to foreign markets. Having succeeded with marketing at the fairs, northern producers of woolens required wider markets for the great quantity of goods produced. The woolens industry depended on the overland trade to open those markets for them; Italians returning from the north took on cargoes of northern textiles as money-making ventures, and some of those textiles were woolens. Though it had not been the case in the 1150s, eventually the demand for northern textiles became so well established that the northern merchants did not have to travel south to sell northern goods. Notarial accounts preserved in Genoa document an overland trade by the men of Arras that carried northern textiles from north to south.[81] By the 1190s visiting southerners regularly came north to the fairs purposely to acquire northern products. The Italians engaged in trade may be characterized as businesslike. They were interested in commerce and the movement of goods; their traffic in northern textiles was only an incidental part of their trade.

The introduction of credit – agreements that allowed goods to be bought in the south with deferred payment to be repaid in the north – was a financial arrangement that had long-term implications for textiles and the textile trade. The merchants from Arras not only sold cloth but were also ready to provide their southern customers with credit; this limited business allowed them to keep their professional contacts alive over time and to sustain their businesses open in the south. 'Next to the contract of sale (*emptio-venditio*) … the loan contract (*mutuum, mutuo, pretito, prêt*) was the most widespread in medieval commerce.'[82] Sometimes the loans made by northerners in Italy were made in the form of cloth such as wool produced by England and Flanders, to cloth speculators who shipped it to countries on the eastern shore of the Mediterranean, hoping for profitable returns. Sometimes, when credit was extended, the contract required that repayment would be made in Provins money, to be paid at the next Fair of Troyes.[83] Such an arrangement helped balance the trade deficit, and brought liquid capital back into the north.[84] Credit was an important part of the business, for the interest charged might be as much as 10 per cent in four months. Once again, taxes on the exchange tables at the fairs where the credit was repaid provided income for the Counts of Champagne and the ecclesiastical institutions.

The next permutation in business anticipated the decline of the fairs. While the fairs of Champagne continued to grow in importance and to become established as an important factor in the exchange of commodities, northern commercial interests reached past the fairs to the Italian markets. The revenue contributed by the Flemish merchants to the fairs through taxes and rents had to be figured into the price of textiles marketed at the fairs. Demand in the south for northern textiles eventually grew sufficiently until northern merchants found it profitable to avoid the mark-up by traveling directly to Italian outlets. Eventually these higher prices in the north combined with a greater security on the roads, and led to a decreased use of the fairs. The dealers from Arras served as the sales representatives in the

south for the industrialized cloth manufacturing cities of England and of Flanders. Northern interests were reflected in the production of quantities of textiles for the world market; merchants of Cambrai, Tournai, Douai, Troyes, Lagny, and other cities of the north engaged in commerce in order keep their products moving. From time to time while they were in the south, these overland tradesmen sold cloth, bought Mediterranean products, and borrowed or loaned funds that were to be repaid in Champagne, though they did so on a smaller scale than the men of Artois.[85]

Moving on

The fairs of Champagne blossomed and flourished at the end of the twelfth century. Along with technological advances, there were institutional changes taking place in France at the same time that this international trade was expanding. The quality and quantities of textiles produced increased in northern Europe at the same time that production was changing around the Mediterranean. The travels of European people affected the world view of the Franks in the twelfth century, and the contacts made between cultures through visits from foreign merchants contributed to a breakdown of the isolation of rural agricultural Europe. The traders functioned as ambassadors of ideas who brought not only merchandise but also information and images from other worlds. Their presence augmented fluctuations in favored textiles and dress. International commerce and trade reshaped the economy of northern Europe. At the same time that the iconography of portal sculpture programs was changing, the appearance of column-figures installed on church façades changed and fueled an increased desire for the kinds of luxurious goods that had been represented. The greater availability of the imported goods represented in public spaces fed interest and sales for merchants at the fairs.

Commercial undertakings and exchange related to the trade fairs had a complex effect upon the sculpture of northern France. In the same way that the success of the fairs resulted from the intersection of market forces, clothing reflected practical decisions, political choices, and tradition. The language of dress was shaped and refined through usage, with all levels of society involved in the conversation. Laws of supply and demand created the market, determining which textiles might have been preferred and produced. The desirability of particular goods and the styles chosen by tailors could have been influenced by availability, and by leaders or charismatic persons. The appearance and materials of courtly dress changed during the period, though the idea of fashion being self-consciously imposed upon society in the modern sense did not exist; taste was not consciously dictated by individuals. More than replicating features of quotidian courtly dress, the depiction of textiles and dress in column-figure sculpture shaped and responded to the community in which it was installed.

Since the overland and maritime businessmen were full-time merchants, they established important, ongoing business relationships. Without experience in the trade, commercial ventures would have been risky. Merchants and traders were accommodated in the fair towns, becoming regular if peripatetic members of the communities. The later twelfth-century church sculpture shifted from addressing an exclusively regional community to this wider, international audience.

Only if the meaning of clothing has been established in some mutually intelligible context can these ensembles function as part of a language of dress and convey information to the observer. The center tympanum in the narthex of the Basilica Church of Saint Mary Magdalene at Vézelay illustrated Frankish interests in foreigners and the distinction between locals and 'others,' as perceived in the early twelfth century. In this relief, all personages appear in ensembles of long or short tunics with cloaks, except perhaps the fur-clad or bare-breasted Panotti. Conversely, in the mid- and late twelfth century, actual visitors from other lands traveled to the northern trade fairs and participated in the life of the community. Through interactions with foreigners, members of the increasingly cosmopolitan society achieved a greater understanding of more varied and sophisticated possibilities for clothing, and learned to recognize subtle vestiary clues such as the left-side mantle fastenings, textiles, and the special accessories or garments that signaled status (Figs I.3, 1.131/Pl. 12, 4.2).

The choices taken by the *ymagiers* as they shaped the appearance of the clothing of the column-figures were conscious ones, since various textiles had been available in northern France throughout the twelfth century. In the 1130s and 1140s, when fabrics like Greek or Syrian silk and fine Egyptian linen were scarce and exotic commodities, their use was limited to a special class of persons. The recognizable origins of these exotic goods implied that anyone wearing them had connections with the East, the region of the Holy Land, or with powerful foreigners. Using a conventional language of dress, *ymagiers* combined the ideas about the personages represented in sculpture with recognizable cloth and clothing to create a meaningful fiction in the appearance of column-figure sculpture. A generation later, the wider availability of imported textiles altered their significance for contemporary observers.

The technological innovations of the eleventh and twelfth centuries coincided with the expansion of trade and the development of international markets in northern France. The textiles depicted on column-figures produced after the 1160s reflect changes in fashion which resulted from the success of the fairs of Champagne and Brie. The markets dictated appearances to the extent that the greater availability of luxury goods could lower their prices, changing profits for businessmen when the preferred goods changed. Ecclesiastical institutions and regional seigneurs were among those who benefited from trade and exchange. This advantage could have accounted for the appearance of sculpture in the region, since the increased sales of

northern stuffs paralleled the changed appearance of represented textiles in portal sculpture installed after the 1160s. Along with the goods exchanged in northern France after the 1160s, contact with merchants from the rest of the world had introduced new ideas and priorities. Rather than simply reflecting the evolving commercial context, the clothing and textiles represented in column-figure sculpture participated in shaping these changes.

Notes

1 Suger, *De administratione*, in Erwin Panofsky (ed.), *Abbot Suger on the Abbey Church of Saint-Denis and its Art Treasures* (Princeton, 1946, 1979), p. 81. Some of the most valuable written documentation describing the significance of textiles and dress in the mid-twelfth century can be found in the writings of Suger, Abbot of Saint-Denis 1122–52. See also Suger's biography of the king, *[Vie de Louis VI, Le Gros] The Deeds of Louis the Fat*, trans. R. Cusimano and J. Moorhead (Washington DC, 1992); and his *Libellus Alter de Consecratione ecclesiae Saancti Dionysii, II*, in Panofsky, *Abbot Suger on the Abbey Church*, and Suger, *Oeuvres complètes de Suger, recueillies, annotées et publiées d'après des manuscrits pour la société de l'histoire de France par A. Lecoy de la Marche* (Paris, 1867).

2 Suger, *The Deeds of Louis the Fat*, p. 154. Suger, 'De rebus in administratione,' in Panofsky, *Abbot Suger on the Abbey Church of Saint-Denis*, Ch. 1, pp. 40–41 and 10–11.

3 David Jacoby, 'Silk Economics and Cross-Cultural Artistic Interaction: Byzantium, the Muslim World, and the Christian West,' *Dumbarton Oaks Papers*, vol. 58 (2004): 213.

4 Egeria/Etheria/Aetheria, an educated Gallic woman, made a pilgrimage to the Holy Land c. 381–384. See Egeria, *Egeria's Travels to the Holy Land*, trans. John Wilkinson (Warminster, 1999).

5 Sandra Benjamin, *The World of Benjamin of Tudela, A Medieval Mediterranean Travelogue* (London and Cranbury NJ, 1995), p. 132. See also Benjamin of Tudela, *The Itinerary of Benjamin of Tudela*, critical text, translation and commentary by M.N. Adler (New York, 1963).

6 See Ivan Dujčev, 'Introduction,' and Edwin Hanson Freshfield, 'Ordinances of Leo VI, c. 895, from the Book of the Eparch, rendered into English' [Cambridge, 1938] in J. Nicole (ed.) [1893], *To eparchikon biblion; The Book of the Eparch; Le livre du préfet* (repr. London, 1970). On silk use, see Anna Muthesius, 'From Seed to Samite: Aspects of Byzantine Silk Production,' *Textile History*, 20 (2) (Autumn 1989): 135–6. See also Jacoby, 'Silk Economics.'

7 Jacoby, 'Silk Economics,' pp. 221–2.

8 Jacoby, 'Silk Economics,' pp. 208–9.

9 Anna Muthesius. 'The Byzantine Silk Industry: Lopez and Beyond,' *Journal of Medieval History*, 19 (1–2) (March/June 1993): 29. The privileges of the Syrian merchants, who were allowed to stay in Constantinople almost as long as they pleased and to sell all kinds of merchandise, seems to verify that much of the clothing of the Byzantine court must have been made from Syrian textiles.

10 David Jacoby, 'Silk in Western Byzantium before the Fourth Crusade,' *Byzantinische Zeitschrift*, 84–5 (1991–92): 473.

11 Jacoby, 'Silk in Western Byzantium,' p. 500.

12 David Jacoby, lecture during *Byzantine Textile Study Day*, British Museum, 11 April 1995.

13 Jacoby, 'Silk in Western Byzantium,' p. 475. See also Yedida K. Stillman, 'The Importance of the Cairo Geniza Manuscripts for the History of Medieval Female Attire,' *International Journal of Middle East Studies*, 7 (1976): 579–89.

14 'Different sources give the literal meaning of the Hebrew word "*geniza*" or "*genizah*" as "container" or "to bury or hide." However, it is generally used for a synagogue depository where worn-out texts are stored …' See <http:// www.lib.cam.ac.uk/Taylor-Schechter/Collection.html> (accessed 3 August 2009).

15 Shelomoh Dov Goitein, *A Mediterranean Society, the Jewish communities of the Arab world as portrayed in the documents of the Cairo Geniza* (2 vols, Berkeley and Los Angeles, 1967).

16 Goitein, *A Mediterranean Society*, vol. 1, pp. 3–4.

17 Goitein, *A Mediterranean Society*, vol. 1, p. 223.

18 'Fustian' is a term to describe 'A wide range of fabrics … The earliest fustians probably made partly of wool; after the 17th century, increasingly of cotton.' Fustians were made of plain or twill weave with a raised nap or pile. See *Fairchild's Dictionary of Textiles*, 7th edn (New York, 1996).

19 Goitein, *A Mediterranean Society*, vol. 1, p. 153.

20 Goitein, *A Mediterranean Society*, vol. 1, pp. 106–8.

21 For *mulham*, silk-cotton compound textiles, see Jean-Michel Tuchscherer, 'Woven Textiles,' in M. Calano and L. Salmon (eds), *French Textiles from the Middle Ages Through the Second Empire* (Hartford CT, 1985), p. 17.

22 Goitein, *A Mediterranean Society*, vol. 2, p. 214. On Venetian shipping, see Jacoby, 'Silk in Western Byzantium,' p. 496.

23 For *ṭirāz*, see Lisa Golombek and Veronika Gervers, '*Ṭirāz* Fabrics in the Royal Ontario Museum,' in Veronica Gervers (ed.), *Studies in History in Memory of Harold B. Burnham* (Toronto, 1977), pp. 82–93.

 'Soon after the advent of Islam, *ṭirāz* came to refer both to garments with inscriptions and to the workshops where these garments were manufactured. The word *ṭirāz* derives from the Persian word for "embroidery" …. The production of *ṭirāz* cloth was the official responsibility of a major government department and the issuing of *ṭirāz* became a royal prerogative such as the minting of coins.' See *Heilbrunn Timeline of Art History* (New York: Metropolitan Museum of Art, 2000), available at <http://www.metmuseum.org/toah/ho/06/ nfe/ho_1971.151.htm> (October 2006) (accessed 15 June 2009).

24 Maurice Lombard, *Etudes d'économie médiévale*, vol. 3, *Les textiles dans le monde musulman du VIIe au XIIe siècle*, Civilisations et Sociétés 61 (Paris, 1978), p. 55.

25 Eugene H. Byrne, 'Commercial Contracts of the Genoese in the Syrian Trade of the Twelfth Century,' *Quarterly Journal of Economics*, 31 (1916–17): 130.

26 Jacoby, 'Silk in Western Byzantium,' p. 460. During the 1160s Italian traders worked actively within the Byzantine Empire, trading imperial silks as well as less expensive silks. Jacoby, 'Silk in Western Byzantium,' p. 494.

27 '… the *commenda* contract is drafted only for the duration of a sea voyage … In
the unilateral *collegantia* (as it is called in Venice) or *commenda* proper (as it is
called almost everywhere else), one party entrusts capital to another party, who
is to use it in an overseas commercial venture and to return it together with a
previously established share of the profit. Usually the investor who remains at
home receives three fourths of the profits and the travelling party receives one
fourth. Any loss on the capital is borne exclusively by the investor; the traveling
party, in turn, loses the reward for his labor if no profit is made.

'In the bilateral *collegantia* or *commenda*, usually called *societas* in Genoa, the
investing party who remains at home contributes two thirds of the capital
whereas the traveling party contributes one third in a addition to his labor.
Profits usually are divided by the half according to original investments; losses
are borne by both investors according to their respective contributions to the
capital…' See Robert S. Lopez and Irving W. Raymond, *Medieval Trade in the
Mediterranean World* (New York, 1955), p. 175.

28 Byrne, 'Commercial Contracts of the Genoese,' p. 129.

29 Another example: *Tapestry woven in Colored Silks*, mid-eleventh century, Egypto-
Arabic; The Metropolitan Museum of Art, Hewitt Fund, 1911 (11.138.1).

30 Lombard, *Etudes d'économie médiévale*, vol. 3, p. 96. See also: 'Spain was another
point of contact between the Muslims and Christians. In addition to regular
trade, regional politics encouraged the exchange of gifts among Islamic rulers
and Christian princes. In AD 997/387 AH, after a military victory, the Muslim
minister, Mansur, rewarded Christian princes and the Muslims who supported
him with 2285 pieces of various kinds of ṭirāz silk, 21 pieces of sea wool, 2 robes
perfumed with ambergris, 11 pieces of scarlet cloth, 15 of striped stuff, 7 carpets
of brocade, 2 garments of Roman (Rumi) brocade and 2 marten furs. These
items remind us of the Islamic silks found in Christian Spain, like the figured
silk with Arabic inscriptions found in the tomb of Bishop Gurb of Barcelona and
the Islamic silks used for Christian liturgy.' See Xinru Liu, *Silk and Religion, An
Exploration of Material Life and the Thought of People (600–1200)* (New York, 1996),
p. 176.

31 Patricia L. Baker, *Islamic Textiles* (London, 1995), p. 61.

32 The *Burgo de Osma Silk*, also known as the *Baghdad Silk*, c. 1100, silk and gilt
membrane threads, Andalusia, 45 × 50 cm, now in The Museum of Fine Arts,
Boston (33.371). '… the inscription on the Boston fragment contains a spelling
peculiarity found in Spain.' See Daniel Walker, 'Fragment of a Textile,' in *The Art
of Medieval Spain, AD 500–1200* (New York, 1993), pp. 108–9.

The group includes the *Chasuble of Saint Edmund*, c. 1150, silk, Andalusia, h. 155
cm, diam. 460 cm; Church of Saint-Quirace, Provins (France). See ibid., p. 107.

33 Goitein, *A Mediterranean Society*, vol. 1, p. 102.

34 Roger II was the Norman King of the Two Sicilies. See Nicétas Choniates, *De
Manuele Comneno*, II, 8, ed. I. Bekker (Bonn, 1835), p. 129; cited by Marielle
Martiniani-Reber, *Lyon, musée historique des tissus: Soieries sassanides, coptes et
byzantine, Ve–XI e siècles* (Paris, 1986), p. 371. The Arabic inscription states that
the mantle was made in the Palermo ṭirāz in AH 528 (1133–34 CE): see Hubert
Houben, *Roger II of Sicily, A Ruler between East and West* (Cambridge, 2002), p.
124. William Tronzo, 'The Mantle of Roger II of Sicily,' in Stewart Gordon (ed.),
Robes and Honor, The Medieval World of Investiture (New York, 2001), pp. 241–53.
Part of the coronation regalia of the Staufen rulers as Holy Roman Emperor,

the *Mantle of Roger II* is now in the Treasury of the Kunsthistorisches Museum in Vienna. See the 'Insignia of the Holy Roman Empire,' in Marie Schuette and Sigrid Müller-Christensen, *A Pictorial History of Embroidery*, trans. Donald King (New York, 1963), illus. 60–62 (coronation mantle); illus. 65–6 (dalmatic); illus. 67, 69, 71 (alb); illus. 68, 70 (gloves).

35 Theban silks had a distinctive quality and were preferred over Corinthian silks. 'In the twelfth century Thebes was the main producer of silk textiles in western Byzantium, some of its products surpassing in quality those of all other silk centers of that region.' See David Jacoby, 'The Production of Silk in Latin Greece,' in *Commercial Exchange Across the Mediterranean: Byzantium, the Crusader Levant, Egypt, and Italy* (Aldershot, 2005), p. 23.

36 See Constantin VII Porphyrogitus, *Le livre des cérémonies*, trans. A. Vogt (Paris, 1935).

37 Jacoby, 'Silk in Western Byzantium,' p. 483.

38 Liu, *Silk and Religion*,' p. 163. See further discussion in Dominique Sourdel, 'Robes of Honor in 'Abbasid Baghdad During the Eighth to Eleventh Centuries,' and Paula Sanders, 'Robes of Honor in Fatimid Egypt,' in Stewart Gordon (ed.), *Robes and Honor, The Medieval World of Investiture* (New York, 2001), pp. 137–45 and 225–39 respectively.

39 Goitein, *A Mediterranean Society*, vol. 1, p. 60.

40 On the fur trade, see Jules Quicherat, *Histoire du costume en France depuis les temps les plus reculés jusqu'à la fin du XVIIIe siècle* (Paris, 1875, 1877), pp. 152–3. The main commodities of Russo–Scandinavian trade were furs. See Agnes Geijer, *A History of Textile Art, a Selective Account* (New York, 1979), p. 227.

41 Vair is a luxury composite fur. Its characteristic pattern of alternating loops of blue and white is a stylization from the pattern created by its being made from the back fur and underbellies of gray squirrels in winter, or from red and white foxes from the region around the Caspian Sea. Other pelts illustrated in medieval art include ermine (originally known as 'Babylon skin'), dark marten or *zibeline*, miniver, *gros vair* and *petit vair*. See François B. Boucher, *20,000 Years of Costume, The History of Costume and Personal Adornment* (New York, 1965; English translation, 1966), pp. 179–80.

42 The pelts of local fauna (otter, badger, weasel, fox, hare, rabbit, lamb) were less valued; they were sewn inside sleeves and between the layers of *pelissons*. 'Les pelleteries provenant de la faune locale (loutre, blaireau, fouine, renard, lièvre, lapin, agneau) sont moins estimées; on les coud à l'intérieur des manches ou entre les deux étoffes des pelissons.' See Michel Pastoureau, 'Introduction,' in *Le vêtement: histoire, archéologie et symbolique vestimentaires au Moyen Age* (Paris, 1989), pp. 7–29.

43 Descriptions verifying '… the color-intoxication of this age …' can be located in orders for textiles and lists of trousseaus found among the Cairo/Fustat Geniza documents. See Goitein, *A Mediterranean Society*, vol. 1, pp. 106–7.

44 Goitein, *A Mediterranean Society*,' vol. 1, p. 106. See p. 419, fn. 41.

45 The results of test and analysis by the Limestone Sculpture Provenance Project have been able to identify the presence of grounds and pigments in twelfth-century stone sculpture. See Lore L. Holmes, unpublished report, 'Memorandum, 10 October 1995, STMAUR-DVJ.R137,' pp. 1–3. See discussion in Appendix B.

46 *The Falconer*: Capital Q *Incipit* Book 35, Gregory the Great, *Moralia in Job*, Dijon, Bibliothèque municipale de Dijon, MS 173, fol. 174.

47 *Enthroned Virgin and Child*, 1260–80, maple, decorated in polychrome and gilt, northeast Spain; The Cloisters collection, The Metropolitan Museum of Art (53.67).

48 *David in Majesty*, in *The Bible of Stephen Harding*, Dijon, Bibliothèque municipale (Dijon 641) MS 14, fol. 13v. The three Hebrews in the furnace appear at the *Incipit* of the Book of Daniel, in *The Bible of Stephen Harding*, MS 14, fol. 64.

49 Luke 8:41–56.

50 In the *Gospels of Henry the Lion*, Herzog August Bibliothek, Wolfenbüttel, Germany, c. 1173–75.

51 Ronald W. Lightbown, *Mediaeval European Jewellery, with a Catalogue of the Collection in the Victoria and Albert Museum* (London, 1992), p. 104, plate 11, see fig. 18.

52 Jacoby, 'Silk Economics,' p. 228.

53 Geijer, *History of Textile Art*, p. 141.

54 Palermo had been the major port for the significant silk trade in Sicily while it was a Muslim principality, with a *ṭirāz* and silk industry like most other Islamic urban centers from Afghanistan to the Atlantic. The Venetians transported textiles from silk centers like Thebes, and they participated in the expansion of Byzantine silk manufacture through financial investments that stimulated economic growth and urban expansion. The records show that before 1171 the Venetians purchased silk fabrics, but not garments, in Thebes and the same holds true of the Genoese at other locations. This deliberate choice of the sort of goods for trade, that is, yardage rather than clothes, gave the merchants more freedom and flexibility in the sale of the merchandise in which they had invested. See Jacoby, 'Silk in Western Byzantium,' p. 497.

55 Goitein, *A Mediterranean Society*, vol. 1, p. 42.

56 John Gilissen, 'The Notion of the Fair in the Light of the Comparative Method,' in *La foire. Recueils de la Société Bodin*, vol. 5 (Paris, 1983), p. 334.

57 Félix Bourquelot, *Etudes sur Les Foires de Champagne, sur la nature, l'étendue et les régles du commerce qui s'y faisait aux XII, XIII, et XIV siècles* (Paris and Provins, 1839–40; repr. in *Manoir de Saint Pierre de Salerne, Mémoires présentés pars divers savants à l'Académie des Inscriptions et Belles-Lettres*, 2 vols (Brionne, 1970) (hereafter *Champagne*), vol. 1, p. 52. See also Auguste Dumas, *Histoire du droit français* (Marseilles, 1978), vol. 6, p. 77; also Michael Bur, *La formation du Comté du Champagne, v. 950–v. 1150* (Nancy, 1977), pp. 334–5.

58 Reportedly, 40,000 men died in the battle of Fontenay-en-Puisaye which took place on 22 June 841. See Marcelle Thiébaux, *The Writings of Medieval Women* (New York, 1994), p. 153. This number, given by Angellus of Ravenna, may have been exaggerated. Eric Goldberg, *Struggle for Empire: Kingship and Conflict under Louis the German, 817–876* (Ithaca NY, 2006), p. 103.

59 Bourquelot, *Champagne*, vol. 1, p. 66. Henri governed the province from 1152 to 1180. 'Henri Le Libéral in particular furthered the cultural and economic development of his country. Troyes and Provins, where he resided, were adorned with magnificent new castles, and more than a dozen hospitals were built during his reign. He ordered the draining of the swamps round Troyes and the construction of canals, along which a flourishing trade began to develop.

Fully alive to the importance of the Fairs, he furthered them in every way he could ….' See also H. Wescher, 'The Cloth Trade and the Fairs of Champagne,' *Ciba Review*, 65 (Basle, March 1948): 2366.

60 Felix Bourquelot, *Histoire de Provins*, 2 vols (Provins, 1839–40), vol. 2, pp. 379–80.

61 Also mentioned in the regulations of 1164; Bourquelot, *Histoire de Provins*, vol. 2, p. 386.

62 The *tonlieu* is a payment tied to sales, a concept that falls between tax and rent. The *tonlieux* depend on and specify what can be sold at a stall, textiles (*draps*) being most common. See Bourquelot, *Champagne*, vol. 2, p. 186; also Michel Bur, *Suger, Abbé de Saint-Denis, Regent de France* (Paris, 1991), p. 340.

63 Theodore Evergates, *Feudal Society in Medieval France. Documents from the County of Champagne* (Philadelphia, 1993), p. xx.

64 *Gallia christiana*, vol. 12, *pièces justif.*, col. 47. See Bourquelot, *Champagne*, vol. 2, p. 180.

65 This rental price appears to have been exorbitant. See ibid., p. 179.

66 Ibid., p. 134.

67 Bibliothèque de Provins, *Cartulaire de M. Caillot*, fol. 228r.

68 Archives de l'Hôtel-Dieu de Provins, *Ier cartulaire*.

69 Bourquelot, *Champagne*, vol. 2, p. 137.

70 Wescher, 'The Cloth Trade,' p. 2395.

71 David Freedberg, *The Power of Images. Studies in the History and Theory of Response* (Chicago, 1989), p. 20.

72 The justification for the 2001 designation of Provins, 'Town of Medieval Fairs,' as a UNESCO World Heritage site is that the architecture, fortifications, and urban layout of the medieval fair town has been preserved. See <http://www.worldheritagesite.org/sites/provins.html>.

73 Bibliothèque nationale Lat. 9902 (*cartulaire de Lagny*), fol. 24v; this act recalls the prior acts of Counts Thibaut and Henri. Also see document #20, Regulations of the Fairs of May, 1164, in Evergates, *Feudal Society Documents*, pp. 28–30.

74 William Provost, 'Marie de Champagne,' in Katharina M. Wilson and Nadia Margolis (eds), *Women in the Middle Ages: An Encyclopedia* (Westport CT, 2004), vol. 2, p. 597.

75 Fabienne Joubert, *La sculpture gothique en France: XIIe–XIIIe siècles* (Paris, 2008), fig. 104.

76 Bourquelot, *Champagne*, p. 243. See note 18 for definition of 'fustian.'

77 Bibliothèque de Provins, *Cartulaire de Michel Caillot*, fol. 260v.

78 L. Chevalier, *Histoire de Bar-sur-Aube* (Bar-sur-Aube, 1851), p. 301; H. d'Arbois de Jubainville, *Histoire de Bar-sur-Aube sous les comtes de Champagne, 1077–1284* (Paris, Troyes, and Bar-sur-Aube, 1859), p. 38.

79 Goitein, *A Mediterranean Society*, vol. 1, p. 9.

80 Francis Oakley, *The Medieval Experience, Foundations of Western Cultural Singularity* (Toronto, Buffalo, and London, 1988), p. 82.

81 R.L. Reynolds, 'Merchants of Arras and the Overland Trade,' *Revue belge de philologie et d'historie*, 9 (June 1930): 503.

82 Lopez and Raymond, *Medieval Trade*, p. 157.

83 'If payment in a different money had to be made in other places, a contract of exchange (*cambium* or … *venditio*) had to be drafted …' See contract no. 76 for the exchange rate 14:16 between Provinsine and Genoese deniers; Lopez and Raymond, *Medieval Trade*, pp. 163 and 166.

84 Reynolds, 'Merchants of Arras,' p. 505.

85 Ibid., pp. 518–19.

SIGNIFICANT STUFF:[1]
TEXTILES AND A LANGUAGE OF DRESS

Out of love of God he there bestowed on the churches, the poor, and the destitute
his gold, silver, attractive vases, tapestries, quilts lined with silk, and all the movable
goods he possessed and found useful. He kept neither his cloaks, his royal garments,
nor even his shirt. He sent through us to the holy Martyrs his valuable cape, his very
costly gospel book encased with gold and gems, his golden censor weighing forty
ounces, his candelabra of one hundred and sixty ounces of gold, his very expensive
chalice with its gold and most precious gems, his ten valuable copes made of silk, and
the very costly hyacinth that had belonged to his grandmother ...[2]

Costumes and fabrics carried broad geographical, religious, and cultural
implications for European audiences during the Middle Ages.[3] Textiles
are mentioned more often in texts written by Suger than in those composed by
his contemporaries, providing a basis for his narrative in observable reality.
The biographical text cited above emphasizes Suger's pro-royal and pro-Saint-
Denis bias and it discloses the use of a language of textiles to convey ideas. As
might be expected, as he approached death as a devout Christian, significant
items Louis VI renounced included portable treasures, gems, silver, and gold.
The surprise is that textiles ranked at the heart of his donation, most especially
luxury garments made of silk. The abbot wrote this account about a decade
after the event, fully cognisant of the powerful role of textiles and dress in
conveying meaning in Frankish society.

William X, Duke of Aquitaine, entrusted guardianship of his daughter and
heir Eleanor to Louis VI. Following William's demise on 9 April 1137, Louis
VI commissioned Suger to lead an embassy accompanying the young King
Louis VII for his marriage with Eleanor, the young Duchess of Aquitaine,
on 25 July 1137, in Bordeaux Cathedral. Though this journey meant that
Suger was absent at the time of the death of Louis VI on 1 August 1137, the
detailed commentary Suger wrote concerning the last days of Louis VI make
it sound as if he had witnessed the events. The care that Suger took in naming
technical details implies that he understood that his compatriots would have
comprehended the significance and hierarchy of textiles. Details include that
Louis felt stronger after divesting himself of silk and tapestry treasures, that

he received the sacraments, and that he returned home to lie down on a linen coverlet.[4] When he was finally too weak to make the trip to Saint-Denis before his death, Louis asked to rest on ashes laid out in the form of a cross on a carpet.[5] After death, his body was wrapped like a holy relic in a precious cloth for burial at Saint-Denis (Fig. 4.16/Pl. 17, another precious fabric shroud).

The system of communication employing textiles and dress that is inherent in the design of portal sculpture is consistent with textual and visual evidence detailed in literature, in images on seals, and in twelfth-century sculpture and *objets d'art* (Figs 1.35/Pl. 1, 1.70, 1.71, 1.92/Pl. 7, 1.122/Pl. 11, 1.124, 3.4). The information provided by extant twelfth-century textiles and decorative arts substantiate the written accounts of trade in textiles and dyestuffs between Western Europeans and the peoples of Egypt, Byzantium, and the Near East. Greek and Islamic textiles, ceramics, ivories, and stucco figures show how important fabric was as a commodity in the East as well as the West.[6] This chapter will present these goods, the sources for them, and their significances.

Meaning

Particular issues of power and influence were articulated by images of textiles and clothing in column-figure sculpture during the middle of the twelfth century. A discrete set of issues belongs to the historic period that begins with the installation of the west façade sculpture at Saint-Denis, extending across north central France, and that continues until the last decade of the reign of Louis VII. The valuing of cloth was not new; luxury textiles – *pallium* or *pallia* – had been among the treasures held at the Abbey of Saint-Denis, where both Louis VI and Louis VII had been educated during childhood.[7] 'Precious cloth was not just another commodity. It possessed special significance. It was the attire of the Byzantine emperor and the aristocracy, an indispensable symbol of political authority, and a prime requirement for ecclesiastical ceremonies. Control of precious cloth, therefore, was a 'powerful weapon.'[8] Europeans' awareness of the metaphorical association of silk with the Byzantine emperor introduced complex associations for the representation of a silk civil *pallium* as part of column-figure dress: that of a Dignitary at Chartres Cathedral was sculpted to resemble a finely woven piece of silk (Fig. 1.16, 1.114, 1.115).[9]

Urban excavations in northern Europe have recovered large numbers of textiles from medieval deposits in Russia, Poland, Germany, The Netherlands, Scotland, England, and the Scandinavian countries.[10] The range of archaeological textiles that have been found in northern European sites confirms that the active international trade in fabrics described in Chapter 3 was well established in the twelfth century. The appearance of exotic goods is not limited to luxury contexts. In addition to European flax and woolen stuffs, types of silk fabrics and wool cloth are represented among excavated archaeological textile finds in the north and around the Mediterranean as well. Graves and tombs also have yielded textiles; these textiles can be dated

with some precision when they can be associated with a known personality, providing a standard against which stuffs from urban excavations can be evaluated.[11] Together, these archaeological textiles and extant fragments of textiles serve to offer tangible evidence concerning what was available, what could be produced, and what might have been used for clothing during the Middle Ages in Europe.

Through their skillful indication of characteristics of textiles in stone sculpture, the *ymagiers* in northern France made it possible for modern scholars to propose identities for the represented fabric in column-figure sculpture. The textile characteristics that were represented in stone are so distinctive that their appearance indicates that the *ymagiers* must have had particular textiles in mind while carving, aiming to exploit these textiles as a means to communicate ideas through depicted costume. The very fine limestone employed for church portal sculpture in northern France during the twelfth century has retained these characteristic details of textiles for more than 850 years, despite damage caused by war, vandalism, and environmental degradation.[12] Because of the durability of the limestone, its condition makes it possible to evaluate the represented textiles and dress as constituent features of the iconography of these particular sculpture programs since they embody contemporaneous ideals of dress (Figs I.7, 1.75).

REPRESENTATION

The fine pleating of the *bliauts* of the column-figures so characterize column-figure clothing that it has been cited as making twelfth-century sculpture appear columnar and architectonic (Fig. I.1).[13] Kidson wrote of the Chartres Master:

… instead of altering the proportions of his figures, he made a virtue of the distortion. They are not just figures attached to columns … Elongation has allowed them to partake in the nature of columns, so that in a remarkable way they emphasize the architectonic function of the members from which they emerge. Nothing in the treatment of the surfaces is allowed to interfere with the general effect. Whereas the figures of the side portals are diversified by elaborate patterns of drapery folds and often enriched by extraneous decoration, those in the centre have their limbs, their braided hair, and their draperies all subjected to a rigorous vertical discipline. The only relief is obtained by skilful variation of very rich textures …[14]

The 'general effect' produced as the result of the Master's representation of particular luxury goods in the 'draperies' replicated the rigorous vertical character of pleated cloth. The skillful depiction of fine linen and silk in the Chartres west façade column-figures contributes to the impression that Kidson and also Katzenellenbogen perceived. The 'multiple linear folds' that enhance the verticality of the slim column-figures was described by Katzenellenbogen in terms of:

… Their elongated forms, contained within vertical outlines, with the arms closely bound to the slender volume of the body, correspond to slightly flattened cylinders

in perfect consonance with the columns behind them … Their tectonic quality is enhanced by the verticality of multiple linear folds. … the female figures show most clearly the keynote of the design, that is to say, verticality. Their long sleeves, the fall of their braids or the ends of their girdles enhance this vertical element and therefore the weightlessness of the figures …[15]

In their carving of column-figures the *ymagiers* appear to have organized their designs to combine the recognizable characteristics of actual textiles in the over-lifesize figures with the conceptual composition of personages arranged along the portal jambs. Extant pieces of actual skirts – *gironées* – demonstrate how successfully the lines of actual clothing were represented in stone. The town of Gamla Lödöse had strategic importance during the Middle Ages as a trading center on the west coast of Sweden, north of Gothenburg, near the mouth of the Göta Alv river, and may have engaged in trade with French-speaking communities on the continent. Ninety textile fragments of finely pleated woolen fabrics have been found at Gamla Lödöse. Discovered in the archaeological layer dated 1100–1350, the largest wool *gironée* fragments are 89 cm long, and they were finely pleated in the warp direction.[16] This kind of pleating and rucking or goffering can be made permanent by binding and boiling the bound fabrics or else, as in some of the finds at Gamla Lödöse, the crisp ridges of the pleats might have been fixed by stitches along the peaks of the folds.

While the delicate pleating and the quality of their folds cause most courtly *bliauts gironés* illustrated in mid-twelfth century artwork to appear to have been made of fine linen or silk, the Gamla Lödöse textiles are made of wool. The width of individual pieces had been increased with gores, and the hems are partly quilted, in much the same manner as the hem of a *bliaut* skirt at Chartres Cathedral appears to have been patterned with woven or quilted decoration (Fig. I.8). Archaeologists have identified these textile fragments as the northern equivalent of the skirts worn by the Chartres west portal women column-figures.[17] Finely pleated linen undergarments found in other Scandinavian excavations also clarify the construction represented in column-figure sculpture textiles. Women column-figures with skirts carved so that they appear to have been pleated and sewn in the same manner as the Scandinavian textile fragments appear at Bourges Cathedral (Figs 1.8, 1.54/Pl. 3); Chartres Cathedral (Figs 1.2, 1.37, 1.38, 1.42, 4.17); Ivry (Fig. 1.26); Le Mans Cathedral (Figs 1.27, 1.43); Nesle-la-Reposte (Fig. 1.121); Saint-Germain-des-Prés (Figs 1.51, 1.59); Saint-Ayoul in Provins (Figs 1.18, 1.50, 1.57, 1.78); Saint-Thibaut, Provins (Fig. 1.60); and at Saint-Loup de Naud (Fig. 4.8).

Exotic goods

In the late eleventh and early twelfth centuries, increased journeys by Europeans to the lands around the Eastern Mediterranean, including the First Crusade and pilgrimages, compounded the significance of fabric

coming from that region. In addition to increasing the desire of European people for fine cloth and clothing because they had witnessed such fine stuffs in the East and believed these might be obtained, the experiences changed the travelers themselves. In the way first-time tourists to Hawaii or the Caribbean are smitten by bright, comfortable clothing, pilgrims and Crusaders appropriated Middle Eastern silk fabrics, finely woven linens with silk tapestry or embroidery, and new forms of clothing. 'Christians seem to have utilized a readily-available vocabulary of forms in an attempt to identify with, not to differentiate themselves from, a particular peer group. In this way, they could advertise their own real sense of rising social status.'[18] The association of fine textiles with pilgrimage to the Holy Land supported an expansion of the commercial exchange that had existed on a smaller scale for centuries between these regions.

Bohemond I of Antioch (c. 1058–3 March 1111), son of Robert Guiscard and a leader in the First Crusade, stands out as a striking celebrity from the Latin kingdoms in the Holy Land. Anna Comnena encountered him (when she was 14) at the Byzantine court and described him as conforming to the canon of Polycleitus – courageous, passionate and horrible.[19] Shortly after the First Crusade, he had established himself as Prince of Antioch, but in 1100 he had been captured by Muslims and imprisoned for three years. Following the unsettling appearance of a comet for three weeks at the beginning of 1106, Bohemond fulfilled the vow he had made during his imprisonment and returned for a sensational visit to France in March.[20] During his European travels throughout Lent, 'he reverently laid relics and silken palls and other desirable objects on the holy altars, delighted in the warm welcome given him'[21]

Just after Easter 1106, the future Louis VI assisted at the celebration of the marriage of his sister Constance (1078–January 1124/26) and Bohemond.[22] Hosted by Adèla of Blois, Countess of Blois-Champagne, the wedding was celebrated in Chartres.[23] '... According to several sources, Adèla spared no expense and thus acted publicly as a faithful vassal to her king at this time of shifting power relations in northwestern France.'[24] Philippe I attended his daughter's nuptials along with the papal legate, Bishop Bruno of Segni, and numerous archbishops, bishops, and barons. At his wedding, Bohemond '... mounted the pulpit before the altar ... and there related to the huge throng that had assembled all his deeds and adventures, urged all who bore arms to attack the Emperor with him, and promised his chosen adjutants wealthy towns and castles.'[25] Certainly some of the 'silken palls' and luxury textiles Bohemond had brought from the East must have figured prominently in the wedding of this Christian Levantine prince and a princess of the Frankish court, foreshadowing the significance of the textiles represented in sculpture that was installed at Chartres 30 years later. Further, the predisposition to value textiles in this context is striking: '... The history and local identity that evolved over the centuries at Chartres was a manifestation of the cloth relic and its unique character.'[26]

Transposed opulence

As has been discussed in Chapter 1, 'Secret Signals,' the visual evidence confirms that the forms of the costumes worn by European courtiers appear to have undergone significant changes by the 1130s. Representations in all media indicate that courtly clothing was made of the most prestigious materials available and that various details and accessories had been appropriated and adapted.[27] On one hand, deluxe northern stuffs like finely woven, fulled and sheared scarlet or other woolen cloth continued in use, and many of the luxurious furs that were preferred could have been obtained through local and regional sources.[28] On the other hand, local tailors seem to have taken advantage of exotic imported materials that had been carried north by merchants, travelers, and diplomats like Bohemond, including precious silk fabrics or finely woven linens with silk tapestry and embroidery insertions. They also obtained more exotic furs through traders from remote sources.[29] Some garments were adorned with precious stones and gilt thread.[30]

By the 1130s, evidently in ways that mirror medieval architectural practices of 'copying,' tailors selected and adapted elements of clothing rather than borrowing foreign costumes entirely as souvenir outfits.[31] New details such as the jeweled neckline cleft at the throat, the *ṭirāz* armband, and the open Islamic sleeve appeared for the first time in the West, adapted from Near Eastern or Mediterranean clothing (Figs 1.10, 1.36, 1.68, 1.129).[32] Rather than literal examples of clothing, abstract ideas of appropriated costume elements were represented in column-figure sculptures because of their significance for visitors who witnessed them. These choices – concerning the ideas and the sculptural stylization – merit evaluation.

4.1 Notre-Dame, Chartres Cathedral, Royal Portal west façade, right portal, right jamb 1 and 2: skirt drapery with *ṭirāz* bands, c. 1145.

Photo: Janet Snyder

Clothing reflects contemporary values, whether in the commercial, the political, the spiritual, or the social spheres. European tailors, whose goal was to produce the pleated, fitted, body-revealing styles preferred by Europeans, were able to choose from local and imported stuffs, and to select particular details of clothing. Choices taken by tailors at the behest of their clients established the core of the language of dress. These textiles could convey the relative status or power of the wearer of the clothing. In sculpture, the fictive status and power of represented personages could be revealed through the same language of dress. Knowledgeable twelfth-century observers would have recognized the sorts of represented fabrics and dress in the column-figure sculpture, especially while the sculpture retained its original brilliant polychromy.[33] The practice of identifying luxury materials according to their places of origin in vernacular literature and in commercial documents demonstrates that readers and consumers knew and cared about these details and would have appreciated specific textiles.[34] With the carefully sculpted fictive textiles, patrons and *ymagiers* could take advantage of observers' visual fluency, knowing that textiles triggered associations with their distant lands of origin (Figs 1.73, 1.76, 4.1, 4.2, 4.3/Pl. 14, 4.10/Pl. 15, 4.11, 4.12).

Goitein has pointed out that the terminology used in documents from the Cairo/Fustat *geniza*[35] suggests the habit of thinking in which a distinction was drawn between peoples in the minds of the writers:

The Mediterranean area was divided into three great regions: … 'The East,' namely Egypt and the Muslim countries of southwestern Asia … 'The Muslim West,' *al-Maghreb*, comprising all North Africa

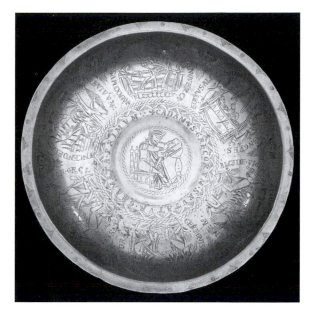

4.2 *Cadmus of Thebes; Birth and Labors of Hercules*, twelfth century, bronze 'Hansa' bowl, German. Found 1824 in the Severn River. British Museum (M&LA, 1921, 3-251). © Trustees of the British Museum.

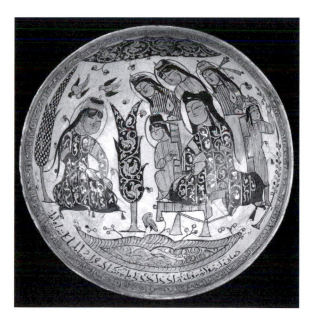

4.3 Fritware bowl, painted with an enthroned ruler and his attendants, 1187 CE, Iran. Signed by Abu Zayd. Inv. 19,451,017.26. © The Trustees of the British Museum/Art Resource, New York.

4.4 Saint-
Etienne, Bourges
Cathedral, south
lateral portal,
left 2: upper
body, sleeve.

Photo: Janet Snyder

west of Egypt, including Muslim Sicily … 'The
Land of the Romans,' *al-Rum* … vaguely from
Christian Europe … The terminology betrays the
existence of a deep barrier between the Muslim
East and the Muslim West and between both and
Europe (including Byzantine Asia Minor). When a
person describes another as a Rumi or a Maghrebi,
without specifying his city or country, he shows
lack of familiarity with, or interest in, the latter's
permanent or original domicile ….[36]

This linguistic differentiation reinforces visual evidence concerning ways of thinking about people from elsewhere. '*Rūm* occurs in Arabic literature with reference to the Romans, the Byzantines and the Christian Melkites interchangeably.'[37] It is possible that this way of thinking or habit of mind, general in the twelfth century, along with a concurrent understanding of a vernacular language of textiles, had a parallel in thinking about the significance of cloth. This meaning enabled Europeans who wore luxury goods imported from Islamic sources to acquire, in the eyes of their own community, some of the prestige associated with the East, which was the region associated with Christ and Jerusalem. Just as the ancient Romans emphasized the extent of imperial might by decorating buildings like the Pantheon with exotic stone introduced from remote regions of the empire, so northern Europeans delivered strong messages about their own power and influence abroad and about the wearer's economic prowess by employing exotic stuffs in northern courtly clothing that had been imported from the Mediterranean basin and the Levant (Figs 4.4, 1.76). The representation of contemporary dress along the jambs at the church entrance, beneath the divine image, extended these messages further, associating the courtiers who wore similar clothing with the high status and authority of Christ and the Church.

Characteristics of fibers and cloth

Through the representation in stone of characteristic cloth creases and folds, it is possible to recognize stuffs that appear to be made of silk or linen cloth and garments that were trimmed with fur and embroidery in new portal sculpture installed in the north between 1140 and 1170. During the eleventh and twelfth centuries, flaxen and woolen stuffs were produced in northern Europe[38] and animal pelts could have been acquired locally or from colder, mountainous regions. In northern communities, cloth of flax, hemp, and

homespun wool yarn was produced for household purposes.[39] During the twelfth century, as markets for goods beyond the local community became established, the commercial development of fine wool cloth was extended. However, the textiles that were represented in sculpture, stained glass, and manuscript illustrations and those described in literature make it clear that the goods favored in northern European courts until 1165–70 were delicate, imported, 'luxury' fabrics instead of the fabrics made in the region.

Column-figures were depicted as if garbed in special garments made of substantial silk textiles, embroidered fabrics, and fine linen cloth as well as fine woolens (Figs 4.18, 1.82). Because of the great care with which *ymagiers* represented these stuffs, not only the fiber content but the likely origins of some textiles could be recognized in images. Access to high-grade silk fabric from Greece may have been limited in the twelfth century, so it is likely that the textiles represented in column-figure sculpture would have been obtained elsewhere. The abundance of mulberry leaves required for silkworm cultivation restricted the zone of silk production to the warm, temperate regions where mulberry trees can thrive. Silk raw materials originating in Sicily were shipped around the Mediterranean to supply textile weavers. Italian merchants traded medium- and lower-grade silk and half-silk fabrics from Romania to Spain, acquired from other sources around the Mediterranean.[40] Workshops in the Nile Delta were known for their very fine linen fabrics, producing many of the finest fabrics available during the mid-twelfth century.

The textiles' appearance and the visual impression conveyed by that appearance can be defined because each type of fiber has individual properties. When spun and made into cloth, the fibers' response to washing, sewing, and pressing is expressed with particular characteristics.[41] Linen fabric is made from fibers of the flax plant which have been retted (soaked). Through this retting and processing, the core of the plant separates into bunches of long individual cellulose fibers contained within the plant stalk. As a result, yarns made of the cellulose flax fibers impart a crispness to the linen cloth produced through weaving. Linen cloth characteristically has creases that end with distinctive points, and the fabric retains wrinkles and holds pleating if it is pressed or polished (Fig. 4.5). The folds of linen that has been smocked is characterized by sharply pointed creases; the sharply pointed ends of creases carved in stone disclose that fine linen was the cloth that would have been used in women's bodices at Chartres and Corbeil (Figs 1.44, 1.49). Sleeves with

4.5 Linen tunic (alb) worn by Thomas Becket during his exile in Sens, 1164–65, linen, silk, and gold (detail): side where gore joins waist. Musée de Sens, Trésor de la Cathédrale.

Photo: Janet Snyder

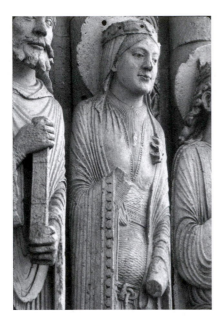

4.6 Notre-Dame, Chartres Cathedral, Royal Portal west façade, center portal, right jamb 3: crown, veil, sleeve, chemise neckline, c. 1145.

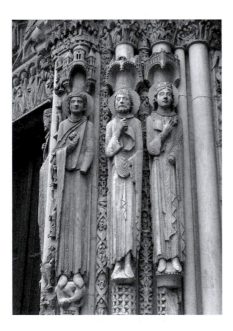

4.7 Notre-Dame, Chartres Cathedral, Royal Portal west façade, right portal, left jamb: left mantle fastening, c. 1145.

Photos: Janet Snyder

such rucked textures appear at Avallon (Fig. 1.111), Bourges (Fig. 4.4), Chartres (Figs 1.24, 1.40, 4.6, 4.7), Saint-Loup de Naud (Fig. 1.63), Le Mans Cathedral (Figs 1.17, 1.27), and Saint-Ayoul (Figs 1.50, 1.57).

Silk, the strong and soft, lustrous fiber that begins as the flexible, extremely thin and long filament taken from the cocoon of the silkworm, can be used to produce substantial or featherweight textiles.[42] Silk cloth is characterized by the pliant and soft filaments that enable tailors to produce minuscule pleating in cloth with slightly rounded folds. The carved women's skirts at Chartres Cathedral and Saint-Loup de Naud have very fine pleats illustrated (Figs 1.36, 4.8). Coarser cloth can be produced from floss silk, waste, and secondary grades of silk, and these types would limit the size of the pleating to slightly larger folds. Depending upon the way the warp-yarns (lengthwise threads) are spaced and the epi ('ends per inch') when the loom is set up, the silk fabric produced can be a lightweight cloth that retains an airy volume disproportionate to its weight, or it can have the dense and heavy qualities of some extant relic wrappings, producing a thick and dimensional, profoundly volumetric impression (Figs 1.19, 1.37, 1.117).[43]

It is possible to weave woolen cloth with gossamer thinness, but the finished cloth has the appearance of a more solid and substantial fabric than silk or linen because the barbed character of individual wool fibers causes them both to attach and to separate from each other. Through the processes of washing, combing, and spinning, sheep's fleece is turned into woolen thread or yarn that preserves the springiness of fleece. Fulling and shearing woolen cloth after weaving interlocks the barbed fleece, drawing the fibers together, and resulting in a finished fabric that appears to be thick and that may resist penetration by wind or water; when draped, wool falls ponderously into substantial, broad drapery folds, whether the cloth is relatively light in weight or dense, fulled stuff (Figs 4.9, 3.3, 3.1). When a fabric is entirely covered with an entangled web of fibers, an 'invisible' felted weave results; a napped surface would have been covered with detached fibers (the archiepiscopal *pallium* in Fig. 3.2).[44]

4.8 Saint-Loup de Naud, left jamb, L2 (detail): *bliaut gironé*, doubly wrapped belt
knotted over pelvic bone, braids *en trecié*, pendant sleeve tippets, c. 1160.

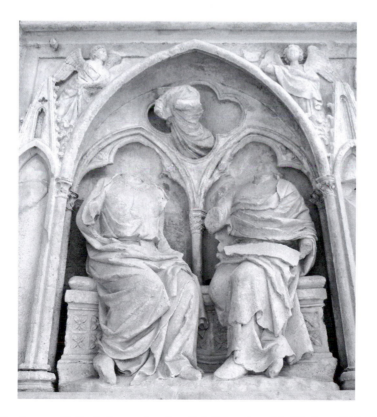

4.9 Auxerre Cathedral, west façade relief, *Coronation of the Virgin*, c. 1215–50.

Photos: Janet Snyder

Some of the very fine stuffs available for courtly clothing – lightweight, fulled worsteds and woolens, silks from the Levant or ṭirāz,[45] and fine linen – were woven or embroidered with metallic thread, pearls and precious jewels. Although in the ninth century Charles the Bald had favored Byzantine ceremonial costume,[46] before 1100, silk textiles were exceptional treasures in northern Europe. The Council of Aachen of 836 encouraged European sovereigns who had received Byzantine imperial textile gifts to donate these silks to the churches.[47] At the beginning of the twelfth century, silk yardage could not be produced in northern France. In addition to cloth made of a single fiber, workshops in the Middle East and Asia produced compound cloths of silk and cotton, silk and linen, and cotton and linen blends. The mixture of silk with a less expensive yarn enabled the production of refined textiles that, though still expensive, were affordable to a larger clientele, including those who might have been unable or unwilling to pay the high price commanded for pure silk textile.[48]

During the Byzantine period, Egyptian Islamic silk centers produced *kandji* with silk warp and cotton weft, and the highly prized *mulham* with silk warp and a weft of another yarn.[49] Most compound cloth that combined silk and cotton has not survived because the quality of these materials was not as substantial as the pure silk stuff; more importantly, as less expensive goods, these stuffs were more frequently used and were not preserved as cherished goods in the way that pure silk has been. Fabrics with silk warp and linen weft had been produced during the Roman Empire.[50] Silk and linen, *sharb* – a type of Egyptian *ṭirāz* – and inscribed and tapestry-decorated *ṭirāz* came from Egypt. Gauze originated in Gaza, and damask, identified with Damascus, was first produced in Syria.[51] Beginning in the thirteenth century, very fine linen was produced in France – most notably in Reims – but earlier in the Middle Ages, Egypt was known as the 'land of linen,' with the finest linens being produced along the Lower Nile.[52] 'According to ... the Arab chronicler al-Tha'albi (d. 1037/38): "People knew that cotton belongs to Khurasan and linen to Egypt."'[53]

Examples of the medium-priced and cheaper stuffs that were commercially available in the West during the twelfth century can be found among the fine linens and silks in the textile collection of the Victoria and Albert Museum.[54] Pieces of twelfth-century Egyptian garments constructed of silk or linen, some with appliquéed borders much like the column-figures' clothing, have been identified; other bits of clothing exist as fragments out of context.[55] Even without touching the material, it is possible for textile historians recognize fabrics according to the appearance of a fabric's characteristic wrinkles and folds of drapery.[56] Very delicate fabrics represented in sculpture as veils, sleeves, and underclothing appear to be made of fine Egyptian linen, as in sculpture from Corbeil (Fig. 1.49). When recognizable characteristics of textiles were reproduced by *ymagiers* in stone sculpture, these features of actual cloth make it possible to identify the fictional fabric, even in small sections of eroded and damaged sculpture (Figs 1.11, 1.115, 4.17).

Deciphered textile and garment details

Literate members of the social elite who observed twelfth-century sculpture in northern Europe would also have been capable of recognizing the clothing that had been given prominence in vernacular literature. In *Le Roman de Brut*, Wace used ermine, costly clothes, costly mantles, costly blouses, etc., to declare elegance and luxury.[57] Readers seem to have esteemed the distant origin of the precious textiles since contemporaneous literature describes courtly costumes similar to those seen on the column-figures, and refers to particular sources for textiles. The verses of the late twelfth-century *lais* of Marie de France specify exotic textiles from Eastern Mediterranean locations that resonated for her readers: Alexandria, Damascus, and Andros. In *Lanval*, Marie specified the lacings of a *bliaut* that compare with lacings sculpted in stone at Angers Cathedral (Fig. 1.34): 'The young girl was ... in a chemise and a tunic that revealed both her sides since the lacing was on each side'[58] Marie could have expected readers of *Le Fresne* to recognize the singular quality and character of the robe of Byzantine silk (Figs 4.15/Pl. 16, 4.16/Pl. 17) she used to trigger the denouement, and also what extraordinary circumstances might have provided this gift of imperial silk to Fresne's father – a situation that would have been unavailable to ordinary persons:

They wrapped the noble child in a linen garment, and then in an embroidered silk robe which the lady's husband had brought back to her from Constantinople, where he had been. They had never seen anything so fine ... She recognized it very well, and the silk cloth too. No doubt about it, now she knew – this was her own daughter.[59]

Literary allusions seem to indicate that northern European cognoscenti distinguished between textiles according to specific manufacturing centers, making distinctions within the larger context. The Europeans certainly would have recognized the fundamental distinction that was drawn between European cloth and goods from 'the East' – that is, east of Venice – and would have associated the region with the Holy Land. The mention in the twelfth-century *Le roman de Thèbes* of a royal garment made of *cendal d'Andre* suggests an even greater familiarity with specific fabrics.[60] The authors of fictional works were inclined to provide an exotic flavor to their stories, but such a precise reference to the particular silk from Andros would have been lost on their readers unless this reference conjured up a particular meaning.[61] Thebes, Andros, and workshops in Central Asia produced specific types of silk or compound cloth, such as the eleventh-century fragment from Central Asia now in the Cleveland Museum of Art that has ecru silk warps and cotton foundation wefts laid beside silver supplementary wefts.[62]

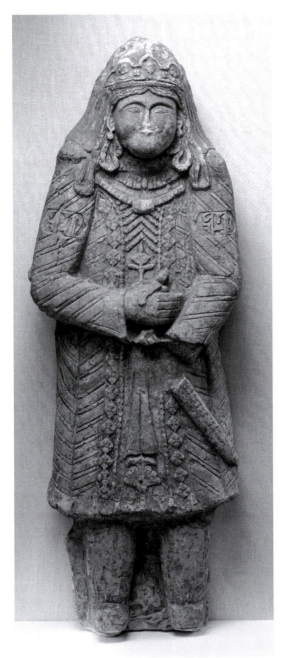

4.10 *Royal Figure with Winged Crown*, eleventh century, stucco, free-formed, incised, painted, gilt, h. 119.4 cm. Iran or Afghanistan. The Metropolitan Museum of Art, New York (57.51.18), Cora Timken Burnett Collection of Persian Miniatures and Other Persian Art Objects, Bequest of Cora Timken Burnett, 1956.

Ṭirāz

Textile-weaving and embroidery workshops, known as *Dar al-ṭirāz* or *Dar al-Kiswa*, were maintained as a standard part of the Islamic communities that stretched from Afghanistan to Spain from the seventh century until about the thirteenth century.[63] Europeans had provided a ready market for luxury loom-woven goods, a commodity with which they were familiar. Textiles that incorporated sections of tapestry into fields of loom-woven cloth were startling discoveries that reflect the impact of the Islamic world on European visitors during the eleventh and twelfth centuries. Typically, a pre-eleventh-century *ṭirāz* was a loom-woven cloth made of bleached or natural plain-weave linen or cotton, with a line of embroidered or tapestry-woven calligraphy inserted into the weaving, '… beginning with *bismillah* ("In the name of Allah") then giving the ruler's name and titles, a salutary phrase, the place of manufacture and the date' (Fig. 4.10/Pl. 15).[64] Sometimes the inscription alone was used but it could be combined with one or more narrow bands of abstract forms or stylized animal or bird motifs contained in cartouches (Figs 4.11, 4.12, 4.3/ Pl. 14). The inscribed *ṭirāz* were reserved for the personal use of the caliph, but the caliph also distributed *ṭirāz* to his close associates, to high functionaries, to ambassadors, to foreign princes, and to all persons whom he chose to honor or to thank.[65]

Interest in these decorated fabrics rose as one result of increased numbers of Europeans who had contact and commerce with the Eastern Mediterranean through pilgrimages, the First Crusade, and greater security in commercial interactions. Some of the textiles represented in twelfth-century northern European sculpture appear to correspond in the weight and quality to the very fine extant linens from Islamic *ṭirāz*.[66] Exceptionally, a stucco *Figure of a Retainer* in the collection of

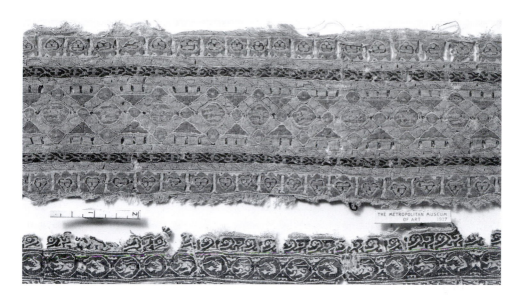

4.11 Fragment of *ṭirāz* in tapestry weave, cotton and silk, eleventh century CE (Islamic). Attributed to Egypt, Fustat, Fatamid period (909–1171), h. 10.2 cm × w. 48.3 cm. The Metropolitan Museum of Art, New York, Rogers Fund, 1927 (27.170.1)/Art Resource, New York.

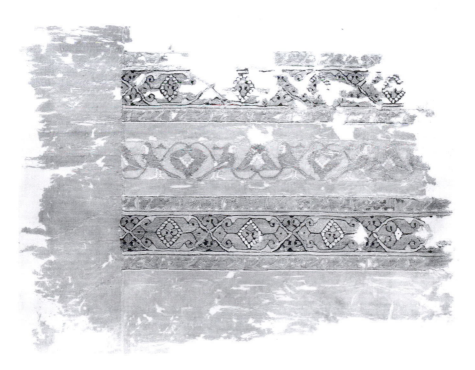

4.12 *Ṭirāz* fragment, eleventh century CE, silk, tapestry weave, Islamic. Attributed to Egypt, Fatamid period (909–1171), h. 32.4 cm × w. 43 cm. The Metropolitan Museum of Art, New York (31.106.66)/Art Resource, New York.

the Victoria and Albert Museum appears with a sleeveband of vine-scroll-patterned *ṭirāz* rather than Kufic or pseudo-Kufic lettering.[67] 'The fashion of elite imitation of the court resulted ultimately in the production of fake *ṭirāz* with pseudo-inscriptions, i.e., of textiles with decorative bands that merely create the appearance of an inscription.'[68] The richness and color of Islamic clothing is conveyed in many manuscript illustrations and painted ceramics (Fig. 4.3/Pl. 14).[69] *Ṭirāz* bands on the men's garments appear to have been placed over the shoulder-sleeve seam that falls on the upper arm; such bands appear transformed into the armbands decorating column-figure upper sleeves at Bourges and Chartres, as described below. 'To the medieval Middle Eastern bourgeoisie *ṭirāz* garments and costly fabrics were status symbols as well as valuable pieces of real property'[70]

One traditional Eastern Mediterranean method of making tunics had been to weave each garment to shape rather to cut pattern pieces out of a rectangular piece of cloth. In Egypt, this 'old' method may have survived among the Christian Coptic community until the eleventh or twelfth century.[71] Conservators' analyses of fifth-to-ninth-century Egyptian Coptic tunics (*qibtis*) explain traditional garment construction and indicate an established use of the application of bands of decorated cloth to early Islamic clothing.[72] These long-sleeved tunics were made on the loom in one piece, like a lower-case letter 't,' the shape being produced without the cloth needing to be cut, an opening having been left at the center for the head to pass through. Decorative bands of contrasting color were applied to the tunics, either in strips that ran from hem to hem over the shoulder like Roman *clavi* or at the ends of the sleeves and around the lower hem.

A second method of tunic construction practiced in the Mediterranean region involved three pieces of fabric: two smaller rectangles (for sleeves) were attached to the sides of a central, rectangular panel that extended from front hem to back hem, and there was a central hole to slip over the head (see Fig. 1.96 – where the head-opening is visible as a tunic hangs upside down over a tree branch). This tunic construction method required less time and skill on the part of the weavers, and could be composed of pieces of cloth cut from a larger piece. When the sleeves were added to the central panel, the shoulder seams dropped to rest upon the upper arms.[73] The 'dropped' shoulder-sleeve seam of men's garments appears to have been concealed with *ṭirāz* bands in the Fatimid period (969–1171), like those on the Metropolitan Museum's royal figures made of stucco (Fig. 4.10/Pl. 15).

Although the upper-armbands of French column-figures follow the placement of Islamic *ṭirāz* bands, neither Kufic nor Roman lettering appears carved on the column-figure '*ṭirāz*' bands. Like some stucco figures or manuscript and ceramic paintings, the column-figures feature sculpted bands with floral or geometric patterns. Among column-figures, *ṭirāz*-style inscribed armbands appear reserved for the right arm; generally, the right-fastening mantle conceals the left arm (Figs 1.12, 4.4). 'The wealthier classes [in Egypt] imitated the court by wearing garments with inscribed

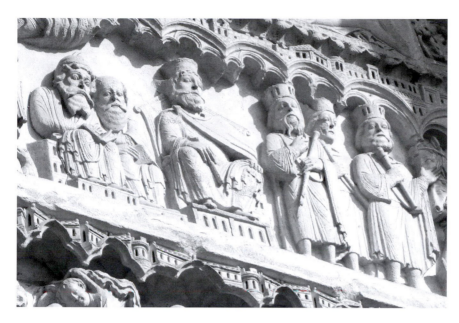

4.13 Notre-Dame, Paris cathedral, west façade, right portal (Portail Sainte-Anne) (detail): Herod on upper lintel, with sculpted *ṭirāz* sleeve and skirt, c. 1155–65.

Photo: Janet Snyder

bands'[74] Comparisons with depictions in other media suggest that the band on the upper right arm might indicate a sign of Eastern power or Eastern authority in the eyes of European readers, like *Cadmus of Thebes* (Fig. 4.2).[75] It not only appears on a number of crowned column-figures, it is also characteristic of the enthroned Herod's costume on the lower part of the lintel of the Portail Sainte-Anne (Fig. 1.107, 4.13) and at Chartres Cathedral (Fig. 1.131/ Pl. 12, upper left). A parallel manuscript illustration in the mid-twelfth-century *Speculum Virginum*[76] makes use of stylized *ṭirāz* band insertions to indicate powerful enemies in the Holy Land. The open-cuff sleeve design of Islamic princely figures[77] is repeated in column-figure sculpture at Angers (Figs 1.21, 1.105) and at Chartres (Figs 1.23, 1.69, 1.129, 4.14). In addition, bands like *ṭirāz* tapestry appear to have been inserted into the fabrics of the skirts of column-figures at Bourges (Figs 1.72–1.74) and Chartres (Fig. 4.1).[78] Broad bands in the skirts of *bliauts* at Chartres and Etampes appear to reveal the represented bias of a fabric skirt made in sections or gores of cloth, causing the skirt to flare more widely from hip to hem (Figs 1.1, 1.14, 1.64, 1.65, 1.77). The abstract quality of an applied decorative panel

4.14 Notre-Dame, Chartres Cathedral, Royal Portal west façade, center portal, right jamb 4: girdle-*pallium*, sleeve, c. 1145.

Photo: Janet Snyder

received emphasis in sculpture, where a complex decorative pattern in a rectangular field cuts across lines of drapery and embraces the leg of these column-figures.

The gold-embroidered or tapestry-woven or inscribed *ṭirāz* armbands of Islamic princes carried the caliph's name, which was sacred and bestowed blessing; the representation of his name blessed those whom it touched.[79] Benjamin of Tudela reported how pilgrims eagerly kissed the corner of the caliph's garment put out of the window to bestow a blessing.[80] It may be that a belief in thaumaturgy – the strengthening and blessing effect of these textile bands that had come in contact with the lord – provided motivation for the appropriation of armbands by Europeans to be worn on their right arms, as at Bourges (Figs 1.29, 4.4). European *bliaut* patterns that incorporated the 'dropped shoulder' sleeve design with upper-armbands may have served to signal a veteran's experience in 'the East' as a crusading warrior-pilgrim (Fig. 1.129).

The sleeves of some men column-figures make it appear that European tailors appropriated not only the decoration but also a detail used in the construction of Islamic princely garb. The sleeve seam on the stucco *Royal Figure* appears to have been left unsewn below the elbow, leaving an open section under his forearm (Fig. 4.10/Pl. 15). In the image of David in the *Stephen Harding Bible*, David appears dressed in the regal dalmatic and also with an open sleeve cuff in Islamic style, signaling his status as ruler of an Eastern kingdom (Fig. 3.4).[81] At Chartres the Chamberlain with the cross armband (Fig. 1.129) has a sleeve with an open section at the cuff much like David's, and similar to the *Royal Figure*'s sleeve. Though no band decorates the upper sleeve, the right forearm sleeve of a figure on the left jamb of the right portal at Saint-Denis also appears to have been made with this open section as well. The sleeve structure with a solid border along the cuff and an open forearm seam would free the hand from the bulk of a hanging sleeve cuff, as illustrated at Saint-Denis (Figs 1.90, 2.3) and at Saint-Loup de Naud (Fig. 1.39). Substantially different from European clothing since it opens completely from the throat at the front, the knee-length coat of the stucco Islamic prince has applied three-dimensional decorative bands along its front edges, and has a round neckline.

Extant fragments of textiles

Fragments of Egypto-Arabic *ṭirāz* in museum collections have tapestry designs that appear to be particularly close to some of the border patterns represented in northern French sculpture (Figs 4.1, 4.12).[82] The circled pearls enclosed by lines, the bands of diamond lozenges, and the diaper grids of diamonds of these textiles are among the most common motifs used by *ymagiers* on sculpted necklines, hemlines, cuffs, belts, armbands, thighbands, and cloak borders in northern French column-figure sculpture,

at Chartres (Figs 1.1, 1.75), Bourges (Fig. I.7), Etampes (Fig. 1.14), Corbeil (Fig. 1.49), Saint-Denis (Figs 1.62, 1.90), and Saint-Loup de Naud (Figs 1.19, 4.8). *Ymagiers* may have had access to exotic textiles for design inspiration but it is more likely that their visual memories were so well developed that they were able to recall precisely the similar textiles in contemporary courtly dress they had seen.

Several fine and large extant eleventh- and twelfth-century textile items made from *ṭirāz* are preserved in church treasuries and museum collections that seem to be similar in weight and quality to the textiles represented in the clothing of twelfth-century French sculpture. In the early twelfth-century cathedral of Apt, in southern France, an eleventh-century *ṭirāz* linen has been revered as the *Veil of Saint Anne*.[83] This rectangle – 3.10 m long – of fine linen gauze with tapestry woven of silk bands and roundels, was made in the Damietta *ṭirāz*. The tapestry inscriptions on this *pallium* consist of a profession of faith and a blessing on the Fatimid Caliph of Egypt, El Musta'lī.[84] It is likely that the *Veil of Saint Anne*, perhaps originally an enveloping garment, either had been received as a gift or was taken as part of the spoils after the fall of Jerusalem, since the Bishop of Apt and Raimbaud de Simiane and Guillaume de Simiane, lords of Apt, took part in the First Crusade (1095–99).

Another Islamic inscribed cloth, the so-called *Veil of Hisham*, is preserved in the Royal Academy in London.[85] The tapestry decorations, circled pearls enclosed by lines, the bands of figures and lozenges, are echoed in the designs of the sculpted borders on column-figure garments (Fig. 4.1). The fabric, the decorative technique of tapestry weave in silk and gold thread, and the pattern arrangement with a band of octagonal shapes containing zoomorphic forms, make it so similar to known Egyptian examples that scholars believe it is likely that this textile is also a product of an Egyptian *ṭirāz*.

The twelfth-century mantles conserved in church treasuries offer substantial information about luxury garments. One of the four chasubles at Riggisberg was originally an open, circular mantle, but it was sewn closed at center-front to when adapted for use as a liturgical vestment.[86] The *Rider Mantle* of the Holy Roman Emperor Henry II, now in the Treasury of Bamberg Cathedral, is a semi-circular mantle of dark blue silk twill and gold embroidery.[87] The width of extant silks like the *Linceul de Saint Remi* – 230 × 190 cm without any selvages – verify that by the tenth century, there were vast looms in the Middle East. The dimensions of this piece of silk provide evidence that is possible for the mantles illustrated in column-figure sculpture to have been constructed of a single piece of cloth, without a seam.[88]

The many fragments of textiles that have been preserved as relic-wrappings in church treasuries and museum collections (Figs 4.15/Pl. 16, 4.16/Pl. 17) furnish examples of the sumptuous, expensive and prestige-linked textiles which had been given by the Byzantine emperor to rulers, lay and church dignitaries, or institutions, or that these fabrics had been acquired by northern Europeans from the workshops around the Mediterranean.[89]

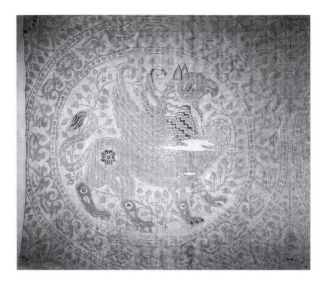

4.15 Textile fragment from the *Reliquary Shroud of St. Sivard*, twelfth century, Byzantine, silk with gold thread, h. 136 cm × w. 8 9 cm. Treasury of the Cathedral of Sens, inv. no. B. 8.

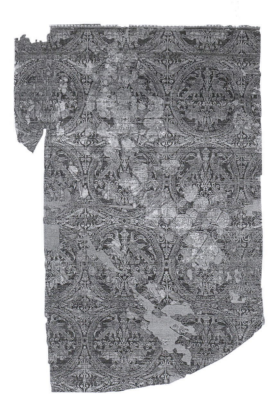

4.16 Large fragment of the *Second Shroud of St. Potentien*, twelfth century, Byzantine, silk samite, h. 145 cm × w. 97 cm. Treasury of the Cathedral of Sens, inv. no. B 7.

Some of the clothing represented in column-figure sculpture might have been made of heavy silk from Byzantium, while that of other column-figures seem to represent linen, silk, or compound fabrics from Islamic *ṭirāz*. Fabric distributions in the Islamic world were not only given out by the caliph to thank or honor, but also took the form of the bestowal of symbolic robes and the exchange of gifts.[90] Because, like gold, many of these textiles were dedicated by those who brought them to northern Europe to the service of the Church, they have been preserved as liturgical furnishings and vestments like chasubles and copes.

Polychromy

Information about textiles in sculpture would have been provided for the observer not only by three-dimensional carving but also by paint applied on the stone surface where only vestiges of tincture remain today. It is likely that the smooth bands bordering garments at Chartres, Etampes, and Saint-Ayoul would have been painted as if they were made of tapestry, inscribed *ṭirāz*, or applied bands (Figs 1.23, 1.77, 1.78, 4.14). The recent washing of the portals at Senlis and Bourges, published by Joubert, revealed archivolt figures wearing patterned fabrics of strong colors.[91] The belts and waistbands of women column-figures on opposite jambs at Saint-Ayoul in Provins suggest the penultimate and ultimate stages of the stone carving with blank fields prepared to be completed with painting (Figs 1.57, 1.78).[92] Since Kufic inscriptions would have been indecipherable for most Europeans, it is likely that patrons and *ymagiers* would have been unable to decipher the meaning of any inscribed *ṭirāz* they obtained. The *ṭirāz* of the Almohad dynasty (c. 1147–1238) assumed a more independent character in its patterning and these patterns may have provided inspiration for column-figure bands.[93] The layering of the elements at Chartres (Figs 1.3, 1.36, 4.17, 4.18) and Angers (Fig. 4.19/Pl. 18), where border bands of pendant sleeves and mantles hang next to pendant belt ends and skirt pleats, creates a pattern similar to non-inscribed *ṭirāz* with tapestry bands (Fig. 4.12) and echoes the distinctive striped *ikat* character of Yemeni *ṭirāz*, with warps dyed on the loom.[94] The configuration

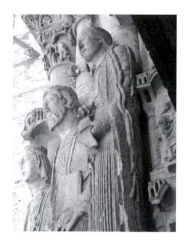

4.17 Notre-Dame, Chartres Cathedral, Royal Portal west façade, left portal, left jamb 1: upper body, mantle with shoulder-collar.

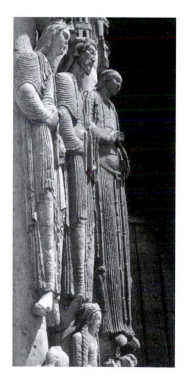

4.18 Notre-Dame, Chartres Cathedral, Royal Portal west façade, left portal, left jamb: parallel borders of mantle, sleeves, tippet, pendant belt.

Photos: Janet Snyder

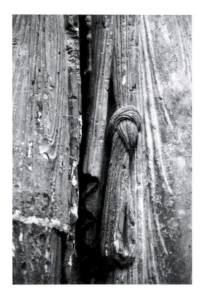

of parallel fields in the decorative bands along the borders of garments created texture and pattern within an individual costume.

Textiles decorated with an overall pattern appear in the eighteenth-century Mabillon engravings for the portal at Saint-Bénigne on two column-figures on the left jamb and one on the right jamb (Figs 4.20, 4.21, 1.13, 1.81).[95] Similar patterns decorate contemporaneous painted wooden sculpture that retains its polychromy, like the seated *Virgin and Child* from Saint-Martin des Champs,[96] or the *colobium* of the *Majestat Batlló* crucifix.[97] Painted textile patterns and texture were apparently preferred by *ymagiers* decorating the clothing of column-figures but textile patterns were carved as three-dimensional texture over the entire garment surface of two smaller figures of the historiated capitals in the church of Saint-Martin at Saujon (Charente-Maritime) (Fig. 4.22).[98] The tradition had already been established in metalwork and ivory for an exaggeration of the relief of textiles in sculpture.[99] The surface of large bronze sculptures like the eleventh-century Fatimid figure, the so-called *Pisa Griffin*, could be incised to suggest a saddle cloth covered with roundels and bordered with bands of Kufic writing.[100] Incised borders decorate the neckband and wrists of the simple tunic of the twelfth-century bronze 'Wolfram' candlestick at Erfurt Cathedral.[101]

4.19 Saint-Maurice, Angers, left jamb 2 (detail): pendant baubles, sleeve knot, mantle.

Photo: Janet Snyder

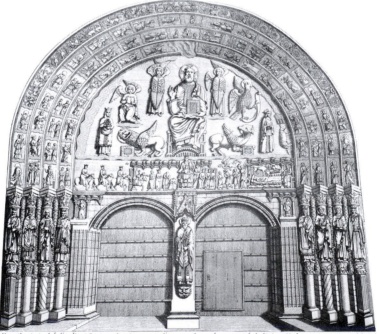

4.20 Saint-Bénigne, Dijon, portal, c. 1160. From Dom Urbain Plancher, *Histoire general et particular de Bourgogne* (Dijon, 1739), p. 503.

Portail principal de l'Eglise S.Benigne de Dijon pris en l'an entre du porche ou Vestibule dislancé de la même Eglise du côté d'occident.

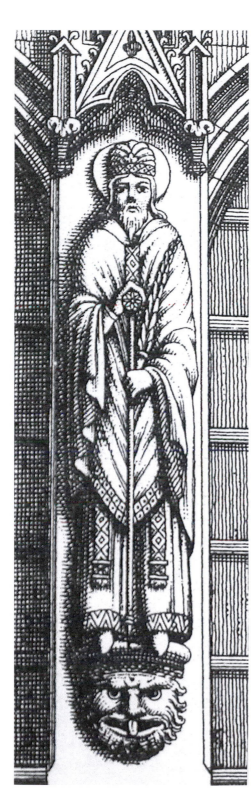

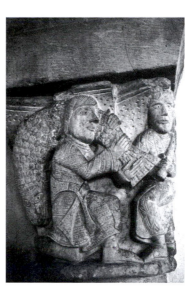

(*left*) 4.21 Saint-Bénigne, Dijon, *trumeau*, c. 1160. From Dom Urbain Plancher, *Histoire general et particular de Bourgogne* (Dijon, 1739), p. 503.

(*right*) 4.22 *Fisherman*, twelfth century, northeast capital, Church of Saint-Martin, Saujon (Charente-Maritime): carved textile patterns.

Photo: Janet Snyder

Textiles in stone

The representation of pleated fine textiles inspired Kidson's characterization of a 'vigorous vertical discipline' among the Chartrain column-figures. The stone was carved to look much like the crisp gathers of linen evident in the garment identified as a liturgical tunic worn c. 1164–65 by Archbishop Thomas Becket, now in the Treasury of Sens Cathedral (Figs 4.23, 4.5).[102] A comparison between the crisp, miniscule pleating of this alb and column-figure surfaces demonstrate that the *ymagiers* finished stone so that it would appear to correspond with contemporary woven textiles. At the points where the gores meet the waistline, the side gores of this linen tunic are delicately pleated into pointed folds that taper into a triangle. The self-embroidery pattern in the transition from gore to seam

4.23 Linen tunic (alb) worn by Thomas Becket during his exile in Sens, 1164–65, linen, silk, and gold. Musée de Sens, Trésor de la Cathédrale.

Photo: Janet Snyder

closely resembles the concave diamond pattern frequently carved in column-figure sculpture. Linen tunics similar to this alb were represented in stone on the *trumeaux* of the Portail Sainte-Anne at Notre-Dame in Paris (Fig. 1.48, 1.120/Pl. 10) and at Saint-Loup de Naud (Figs 1.19, 2.6).

Summary

The clothing depicted on northern French column-figure sculpture documents both the use of fine imported cloth for courtly dress and the European appropriation of the Islamic mode of decorating garments with *ṭirāz* textiles in the twelfth century. This use of fabrics and vestiary elements signaled a kind of optimism on the part of the pilgrims, crusaders, and businessmen returning from the Middle East. These fabrics and clothing details serve as confident reminders that the promises, temporal and eternal, made to Christian visitors to the Holy Land might be fulfilled. In removing Islamic *ṭirāz* and fine cloth from their originating contexts and providing them with new significances, these travelers revised the meaning of the luxurious textiles they brought home.

Exclusively European clothing had been transformed by the use of such extraordinary stuffs between 1140 and 1160, metamorphosing the owners and wearers of sumptuous imported materials through an association with textile sources in the East. The paradigm shift of the 1160s can be noted as the textiles represented in column-figure sculpture shifted away from the style described here as being associated with the authority of the court centered in the Ile-de-France. The center moved away from Paris and the Ile-de-France and towards the courts of Champagne and Blois, where fashions in clothing favored the textiles promoted at the fairs of Champagne and Blois. Art historians have characterized sculpture installed in the later twelfth century by its tubular folds, or its broad-fold drapery, both recognizable characteristics of the textiles preferred after the 1170s (Figs 4.9, 3.1, 3.2, 3.3). Simultaneous shifts in fashion and in content can be recognized in the 1160s at Senlis Cathedral (Fig. 2.8). At the same time, an iconographic change occurred in the focus of the portal program formula. In the Senlis tympanum composition, the *Coronation of the Virgin* replaced the *Majestas Domini* characteristic of mid-century tympanums, while the jambs at Senlis were thematically peopled with personages representing scenes emphasizing Old Testament prefigurations of Christ. The marked coherence of the program at Senlis, in which each column-figure articulates a story as part of the overall theme of the portal sculpture program, distinguishes this church portal sculpture design from those characterized by an *adventus* reception tableau.

The portal program at Senlis introduced an alternative design formula that would be carried forward in the next generation of column-figure

compositions. As has been discussed in Chapter 3, 'Good Business,' when the northern trade fairs of Champagne and Brie emerged as centers of mercantile exchange in northern Europe, cloth represented in sculpture shifted to favor the different luxury materials more readily available through those market networks. With the commercial shifts after 1170, delicate Egyptian linens and volumetric stuffs gave place to the more substantial northern textiles including wool cloth like *escarlet*, and *fustian*. In the late twelfth century, commercial Italian silk production geared up in Lucca, making heavier *samite*, *cendal*, and *damask* silk cloth more available. Not only did the Venetians and Genoese shippers continue to handle the fine fabrics of Eastern manufacture that they carried north to the fairs, they also brought with them new and distinctly Italian textiles. With the change to Italian materials came a change in the meaning for northern European viewers of the luxury stuffs represented in artworks. It seems likely that the effectiveness of the sculptural vehicle had been demonstrated, making it possible for the next generation of patrons and designers to shift their focus to composing portal sculpture designs with other priorities. Alteration in the represented forms of bodies and clothing of the column-figures coincides with the altered intellectual concerns of the patrons.

Notes

1 'Stuff,' a general term, in this context means woven material, fabric, or unspecified textiles: from *étoffe*, from the Old French *éstophe*, 'materiaux,' 1241. See *Le nouveau petit Robert* (Paris, 1996), p. 832.

2 Suger, *[Vie de Louis VI, Le Gros] The Deeds of Louis the Fat*, trans. Richard Cusimano and John Moorhead (Washington DC, 1992), p. 154. The term 'hyacinth' in the last line would probably translate as 'sapphire' in modern usage.

3 See Eunice R. Goddard, *Women's Costume in French Texts of the Eleventh and Twelfth Centuries* (Baltimore, 1927).

4 Suger, *The Deeds of Louis the Fat*, p. 155.

5 Ibid., p. 158.

6 See David Jacoby, 'Genoa, Silk Trade and Silk Manufacture in the Mediterranean Region (ca. 1100–1300),' in *Commercial Exchange Across the Mediterranean: Byzantium, the Crusader Levant, Egypt, and Italy* (Aldershot, 2005), pp. 11–40.

7 Agnes Geijer, *A History of Textile Art, a Selective Account* (New York, 1979), p. 130.

8 Robert S. Lopez, 'Silk Industry in the Byzantine Empire,' *Speculum*, 20 (1) (January 1945): 1.

9 See discussion of the civil *pallium* as a designator of rank in Chapter 1, 'Secret Signals.'

10 Elisabeth Crowfoot, Frances Pritchard, and Kay Staniland, *Textiles and Clothing, c. 1150–c. 1450* (London, 1992), p. 1. See also Antoinette Rast-Eicher and Renate Windler (eds), *NESAT IX: Archaologische Textilfunde – Archaeological Textiles* (Oxford, 2007).

11 Archaeological excavations of Egyptian graves, undertaken in response to widespread grave-robbing in the 1930s, noted underneath linen *ṭirāz* there were at times layers of silk funerary wrappings which disintegrated when handled by the excavators. 'While *ṭirāz* textiles as we know them are characterized by linen or cotton fabrics with woven or embroidered inscriptions and/or decorative bands, the court registers of the Fatimids, for example, tell us about sumptuous and colorful silk garments, gold-woven turbans and jeweled dresses, none of which seem to have survived or have just not been identified.' See Jochen A. Sokoly, 'Between Life and Death: The Funerary Context of *Ṭirāz* Textiles,' *Islamische Textilkunst des Mittelalters: Aktuelle Probleme* (Riggisberg, Switzerland, 1997): 71.

12 See Appendix B, 'From Quarry to Cathedral.' Working with geologists of the CNRS, the Limestone Sculpture Provenance Project has identified the limestone used for many mid-twelfth-century column-figures as *liais de Paris*. Access to the database and information about the analysis of stone are available at <http://www/medievalart.org/limestone>.

13 Paul Williamson, *Gothic Sculpture 1140–1300* (New Haven and London, 1995), pp. 12–25.

14 Peter Kidson, *Sculpture at Chartres* (London, 1958), pp. 23–4.

15 Adolf Katzenellenbogen, *The Sculptural Programs of Chartres Cathedral: Christ, Mary, Ecclesia* (Baltimore, 1959), p. 42.

16 Lena Hammarlund and Kathrine Vestergaard Pedersen, 'Textile Appearance and Visual Impression – Craft Knowledge applied to Archaeological Textiles.' Available online at <http://www.textilarkeolog.dk/nesat.pdf>, pp. 1–7.

17 Margarita Nockert, 'Medeltida dräkt i bild och verklighet,' in *Den Ljusa Medeltiden* (Stockholm, 1984): 191–6.

18 Linda Seidel, *Songs of Glory, The Romanesque Façades of Aquitaine* (Chicago, 1981), p. 81.

19 Anna Comnena, *Alexiad*, XIII, x. 4, 5, pp. 122–4.

20 See Suger, *La geste de Louis VI et autres oeuvres*, intro. by M. Bur (Paris, 1994), Ch. 10, pp. 66–7.

21 Orderic Vitalis, *The Ecclesiastical History of Orderic Vitalis*, ed. and trans. by Marjorie Chibnall (Oxford, 1978), vol. 6, pp. 68–9.

22 'Prince Bohemond had an interview with King Philip and asked for the hand of his daughter Constance in marriage. He finally married her at Chartres after Easter, and the Countess Adèla provided a splendid wedding-feast for everyone. The king of France attended with a great retinue and gave away his daughter to Bohemond' Orderic Vitalis, *Ecclesiastical History*, vol. 6, pp. 70–71.

See also Archives nationales, *Le sacre*, no. 36, mars 25–mai 26, 1106, Chartres. For a document relating to the marriage, see Achille Luchaire, *Louis VI le Gros, annales de sa vie et de son règne (1081–1137)* (repr. Brussels, 1964), #36, p. 22: Constance, daughter of Philippe I, marriage with Bohémond of Antioch.

23 Guibert of Nogent, *Gesta Dei per Francos. Recueil des historiens des croisades: historiens occidentaux*, 5 vols (Paris, 1844–95), vol. 4, p. 254, n. 7; Suger, *Vita Ludovici Grossi regis*, Ch. 9 in *Vie de Louis VI le Gros*, ed. and trans. Henri Waquet (Paris, 1929), p. 49; Suger, *The Deeds of Louis the Fat*, p. 45. See also Eadmer, *Historia novorum*, book 4 (Rule, p. 180).

24 Kimberly A. LoPrete, 'Adèla of Blois: Familial Alliances and Female Lordship,'
 in Theodore Evergates (ed.), *Aristocratic Women in Medieval France* (Philadelphia,
 1999), p. 33. He gained support for a crusade against Alexius of Constantinople,
 but was defeated in 1108.

25 Orderic Vitalis, *Ecclesiastical History*, vol. 6, p. 71.

26 Margot Fassler, *The Virgin of Chartres, Making History through Liturgy and the Arts*
 (New Haven and London, 2010), p. ix.

27 'Silk is the cloth of kings' Sandra Benjamin, *The World of Benjamin of Tudela, A
 Medieval Mediterranean Travelogue* (London and Cranbury NJ, 1995), p. 239.

28 See Michael Gervers, 'The Textile Industry in Essex in the Late 12th and 13th
 Centuries: A Study based on Occupational Names in Charter Sources,' *Essex
 Archaeology and History*, 20 (1989) (The University of Toronto DEEDS Research
 Project).

29 See discussion of sources in Chapter 3, 'Good Business,' fn. 40–42.

30 See vestments illustrated in Mechthild Flury-Lemberg, *Au sujet de quatre
 vêtements sacerdotaux au Moyen-Age et de leur conservation* (Bern, 1987).

31 Richard Krautheimer, 'Introduction to "An Iconography of Mediaeval
 Architecture,"' *Journal of the Warburg and Courtauld Institutes*, 5 (1942): 13.

32 Madeline Harrison Caviness, 'Reception of Images by Medieval Viewers,' in
 Conrad Rudolph (ed.), *A Companion to Medieval Art: Romanesque and Gothic in
 Northern Europe* (Oxford, 2006), p. 67.

33 See Denis Verret and Delphine Steyaert (eds), *La couleur et la pierre: Polychromie
 des portails gothiques* (Paris, 2002).

34 David Jacoby, 'The Production of Silk Textiles in Latin Greece,' in *Commercial
 Exchange Across the Mediterranean: Byzantium, the Crusader Levant, Egypt, and Italy*
 (Aldershot, 2005), pp. 22–3.

35 Some 140,000 documents were preserved a storage room – *geniza* – of the Ben
 Ezra Synagogue in Cairo. See Chapter 3 for discussion. The *geniza* contained a
 'considerable quantity of the ordinary literature of life – mundane legal papers,
 business correspondence, medical prescriptions, musical notations, illuminated
 pages, marriage contracts, children's schoolbooks and everyday letters'
 See <http://www.lib.cam.ac.uk/Taylor-Schechter/Collection.html> (accessed 11
 September 2009).

36 Shelomoh Dov Goitein, *A Mediterranean Society, the Jewish Communities of the
 Arab World as Portrayed in the Documents of the Cairo Geniza*, vol. 1, *Economic
 Foundations* (Berkeley and Los Angeles, 1967), pp. 43–4.

37 Nadia El Cheikh, 'Rūm,' in *The Encyclopaedia of Islam. Glossary and Index of Terms*,
 vol. 8 (Leiden, 2006), p. 601a.

38 For early twelfth-century records of trade in Flemish cloth and imported long-
 staple wool from England, see J.S.P. Tatlock, 'The English Journey of the Laon
 Canons,' *Speculum*, 8 (1933): 454–64. See also

 R. van Uytven, 'Cloth in Medieval Literature of Western Europe,' in N.B. Harte
 and K.G. Ponting (eds), *Cloth and Clothing in Medieval Europe. Essays in Memory
 of Professor E.M. Carus-Wilson*, Pasold Studies in Textile History 2 (London,
 1983).

39 Benjamin, *The World of Benjamin of Tudela*, pp. 239–40. Benjamin describes the preparation techniques for the production of linen in Pumbeditha, near Baghdad; these would have been followed wherever flax was made into cloth.

40 See discussion of sources and shipping in Chapter 3. '… in a letter written around 1135 … a Genoese woman asked her husband to send her two pieces of silk cloth manufactured in the Aegean island of Andros, one of sandal … and another of samite ….' See Jacoby, 'Genoa,' p. 12.

41 Hammarlund and Pedersen, 'Textile Appearance,' p. 3.

42 The silkworm is *Bombyx mori*. The extremely thin and long filaments unwound from the inner rounds of several silkworm cocoons can be combined for spinning to produce yarns to be woven into cloth.

43 Hammarlund and Pedersen, 'Textile Appearance,' illus. 3–4, p. 3; illus. 5–6, p. 4.

44 Ibid., p. 4.

45 The word *ṭirāz* can refer to the tapestry-woven or embroidered inscription band worked as part of a textile, or to the garment bearing the band, or to the workshop where the cloth was woven or ornamented. See Lisa Golombek and Veronika Gervers, 'Ṭirāz Fabrics in the Royal Ontario Museum,' in Veronica Gervers (ed.), *Studies in History in Memory of Harold B. Burnham* (Toronto, 1977), pp. 82–93.

46 Apparently, after he had been crowned as emperor by Pope John VIII, Charles the Bald assumed Byzantine imperial dress for special occasions. See Janet Nelson, *Charles the Bald* (London, 1992), p. 17, cited in Leslie Brubaker, 'The Elephant and the Ark: Cultural and Material Interchange across the Mediterranean in the Eighth and Ninth Centuries,' *Dumbarton Oaks Papers*, 58 (2004), p. 189.

47 Adèle La Barre Starensier, *An Art Historical Study of the Byzantine Silk Industry* (dissertation, Columbia University, 1982), p. 152.

48 See Maurice Lombard, *Etudes d'économie médiévale*, vol. 3, *Les textiles dans le monde musulman du VIIe au XIIe siècle* (Paris, 1978), pp. 69–70.

49 David Jacoby, 'Silk in Western Byzantium before the Fourth Crusade,' *Byzantinische Zeitschrift*, 84–5 (1991–92): 474.

50 Jacoby identifies this as being called *tramoserica*, produced since the second century CE. See ibid.

51 Roman damask silks were produced on the horizontal loom with multiple heddle rods, developed by weavers in Syria. John Peter Wild, 'The Roman Horizontal Loom,' *American Journal of Archaeology*, 91 (3) (July 1987): 464.

 Damask is a reversible fabric, its elaborate patterns being created by areas of satin weave contrasting with others that are matt; *siglaton* comes from the Cyclades, *bofu* from Byzantium, *baudequin* from Baghdad. Samite, a thick and luxurious fabric, was much sought after, as was *paile*, fine brocade made in Alexandria, and *cendal*, a very supple stuff like modern taffeta. See Michel Pastoureau, *La vie quotidienne en France et en Angleterre au temps des chevaliers de la table ronde (XII–XII siècles)* (Paris, 1976), pp. 93–4.

52 Fine linens were produced at Alexandria, Tinnis, Damietta and in Lower Egypt. See Thelma Thomas, *Textiles from Medieval Egypt AD 300–1300* (Pittsburgh PA, 1990), p. 29. See also E. Sabbe, 'L'importation des tissus orientaux en Europe

occidentale du haut Moyen Age IX–X siècles,' in *Revue belge de philologie et d'histoire* (July–December 1935): 1276; and M. Lombard, *Etudes d'économie médiévale*, vol. 3, pp. 69–70; and Jules Quicherat, *Histoire du costume en France depuis les temps les plus reculés jusqu'à la fin du XVIIIe siècle* (Paris, 1875, 1877), p. 188.

'… wool is the main cloth of the Holy Land; … Jews have prospered in Babylonia since biblical times by applying their skills to flax and linen.' See Benjamin, *The World of Benjamin of Tudela*, p. 239.

53 Golombek and Gervers, 'Ṭiraz Fabrics,' p. 83. See also Thomas, *Textiles from Medieval Egypt*, p. 29; Sabbe, 'L'importation,' p. 1276; Quicherat, *Histoire de costume*, p. 188.

54 Jacoby, 'Silk in Western Byzantium,' p. 500.

55 Part of a jacket (inv. no. 778-1898) and trousers (inv. no. 763-1868), twelfth or thirteenth century, silk lined in cotton, Egyptian or Mesopotamian, from El A'zam, Upper Egypt; Victoria and Albert Museum.

56 Smithsonian Institution Cooper-Hewitt National Design Museum, Curator of Textiles, personal communication, July 1995.

57 Wace, *Le roman de Brut/The French Book of Brutus*, trans. Arthur Wayne Glowka (Tempe AZ, 2005), XI, 10412ff; 10600 ff. Henry II and Eleanor were among the audience for Wace's text, c. 1150–70.

58 The poem has been cited more fully in Chapter 1. See Marie de France, *Lanval*, lines 559–662, as translated by Robert Hanning and Joan Ferrante, in *The Lais of Marie de France* (Durham NC, 1978).

59 Marie de France, *Le Fresne*, lines 121–6; and lines 445–8, in *The Lais*, trans. Hanning and Ferrante.

60 Anonymous [1150], *Le roman de Thèbes*, ed. G. Raynaud de Lage (Paris, 1968), vol. 2, p. 81, verse 8658. See Goddard, *Women's Costume*, p. 45.

61 Andros is an island situated on the navigation route linking Italian ports via southern Greece, the Cyclades and Chios to the Byzantine capital (see note 40). See Jacoby, 'Genoa,' p. 12.

62 Cleveland Museum of Art (1993.139). James C.Y. Watt and Anne E. Wardwell, *When Silk Was Gold, Central Asian and Chinese Textiles* (New York, 1997), pp. 50–51.

63 'During the first centuries of Islam it was Egypt that was most renowned for its textiles, its ṭirāz, and for several centuries it continued to supply the caliphate with the cloth for the so-called robes of honor. By extension, the word ṭirāz was applied also to the armbands or brassards of gold thread decorated with calligraphy that are seen in many Arabic miniatures and that were conferred on worthy individuals along with the robes of honor. Brocades were abundantly used for garments, curtains, hangings, and cushions ….' See Alexandre Papadopoulo, *Islam and Muslim Art* (New York, 1979), p. 190.

64 Patricia L. Baker, *Islamic Textiles* (London, 1995), p. 57.

65 Texts in which these fabrics are mentioned deal exclusively with the nobility, the higher clergy and monks. Gifts of liturgical ornaments to churches came from the same social class. See Sabbe, 'L'importation,' p. 1284.

66 See Annemarie Stauffer, *Textiles d'Egypte de la collection Bouvier, Antiquité tardive, période copte, premiers temps de l'Islam*, exh. cat. September 1991–January 1992, Musée d'art et d'histoire Fribourg (Bern, 1991). Two very fine examples: (1) *Ṭirāz* fragment, eleventh century, silk, silk and gold designs in tapestry weave, Egypt, Fatimid period; The Metropolitan Museum of Art (31.106.66); (2) *Ṭirāz* textile fragment, early twelfth century, linen, silk tapestry woven decorative band, Egypt, Fatimid period; The Brooklyn Museum (86.227.102).

67 Rudolf M. Riefstahl, 'Persian Islamic Stucco Sculptures,' *The Art Bulletin*, 13 (4) (December 1931): 439–63, fig. 10 at 441.

68 Yedida K. Stillman and Paula Sanders, 'Ṭirāz,' in Nadia El Cheikh (ed.), *The Encyclopaedia of Islam. Glossary and Index of Terms* (Leiden, 2006), *Glossary*, p. 537b.

69 The armbands also decorate sleeves in ceramic decorations like the *Bowl*, late twelfth–early thirteenth century; composite body, opaque white glaze with gilding, overglaze painting, Seljuq Iranian, attributed to central or northern Iran Mina'i ware, h. 9.5 cm, diam. 18.7 cm; Purchase, Rogers Fund, and Gift of The Schiff Foundation, 1957, The Metropolitan Museum of Art, New York (57.36.4).

70 Yedida K. Stillman, 'The Importance of the Cairo Geniza Manuscripts for the History of Medieval Female Attire,' *International Journal of Middle East Studies*, 7 (1976): 582–3.

71 See T.E.A. Dale, 'The Power of the Anointed: The Life of David on Two Coptic Textiles in the Walters Art Gallery,' *Journal of the Walters Art Gallery*, 51 (1993): 32–5.

72 Hilary Granger-Taylor, 'The Construction of Tunics,' in C. Rogers (ed.), *Early Islamic Textiles* (Brighton, 1983), pp. 10–12. See also Baker, *Islamic Textiles*, pp. 36–7.

73 *Bowl with Coptic Monk*, second half of eleventh century, glazed, luster-painted, and incised composite body, Fatamid, Luxor; The Board of Trustees of the Victoria and Albert Museum, London (C49-1952). Illustrated in Helen C. Evans and William D. Wixom (eds), *The Glory of Byzantium: Art and Culture of the Middle Byzantine Era AD 843–1261* (New York, 1997), p. 417.

74 Stillman and Sanders, 'Ṭirāz,' *Glossary*, p. 537b.

75 In the British Museum, a patterned band decorates the upper sleeve of Cadmus on the bronze ('Hansa') bowl engraved with mythological scenes. It dates from the twelfth century, and is probably German. It was found in June 1824 in the River Severn between Tewkesbury and Gloucester. In the center is King Cadmus of Thebes, inventor of the Greek alphabet; medallions show the birth and labors of Hercules (M&LA 1921, 3-25, 1).

76 The British Library, Arundel 44, fol. 34v, probably south German. Conrad of Hirsau (?) *Speculum Virginum. Victory of Humility over Pride* [Jael over Sistara, *Humility* over *Pride*, and Judith over Holofernes]. The skirt of *Pride* and the upper arm of Holofernes are marked with ṭirāz bands. See http://www.bl.uk/catalogues/illuminatedmanuscripts/ILLUMIN.ASP?Size=mid&IllID=6977.

77 See Islamic sleeves discussed in Chapter 1, 'Secret Signals.'

78 'The so-called Marwan silk with its aligned rows of "Sasanian pearl" roundels is indeed a ṭirāz. Its embroidered Kufic legend in split-stem-stitch names the place of production as Ifriqiya, a region outside Umayyad control during the caliphate of Marwan I (684–5), so the Marwan given as Commander of the Faithful (a caliphal title) in the inscription was presumably Marwan II (744–50). The second

fragment in the Textile Museum, Washington, DC (inv. no. 73.524), also refers to Marwan but this has a very different structure, of goods worked in a fine-toothed tapestry weave with z-spun weft and z-plied warp. These weave details suggest it was made in the eastern Islamic lands (Kühnel and Bellinger 1952).' See Baker, *Islamic Textiles*, p. 57.

79 Sokoly, 'Between Life and Death,' p. 72.

80 Sandra Benjamin, 'Letter from Baghdad,' in *The World of Benjamin of Tudela*, p. 219.

81 *Bible known as the Stephen Harding Bible*, after 1109, Abbey of Cîteaux; Dijon, Bibliothèque municipale, MS 14. *David in Majesty* (Dijon 641), MS 14, fol. 13v.

82 See also the Egyptian twelfth-century fragments in the Textile Collection of the Cleveland Museum of Art: *Fragment of a Ṭirāz-Style Textile*, 1094–1130 (AH 487–524), tabby ground with inwoven tapestry ornament, linen and silk, Egypt, Fatimid period, Caliphate of al-Mustaʿli or alʿAmir, 20.7 × 26.1 cm; Cleveland Museum of Art (1982.78). For an inscribed *ṭirāz* which can be read, see *Fragment of a Ṭirāz*, twelfth century, tabby ground with inwoven tapestry ornament, linen and silk, Egypt, Fatimid period, 27 × 63.2 cm; Cleveland Museum of Art (1982.291).

83 *Voile de Sainte Anne*, 1096–97, linen, silk and gold-weave linen canvas with insertion of three bands of polychrome silk tapestries and gold thread, 310 × 152 cm; Treasury of the Cathedral of Apt, Provence, France. See Brigitte Delluc and Gilles Delluc, 'Le suaire de Cadouin et son frère: Le voile de sainte Anne d'Apt (Vaucluse). Deux pièces exceptionnelles d'archéologie textile,' *Bulletin de la Société historique et archéologique du Périgord*, 128 (4) (2001): 607–26.

84 Fatimid Caliph of Egypt El Mustaʿli reigned 1094–1101.

85 H.A. Elsberg and R. Guest, 'Another Silk Fabric Woven at Baghdad,' *Burlington Magazine*, 64 (375) (June 1934): 271–2. The inscription names the Córdoban ruler Hisham II (976–1009; 1010–13). See Lynn Meyer, 'Textiles of Islamic Spain,' *Complex Weavers' Medieval Textile Study Group Newsletter*, Issue 24 (June 2000), p. 6. Illustrated in Baker, *Islamic Textiles*, p. 61.

86 'The chasuble associated with Saint Ladislas I Arpád, king of Hungary (1077–1095).' See Flury-Lemberg, *Quatre vêtements sacerdotaux*, p. 19.

87 *The Rider Mantle* is illustrated in Marie Schuette and Sigrid Müller-Christensen, trans. Donald King, *A Pictorial History of Embroidery* (New York, 1963), p. 298, illus. 27 and 28; color plates II–III.

88 Anna Muthesius, 'The Byzantine Silk Industry: Lopez and Beyond,' *Journal of Medieval History*, 19 (1–2) (March/June 1993): 54. No. 283: The *Linceul de saint Remi* is deposited in the Musée Saint-Remi in Reims.

See also Marielle Martiniani-Reber, 'Les textiles IXe–XIIe siècle,' in *Byzance, L'art byzantin dans les collections publiques français* (Paris, 1992–93), pp. 374–80; catalogue entries no. 280–89.

89 Workshops in Greece, Spain, Egypt, Sicily, or the Near East. Such textile fragments are held in the collections of the Musée des arts décoratifs in Paris, the Musée historique des tissus in Lyons, and the Treasury of the Cathedral de Sens.

90 Paula Sanders, 'Robes of Honor in Fatimid Egypt,' in Stewart Gordon (ed.), *Robes and Honor, The Medieval World of Investiture* (New York, 2001), pp. 225–39.

See also Xinru Liu, *Silk and Religion, An Exploration of Material Life and the Thought of People (600–1200)* (New York, 1996), p. 163.

91 Fabienne Joubert, *La sculpture gothique en France: XIIe–XIIIe siècles* (Paris, 2008), p. 210, pl. XXVI–XXVIII.

92 For a discussion of aspects of limestone carving, see Appendix B. See also Vibeke Olson, 'Oh Master, You are Wonderful! The Problem of Labor in the Ornamental Sculpture of the Chartres Royal Portal,' and Janet Snyder, 'Written in Stone: The Impact of the Properties of Quarried Stone on the Design of Medieval Sculpture,' *AVISTA Forum Journal*, 13 (1) (2003): 6–13 and 1–5 respectively.

93 Baker, *Islamic Textiles*, p. 61.

94 *Ṭirāz fragment*, tenth century, cotton, ink, gold leaf, plain weave with painted decoration, attrib. to Yemen, 58.4 × 40.6 cm; Gift of George D. Pratt, 1929, The Metropolitan Museum of Art (29.179.9).

95 Dom Urbain Plancher, *Histoire générale et particulière de Bourgogne* (Dijon, 1739, repr. Paris, 1974), p. 503.

96 *Virgin and Child*, from Saint-Martin de Champs, third quarter of the twelfth century, polychrome wood; now in the basilica at Saint-Denis. See illustration in Georges Duby, Xavier Barral i Altet, Sophie Guillot de Suduiraut, *Sculpture, the Great Art of the Middle Ages from the Fifth to the Fifteenth Century* (Geneva, 1990), p. 118.

97 The so-called oriental silk *colobium* of the *Majestat Batlló* has a pattern similar to the Burgo de Osma silk. See Janice Mann, 'Majestat Batlló,' *The Art of Medieval Spain, AD 500–1200* (New York, 1993), pp. 322–3.

98 There are four twelfth-century capitals remaining from the church of Saint-Martin, which had been a dependency of Saint-Martial of Limoges in the twelfth century. See 'Saujon, Chapiteaux de l'ancienne église Saint-Martin,' in J. Lacoste, *L'imaginaire et la foi. La sculpture romane en Saintonge* (Saintes, 1998), pp. 327–9, as cited in Evelyne Proust, *La sculpture romane en Bas-Limousin* (Paris, 2004), p. 165.

99 For metalwork example, see *234. Saint George*, late eleventh–early twelfth century, gold, silver, and cloisonné enamel, Byzantine (Constantinople); The Metropolitan Museum of Art, New York, Gift of J. Pierpont Morgan (17.190.678). Illustrated in Evans and Wixom, *The Glory of Byzantium*, pp. 346–7.

For ivory example, see *Plaque with the Journey to Emmaus and Noli Me Tangere*, c. 1115–20, ivory, traces of gilding, Spanish, made in León, overall size 27 × 13.4 × 1.9 cm; Gift of J. Pierpont Morgan, 1917, The Metropolitan Museum of Art, New York (17.190.47).

100 *Fountainhead in Griffin Form*, eleventh century, cast bronze with incised decoration, Egypt, approx. h. 99 cm; now in the Camposanto Museum, Pisa. See Marilyn Jenkins, 'Al-Andalus: Crucible of the Mediterranean,' *The Art of Medieval Spain, AD 500–1200* (New York, 1993), p. 81.

See also *Relief with the Adoration of the Magi*, first half of the twelfth century, whalebone, northern Spain; now in the Victoria and Albert Museum, London (142–1866), in Charles T. Little, 'Relief with the Adoration of the Magi,' in *The Art of Medieval Spain, AD 500–1200* (New York, 1993), p. 287. In addition to the decorative bands bordering all of her garments, there are pearled stripes in the skirt of the enthroned Virgin similar to *ṭirāz* fabrics.

101 'Wolfram' candlestick, c. 1180, St. Mary's Cathedral, Erfurt, Thuringia, Germany. Marcel Durliat, *L'art roman* (Paris, 1982), p. 551.

102 Linen *Alb* worn by Thomas Becket during his exile in Sens in 1164–65, linen, silk, and gold; Musées de Sens, Trésor de la cathédrale. (As opposed to the archiepiscopal alb worn over the chasuble, this alb is a white linen undertunic. This also differs from the dalmatic, made of panels unsewn and open down the sides, that may be worn over the alb. The chasuble may be worn by the celebrant over both alb and dalmatic.)

The length of Becket's alb was originally about 2 meters, until an ecclesiastic who used it on 29 December 1821, the anniversary of the martyrdom of Saint Thomas, had the alb shortened to be less inconvenient during the celebration of the Mass. In this mutilation the bells (*tintinnabula*) disappeared, along with the peppers or pomegranates which decorated the lower border, and which can be found on the stole and the maniple. See Abbé E. Chartraire, *Inventaire du trésor de l'église primatiale et métropolitaine de Sens* (Sens, 1897); and Ch. de Livas, 'Rapport sur les anciens vêtements sacerdotaux et les anciennes étoffes du Trésor de Sens,' extract from *La revue des sociétés savantes*, 2 (1857).

APPENDIX A: PORTAL PLANS

ANGERS Cathedral, Saint-Maurice c. 1149–59
L4	Chevalier
L3	Monarch
L2	Grande Dame
L1	Chamberlain
R1	Chevalier
R2	Chamberlain
R3	Norman Lady
R4	Elite

AVALLON, Saint-Lazare. before 1170
R	Elite

BOURGES Cathedral, Saint-Etienne
North lateral portal ... c. 1160
L	Grande Dame
R	Grande Dame

BOURGES Cathedral, Saint-Etienne
South lateral portal c. 1150–60
L3	Chamberlain
L2	Elite
L1	Chamberlain
[Later *trumeau*]	
R1	Chevalier
R2	Chamberlain
R3	Elite; open mantle and lifted *bliaut*

CHARTRES Cathedral, Notre-Dame, left c. 1145–55
LL3	Seigneur

LL2 Seigneur
LL1 Court Lady

LR2 Dignitary/Chamberlain
LR4 Dignitary/Chamberlain

CHARTRES Cathedral, Notre-Dame, center
CL5 Court Lady
CL3 Court Lady
CL2 Dignitary/Elite
CL1 Chevalier

CR1 Dignitary/Chamberlain
CR2 Dignitary/Chamberlain
CR3 Court Lady
CR4 Chamberlain

CHARTRES Cathedral, Notre-Dame, right
RL4 Chevalier
RL3 Chevalier
RL2 Chevalier

RR1 Elite/Associate with bare feet
RR2 Chamberlain
RR3 Court Lady

Sundial Dignitary/Associate with bare feet

CORBEIL, Notre-Dame [Musée du Louvre] . c. 1158
 Court Lady
 Chamberlain

DIJON, Saint-Bénigne . c. 1160
L4 Chevalier/Monarch
L3 Cleric
L2 Dignitary/Elite/Associate, bare feet
L1 Monarch
Trumeau Cleric
R1 Elite/Monarch
R2 Elite/Associate with bare feet
R3 Elite/Associate with bare feet
R4 Court Lady

ETAMPES, Notre-Dame-du-Fort . c. 1140
L3 Court Lady

L2	Seigneur
L1	Chamberlain
R1	Seigneur
R2	Seigneur
R3	Court Lady
	Seigneur/Associate with bare feet
	Seigneur/Associate with bare feet

LE MANS Cathedral, Saint-Julien . before 1158
L5	Chamberlain
L4	Elite
L3	Court Lady
L2	Elite
L1 relief	Chamberlain/Associate, bare feet
R1 relief	Chamberlain/Associate, bare feet
R2	Chamberlain
R3	Court Lady
R4	Elite
R5	Elite, broken feet

LOCHES, Saint-Ours . before 1168
L relief	Cleric
R relief	Chamberlain/Associate, bare feet

NESLE-LE-REPOSTE, Notre-Dame . c. 1160
L3	Elite
L2	Elite
L1	Elite
R1	Cleric
R2	Court Lady
R3	Elite

PARIS Cathedral, Notre-Dame . before 1163
RL4	Dignitary/Monarch
RL3	Court Lady
RL2	Monarch
RL1	Chamberlain/Associate with bare feet
Trumeau	Cleric
RR1	Elite/Associate with bare feet
RR2	Monarch
RR3	Norman Lady

RR4	Elite

PARIS, Saint-Germain-des-Prés . 1163

L4	Chamberlain
L3	Court Lady
L2	Dignitary/Seigneur
L1	Cleric

R1	Seigneur with one bare foot
R2	Monarch
R3	Court Lady
R4	Dignitary/Elite

PROVINS, Saint-Ayoul . c. 1160

L4	Elite/Associate, broken bare feet
L3	Court Lady
L2	Elite/Associate with bare feet
L1	Elite

R1	Chevalier/Chamberlain
R2	Chamberlain
R3	Court Lady
R4	Chamberlain

PROVINS [Musée Romane]

Fragment	'David' Chevalier/Monarch
Fragment	Cleric
Gisant	Cleric

PROVINS, Saint-Thibaut [Glencairn Foundation]

	Court Lady

ROCHESTER Cathedral, England . c. 1160

L	Dignitary/Chamberlain
R	Court Lady

SAINT-DENIS Abbey Church

West, left . c. 1137–40

LL3	Elite
LL2	Elite
LL1	Elite

LR1	Elite
LR2	Associate
LR3	Elite

SAINT-DENIS Abbey Church
West, center . c. 1137–40

CL4	Monarch
CL3	Court Lady
CL2	Elite
CL1	Dignitary/Elite

CR1	Norman Lady
CR2	Elite with no mantle
CR3	Elite
CR4	Seigneur

SAINT-DENIS Abbey Church
West, right . c. 1137–40

RL3	Elite
RL2	Chamberlain
RL1	Elite

RR1	Elite?
RR2	Chamberlain
RR3	Chamberlain/Associate with bare feet

SAINT-DENIS Abbey Church
'Porte des Valois' sculpture . c. 1140

L3	Chamberlain
L2	Monarch
L1	Monarch
[Later *trumeau* figure]	
R1	Monarch
R2	Monarch
R3	Chamberlain

SAINT-LOUP DE NAUD, priory church of Saint-Loup c. 1160

L3	Dignitary/Elite
L2	Court Lady
L1	Dignitary/Elite/Associate with bare feet
Trumeau	Cleric
R1	Dignitary/Chamberlain/Associate with bare feet
R2	Dignitary/Elite
R3	Dignitary/Elite

VERMENTON, Notre-Dame . c. 1170

L3	Elite Chevalier
L2	Elite/Associate with bare feet
L1	Monarch

[*Trumeau* Saint John]
R1 Cleric
R2 Grande Dame
R3 fragment Monarch(?)

Index of costume types

CHAMBERLAIN [C]:
Angers L1, R2; Bourges South L3, L1, R2; Chartres LR2, LR4, CR1, CR2, CR4, RR2; Corbeil M; Etampes L1; LeMans L5, L1, R1, R2; Loches R; Saint-Germain L4; Saint-Ayoul R1[V], R2, R4; Rochester L; Saint-Denis RL2; RR2, RR3; Porte des Valois L3, R3; Saint-Loup R1

CHEVALIER [V]:
Angers L4, R1; Bourges South R1; Saint-Bénigne L4; Saint-Ayoul R1[C]; Provins David[M]; Vermenton L3

CLERIC:
Saint-Bénigne L3, trumeau; Loches L; Nesle R1; Notre-Dame, Paris trumeau; Saint-Germain L1; Saint-Loup trumeau; Vermenton R1

ASSOCIATE:
Chartres RR1; Saint-Bénigne L2, R2, R3; Etampes 2 interior figures; LeMans L1, R1; Loches R; Notre-Dame, Paris RL1[C], RR1[E]; Saint-Ayoul L4[E], L2[E]; Saint-Denis: LR2, RR3[C]; Saint-Loup L1[E], R1[C]; Vermenton L2

DIGNITARY:
Chartres: LR2, LR4, CL2, CR1, CR2; Notre-Dame, Paris: RL4[M]; Saint-Germain: L2[S], R4[E]; Rochester L[C]; Saint-Denis: CL1; Saint-Loup:L3, L1, R2, R3

ELITE [E]:
Angers R4; Avallon R; Bourges South L2, R3; Chartres CL2, RR1; LeMans L2, L4, R4, R5; Nesle L3, L2, L1, R3; Notre-Dame, Paris RR1, RR4; Saint-Ayoul L4, L2, L1; Saint-Denis LL3, LL2, LL1, LR3, CL2, CL1, CR2, CR3, RL3, RL1, RR1[?]; Saint-Loup L3, L2, R2, R3; Vermenton L3, L2

MONARCH [M]:
Angers L3; Saint-Bénigne L4, R1; Saint-Germain R2; Notre-Dame, Paris RL4, RL2, RR2; Provins David; Saint-Denis CL4; Porte des Valois L2, L1, R1, R2; Vermenton L1, R3

SEIGNEUR [S]:
Chartres LL3, LL2; Etampes L2, R1,R2; Saint-Germain L2, R1; Saint-Denis CR4

GRANDE DAME:
Angers L2; Bourges North L, R; Vermenton R2

NORMAN LADY:
Angers R3; Notre-Dame, Paris RR3; Rochester R; Saint-Denis CR1

COURT LADY:
Chartres LL1, CL5, CL3, CR3, RR3; Corbeil W; Saint-Bénigne R4; Etampes L3, R3; LeMans L3, R3; Nesle R2; Notre-Dame Paris RL3; Saint-Germain L3, R3; Saint-Ayoul L3, R3; Saint-Thibaut W; Saint-Denis CL3; Saint-Loup L2

APPENDIX B:
FROM QUARRY TO CATHEDRAL –
LIMESTONE, TRANSPORTATION, SCULPTURE

Our sufficiency is of God. Through a gift of God a new quarry, yielding
very strong stone, was discovered such as in quality and quantity had never
been found in these regions.[1]

In the ambulatory of the Royal Abbey Church of Saint-Denis, not only
coursed piers but also monolithic limestone columns hold up the ribbed
vaults, leaving openings of unprecedented size for the stained-glass
windows.[2] In *Libellus Alter de Consecratione ecclesiae Sancti Dionysii,* Suger
defended his refurbishing of the abbey church and he credited God with
the 'miraculous' discovery by his masons of a millstone quarry with stone
suitable for 'very fine and excellent' columns. He goes on to give credit
to the Lord's blessing on the construction for the miraculous recovery
of a column against all odds from the quarry at Pontoise.[3] In employing
monolithic columns like those he had seen in Rome, Suger appears to have
assigned to Saint Denis a status comparable with that of Saint Peter. He
hints that the remodeling of the east end of the Royal Abbey's basilica was
blessed with divine intervention in locating the needed building stones.

In claiming marble for the building fabric, Suger may have overstated his
case, for limestone had been used for construction in northern France since
Roman times due to the extraordinary quality and quantities of limestone
available to builders (Fig. B.1). The façades of most great churches were
made from several types of limestone, with different materials chosen
because particular qualities were required for each use of the stone.[4] These
different kinds of local stone account for some of the radical differences in
the appearance of regional French architecture (see Figs B.2, B.3, B.4).[5] The
weight and expense involved in the transport of materials meant that local
stone was preferred. Records indicate that during the eleventh century, the
price of its transportation could double the price of stone. The practice of
roughing out stones appears to have been a common one during the eleventh
century,[6] and the *Life of Lanfranc* described stones which had been squared

B.1 Simplified geological map of the Paris Basin, with modern sites indicated. Drawing: Janet Snyder after Annie Blanc and Claude Lorenz, 'Etude géologique des anciennes carrières de Paris,' in P. Marinos and G. Kopukis (eds), *The Engineering Geology of Ancient Works, Monuments and Historical Sites, Preservation and Protection* (Rotterdam, 1968), and *Bulletin d'information géologique Bassin de Paris*, 16 (4) (1979).

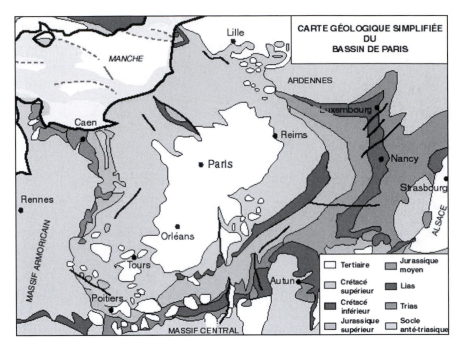

when they left the quarries.[7] Contemporary documents affirm that an effort was made to economize by reducing the dimensions and weight of building materials and shipping blocks of Caen stone which had been rough-cut at the quarry.[8]

The great churches of the twelfth and thirteenth centuries were not produced in artistic isolation. Technical and design innovations were carried across northern Europe by *ymagiers* who moved from project to project, for it appears that it was the stoneworkers who requisitioned particular stone to be shipped from quarries to cathedral *chantiers*.[9] The difficulties and the expenses associated with the acquisition of the deluxe stone used for column-figure sculpture would have been well known to contemporary visitors. This appendix describes the exportation of stone from Parisian quarries that was required for mid-twelfth-century sculpture for churches outside of Paris (Fig. 2.1). A brief explanation of the geology of the region is provided and the modern techniques that have been used to identify the particular stone used for column-figures are described. Connoisseurship and art historical methodology have been combined with the chemical 'fingerprinting' of the stone employed for sculpture of monuments from Angers in the west to Provins in the east and south to Bourges during this period.

Lacking written documentary evidence for twelfth-century sculpture technical production,[10] scholars and scientists have found that the sculpture and the spaces prepared for its installation constitute the best evidence for twelfth-century sculpture workshop practice. Analysis of the character of finished stone surfaces produces information about individual carvers and

B.2 Chartres Cathedral construction stone.

B.3 Oise River construction stone from Rhuis.

B.4 Bourges Cathedral construction stone.

Photos: Janet Snyder

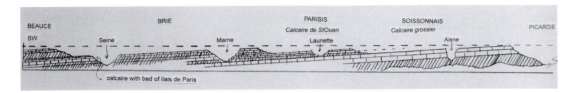

BEAUCE | BRIE | PARISIS | SOISSONNAIS | PICARDIE
SW | | Calcaire de StOuen | Calcaire grossier |
| Seine | Marne | Launette | Aisne
calcaire with bed of liais de Paris

B.5 Geological section of northern France, indicating stone formations and erosion of rivers. Drawing by Janet Snyder after Charles Pomerol, *Geology of France with Twelve Itineraries* (Paris, 1980).

their techniques. It has become clear that even in widely separated locations the limestone fabric of the sculpture was taken from the same geological stratum of stone (Figs B.5, B.6). The seeming contradictions between the similarities of form and the pronounced differences in finished detail of the column-figures may be explained through an analysis of the sequence of carving in the workshop. It is likely that the quarrymen sent large rough-cut blocks of limestone to the churchside *chantiers* where teams of artist/masons – *ymagiers* – finished and installed the column-figures to suit a specific portal design (Fig. B.7).

Among the scarce written documents for twelfth-century stone transport is the description recorded by the scribe Gervase of the work of William of Sens, the master mason who requisitioned stone for the new choir of Canterbury Cathedral after the fire of 1174:

> He addressed himself to the procuring of stone beyond the sea. He constructed ingenious machines for loading and unloading ships, and for drawing cement and stones. He delivered moulds (templates) for shaping the stones to the sculptors who were assembled.[11]

The appellation 'de Sens' infers that William must have been selected by patrons in Canterbury because of his abilities and familiarity with construction techniques of northern France. It is likely that he would have followed the practices of the great church *chantiers* in France that had produced column-figure sculpture (Fig. 1.116).[12] His choice to acquire Caen stone and the design he directed his masons to produce makes it clear that William extended the stone-working community of northern France into French-speaking Britain. Apparently, William of Sens was not the only mason working in the French tradition on the northern

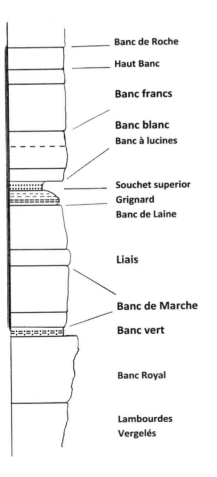

Banc de Roche

Haut Banc

Banc francs

Banc blanc
Banc à lucines

Souchet superior
Grignard
Banc de Laine

Liais

Banc de Marche

Banc vert

Banc Royal

Lambourdes
Vergelés

(*left*) B.6 Schematic illustrating the limestone strata in Parisian quarries. Drawing by Janet Snyder, derived from Annie Blanc and Jean-Pierre Gély, 'Le Lutétien supérieur des anciennes carrières de Paris et de sa banlieue: Essai de corrélations lithostratigraphiques et application a l'archéologie,' in Jacqueline Lorenz, Paul Benoit, and Daniel Obert, *Pierres et carrières, géologie, archéologie, histoire* (Paris, 1997), pp. 175–81.

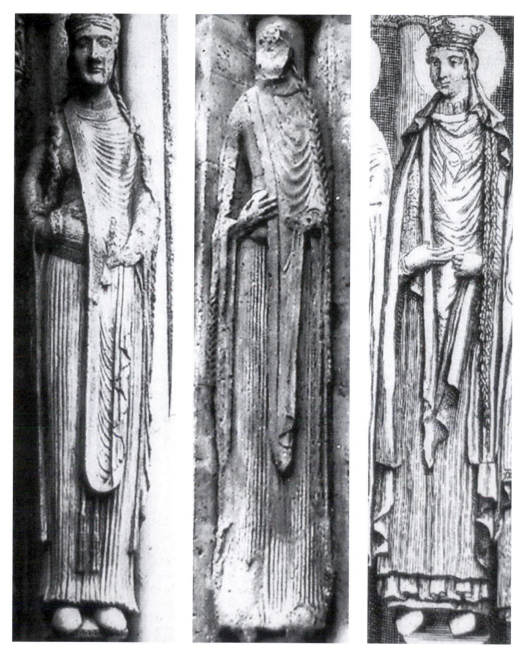

B.7 Comparison of three column-figures with low elbows, hands at center front, right mantle fastening, suggesting a common rough-cut block form. Chartres west portal RR3; Saint-Ayoul (Provins) L3; Saint-Germain-des-Prés R3.

Photo: Janet Snyder

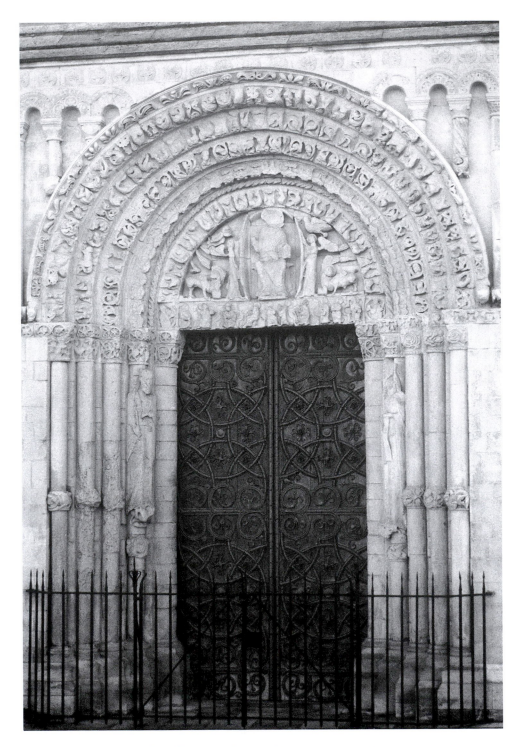

B.8 Rochester Cathedral (Kent), west portal.

Photo: Janet Snyder

shore of the Channel, for the installation of two column-figures made of local stone at Rochester Cathedral has been dated to the years immediately before Gervase began his narrative (Fig. B.8).

Petrographic analysis

Much of the stone used for column-figures both in Paris and outside the capital was identified through petrographic analysis by Annie Blanc of the Centre de recherches sur les monuments historiques, Paris, as a particular *Lutétian* limestone (see below), the *liais de Paris*.[13] The *liais de Paris* is a very homogeneous, fine-grained limestone, only rarely containing traces of discernable fossils. It is quite hard and very resistant to weathering. Mid-twelfth-century church portal program design in north central France was shaped in part by the specific properties of *liais de Paris* – its fine grain, hardness, and the dimensions of the beds in the quarries – and aspects of column-figure execution must have been influenced by the stone's rarity and expense.[14]

The Paris Basin is the term used to describe a geological formation that extends from Angers to the Saverne (Fig. B.1). Historically, limestone from a deposit of *calcaire grossier* has been the construction material par excellence in this area.[15] This limestone deposit was laid down about 45 million years ago, in a period named *Lutétien* by French geologists.[16] During the Cenozoic era, after a glauconitic detrital episode which produced coarse glauconite, during the lower Lutetian era, the great carbonate period in the Paris Basin began. The North Sea and the English Channel extended south of Paris in a shallow, warm sea, and conditions produced limestone with particular fossils.[17] The fossil record shows that palm trees, turtles, and crocodiles flourished in the sub-tropical lowlands which bordered this sea.[18] The entire region subsequently deformed and inclined, and this caused different layers of sedimentary stone to be exposed in relatively narrow zones (Fig. B.5).[19] The Seine has eroded through the surface layers, thus exposing *calcaire grossier* in the Lutetian limestone formation and in particular the parts of the formation known as the *banc royale* and *liais de Paris*.[20] The incline of the limestone beds means these strata are exposed only in the quarries around Paris and the *liais de Paris* is found in only *some* of the Paris quarries (Figs B.6, B.9).[21]

B.9 Diagram of medieval Paris, including the valley of the Bièvre River, Abbey of Sainte-Geneviève, Abbey of Saint-Victor, Notre-Dame cathedral, Abbey of Saint-Germain. From J.G. Bartholomew, *Literary and Historical Atlas of Europe* (1912).

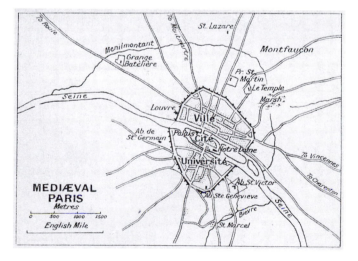

The Limestone Sculpture Provenance Project

Beginning in 1975, the Limestone Sculpture Provenance Project (LSPP), a singular collaboration between nuclear chemists, geologists, museum professionals, and art historians, engaged in research that has provided revolutionary insight into the production of medieval sculpture.[22] The combination of petrographic analyses with compositional characterization by neutron activation analysis and multivariate statistics of limestone used in twelfth-century sculpture has begun to provide evidence which may enable researchers to understand the work of medieval *ymagiers*. Because many sculptures in public collections were removed from their original sites long ago, scientists and art historians using a scientific methodology collaborated to analyze them. The LSPP has been able to provide some answers to questions concerning the geographic origin and the attribution of medieval limestone sculpture.

Neutron activation analysis is used to determine the concentrations of elements present in each sample of stone, thus identifying its compositional profile or 'fingerprint.' This method is the best currently available for limestone analysis for several reasons: its precision and accuracy allows the testing of very small samples; it determines many elemental concentrations simultaneously; and its sensitivity permits the determination of constituents present in very small concentrations. Samples of limestone (calcium carbonate) are collected, weighed and sealed in high-purity quartz for irradiation in a nuclear reactor.[23] The encapsulated limestone is bombarded with neutrons that convert the nuclei of the constituent elements present in the stone to radioactive isotopes. These radioactive isotopes decay and eventually achieve stability by emitting their extra energy in the form of gamma-ray photons. Each radioactive isotope of a given element has a characteristic mode of decay and a characteristic decay lifetime. The energies and the intensities of the gamma rays emitted by the elements in each irradiated sample are measured using a germanium detector. The resulting spectrum shows not only which elements are present but their relative amounts as well. Stones from different sources have distinctive concentrations of trace elements.

In the Paris Basin, the sources for limestone construction materials were either open-pit or subterranean quarries. Petrographic comparison of materials allowed geologists of the Centre national de la recherche scientifique and the Centre des recherches des monuments historiques to identify stone for a particular monument as having come from a particular stratum in the limestone formation with a reasonable certainty (Fig. B.6). Although the date of the transition from open-pit quarries to subterranean quarries in Paris is not known, it is likely that it took place in the twelfth century.[24] In Paris, the open-pit stone sources were emptied of stone – 'quarried out' – and those quarries have disappeared. As a result, while some of the underground quarries may

still be accessible, not all medieval stone sources can be known. The breakthrough made by the LSPP has been to determine with reasonable probability not only the stratum in the formation but also the quarry provenance of limestone from particular monuments, because trace elements identified through compositional characterization by neutron activation analysis and multivariate statistics distinguish the limestone.[25] A particular stone source can be recognized even when its location cannot be identified.

Paris stone

Although the limestone beds beneath Paris may be 20–30 meters thick, only the top 3–7 meters of the beds have been exploited because of their qualities as building stones. In the twelfth century, it was possible to find good building stone in some of the Parisian open-pit quarries. The underground quarries are divided into upper and lower stages by an unusable layer called 'banc vert.' It is probable that the relationship of the strata would have been the same in the open-pit quarries. The usable strata of the upper level of Parisian quarries varies in depth: it is five meters under Val de Grâce, but only two to three meters toward Denfert-Rochereau, and in certain zones it seems to disappear completely. Of these beds, several strata or groups of limestone beds were especially desirable for their characteristics and qualities as building materials. The lowest part of the upper level, the banc de marche, generally was used for paving rather than for building stone.[26]

The liais de Paris lies just above the banc de marche. The normal method of extracting stone from an underground quarry would have been to remove all the different types of limestone from ceiling to floor, except for pillars of stone left to support the roof. The great wealth of the large chantiers at Chartres or Notre-Dame of Paris enabled the masons to exploit quarries for the best stone in huge quantities. These large well-endowed chantiers would have employed ymagiers to carve everything needed, and masons could reject less-than-perfect stones.[27] Because these chantiers could afford it, on their orders the quarrymen could be required to follow specific beds of stone straight back through the quarry rather than taking out all the different grades of limestone from quarry roof to floor. In some cases, it was feasible to open small, very deep quarries simply to extract the liais de Paris.[28] According to archival documents, the high price of liais de Paris completely covered the expenses of the quarrymen, especially when they had located a good venue. Liais de Paris was rarely more than 0.5 meter thick, and even that might be subdivided into several superimposed beds.[29] In this context, 'good' applied if there was little fracturing in stone that was sufficiently thick, or if large pieces of limestone could be removed from this bed.

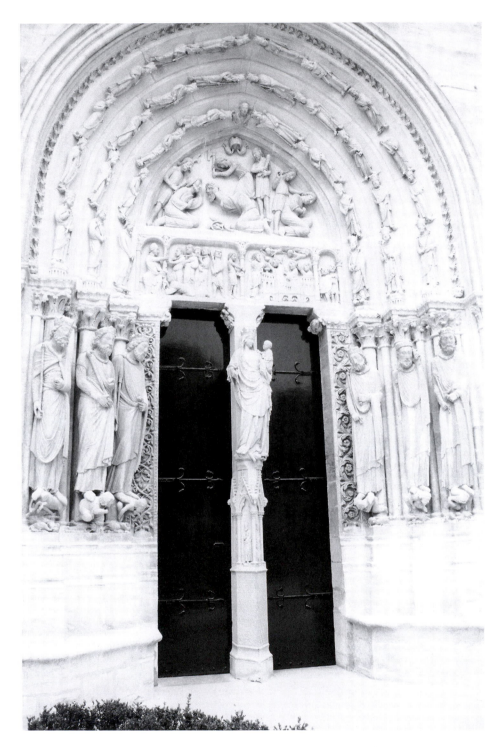

B.10 The 'Porte des Valois,' north transept, Abbey Church of Saint-Denis.

Photo: Janet Snyder

During the Middle Ages, *liais de Paris* enjoyed such prestige that it was used not only for the column-figures installed in the jambs of Saint-Denis and of Parisian churches (Figs B.10, 1.53, 1.82, 1.83, 1.84, 1.85, 1.120/Pl. 10), it was also exported for the column-figures of the Royal Portal of Chartres Cathedral and other churches (Fig. I.1).[30] Parisian limestone has been recognized through petrographic analysis at Etampes, and at Saint-Eliphe, Rampillon, near Provins (Figs I.2, 3.1).[31] The architectural envelope of these churches is composed of lacustre limestone of the Oligo-Miocene period; the local stone at Chartres, for example, is *calcaire de Beauce*. This lacustre limestone was difficult to cut into blocks and it was even more difficult to sculpt, making *liais de Paris* a preferred alternative and a better choice for sculpture.

LSPP scientists have analyzed the results of tests of samples of stone from medieval sculpture and medieval quarries. Originally compiled by Lore Holmes, by 2009 the database included the results of some 2,300 tests of samples obtained from quarries, from architecture, and from sculpture.[32] Among others, samples of stone were tested that had been taken of sculpture known to be from Notre-Dame of Paris; the Abbey of Saint-Denis; Saint-Martin-des-Champs; Chartres Cathedral; Saint-Thibaut in Provins; the cathedrals of Sens, Noyon, and Senlis; the Abbey of Saint-Maur-des-Fossés and sculpture believed to be from Saint-Germain-des-Prés, among others.[33] The Paris quarry reference group includes the quarries at Port Mahon, Charenton, Arcueil, and sites in the Val-de-Grâce.[34]

'A similarity found to exist in chemical composition' refers to the stone used to build a particular monument. Sculpture samples with such a similarity may have but did not necessarily embellish that monument. Similarities indicate the stone used for compared groups was probably quarried at the same time from the same location or one very nearby in a quarry/stone source.[35] Using the processes of neutron activation analysis and multivariate statistics, scientists have been able to match quarries along the Seine in Paris with reasonable certainly with sculpture on buildings 60–80 kilometers away.

The modern notion that an individual – the architect – conceived and designed an entire structure cannot be applied in twelfth-century practice, where the person in charge of construction of the building of each church was known as the Master Mason. In one quatrefoil of a south nave aisle window at Chartres Cathedral, laborers shoulder shaped stones and mount the ladder; there is an ox cart loaded with stones from the quarry and carpenters work, sawing and shaping timbers and stones (Fig. B.11/Pl. 19). In the lower quadrant, a mantle and a long gown worn by a man holding a rod help to identify him as the Master (Fig. B.12/Pl. 20). His rod constitutes his significant attribute: the Master held the fundamental design unit for the construction of the building since the units of measurement had not yet been standardized.[36] Key to the dimensions of whole building was the precise length of the 'foot' employed, which differed according to location

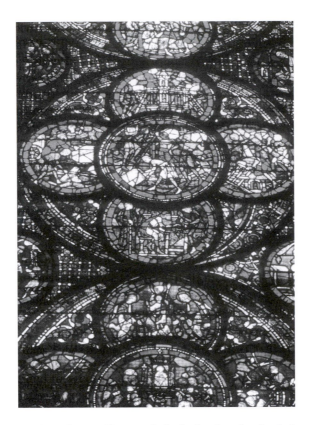

B.11 Notre-Dame, Chartres Cathedral, painted stained glass,
south aisle (*Architect*) window: '*Construction.*'

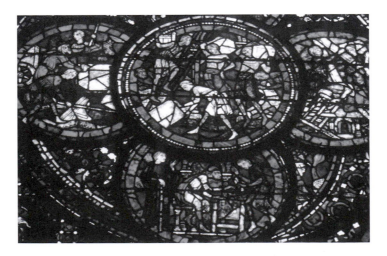

B.12 Notre-Dame, Chartres Cathedral, painted stained glass,
south aisle (*Architect*) window: '*Conference.*'

Photos: Janet Snyder

– Paris, Reims, Amiens, Saint-Quentin, etc.[37] In the Chartres Cathedral south aisle window, the Master Mason appears to supervise the cathedral-building operation: he wears a long *bliaut* and stands behind a man seated at a table, who appears to be the supervisor of the *chantier*. In this roundel, the supervisor appears to be engaged in a conversation across the table with a standing man who is dressed in a short gown.

The Master Mason must have supervised the ordering of appropriate materials for the building fabric, including column-figures. The names of more than a dozen *ymagiers* – Gislebertus, Gofridus, Foulques, Pierre, Ugo Monederius, Petrus Brunus, Rogerus, Giraldus, Bernardus, etc. – appear as signatures applied to sculpted work in eleventh- and twelfth-century France.[38] Beyond their names and the distinctive styles of their signed sculpture, and speculation about where they may have learned their craft or where they worked, not much more is known about these specialists who produced images. The identification of *liais de Paris* 60–80 kilometers from its source implies a scenario in which the stone-workers exercised some significant control over the fabric of the churches they were commissioned to decorate.[39] Their acquisition of materials from the vicinity of Paris opens the possibility that in the twelfth century the *ymagiers* with special skills for sculpture might have been associated with the quarries in Paris.[40] Suger had employed special artisans at Saint-Denis[41] and Benedict Biscop had brought stained-glass workers from France to England.[42]

The separate narrative scenes in the stained-glass painting at Chartres show that the church building has been planned, the supplies are being gathered, and the building is going up. The complexity of the task seems overwhelming, whether from a vantage point that looks back from the finished church or one that looks forward from a diagram on the table. Some of the Master Mason's important jobs concerned budget and organization. For practical reasons, the first materials to be used, such as the stones needed for the foundations, etc., were usually from sources that were relatively close at hand. Reused materials from destroyed buildings have been found in the foundations of later buildings at Notre-Dame of Paris – capitals[43] – and Notre-Dame-en-Vaux at Châlons-sur-Marne – cloister sculpture.[44] These fragments provide invaluable substantial and formal histories of the buildings and their *chantiers*.

Since Vöge published his assessment in the 1890s, architectural sculpture produced during the twelfth century has been attributed to artist-masons working as individual geniuses, called 'headmaster,' 'assistant,' etc.[45] Though capitals or *en-de-lit* shafts might have been fabricated in series in an atelier and shipped, the significantly heavier and larger column-figures in northern France disallow the same practice since finely finished figures in *liais de Paris* could have been easily damaged in transit.[46] Nonetheless, it seems clear that the *ymagiers* must not have worked in isolation and the contacts between the masons partially explains the rapid adoption of portal programs with column-figures.[47]

Geology

A petrographic study of Notre-Dame of Paris was possible during the washing of the exterior in 1969 and of the interior in 1984. The scaffolding allowed Annie Blanc to study the walls and the sculptures under a *loupe*; she proceeded to describe the stones and compare them with samples collected from the ancient quarries of Paris. She found that large blocks of stones of *liais de Paris* less than 40 cm thick were used for the sculpture of the portals, tympanums, voussoirs and bas-reliefs. She also recognized this type of *liais* in the embrasures of each side of the Portail Sainte-Anne.[48] Much of the stone for Notre-Dame of Paris is believed to have come from open-pit quarries on the east side of the valley of the Bièvre River, where the anticlinal deformation exposed *calcaire grossier*, though other limestone sources may have been farther down the Seine (Fig. B.9).[49] Some 25 samples from Notre-Dame of Paris analyzed by the LSPP created a compositional profile of the limestone used at Notre-Dame in the twelfth and thirteenth centuries.[50] The composition of *liais de Paris* from medieval sculpture of Notre-Dame's west façade is consistent with an origin in the quarries at Charenton, just southeast of Paris.[51]

Liais de Paris was not the only limestone shipped significant distances for use in sculpture programs. In 1994, Charles Little of the Metropolitan Museum of Art studied five seated figures from the jambs of the portal at Noyon. Compositional characterization by neutron activation analysis and multivariate statistics indicated that the composition of the stone used for the figures was not all the same. Samples from two of the five figures, the *Virgin and Child* and the figure of *Moses*, are consistent with stone quarried in the vicinity of Noyon; one of the others, *Aaron*, has a chemical profile much closer to stone from quarries near Senlis.[52] Noyon and Senlis are both in the Oise valley river system. Little's interpretation of these results, combined with stylistic dating and petrographic analysis, concluded that the *ymagiers* worked first at Senlis and then moved to Noyon. Because they were familiar with Senlis stone, the *ymagiers* might have taken some of it with them, importing their preferred stone for their next major commission.[53]

Additional details in LSPP results

There appears to be some similarity in composition of the *liais de Paris* of 34 samples of stone from sculptures that once decorated buildings of the Abbey of Saint-Maur-des-Fossés with stone from the quarries at Charenton.[54] Compared with Notre-Dame of Paris, Saint-Martin-des-Champs, Chartres, and Sens, the composition of the Saint-Maur-des-Fossés samples most closely resembles stone from Notre-Dame of Paris. Two

unexpected bits of information also emerged from the analysis: the first concerned the dates when quarries were used, and the second, the question of painted sculpture. Even within the same quarry, some distinctions can be determined through LSPP analyses: the *liais de Paris* used for the sculptures thought to have been produced during the period 1140–50 can be distinguished from that used for those carved during the early eleventh century and the early twelfth century, showing that a different part of the quarry was used for the later than for the earlier sculptures. The explanation for the unexpected appearance of the elements of mercury and zinc during the LSPP analysis is related to surface treatments. The presence of mercury in limestone samples suggests mercury pigments like cinnabar were used in painting the sculpture. Zinc is a constituent of compounds used in the cleaning and conservation of stone which may explain the presence of zinc peaks in the gamma spectra of some samples.

In 1995, following the petrographic studies that identified *liais de Paris* at the cathedral of Chartres, Professor Anne Prache undertook a new study of Chartres stone using LSPP analysis, considering the results of the analysis of two dozen samples taken at Chartres from the sculpture of the Royal Portal, the portals of the transept, from fragments of the *jubé*, and the Vendôme chapel.[55] These results confirmed that *liais de Paris* had been used in the Royal Portal, and that it is very likely that the stone for a subgroup of 20 of the Chartres samples came from the same quarrying location.[56] Further, the samples of sculpture from Chartres have a significant probability of matching stone from medieval monuments and quarries near Paris. Although the quarry/stone-source of the limestone used at Saint-Denis has not been identified, Chartres stone resembles stone from the basilica of Saint-Denis and it also resembles that of specimens from Notre-Dame of Paris, Saint-Martin-des-Champs and Saint-Maur-des-Fossés.[57] The characteristics of stone for those buildings is consistent with that of the stone from quarries at Charenton. That Chartres stone does not resemble limestone from the more proximate quarries in the valleys of the Seine and Oise Rivers that has been analyzed indicates that some priority was given to *liais de Paris* of the Charenton type.

The head thought to be that of a column-figure on the left jamb of the Portail Sainte-Anne of the west façade of Notre-Dame in Paris is now in the Metropolitan Museum of Art (Fig. 1.22).[58] This *Head of David* has been found to most probably have come from same stone source as other twelfth-century sculpture from the Portail Sainte-Anne, and probably to match samples from the quarry at Charenton.[59] Analyses of tested stone revealed that it is possible that stone with the same chemical fingerprint was used for a voussoir in the right portal and for the base of a jamb statue, and also for the north transept porch column-figures of Saint Modeste and Saint Potentin on the north transept portal at Chartres Cathedral Fig. B.13).

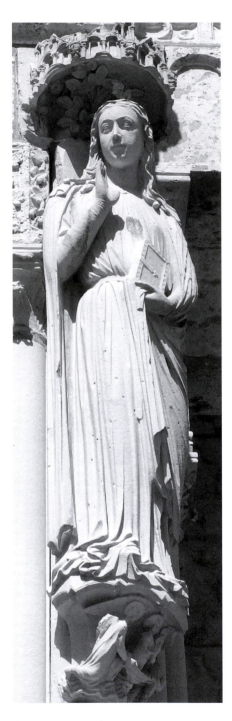

B.13 Sainte Modeste, Notre-Dame, Chartres Cathedral, north transept west porch, c. 1210–20.

Photo: Janet Snyder

The stone used for two other Chartres north transept porch column-figures and a west façade *colonnette* now at the Musée de Cluny appear to be very probable matches with the sample group from Notre-Dame in Paris. It is tempting to try to propose that stone from Charenton must have been in high demand. In truth, the fact that such similarities can be found between these samples is an exception to the general rule. It may possible to distinguish stone used for twelfth-century sculpture at Notre-Dame Cathedral in Paris from that used at the same building during the thirteenth century, but there seems to be little difference among sculpture and masonry stone at Notre-Dame Cathedral in Paris, unlike masonry and sculpture stone at Chartres. The great wealth of the Parisian *chantier* and its proximity to open-pit quarries in the valley of the Bièvre make it likely that quantities of the best stone were requisitioned for the cathedral from those sources.

In commerce with their suppliers at the sources of stone for several buildings,[60] it is likely that there were meetings at the quarries between the 1130s and the 1160s among the *ymagiers* working to produce façade sculpture. The circle of sculpture in *liais de Paris* around Paris – at Chartres, Etampes, Rampillon, Auxerre, Provins – reveals much about the artisans and twelfth-century workshop practice, construction, stone cutting, and carving.

Land transport

There were two options available to bring stone from the quarry sites to the churches requiring architectural sculpture made of *liais de Paris* – either by land or by water.[61] The long and arduous overland journey of cartloads of *liais de Paris* from quarries in Paris to churchside *chantiers* might have been possible if the Roman roads had been maintained in good condition, but by the twelfth century, older roads had deteriorated. The extension of the royal domain and the growth of the powers of the sovereign constituted a factor favorable to the establishment of large 'privileged' roads. The *grandes routes* were established to meet the need for the transport of merchandise from Flanders toward Paris and toward Champagne

and from there to cross Burgundy or the Auvergne, toward the south. The merchants traveled over these routes crossing to and from the fairs under the *conduit des foires*.[62] A principal element of success in commercial enterprises was the security of the *grandes routes*, maintained as part of the peace of the realm. It was after this *conduit des foires* had been violated in 1148 that Thibaut II of Champagne appealed for royal justice.[63]

In the last third of the twelfth century, a change in the means of commercial transport was made possible by the improved road conditions: instead of mules and horses loaded as pack animals to move merchandise in merchants' pack trains, four-wheeled carts predominated on the upgraded road system.[64] Technological innovations like the horse collar and iron-shod carts allowed the merchants to move greater quantities of goods in heavy wagons pulled by teams of efficiently harnessed horses rather than phlegmatic oxen. Regular travel with heavy loads required both paved roads and metal bands on cartwheels. Such wheel bands had become available because recent technological developments in iron-working had provided carters with affordable equipment.

Only the most cursory written records of the business of stone transport and sculpture practice in twelfth-century France have been discovered. The notarial trade came into its own with the development of letters of credit and commercial contracts in the late twelfth century. One difficulty in locating written documentation for the transport of materials is that notaries were employed to record expensive and unusual transactions more often than they wrote down everyday transactions.[65] Such a practice indicates that the shipment of many tons of *liais* for a distance of 80 kilometers or more was an unremarkable feat.

Water transport

Though for short distances stone for sculpture and construction might have been transported overland, the cheapest and safest method of cartage was by water.[66] The advantages of water transport for so heavy and valuable a commodity were huge: the distance to be traveled was less important than the weight and quantity, and better security could be assured via water than overland.[67] Travelers by road were under the constant threat of highway robbery.[68] Because they were required to pay considerable tariffs at regular intervals along the roads, carters would have been more concerned about the loss of the currency they had to carry to pay tolls to local stakeholders than about the risk of a hijacking of oxcarts carrying several tons of limestone.

Modern maps seem to indicate it would have been unlikely that there would have been clear, navigable waterways between the Parisian quarries and destinations more than 80 kilometers away, such as Chartres and Etampes. Further, the distance is far greater via water courses than overland.

Such a modern concern presumes that the levels of the water table and the volume of streams must have remained constant for a thousand years. Stone from the Oise River stone sources have been found by archaeologists in excavations at Chartres (Fig. B.3). These imported Oise stones came to light not only in the Gallo-Roman layer of the excavations but also in the layer beneath the Gallo-Roman materials.[69] Before the ancient Roman roads had been built, such stone could only have been carried to Chartres by water. While there is little written information from the medieval period about the location of sources of limestone, the 'fingerprint' of the stone verifies the origin of limestone used in the sculpture programs of medieval monuments. Documentation does exist for the shipping of stone via French rivers at the end of the Middle Ages, and the transport of stone by water appears to have continued through the Early Modern Period.[70]

All of the churches with portal programs containing column-figure sculpture made from *liais de Paris* are located in towns situated on tributaries of the Seine. What would have been the capacity of smaller river systems to handle substantial barge traffic? Although it seems likely that river traffic on streams would have been interrupted by water mills and fishery weirs, manuscript maps and modern charted surveys clarify the relationship of the passage of commercial shipping in the Seine basin to manmade obstructions in regional waterways, particularly in the vicinity of quarry sites. Even on small waterways commercial passage was provided through or around millponds, dams, bridges and fisheries, with locks and diversions.[71] The archeological evidence indicates that obstructions were in place by the twelfth century for adjusting the depth and width of rivers. The precursor of the chamber-lock, the *porte d'eau*, was mentioned in a charter in the period of Philip I of France (c. 1080–85), along with the *overdraghe*.[72] Developed further in the twelfth century, the *overdraghe* allowed boats to overcome blockages like dams and weirs in rivers. Barges loaded with stone could have circumvented obstacles. In later centuries, the expansion of weirs, mills and fisheries caused serious problems for commercial shipping as evidenced by the repeated passage of laws limiting or prohibiting such obstacles.

A *chantier*'s choreography of sculpture and building materials was significantly impacted by weather and seasonal variations in water levels and road conditions. Various environmental factors conspired against transportation. In the rainy season, navigable high-water river levels occurred at the same time that the weather made the terrain impassable. In the dry season, when overland transportation was reliable, low water levels made the navigation of streams impossible.[73] It is likely that the depth and levels of shipping streams might have been adjusted through flow-control systems and dredging, and that materials were moved when seasonal fluctuations allowed shipping. The difficulties encountered in the sixteenth century by Conrad Meyt in bringing Carrara marble to the Abbey of Brou for *gisant* sculpture demonstrate the complexities of transportation, for Meyt had to wait two years for the marble to arrive.[74] For Meyt, transport of stone was first by sea

from Italy, then up the Rhone River to Neyron (against the flow of the river), and finally overland by ox cart to the abbey.

It may be possible to make some inferences concerning a twelfth-century mason's practice from the fabric accounts Stephen Murray analyzed for Troyes Cathedral: in 1495–96 the masons chiseled clerestory tracery at the quarry[75] but in 1507–1508 and 1508–1509, rather than masons, paper – or 'false' – templates were sent to the quarries.[76] This reorganization of workshop practice under Martin Chambiges affirms that earlier work had followed a pattern of roughing out masonry at the quarries, since masons were dispatched to the quarries to prepare the stones.

BARGES

Archaeologists of the commercial use of rivers have discovered vessels of a Celtic design type that could be used to move the stone: dugout log-boats, some with planks attached on each side to allow deeper draught without swamping; riverboats with abutted planks laid for the floor; and prams.[77] These vessels traveled easily on shallow rivers, loaded to pass with tolerances of only 10 cm beneath bridges while carrying up to 8 metric tons.[78] Shallow-draft, solid little barges were used for agricultural transport from Neolithic times to the seventeenth century in France, either made from a single tree trunk or assembled from several dugout logs. The extant examples of French river cargo vessels, which are between 4 and 15 meters long, certainly could have transported the long narrow pieces of *liais* intended to be used for column figures.[79] *Liais de Paris* most certainly could have been transported for most of its journey from Paris to churchside *chantiers* in quotidian barges via waterways.

Scientific analyses of oak *pirogues* confirm that vehicles for river transport were in use at the time that *liais de Paris* was transported from Parisian quarries to portals: oak *pirogues* and assembled barges found in the site at Orlac have been carbon-dated between 982 and 1029, and between 1021 and 1042. The *pirogue* found at Massay-sur-Arnon dates between 1000 and 1230. Dendrochronology places the cutting of the oak used for the *pirogue* found at Noyen-sur-Seine at 834.[80] At Zwammerdam, in the Netherlands, excavations unearthed four barge wrecks from c. 200, and three are Celtic types that could carry 30 tons of heavy cargo such as building stone. The largest was 36 meters long and one made of oak was 23 meters long.[81]

The lost cargo from a logboat accident in England confirms the shipping of stone: blocks of Barnack stone intended for use during the 1190s in the construction of Sawtry Abbey were discovered after the draining of the Wittlesey Mere in the nineteenth century.[82] Each of the four blocks from this wreck weighs approximately 1 ton; these apparently had been lost in the mere with the logboat pram carrying them. A capital from Notre Dame of Paris, made of *liais de Paris* from the quarries along the banks of the Bièvre River and shipped to the Ile-de-la-Cité through the canal of Saint-Victor

weighed 3 tons (Fig. B.9).[83] Such discoveries confirm the capability and capacity of small-river craft for which little written documentation remains. In the pre-notarial period, a few charters had mentioned wood or stone provided for construction or the means of their conveyance. William the Conqueror loaned boats to ferry Caen stone across the Channel for Battle Abbey.[84] Texts document medieval architectural history, stone and timber acquisition and transportation, and quarry practice, though fabric accounts provide little information about the vessels that were used.[85] Bills of lading documenting the unloading of stone from river transport have been discovered for the construction of the cathedral at Sens.[86]

Notes

1 Suger, *De Consecratione*, in Erwin Panofsky (ed.), *Abbot Suger on the Abbey Church of Saint-Denis and its Art Treasures* (Princeton, 1946, 1979), p. 91.

2 Suger, *Libellus Alter de Consecratione ecclesiae Sancti Dionysii, II*, in Panofsky, *Abbot Suger on the Abbey Church*, pp. 90–93.

3 Suger, *La geste de Louis VI et autres oeuvres*, intro. Michel Bur (Paris, 1994), citing *Oeuvres complètes de Suger, recueillies, annotées et publiées d'après des manuscrits pour la Société de l'histoire de France par A. Lecoy de la Marche*, XXIX (Paris, 1867), pp. 193–6.

4 Annie Blanc, Pierre Lebouteux, Jacqueline Lorenz, and Serge Debrand-Passard, 'Les pierres de la cathédrale de Bourges,' *Archeologia*, 171 (October 1982): 30–32.

5 B.2: Chartres Cathedral construction stone. B.3: Oise River construction stone from Rhuis. B.4: Bourges Cathedral construction stone.

6 *Les miracles de saint Augustin de Cantorbéry*. The practice was already in use in the exportation of stone to Flanders at the end of the eleventh century, as applied to the stones for making walls, columns, and capitals ('*saxa ad basas, ad columnas, ad capitella et epistyle*'): this contrasts with the shipping from Caen of *finished* construction stones, columns and large capitals ('*basibus, columnis et capitellis grandibus*'). See 'Goscelini Miracula sancti Augustini episcopi Cantuariensis,' *Acta Sanctorum*, Mai, V, pp. 398–9, c. 16–20: where stones were brought by boat to England for the royal palace at Westminster ('*negotiatores ex Anglia, quindecim navibus ... Catomensi foro appulsi, ubi peractis mercimoniis parabant regredi, convehendis lapidibus ad regis palatium Westmonasterii ...*'). At about the same time, stone was furnished for the Abbey of Canterbury: see *Acta Sanctorum*, Mai, V, p. 399, c. 23.

7 Lanfranc was Archbishop of Canterbury from 1070 to 1089. '*Quadros lapides*' sound like more or less cubic blocks, as if they had been shaped already when they left the quarries: see *Vita b. Lanfranci archiepiscopi Cantuariensis*, C.9, in O. Lehmann-Brockhaus, *Lateinische Schriftquellen zur Kunst in England, Wales und Schottland, vom Jahre 901 bis zum Jahre 1307* (Munich, 1955), vol. 1, pl. 179, no. 664: '*et quod mirum admodum sit de Cadomo, ubi abbas exstitit, velivolis navibus per mare transvehi faciebat quadros lapides ad aedificandum ...*'

8 Lucien Musset, 'La pierre de Caen: extraction et commerce, XIe–XVe siècles,' in Odette Chapelot and Paul Benoit (eds), *Pierre et métal dans le bâtiment au Moyen Age* (Paris, 1985), p. 226.

9 Ania Guini-Skliar, 'Les carrières parisiennes aus frontières de la ville et de la campagne,' *Histoire urbaine* 2003/2/8 (2003): 41–56 (esp. 47).

10 The archives of the Inspection Générale des Carrières were burned in the Hôtel de Ville during the fire of 1871. See ibid., p. 42.

11 Gervase is quoted in translation in Nicola Coldstream, *Masons and Sculptors* (Toronto, 1991), pp. 15–16.

12 Saint-Loup de Naud was a priory church of Sens Cathedral.

13 Annie Blanc and Claude Lorenz, 'Pierres de Paris: Identification d'une pierre,' *Lithiques*, 4 (1987): 24. Annie Blanc, Lore L. Holmes, and Garman Harbottle, 'Lutetian Limestones in the Paris Region: Petrographic and Compositional Examination,' Brookhaven National Laboratory-66036. Available at <http://www.osti.gov/bridge/servlets/purl/758976-LduYGt/native/758976.pdf>.

14 Annie Blanc and Claude Lorenz, 'Observations sur la nature des matériaux de la cathédrale Notre-Dame de Paris,' *Gesta*, 29 (1990): 132–8.

15 Blanc and Lorenz, 'Pierres de Paris,' p. 16.

16 The stratigraphy was explained through the fossil record. J.B. d'Omalius d'Halloy published the first map of the region in 1816, with the Jurassic, Cretaceous and Tertiary areas of the Paris Basin illustrated. See <www.mnhn.fr/mnhn/geo/collectionlutetien/fichebp.html> (accessed 4 August 2007). See also Charles Pomerol, *Geology of France with Twelve Itineraries* (Paris, New York, 1980), figs 7 and 20. See also 'Simplified Map of the Bassin de Paris,' in *Bulletin d'information des géologues du Bassin de Paris*, 16 (4) (1979).

17 These fossils were *Nummulites laevigatus* and especially limestone with miliolids and *Orbitolites complanatus*. See Pomerol, *Geology of France*, p. 51.

18 Some palm leaves have been observed in stone from the quarry of Chaillot.

19 Pomerol, *Geology of France*, fig. 19, p. 52.

20 See Ania Guini-Skliar, Marc Viré, Jacqueline Lorenz, Jean-Pierre Gély, and Annie Blanc, *Les souterraines de Paris: les anciennes carrières souterraines* (Cambrai, 2000), pp. 12–13.

21 Claude Lorenz and Jacqueline Lorenz, with Annie Blanc, 'Observations stratigraphiques et sédimentologiques sur le calcaire grossier Lutétien des anciennes carrières du Val-de-Grâce à Paris,' *Bulletin d'information des géologues du Bassin de Paris*, 19 (4) (1982): 3–13.

 Diagram of 'Carrières-Saint-Denis: carrière de Mme Foulon, coupe dressé,' by P. Michelot (1852), reproduced in Annie Blanc, *Limestone Pits: Lutétian Limestone, Senonian Chalk*, unpubl. report of 4–6 July 1990, p. 13.

22 The late Lore Holmes, an impeccable scientist and invaluable advocate, merits my profound gratitude for her expertise and encouragement. See <www.limestonesculptureanalysis.com>.

23 For many years, scientists at Brookhaven National Laboratory tested and analyzed the samples, and testing has also been conducted at the University of Missouri Research Reactor.

24 Guini-Skliar, 'Les carrières parisiennes,' p. 44.

25 This work was made possible by the liberal financial support of the Florence J. Gould Foundation (1990–92) and generous grants by the Getty Grant

Program and the Samuel H. Kress Foundation (1993–95), administered by The Metropolitan Museum of Art, New York. It was carried out at the Brookhaven National Laboratory under contract DE-AC02-76CH00016 with the United States Department of Energy.

26 Blanc and Lorenz, 'Pierres de Paris,' pp. 13–30.

27 In the estimation of Marc Viré, because of their dimensions and stone source, the *en-de-lit* shafts of Saint-Julien-le-Pauvre, on the left bank, across the Seine from Notre-Dame de Paris, appear to be the shafts rejected by the cathedral *chantier*.

28 Blanc and Lorenz, 'Pierres de Paris,' p. 18.

29 'Le liais, un calcaire au grain très fin, forme un banc de 10 à 50cm. d'épaisseur, particulièrement propre à la sculpture.' ['The liais, a very finely-grained limestone, forms a stratum 10–50 cm thick, especially good for sculpture.'] Anne Prache, 'Une expérience d'analyse par activation neutronique sur des sculptures chartraines,' unpublished report to Medieval Congress at Leeds, 1996.

30 Annie Blanc, Claude Lorenz, and Marc Viré, 'Le liais de Paris et son utilisation dans les monuments,' in J. Lorenz and P. Benoît (eds), *Carrières et construction en France et dans les pays limitrophes: 115e congrès national des sociétés savants, Avignon 1990*, Colloques du CTHS 7 (Paris, 1991), pp. 247–59. At Etampes, the sculpture of the south portal of the church of Notre-Dame and the two angels on each side are made of a *calcaire à milioles*, a type of limestone which probably came from the quarries of Paris, though it is less hard than *liais*.

31 Annie Blanc and Claude Lorenz, 'Etude géologique des anciennes carrières de Paris: son utilité pour la connaissance et la restauration des monuments,' in P. Marinos and G. Koukis (eds), *The Engineering Geology of Ancient Works, Monuments and Historical Sites, Preservation and Protection/Gèologie de l'ingènieur appliquée aux travaux anciens, monuments et sites historiques* (Rotterdam, 1988), p. 645.

32 For a bibliography of the procedure, see Lore L. Holmes and Garman Harbottle, 'Compositional Fingerprinting: New Directions in the Study of the Provenance of Limestone,' *Gesta*, 33 (1) (1994): 10–18.

33 Lore Holmes, 'Limestone Sculpture Provenance Project Reports and Memoranda:' 30 October 1995; 6 March 1995; 9 March 1995; 24 April 1995; 4 December 1995; 4 May 1992; 10 October 1995; 9 July 1993; 11 January 1996.

Previously untested portal sculpture, particularly column-figures from the following monuments, remain to be tested and these could then also be evaluated relative to the Paris quarry group: Corbeil, Notre-Dame (in the Louvre); Ivry-la-Bataille, Notre-Dame; Saint-Loup de Naud, priory church of Saint-Loup; Provins, Saint-Ayoul; Etampes, Notre-Dame-du-Fort; Dijon, tympanum from Saint-Bénigne (in the Musée archéologique at Dijon); the Saint-Denis heads in the Walters Art Gallery and the Musée nationale du Moyen Age (Fig. 1.53). For the backs of the heads, see Whitney S. Stoddard, *Sculptors of the West Portals of Chartres Cathedral: Their Origins in the Romanesque and Their Role in Chartrain Sculpture Including the West Portals of Saint-Denis and Chartres*, PhD dissertation (Harvard University, 1952; rev. and repr. New York and London, 1987), plate VIII.

34 Quarries lie below the Church of Saint-Jacques du Haut-Pas; and beneath the Maison de la Géologie, 77 rue Claude Bernard. See 'Regional Map of Quarries,' in Jacques Philippon, Daniel Jeannette, and Roger-Alexandre Lefevre, *La conservation de la pierre monumental en France* (Paris, 1992), p. 28.

35 Blanc and Lorenz, 'Pierres de Paris,' p. 24.

36 The length of a meter was not standardized until the eighteenth century, during the French Revolution.

37 Nancy Y. Wu, 'Hugues Libergier and his Instruments,' *Nexus Network Journal*, 2 (2000): 93–102.

38 Michèle Beaulieu and Victor Beyer, *Dictionnaire des sculpteurs français du Moyen Age* (Paris, 1992).

39 Modern scholars concur that the ymagiers must have been aware of contemporary developments in portal design at regional churches – and that the same artist-mason worked on the figures of Mary as *Throne of Wisdom* at Chartres and at Notre-Dame in Paris – and that artist-masons also might have met each other in the quarries (Figs I.1, 2.7). '... les sculpteurs ... ont dû se rencontrer plus d'une fois sur les sites des carrières.' ['The sculptors must have met more than once at the quarry sites.'] Prache, 'Une expérience.' See Dany Sandron, 'Review of 1995 Leeds program,' *Bulletin monumental* (1996): 80–81.

40 Guini-Skliar, 'Les carrières parisiennes,' p. 47.

41 '... many masters from different regions' See Suger, *Abbot Suger on the Abbey Church*, p. 73.

42 Bede, *A History of the Abbots of Wearmouth and Jarrow*, trans. J.E. King (Cambridge MA, and London, 1954), vol. 2, pp. 401–7.

43 'Newly excavated architectural fragments, capitals and bases from a 12th-century doorway, found in the nave of Notre-Dame in 1983' See William W. Clark and Franklin M. Ludden, 'Notes on the Archivolts of the Sainte-Anne Portal of Notre-Dame de Paris, *Gesta*, 25 (1) (1986): 110–12. See M. Fleury, 'Découvertes à Notre-Dame de Paris,' *Archéologia*, 183 (October 1983): 14–15.

44 'The cloister was constructed against the north flank of this church towards 1170–1180. Its demolition was begun in 1759 and the materials were for the most part reutilized in new constructions on the same site.' Sylvie and Léon Pressouyre, *The Cloister of Notre-Dame-en-Vaux at Châlons-sur-Marne*, trans. Danielle Valin Johnson (Nancy, 1981), p. 6.

45 Wilhelm Vöge, *Die Anfänge des monumentalen Stiles im Mittlealter. Eine Untersuchung über die erste Blützeit französisch Plastik* (Strassburg, 1894). See also Stoddard, *Sculptors of the West Portals of Chartres Cathedral*.

46 See below on Burgundian capitals, etc., Paul Deschamps, *La sculpture française à l'Epoque roman. Onzième et douzième siècles* (Florence and Paris, 1930), pp. 39–40, pl. 40C and D (Valence), cited in François Salet, *Cluny et Vézelay, L'oeuvre des sculpteurs* (Paris, 1995), p. 143.

47 Sandron, 'Review,' pp. 80–81.

48 Blanc and Lorenz, 'Pierres de Paris,' p. 20.

49 Sources may be at Carrières-Saint-Denis (now Carrières-sur-Seine), Conflans-Saint-Honorine or on the Oise, at Saint-Ouen l'Aumône. See Blanc and Lorenz, 'Pierres de Paris,' p. 28. See also Annie Blanc, *Paris 3 juillet 1990*, unpublished report, p. 2.

50 Holmes and Harbottle, 'Compositional Fingerprinting,' figure 7, p. 15.

51 Lore L. Holmes, Charles T. Little, and Edward V. Sayre, 'Elemental Characterization of Medieval Limestone Sculpture from Parisian and Burgundian Sources,' *Journal of Field Archaeology*, 13 (1986): 420.

52 *Moses*, c. 1170 (The Cloisters Collection, 65.268), and *Aaron*(?), c. 1170 from
 Noyon Cathedral (22.60.17), both in The Metropolitan Museum of Art, New
 York. See Charles T. Little, 'Searching for the Provenances of Medieval Stone
 Sculpture: Possibilities and Limitations,' *Gesta*, 33 (1) (1994): figure 13, *Moses*,
 and figure 14, *Aaron*(?), pp. 34–5.

53 Charles T. Little, personal communication, 13 December 1996.

54 Lore L. Holmes, unpublished report, 'Memorandum, 10 October 1995,
 STMAUR-DVJ.R137,' pp. 1–3. For another sculpture from Saint-Maur, see
 Pamela Z. Blum, 'An Archaeological Analysis of the Statue-Column from Saint-
 Maur-des-Fossés at Dumbarton Oaks,' *Gesta*, 17 (2) (1978): 23–8.

55 See *Head of Joseph*, c. 1230, limestone with traces of polychrome, Chartres; The
 Metropolitan Museum of Art, New York (2007.143). This head can be directly
 linked to the decoration of the celebrated *jubé* (choir screen) erected in Chartres
 Cathedral about 1230. See <www.metmuseum.org/toah/hd/face/ho_2007.143.
 htm>.

56 Further, analysis of the limestone head from the *jubé* at Chartres now at
 Bowdoin College indicates its composition is consistent with stone from the
 Conflans-Sainte-Honorine quarry. See Dorothy Gillerman, 'The Materials
 of Gothic Sculpture,' in *Gothic Sculpture in America*, vol. 1, *The New England
 Museums* (New York, 1989), p. xi.

57 Lore Holmes, 'Memorandum, 9 March 1995, filename: CHARTR-AP.R109,' p. 4.

58 *Head of King David*, c. 1145, limestone, Notre-Dame Cathedral, south portal of
 west façade (Portail Sainte-Anne), h. 28.6 cm; The Metropolitan Museum of Art,
 New York, Harris Brisbane Dick Fund, 1938 (38.180). Illustrated in Charles T
 Little (ed.), *Set in Stone: The Face in Medieval Sculpture* (New York, 2006), cat. no.
 13, p. 50.

59 MMA 38.180, filename SNYDER.LIS from Lore Holmes, 7 December 1998. See
 Gesta, 33 (1): 14; see also The Metropolitan Museum of Art, New York; Harris
 Brisbane Dick Fund, 1938 (38.180), as illustrated in Little, *Set in Stone*, pp. 50–51,
 '13. *Head of King David*.'

60 Blanc and Lorenz. 'Etude géologique,' figure 5, p. 245. See also Guini-Skliar et
 al., *Les souterraines de Paris*.

61 Blanc and Lorenz. 'Pierres de Paris,' pp. 13–30.

62 Through this important safeguard, travelers were guaranteed safe passage to
 and from the fairs of Champagne. See discussion of the fairs in Chapter 3.

63 See discussion in Chapter 2.

64 The saving in time was considerable, since pack animals had to be loaded and
 unloaded each night but wheeled carts remained loaded. Félix Bourquelot,
 *Etudes sur Les Foires de Champagne, sur la nature, l'étendue et les régles du commerce
 qui s'y faisait aux XII, XIII, et XIV siècles* (2 vols, Paris and Provins, 1839–40;
 repr. Manoir de Saint Pierre de Salerne, *Mémoires présentés pars divers savants à
 l'Académie des Inscriptions et Belles-Lettres* (Brionne, 1970)), vol. 1, p. 84.

 The use of nailed horseshoes had become common by the end of the eleventh
 century. See Lynn White, Jr., *Medieval Technology and Social Change* (London,
 1962), p. 59.

65 Eric Rieth, *Des bateaux et des fleuves: Archéologie de la batellerie du néolithique aux
 temps modernes en France* (Paris, 1998), p. 48.

66 Albert C. Leighton, *Transport and Communication in Early Medieval Europe AD 500–1100* (Newton Abbot, 1972), p. 125.

67 Jean-Noel Dutheil, *Mille ans d'histoire, les carrières de France* (Coulandon, 1984), pp. 26–7.

68 The transport of building materials would not have been assured the same security as the *conduit des foires* guaranteed for travelers to and from the fairs of Champagne.

69 Personal communication from Annie Blanc, 1998. In the Département de Cartes et Plans of the Bibliothèque nationale (Paris) (BN), there are maps of ancient roads which remain in northern France (published by the Institute géographique national).

70 Personal communication, 14 May 1997. Interview with Denis Cailleaux by the author. See also Denis Cailleaux, *L'oeuvre de la croisée de la cathédrale de Sens: un grand chantier ecclésiastique à la fin du Moyen Age d'après les sources comptables* (doctoral thesis, University of Paris 1, 1994).

71 See, in BN's Département de Cartes et Plans, GeDD 3020 (8) Seine 15; photo 90.C 148054 in France – Ile-de-France, Yvelines, c. 1750: a diagram plan of the Pont de Poissi indicates passage around mills on bridges, *pertuis*, *digues*, etc. For obstructions, see Rieth, *Des bateaux et des fleuves*, p. 117.

72 The *overdraghe* was '… an inclined plane of wood barring a river. Water constantly ran down over the *overdraghe*, so boats could slide down the inclined plane or be hauled up it by cable and capstan.' See Leighton, *Transport and Communication*, p. 125.

73 Musée de Brou, *Brou, les bâtisseurs du XVIe siècle* (Bourg-en-Bresse, 1996), pp. 32–3.

74 Marie-Françoise Poiret and Marie-Dominique Nivière, *Brou, Bourg en Bresse*, photos by Hervé Nègre (Bourg-en-Bresse, 1990), pp. 49–50.

75 Stephen Murray, *Building Troyes Cathedral, The Late Gothic Campaigns* (Bloomington IN, 1987), p. 83.

76 '1496–97, … 6. Audit Jehançon Garnache et Colas Savetier … et faire tous les faulx mosles pour porter a la perriere de Tonnerre pour sur yceulx esboscher lesd. pierres desd. verrieres …' ('[paid] To the said Jehançon Garnache and Colas Savetier … to make all the false templates to take to the quarry in Tonnerre in order to cut out the stones of the said windows on the said [templates] …') See FA Archives de l'Aube G 1570, 235r, cited in Murray, *Building Troyes Cathedral*, pp. 170–71.

77 Log-boat or *pirogue monoxyle*: a single-log dugout vessel in common use throughout the globe; the plank-built pram or *monoxyle assemblé* is a specialized, flat-bottomed punt. See Gillian Hutchinson, *Medieval Ships and Shipping* (Rutherford NJ, 1994), pp. 122–3; Dirk Meier, *Seafarers, Merchants and Pirates in the Middle Ages*, trans. Angus McGeogh (Woodbridge, 2006), p. 12.

78 1 tonne = 2204.62 lbs; 3.9 metric tons = 8,598.018 lbs.

Reith explains that a 5-meter *pirogue* could carry 3.9 tons: 'La principale question qui se pose, dans la perspective de l'histoire de cette "première" batellerie de la Charente, est celle de la fonction de ces embarkations monoxyles. Une des responses, formulae sous forme d'hypothèse, est à chercher dans le rapport entre le poids de la coque vide et la capacité de charge de la pirogue. Pour une

longueur de l'ordre de 5 mètres, le poids à vide de la pirogue de Port-d'Envaux, par exemple, a été évalué à 190 kg et sa capacité de charge maximum, avec un franc-bord de 10 cm, à 220 kg. Pour une longueur de 12,80 mètres, le poids à vide de la pirogue de Port-Berteau 1 a été estimé à 1,35 tonne et sa capacité de charge maximum, pour un frac-bord de 10 centimetres à 3,90 tonnes.' Rieth, *Des bateaux et des fleuves*, pp. 120–22.

79　*Pirogue of the Havre* (Seine-Maritime) had the mean around 5–6 meters. Note that the mean dimension is the same as the Neolithic oak *pirogue* found at Bourg-Charente (Charente) which is 5.56 meters long, and the oak *pirogue* from the end of the Neolithic period found at Paris-Bercy, which is 5.35 meters long and 80 cm wide. This is consistent with the maximum use of the sort of oak that was growing in France at the time. See Rieth, *Des bateaux et des fleuves*, p. 67.

80　Ibid., the *pirogue monoxyle carolingienne*, p. 46.

81　Richard W. Unger, *The Ship in the Medieval Economy 600–1600* (London, 1980), p. 57.

82　Hutchinson, *Medieval Ships and Shipping*, p. 121. See H.J.K. Jenkins, 'Medieval Barge Traffic and the Building of Peterborough Cathedral,' *Northamptonshire Past and Present*, 8, 255–61.

83　See Blanc and Lorenz, 'Observations sur la nature …,' p. 133.

84　*Pierre de Caen* was employed primarily in the decorative elements of English buildings. William's builders were able to locate suitable building stone near the site of the future Hastings Abbey. William was determined to give thanks to God by building an abbey on the site of his victory. See David Parsons, 'Stone,' in John Blair and Nigel Ramsay (eds), *English Medieval Industries: Craftsmen, Techniques, Products* (London and Rio Grande OH, 1991), p. 17. See *The Chronicle of Battle Abbey*, 10, cited in 'Houses of Benedictine Monks: Abbey of Battle,' *A History of the County of Sussex*, Victoria County History series (London, 1973), vol. 2, pp. 52–6. See <http://www.british-history.ac.uk/report. aspx?compid=36583> (accessed 26 October 2009).

85　Hutchinson, *Medieval Ships and Shipping*, p. 121.

86　Personal communication, 14 May 1997. Interview with Denis Cailleaux by the author. See also Cailleaux, *L'oeuvre de la croisée*.

BIBLIOGRAPHY

Acta Sanctorum quotquot toto orbe coluntur, vel à cathollicis scriptoribus celebrantur quae ex Latin & Graecis, aliarumque gentium antiquis monumentis. Collegit, digessit, notis illustravit Joannes Bolandus [1596–1665] ...; *operam et studium contulit Godefridus Henschenius* [1601–81] (Brussels: Culture et Civilisation, 1965).

Adhémar, Jean, 'Les tombeaux de la collection Gaignières. Dessins d'archéologie du XVIIe siècle,' *Gazette des beaux-arts*, 1 (July–September 1974); 2 (July–August 1976), no. 1290–1291; 3 (1977).

Åkerström-Hougen, Gunilla, '*Adventus* Travels North, A Note on the Iconography of some Scandinavian Gold Bracteates,' in *Imperial Art as Christian Art – Christian Art as Imperial Art: Expression and Meaning in Art and Architecture from Constantine to Justinian*, eds J. Rasmus Brandt and Olaf Steen, Acta Ad Archaeologiam et Artium Historiam Pertinentia 15/1 (Rome: Bardi Editore, 2001), pp. 229–44.

Anonymous, *Le roman de Thèbes* [1150], ed. Guy Raynaud de Lage (2 vols, Paris: Champion, 1968).

Archibald, Elizabeth, *Apollonius of Tyre, Medieval and Renaissance Themes and Variations: Including the Text of the Historia Apollonii Reqis Tyri with an English Translation* (Cambridge: D.S. Brewer, 1991).

Archives nationales, *Le sacre à propos d'un millénaire 987–1987* (Paris: Archives nationales, Musée de l'Histoire de France, 1987).

Armi, C. Edson, *The 'Headmaster' of Chartres and the Origins of 'Gothic' Sculpture* (University Park PA: Pennsylvania State University Press, 1994).

————— , *Masons and Sculptors in Romanesque Burgundy, The New Aesthetic of Cluny III* (University Park PA: Pennsylvania State University Press, 1983).

Aubert, Marcel. 'Le portail royal et la façade occidentale de la cathédrale de Chartres, essai sur la date de leur exécution,' *Bulletin monumental*, no. 100 (1941): 177–218.

Augustine (Saint), *The City of God*, trans. Gerald Walsh, Demetrius B. Zema, Grace Monahan, and Daniel J. Honan (New York: Doubleday, 1958).

Bak, János M. (ed.), *Coronations: Medieval and Early Modern Monarchic Ritual* (Berkeley: University of California Press, 1990). Available at <http://ark.cdlib.org/ark:/13030/ft367nb2f3/> (accessed 6 June 2007).

Baker, Patricia L., *Islamic Textiles* (London: British Museum Press, 1995).

Balard, Michel, Jean-Philippe Genet, and Michel Rouche, *Le Moyen Age en Occident* (Paris: Hachette, 1990).

Baldwin, John W., *The Scholastic Culture of the Middle Ages, 1000–1300* (Lexington MA: D.C. Heath, 1971).

———, *Masters, Princes and Merchants, The Social Views of Peter the Chanter and his Circle* (2 vols, Princeton: Princeton University Press, 1970).

Barnes, Carl F., Jr., 'Le "Probleme" Villard de Honnecourt,' in Roland Recht (ed.), *Les batisseurs des cathédrales gothiques* (Strasbourg: Editions Les Musées de la ville de Strasbourg, 1989), pp. 209–23.

Barthes, Roland, *La system de la mode* (Paris: Editions du Seuil, 1983).

Bartsch, Shadi, 'The Philosopher as Narcissus: Vision, Sexuality, and Self-Knowledge in Classical Antiquity,' in Robert S. Nelson (ed.), *Visuality Before and Beyond the Renaissance, Seeing as Others Saw* (New York: Cambridge University Press, 2000).

Bautier, Robert-Henri, *Sur l'histoire économique de la France médiévale: la route, le fleuve, la foire* (Aldershot: Variorum, 1991).

Bayard, J.-P., and P. de la Perrière, *Les rites magiques de la royauté* (Paris: Friant, 1982).

Bayard, Tania, 'Thirteenth-Century Modifications in the West Portals of Bourges Cathedral,' *Journal of the Society of Architectural Historians*, 34 (1975): 215–25.

Beaulieu, Michèle, 'Essai sur l'iconographie des statues-colonnes de quelques portails du premier art gothique,' *Bulletin monumental*, 142 (1984): 273–307.

Beaulieu, Michèle, and Victor Beyer, *Dictionnaire des sculpteurs français du Moyen Age* (Paris: Picard, 1992).

Beckwith, John, *Ivory Carvings in Early Medieval England* (New York: Harvey Miller & Medcalf, 1972).

Bechman, Roland, *Les racines des cathédrales* (Paris: Payot, 1996).

Bede, *A History of the Abbots of Wearmouth and Jarrow*, trans. J.E. King (Cambridge MA and London, 1954).

Bedos-Rezak, Brigitte, *When Ego Was Imago: Signs of Identity in the Middle Ages* (Boston: Brill, 2011).

———, 'Medieval Identity: A Sign and a Concept,' *The American Historical Review*, 105 (5) (December 2000): 1489–1533.

———, *Form and Order in Medieval France, Studies in Social and Quantative Sigillography* (Aldershot: Variorum, 1993).

———, 'Women, Seals, and Power,' in Mary Erler and Maryanne Kowaleski (eds), *Women and Power in the Middle Ages* (Athens, GA and London: University of Georgia Press, 1988), pp. 61–82.

Benjamin, Sandra, *The World of Benjamin of Tudela, A Medieval Mediterranean Travelogue* (London and Cranbury NJ, 1995).

Benjamin of Tudela, *The Itinerary of Benjamin of Tudela*, trans. M.N. Adler (New York: Philip Feldheim, 1963).

Berger, Elie, *La formule 'Rex francorum et dux aquitanorum' dans les actes de Louis VII.* Extrait de la *Biblothèque de l'Ecole des chartes*, vol. 45 (1884) (Nogent-le-Rotrou, 1884).

Bernard of Clairvaux, *On the Song of Songs*, trans. Kilian Walsh (Spencer MA, Cistercian Publications, 1971–80), vol. 2.

Bessac, Jean-Claude, et al., *La construction en pierre* (Paris: Editions Errance, 1999).

Biernoff, Suzannah, *Sight and Embodiment in the Middle Ages* (Basingstoke and New York: Palgrave Macmillan, 2002).

Bisson, Thomas N. (ed.), *Cultures of Power: Lordship, Status, and Process in Twelfth-Century Europe* (Philadelphia: University of Pennsylvania Press, 1995).

Blanc, Annie, *Paris 3 juillet 1990*, unpublished report.

———, *Limestone Pits: Lutétien Limestone, Senonian Chalk*, unpublished report, July 4–6, 1990.

Blanc, Annie, and Jean-Pierre Gély, 'Le Lutétien supérieur des anciennes carrières de Paris et de sa banlieue: Essai de corrélations lithostratigraphiques et application à l'archéologie,' in Jacqueline Lorenz, Paul Benoit, and Daniel Obert, *Pierres et carrières, géologie, archéologie, histoire* (Paris: Association des Géologues du Bassin de Paris, 1997), pp. 175–81.

Blanc, Annie, and Claude Lorenz, 'Observations sur la nature des matériaux de la cathédrale Notre-Dame de Paris,' *Gesta*, 29 (1) (1990): 132–8.

——— and Claude Lorenz, 'Etude géologique des anciennes carrières de Paris: son utilité pour la connaissance et la restauration des monuments,' in P. Marinos and G. Koukis (eds), *The Engineering Geology of Ancient Works, Monuments and Historical Sites, Preservation and Protection / Gèologie de l'ingènieur appliquée aux travaux anciens, monuments et sites historiques* (Rotterdam: Balkema, 1988).

——— and Claude Lorenz, 'Pierres de Paris. Identification d'une pierre,' *Lithiques*, 4 (1987): 13–30.

Blanc, Annie, Lore L. Holmes, and Garman Harbottle, 'Lutetian Limestones in the Paris Region: Petrographic and Compositional Examination,' Brookhaven National Laboratory 66036. Available at <http://www.osti.gov/bridge/servlets/purl/758976-LduYGt/native/758976.pdf>.

Blanc, Annie, Claude Lorenz, and Marc Viré, 'Le liais de Paris et son utilisation dans les monuments,' in J. Lorenz and P. Benoît (eds), *Carrières et construction en France et dans les pays limitrophes: 115e congrès national des sociétés savants, Avignon 1990*, Colloques du CTHS 7 (Paris: Colloques du CTHS, 1991), pp. 247–59.

Blanc, Annie, Pierre Lebouteux, Jacqueline Lorenz, and Serge Debrand-Passard, 'Les pierres de la cathédrale de Bourges,' *Archeologia*, 171 (October 1982): 30–32.

Blanc, Odile, 'Historigraphie du vêtement: un bilan,' in Michel Pastoureau (ed.), *Le vêtement: Histoire, archéologie et symbolique vestimentaires au Moyen Age*, Cahiers du Léopard d'Or (Paris: Editions Léopard d'Or, 1989), pp. 7–29.

———, 'Vêtement féminin, vêtement masculin a la fin du moyen âge. Le point de vue des moralists,' in Michel Pastoureau (ed.), *Le vêtement: Histoire, archéologie et symbolique vestimentaires au Moyen Age*, Cahiers du Léopard d'Or (Paris: Editions Léopard d'Or, 1989), pp. 243–53.

Blum, Pamela Z., *Early Gothic Saint-Denis. Restorations and Survivals* (Berkeley and Los Angeles: University of California Press, 1992).

———, 'The Statue-Column of a Queen from Saint-Thibaut, Provins, in the Glencairn Museum,' *Gesta*, 29 (2) (1990): 214–33.

_____ , 'The Lateral Portals of the West Façade of the Abbey Church of Saint-Denis: Archaeological and Iconographical Considerations,' in Paula Gerson (ed.), *Abbot Suger and Saint-Denis. A Symposium* (New York: Metropolitan Museum of Art, 1981), pp. 199–227.

_____ et al., 'Fingerprinting Stone at Saint-Denis: A Pilot Study,' *Gesta*, 33 (1) (1994): 19–28.

Bojcov, Mikhail A., 'How One Archbishop of Trier Perambulated his Lands,' in Björn Weiler and Simon MacLean (eds), *Representations of Power in Medieval Germany 800–1500*, International Medieval Research 16/3 (Turnhout: Brepols, 2006), pp. 319–48.

Bonnefin, A., *Le sacre royal dans l'histoire de France, permanence d'une valeur fondamentale* (Paris: Bonnefin, 1993).

Bony, Jean, 'The Resistance to Chartres in Early Thirteenth-Century Architecture,' *Journal of the British Archaeological Association*, 20–21 (1957–58): 35–52.

Bordaz, O., 'Les broderies médiévales du musée historique des tissus à Lyon,' doctoral dissertation (Paris: University of Paris IV, 3e, 1980).

Bosredon, Ph. de, *Répertoire des sceaux des rois et reines de France et des princes et princesses, de trois races royales de France* (Périgueux: Imprimerie de la Dordogne (Anc. Dupont et Cie), 1893).

Bossaut, Robert, Louis Pichard, and Guy Raynaud de Lage, *Dictionnaire des lettres françaises, Le Moyen Age* (Paris: Fayard, 1964).

Bouchard, Constance B., 'Rural Economy and Society,' in Marcus Bull (ed.), *France in the Central Middle Ages: 900–1200* (Oxford and New York: Oxford University Press, 2002), pp. 77–100.

Boucher, François B., 'Le costume de l'Europe et Occidentale du IXe au XIe siècle,' in *Histoire du costume en occident de l'antiquité à nos jours* (Paris: Flammarion, 1983).

_____ , *20,000 Years of Costume: The History of Costume and Personal Adornment* (New York: Harry N. Abrams, 1966, 1987).

Boureau, Alain, 'The Sacrality of One's Own Body in the Middle Ages,' trans. Benjamin Semple from the original *Corps mystique, corps sacre*, in *Textual Transfigurations of the Body from the Middle Ages to the Seventeenth Century*, Yale French Studies 86 (New Haven: Yale University Press, 1994), pp. 5–17.

Bournazel, Eric, 'Suger and the Capetians,' in Paula Lieber Gerson (ed.), *Abbot Suger and Saint-Denis. A Symposium* (New York: Metropolitan Museum of Art, 1986), pp. 55–72.

Bourquelot, Félix, *Etudes sur les Foires de Champagne, sur la nature, l'étendue et les règles du commerce qui s'y faisait aux XII, XIII, et XIV siècles* (2 vols, Paris and Provins: 1839–40: repr. Manoir de Saint Pierre de Salerne, as *Mémoires présentés pars divers savants à l'Académie des Inscriptions et Belles-Lettres*, 2 vols, Brionne: Le Portulan, 1970).

_____ , *Histoire de Provins* (2 vols, Provins: Lebeau, 1839–40).

Brandenburg, Hugo, *Ancient Churches of Rome from the Fourth to the Seventh Century* (Turnhout: Brepols, 2005).

Branner, Robert, *Manuscript Painting in Paris during the Reign of Saint-Louis* (Berkeley, Los Angeles, and London: University of California Press, 1977).

_____ , *Chartres Cathedral* (New York: Norton, 1969).

_____ , 'Encore Bourges,' *Journal of the Society of Architectural Historians*, 25 (1966): 299–301.

Brown, Elizabeth A.R., '"Franks, Burgundians and Aquitanians" and the Royal Coronation Ceremony in France,' *Transactions of the American Philosophical Society*, (Philadelphia: American Philosophical Society, 1992), pp. i–xii and 1–89.

Bruzelius, Caroline, 'The Construction of Notre-Dame in Paris,' *Art Bulletin*, 69 (4) (December 1987): 540–69.

Brubaker, Leslie, 'The Elephant and the Ark: Cultural and Material Interchange across the Mediterranean in the Eighth and Ninth Centuries,' *Dumbarton Oaks Papers*, 58 (2004): 175–95.

Bryant, Lawrence M., 'The Medieval Entry Ceremony at Paris,' in János M. Bak (ed.), *Medieval and Early Modern Monarchic Ritual* (Berkeley, Los Angeles and Oxford: University of California Press, 1990). Available at <http://ark.cdlib.org/ark:/13030/ft367nb2f3/> (accessed 7 June 2007).

Bull, Marcus, *France in the Central Middle Ages: 900–1200* (Oxford and New York: Oxford University Press, 2002).

Bulletin d'information des géologues du Bassin de Paris, 'Simplified Map of the Bassin de Paris,' 16 (4) (1979).

Bunt, Cyril G.E., *Byzantine Fabrics* (Leigh-on-Sea: F. Lewis Publications Ltd, 1967).

Bur, Michel, *Suger, Abbé de Saint-Denis, Regent de France* (Paris: Perrin, 1991).

_____ , 'A Note on Suger's Understanding of Political Power,' in Paula Gerson (ed.), *Abbot Suger and Saint-Denis. A Symposium* (New York: Metropolitan Museum of Art, 1986), pp. 73–5.

_____ , *La formation du Comté du Champagne, v.950–v.1150* (Nancy: Publications de l'université de Nancy, 1977).

Burnham, Dorothy K., *Warp and Weft, A Textile Terminology* (Toronto: Royal Ontario Museum. 1980).

_____ , *Cut my Cote* (Toronto: Royal Ontario Museum, 1973).

Burns, E. Jane, *Courtly Love Undressed, Reading through Clothes in Medieval French Culture* (Philadelphia PA: University of Pennsylvania Press, 2002).

Bynum, Carolyn Walker, *Jesus as Mother: Studies in the Spirituality of the High Middle Ages* (Berkeley: University of California Press, 1982).

Byrne, Eugene H., 'Genoese Trade with Syria in the Twelfth Century,' *American Historical Review*, 25 (1919–20): 191–219.

_____ , 'Commercial Contracts of the Genoese in the Syrian Trade of the Twelfth Century,' *Quarterly Journal of Economics*, 31 (1916–17): 123ff.

Cahn, Walter, 'Romanesque Sculpture in American Collections. XVI. The Academy of the New Church, Bryn Athyn, PA,' *Gesta*, 16 (2) (1977): 73–8.

_____ , 'The Tympanum of the Portal of Saint-Anne at Notre-Dame de Paris and the Iconography of the Division of the Powers in the Early Middle Age,' *Journal of the Warburg and Courtauld Institutes*, 32 (1969): 55–72.

_____ and Linda Seidel, *Romanesque Sculpture in American Collections*, vol. 1, *New England Museums* (New York: B. Franklin, 1979).

Cailleaux, Denis, *Les comptes de construction des cathédrales médiévales* (Edition électronique, 2006).

———, *La cathédrale en chantier: la construction du transept de Saint-Etienne de Sens d'après les comptes de la fabrique, 1490–1517* (Paris: Comité des travaux historiques et scientifiques, 1999).

———, *L'oeuvre de la croisée de la cathédrale de Sens: un grand chantier ecclésiastique à la fin du Moyen Age d'après les sources comptables* (doctoral thesis, University of Paris 1, 1994).

Calano, Marianne, and Larry Salmon (eds), *French Textiles from the Middle Ages Through the Second Empire* (Hartford CN: Wadsworth Antheneum, 1985).

The Cambridge Medieval History, vol. 3, eds H.M. Gwatkin, J.P. Whinney, J.R. Tanner, and C.W. Previté-Orton (Cambridge: Cambridge University Press, 1922); vols 5 and 6, eds J.R. Tanner, C.W. Previté-Orton, and Z.N. Brooke (Cambridge: Cambridge University Press, 1929).

Camille, Michael, 'Signs of the City: Place, Power, and Public Fantasy in Medieval Paris,' in Barbara A. Hanawalt and Michel Kobialka (eds), *Medieval Practices of Space* (Minneapolis: University of Minnestoa Press, 2000), pp. 1–36.

———, 'Seeing and Reading: Some Visual Implications of Medieval Literacy and Illiteracy,' *Art History*, 8 (1) (March 1985): 26–49.

Carr, Carolyn Kinder, *Aspects of the Iconography of Saint Peter in Medieval Art of Western Europe to the Early Thirteenth Century*, PhD dissertation (Cleveland: Case Western Reserve University, 1978).

Carruthers, Mary, *The Book of Memory, A Study of Memory in Medieval Culture* (New York and London: Cambridge University Press, 1990).

———, and Jan M. Ziolkowski (eds), *The Medieval Craft of Memory, An Anthology of Texts and Pictures* (Philadelphia: University of Pennsylvania Press, 2002).

Carus-Wilson, Eleanora M., 'The English Cloth Industry in the Late Twelfth and Early Thirteenth Centuries,' in *Medieval Merchant Venturers, Collected Studies* (London: Methuen, 1967), pp. 211–38.

Caviness, Madeline Harrison, 'Reception of Images by Medieval Viewers,' in Conrad Rudolph (ed.), *A Companion to Medieval Art: Romanesque and Gothic in Northern Europe* (Oxford: Blackwell, 2006), pp. 65–85.

———, *Art in the Medieval West and Its Audience* (Aldershot and Burlington VT: Ashgate Variorum, 2001).

Chartraire, E. (Abbé), *Inventaire du trésor de l'église primatiale et métropolitaine de Sens* (Sens, 1897).

Chastel, André, 'Le rencontre de Solomon et de la reine de Saba dans l'iconographie médiévale,' *Gazette des beaux-arts*, series 6, 35 (1949): 100–114.

Chevalier, A., and J.E. Nenninger, 'Medieval Dress,' *Ciba Review*, 57 (Basle) (June 1947): 2054–85.

Chevalier, L., *Histoire de Bar-sur-Aube* (Bar-sur-Aube: Chez l'auteur, rue Notre-Dame, no. 37, 1851).

Christe, Yves, *Les grands portails romans, études sur l'iconologie des théophanies romanes* (Geneva: Droz, 1969).

_____ , 'A propos du tympan de la Vierge à Notre-Dame de La Charité-sur-Loire,' *Cahiers de civilisation médiévale* (Poitiers: Université de Poitiers, Centre d'études supérieures de civilisation médiévale) (April–June 1966): pp. 221–3.

Chronique de Morigny [1095–1152], ed. Léon Mirot, Collection de textes pour servir à l'étudient à l'énseignement de l'histoire 41 (Paris: Alphonse Picard, 1909).

Clark, William W., 'Head of an Old Testament King,' in Charles Little (ed.), *Set in Stone: The Face in Medieval Sculpture* (New York: Metropolitan Museum of Art, 2006), pp. 81–2.

Clark, William W., and Franklin M. Ludden, 'Notes on the Archivolts of the Sainte-Anne Portal of Notre-Dame de Paris,' *Gesta*, 25 (1) (1986): 110–12.

Coldstream, Nicola, *Masons and Sculptors* (Toronto: University of Toronto Press, 1991).

Cohen, Mark R., *Jewish Self-Government in Medieval Egypt: The Origins of the Office of Head of the Jews, ca. 1065–1126* (Princeton: Princeton University Press, 1980).

Collette, Carolyn P., 'Some Aesthetic Implications of *Multiplication of Species,' AVISTA Forum Journal*, 9 (1) (1995): 3–5.

Collingwood, Peter, *The Technique of Tablet Weaving* (New York: Watson/Guptill Publications, 1982).

Comnena (Komnene), Anna, *The Alexiad*, ed. and trans. Elizabeth A. Dawes (London: Routledge & Kegan Paul, 1928); available at <http://www.fordham.edu/halsall/pgc.asp?page=basis/annacomnena-alexiad05.html> (accessed 20 June 2009).

Complex Weavers' Medieval Textile Study Group, issue 24 (June 2000).

Conant, Kenneth J., *Carolingian and Romanesque Architecture, 800 to 1200* (London: Penguin, 1978).

Constable, Giles, *Monks, Hermits and Crusaders in Medieval Europe* (Aldershot: Variorum Reprints, 1988).

_____ , 'Papal, Imperial and Monastic Propaganda in the Eleventh and Twelfth Centuries,' in G. Makdisi, D. Sourdel, and J. Sourdel-Thomine (eds), *Prédication et propagande au Moyen Age: Islam, Byzance, Occident; Penn-Paris-Dumbarton Oaks Colloquia, III (20–25 octobre 1980)* (Paris: Presses Universitaires de France, 1983). Repr. in G. Constable, *Monks, Hermits and Crusaders in Medieval Europe* (Aldershot: Variorum Reprints, 1988).

Constable, Olivia Remie, *Housing the Stranger in the Mediterranean World: Lodging, Trade, and Travel in Late Antiquity* (New York: Cambridge University Press, 2003).

Constantin VII Porphyrogitus, *Le livre des cérémonies*, trans. A. Vogt (Paris: Les Belles Lettres, 1935).

Coss, Peter, *The Knight in Medieval England 1000–1400* (Conshohocken PA: Combined Books, 1996).

Coulin, A., *Inventaire des sceaux de la Burgogne, recueillis dans les depôts d'archives, musées et collections particulières des départements de la Côte-d'Or, de Saône-et-Loire et de l'Yonne* (Paris: E. Leroux, 1912).

_____ , *Inventaire de la Champagne, recueillis dans les depôts d'archives, musées et collections particulières des départements de la Marne, de l'Aube, de la Haute-Marne et des Ardennes*, manuscript.

_____ , *Dictionnaire de la noblesse*, vol. 4 (Paris: La Veuve Duchesne, Libraire, 1777).

Cowdrey, H.E.J., 'The Peace and Truce of God in the Eleventh Century,' in *Popes, Monks and Crusaders* (London: Hambledon Press, 1984), pp. 42–67.

Crosby, Sumner McKnight, *The Royal Abbey of Saint-Denis from its Beginnings to the Death of Suger, 475–1151*, ed. Pamela Z. Blum (New Haven and London: Yale University Press, 1987).

_____ , Jane Hayward, Charles T. Little, and William Wixom, *The Royal Abbey of Saint-Denis in the Time of Abbot Suger (1122–1151)* (New York: Metropolitan Museum of Art, 1981).

Crowfoot, Elisabeth, Frances Pritchard, and Kay Staniland, *Textiles and Clothing, c.1150–c.1450* (London: HMSO, 1992).

Crozet, René, 'Sur un détail vestimentaire féminin du XIIe siècle,' *Cahiers de civilisation médiévale, Xe–XIIe siècles*, 4 (1961): 55–6.

Dalas, Martine, *Corpus des sceaux français du moyen âge*, vol. 2, *Les sceaux des rois et de régence* (Paris: Archives nationales, 1991).

d'Arbois de Jubainville, H., *Histoire des ducs et des comtes de Champagne depuis le VI siècle jusqu'à la fin du XI siècle*, vol. 3, *1152–1181* (Paris, 1869).

_____ , *Histoire de Bar-sur-Aube sous les comtes de Champagne, 1077–1284* (Paris, Troyes, and Bar-sur-Aube, 1859).

Dale, Thomas E.A., 'The Power of the Anointed: The Life of David on Two Coptic Textiles in the Walters Art Gallery,' *Journal of the Walters Art Gallery*, 51 (1993): 32–5.

Dectot, Xavier, 'Beheaded We Stand: The Heads of Saint-Denis and the Problem of Eighteenth-Century Prerevolutionary Vandalism,' *Facing the Middle Ages* symposium, 14 October 2006, Metropolitan Museum of Art, New York.

Delluc, Brigitte, and Gilles Delluc, 'Le suaire de Cadouin et son frère: le voile de sainte Anne d'Apt (Vaucluse). Deux pièces exceptionnelles d'archéologie textile,' *Bulletin de la Société historique et archéologique du Périgord*, 128 (4) (2001): 607–26.

Demay, Germain, *Le costume au Moyen Age d'après les sceaux* (Paris: Libraire de D. Dumoulin et Co., 1880. 2nd edn, intro. by Jean-Bernard de Vaivre, Paris, 1978).

_____ , *Inventaire des sceaux de Normandie recueillis dans les depôts d'archives, musées et collections particulières du départements du Seine-Inférieure, du Calvados, de l'Eure; de la manche et de l'Orne avec une introduction sur la Paléographie des sceaux et seize planches photoglyptiques* (Paris: Imprimerie nationale, 1881).

_____ , *Inventaire des sceaux de l'Artois et de la Picardie, recueillis dans les depôts d'archives, musées et collections particulières des départements du Pas-de-Calais, de l'Oise, de la Somme, de l'Aisne, avec un catalogue des pierres gravées ayant servi a sceller, et vingt-quatre planches photoglyptiques* (Paris: Imprimerie nationale, 1877).

_____ , *Inventaire des sceaux de Flandre recueillis dans les depôts d'archives, musées et collections particulières du département du Nord, ouvrage accompagné de trente planches photoglyptiques* (2 vols, Paris: Imprimerie nationale, 1873).

Depraetere-Dargery, Monique, *Tissu et vêtement, 5000 ans de savoir-faire* (Guiry-en-Vexin: Musée archéologique départemental du Val-d'Oise, 1986).

Desrosiers, Sophie, and Gabriel Vial, with Daniël De Jonghe, 'Cloth of Aresta, A Preliminary Study of its Definition, Classification, and Method of Weaving,' *Textile History*, 20 (2) (1989): 199–223.

Deurbergue, M., *Les sceaux des dames jusqu'en 1350 specialement en Ile-de-France*, thesis, Ecole des Chartes (Paris, 1966).

Dodds, Jerrilyn D., et al., *The Art of Medieval Spain, AD 500–1200* (New York: Metropolitan Museum of Art, 1993).

Doherty, Anne Claire, *Burgundian Sculpture in the Middle of the Twelfth Century: Its Relationship to Sculpture in the Ile-de-France and Neighboring Provinces*, PhD dissertation (University of Wisconsin-Madison, 1980).

Doig, Allan, *Liturgy and Architecture from the Early Church to the Middle Ages* (Aldershot: Ashgate, 2008).

Douët d'Arcq, Louis Claude, *Inventaire de la collection des sceaux des Archives nationales* (Paris: Plon, 1863–68).

Dressler, Rachel, *Of Armor and Men in Medieval England: The Chivalric Rhetoric of Three English Knights' Effigies* (Aldershot: Ashgate, 2004).

Duby, Georges, *Hommes et structures du Moyen Age* (Paris: Presses universitaires du France, 1984).

——— , *The Three Orders, Feudal Society Imagined*, trans. Arthur Goldhammer (Chicago: University of Chicago Press, 1978; 1980).

Duby, Georges, Xavier Barral i Altet, Sophie Guillot de Suduiraut, *Sculpture, the Great Art of the Middle Ages from the Fifth to the Fifteenth Century* (Geneva: Editions d'Art Albert Skira SA, 1990).

Dufour, Jean, *Recueil des actes de Louis VI, roi de France (1108–1137)*, Chartes et diplômes relatifs à l'histoire de France (Paris: Diffusion de Boccard, 1994).

Dumas, Auguste, *Histoire du droit français* (Marseilles: Impr. ASB, 1978), vol. 6.

Durliat, Marcel, *L'art roman* (Paris: Maznod, 1982).

Dutheil, Jean-Noel, *Mille ans d'histoire, les carrières de France* (Foyer laïc de Coulandon) (Coulandon, Allier, 1984).

Dutrait, Liliane, 'Les voies romaines,' *Prehistoire et archéologie*, 40 (March 1982): 20–36.

Egan, Geoff, and Frances Pritchard, *Dress Accessories c.1150–c.1450* (London: HMSO, 1991).

Egeria, *Egeria's Travels to the Holy Land*, trans. John Wilkinson (Warminster: Aris & Phillips, 1999).

El Cheikh, Nadia, 'Rūm,' in *The Encyclopaedia of Islam. Glossary and Index of Terms*, vol. 8 (Leiden: Brill, 2006), p. 601a.

Elsberg, H.A., and R. Guest, 'The Veil of Saint Anne,' *Burlington Magazine*, 68 (396) (1936): 140, 144–5, 147.

Enlart, Camille, *Manuel d'archéologie française depuis les temps mérovingiens jusqu'à la Renaissance*, vol. 3, *Le costume* (Paris: Auguste Picard, 1916).

Entretiens du patrimoine, *Architecture et decors peint: Amiens, octobre 1989* (Paris: Ministère de la culture de la communication des grands travaux et du bicentenaire, 1990).

Erlande-Brandenburg, Alain, 'Une tête de prophète provenant de l'abbatiale de Saint-Denis portail de droite de la façade occidentale,' in *Comptes rendus de l'Académie des Inscriptions et Belles-Lettres* (Paris: Diffusion de Boccard, July–October 1992), pp. 515–42.

_____ , *L'art gothique* (Paris: Editions d'Art Lucien Mazenod, 1983).

_____ , 'Un gisant royal du milieu du XIIe siècle provenant de Saint-Germain-des-Prés à Paris,' *Bulletin archéologique*, 15 (1979) (Paris, 1982): 33–50.

_____ , *Les sculptures de Notre-Dame de Paris au* musée de Cluny (Paris: Editions de la Renunion des musées nationaux, 1982).

_____ , *Les sculptures de Notre-Dame de Paris récemment découvertes* (Paris: Musée de Cluny, 1977).

_____ , *Le roi est mort, étude sur les funérailles les sépultures et les tombeaux des rois de France jusqu'à la fin du XIIIe siècle* (Paris: CNRS, 1975).

Evans, Helen C., and William D. Wixom (eds), *The Glory of Byzantium: Art and Culture of the Middle Byzantine Era AD 843–1261* (New York: Metropolitan Museum of Art, 1997).

Evans, Joan, *Dress in Mediaeval France* (Oxford: Clarendon Press, 1952).

Evergates, Theodore, *The Aristocracy in the County of Champagne, 1100–1300* (Philadelphia: University of Pennsylvania Press, 2007).

_____ , *Aristocratic Women in Medieval France* (Philadelphia: University of Pennsylvania Press, 1999).

_____ , *Feudal Society in Medieval France. Documents from the County of Champagne* (Philadelphia: University of Pennsylvania Press, 1993).

_____ , *Feudal Society in the Bailliage of Troyes under the Counts of Champagne, 1152–1284* (Baltimore: Johns Hopkins University Press, 1975).

Falke, Otto von, *Decorative Silks* (New York: William Helburn, 1936).

Fassler, Margot, *The Virgin of Chartres, Making History through Liturgy and the Arts* (New Haven CT and London: Yale University Press, 2010).

_____ , '*Adventus* at Chartres. Ritual Models for Major Processions,' in Nicholas Howe (ed.), *Ceremonial Culture in Pre-Modern Europe* (Notre Dame IN: University of Notre Dame Press, 2007), pp. 13–62.

_____ , 'Liturgy and Sacred History in the Twelfth-Century Tympana at Chartres,' *The Art Bulletin*, 75 (3) (September 1993): 499–520.

Fawtier, Robert, *The Capetian Kings of France, Monarchy and Nation (987–1328)*, trans. Lionel Butler and R.J. Adam (London: Macmillan, 1964).

Fleury, M., 'Découvertes à Notre-Dame de Paris,' *Archéologia*, 183 (October 1983): 14–15.

Flury-Lemberg, Mechthild, *Au sujet de quatre vêtements sacerdotaux au Moyen-Age et de leur conservation* (Bern: Abegg-Stiftung Riggisberg, 1987).

Formigé, Jules, *L'abbaye royale de Saint-Denis, recherches nouvelles* (Paris: Presses universitaires de France, 1960).

Forsyth, Ilene H., 'The Vita Apostolica and Romanesque Sculpture: Some Preliminary Observations,' *Gesta*, 25 (1) (1986): 75–82.

Fortescue, Adrian, *The Ceremonies of the Roman Rite Described* (London: Burns & Oates, 1918).

Foys, Martin, *The Bayeux Tapestry on CD-ROM* (Scholarly Digital Editions CD-ROM), 8 November 2002.

Freedberg, David, *The Power of Images, Studies in the History and Theory of Response* (Chicago: University of Chicago Press, 1989).

Gaborit, Jean René, *Great Gothic Sculpture*, trans. Carole Sperri and Lucia Wildt (Milan: Reynal, 1978).

Gaignières, Roger de, *Les dessins d'archéologie de Roger de Gaignières, publiés sous les auspices et avec le concours de la Société d'histoire de l'Art français par Joseph Guibert, conservateur-adjoint du cabinet des estampes à la bibliothèque nationale* (Paris: Berthaud Frères, 1911).

Gardner, Arthur, *An Account of Medieval Figure-Sculpture in England* (Cambridge: Cambridge University Press, 1951).

Garnier, François, *Le langage de l'image au Moyen Age*, vol. 2, *Grammaire des gestes* (Paris: Le Léopard d'Or, 1984).

Gaspari, Françoise, *Le XIIᵉ siècle, Mutations et renouveau en France dans la première moitié du XIIe siècle* (Paris: Cahiers du Léopard d'Or, 1994).

Gay, Victor, *Glossaire archéologique du Moyen Age et de la Renaissance*, ed. H. Stein (2 vols, Paris: Editions Auguste Picard, 1928).

Geary, Patrick, *Phantoms of Remembrance: Memory and Oblivion at the End of the First Millennium* (Princeton: Princeton University Press, 1994).

Geijer, Agnes, *A History of Textile Art, a Selective Account* (New York: Sotheby Parke Bernet, 1979).

Gerson, Paula Lieber, 'Suger as Iconographer: The Central Portal of the West Façade of Saint-Denis,' in Paula Gerson (ed.), *Abbot Suger and Saint-Denis. A Symposium* (New York: Metropolitan Museum of Art, 1986).

⸺ (ed.), *Abbot Suger and Saint-Denis. A Symposium* (New York: Metropolitan Museum of Art, 1986).

Gervers, Michael, 'The Textile Industry in Essex in the Late 12th and 13th Centuries: A Study based on Occupational Names in Charter Sources,' *Essex Archaeology and History*, series 3, vol. 20 (1989): 34–73. The University of Toronto DEEDS (Documents of Early England Data Set) Research Project.

Gervers, Veronika, 'Medieval Garments in the Mediterranean World,' in N.B. Harte and K.G. Ponting (eds), *Cloth and Clothing in Medieval Europe* (London: Heinemann Educational, 1983), pp. 279–315.

⸺ (ed.), *Studies in Textile History in Memory of Harold B. Burnham* (Toronto: Royal Ontario Museum, 1977).

Giesey, Ralph E., 'Two Inaugural Aspects of French Royal Ceremonials,' in János M. Bak (ed.), *Coronations Medieval and Early Modern Monarchic Ritual* (Berkeley: University of California Press, 1990). Available at <http://ark.cdlib.org/ark:/13030/ft367nb2f3/> (accessed 6 June 2007).

Gilissen, John, 'The Notion of the Fair in the Light of the Comparative Method,' in *La foire. Recueils de la Société Jean Bodin*, V (Paris, 1983), pp. 333–42.

Gillerman, Dorothy, 'The Materials of Gothic Sculpture,' in *Gothic Sculpture in America*, vol. 1, *The New England Museums* (New York: Garland, 1989), p. xi.

Gimpel, Jean, *The Medieval Machine, the Industrial Revolution of the Middle Ages.* (London: Victor Gollancz, 1977).

Giscard d'Estaing, François, Michel Fleury, and Alain Erlande-Brandenburg, *Les rois retrouvés* (Paris, pr. in Bienne, Switzerland: Weber, 1977).

Goddard, Eunice R., *Women's Costume in French Texts of the Eleventh and Twelfth Centuries* (Baltimore: Johns Hopkins University Press; and Paris: Presses universitaires de France, 1927).

Goldsheider, Cecile, 'Les origines du portail à statues-colonnes,' *Bulletin des musées de France*, 11 (August–September 1946): 22–5.

Goitein, Shelomoh Dov, *Letters of Medieval Jewish Traders* (Princeton: Princeton University Press, 1973).

_____ , *A Mediterranean Society – The Jewish Communities of the Arab World as Portrayed in the Documents of the Cairo Geniza* (2 vols, Berkeley and Los Angeles: University of California Press, 1967).

Golombek, Lisa, and Veronika Gervers, 'Ṭiraz Fabrics in the Royal Ontario Museum,' in Veronica Gervers (ed.), *Studies in History in Memory of Harold B. Burnham* (Toronto: Royal Ontario Museum, 1977), pp. 82–93.

Goy, Jean, 'Les reliques de saint Remi apôtre des Francs,' in Michel Rouche (ed.), *Clovis, histoire et mémoire* (Paris: Presses de l'Université de Paris-Sorbonne, 1997), pp. 649–58.

Grandjean, Suzenne, *Le costume féminin en France depuis le milieu du XIIe siècle jusqu'à la mort de Charles VI (1150–1422)*, Positions de thèses de l'Ecole [nationale] de Chartes, 1941.

Granger-Taylor, Hero, 'The Construction of Tunics,' in Clive Rogers (ed.), *Early Islamic Textiles* (Brighton: Rogers & Podmore, 1983), pp. 10–12.

Grant, Lindy, *Abbot Suger of St.-Denis: Church and State in Early Twelfth-Century France* (London and New York: Longman, 1998).

Grodecki, Louis, 'Sculpture gothique,' *Art de France*, vol. 1 (Paris: Herman, 1961), pp. 271–3.

_____ , 'La "première sculpture gothique". Wilhelm Vöge et l'état actuel des problèmes,' *Bulletin monumental*, 117 (4) (1959): 265–89.

_____ , 'A propos de la sculpture française autour de 1200,' *Bulletin monumental*, 115 (2) (1957): 119–26.

Grönwoldt, Ruth, 'Miszellen zur Textilkunst der Stauferzeit,' *Die Zeit der Saufer*, vol. 5 (Stuttgart: Württembergesches Landesmuseum, 1979): 388–405.

Guibert of Nogent, *Gesta Dei per Francos, Recueil des historiens des croisades: historiens occidentaux*, ed. Académie des inscriptions et belles-lettres (4 vols, Paris, 1879).

Guini-Skliar, Ania, 'Les carrières parisiennes aux frontières de la ville et de la campagne,' *Histoire urbaine*, 2003/2/8 (2003): 41–56.

_____ , Marc Viré, Jacqueline Lorenz, Jean-Pierre Gély, and Annie Blanc, *Les souterraines de Paris: les anciennes carrières souterraines* (Cambrai: Nord Patrimoine Editions, 2000).

Hahn, Cynthia. 'VISIO DEI, Changes in Medieval Visuality,' in Robert S. Nelson (ed.), *Visuality Before and Beyond the Renaissance: Seeing as Others Saw* (New York: Cambridge University Press, 2000), pp. 169–96.

Halfren, Roland, *Chartres, Schopfungsban un Ideevelt*, vol. 1, *Das Konigsportal* (4 vols, Stuttgart and Berlin: Mayer, 2001).

Hallam, Elizabeth M., *Capetian France 987–1328* (London and New York: Longman 1980).

Halsall, Paul, 'Fiefs and Jurisdiction,' *The Medieval Sourcebook* (1996). Available at <http://www/fordham.edu/halsall//source/feud-fief2.htmml> (accessed 3 October 2008).

Hamann McLean, Richard, 'Les origines des portails et façades sculptés gothiques,' *Cahiers de civilization medievale*, 2 (1959): 157–75.

Hammarlund, Lena, and Kathrine Vestergaard Pedersen, 'Textile Appearance and Visual Impression – Craft Knowledge applied to Archaeological Textiles.' Available at <http://www.textilarkeolog.dk/nesat.pdf>, pp. 1–7.

Hanawalt, Barbara A., and Michel Kobialka (eds), *Medieval Practices of Space* (Minneapolis: University of Minnesota Press, 2000).

Harris, Jennifer M., '"Thieves, Harlots and Stinking Goats": Fashionable Dress and Aesthetic Attitudes in Romanesque Art,' *Costume*, 5 (21) (1987): 4–15.

––––– , *The Development of Romanesque-Byzantine Elements in French and English Dress 1050–1180*, PhD thesis (Manchester: University of Manchester, 1977).

Harte, N.B., and Kenneth G. Ponting, *Cloth and Clothing in Medieval Europe. Essays in Memory of Professor E.M. Carus-Wilson*, Pasold Studies in Textile History 2 (London: Heinemann Educational, 1983).

Hartog, E. den, *Romanesque Architecture and Sculpture in the Meuse Valley* (Leeuwarden/Mechelen: Eisma, 1992).

Hearn, Millard Filmore, *Romanesque Sculpture, The Revival of Monumental Stone Sculpture in the Eleventh and Twelfth Centuries* (Ithaca NY: Cornell University Press, 1981).

Henri, Comte de Paris (with Gaston Ducheta-Suchaux), *Les rois de France et le sacre* (Paris: Editions du Rodier, 1996).

Herlihy, David, *Opera Mulibria, Women and Work in Medieval Europe* (Philadelphia: Temple University Press, 1990).

––––– , 'The Agrarian Revolution in Southern France and Italy, 801–1150,' *Speculum*, 33 (1958): 23–37.

Herzfeld, Ernst, *Die Malereien von Samarra* (Berlin: Verlag Dietrich Reimer/Ernst Vohsen, 1927).

Heslop, T.A., 'Seals,' in *English Romanesque Art 1066–1200*, Hayward Gallery #337 (London: Arts Council of Great Britain, 1984), pp. 298–319.

Hill, Margot Hamilton, and Peter A. Bucknell, *The Evolution of Fashion, Pattern and Cut from 1066 to 1930* (London: B.T. Batsford, 1967).

Hodges, Richard, and David Whitehouse, *Mohammed, Charlemagne and the Origins of Europe: Archaeology and the Pirenne Thesis* (London: Duckworth, 1983).

Hollander, Anne, *Seeing Through Clothes* (New York: Viking Press, 1978).

Hollister, C. Warren, and John W. Baldwin, 'The Rise of Administrative Kingship: Henry I and Philip Augustus,' *American Historical Review*, 83 (1978): 867–905.

Holmes, Lore L., report to Janet Snyder from Lore Holmes, January, 1999.

––––– , 'filename SNYDER.LIS' from Lore Holmes, 7 December 1998.

_____ , 'Limestone Sculpture Provenance Project Reports and Memoranda': 30 October 1995; 6 March 1995; 9 March 1995; 24 April 1995; 4 December 1995; 4 May 1992; 10 October 1995; 9 July 1993; 11 January 1996.

_____ , unpublished report, 'Memorandum, 10 October 1995, STMAUR-DVJ.R137,' pp. 1–3.

_____ , 'Memorandum, 9 March 1995, filename: CHARTR-AP.R109,' p. 4.

_____ and Garman Harbottle, 'Compositional Fingerprinting: New Directions in the Study of the Provenance of Limestone,' *Gesta*, 33 (1) (1994): 10–18.

_____ , Charles T. Little, and Edward V. Sayre, 'Elemental Characterization of Medieval Limestone Sculpture from Parisian and Burgundian Sources,' *Journal of Field Archaeology*, 13 (1986): 420.

Horste, Kathryn, 'A Child is Born': The Iconography of the Portail Sainte-Anne at Paris,' *Art Bulletin*, 69 (2) (June 1987): 187–210.

Houben, Hubert, *Roger II of Sicily; A Ruler between East and West* (Cambridge: Cambridge University Press, 2002).

Howe, Nicholas (ed.), *Ceremonial Culture in Pre-Modern Europe* (Notre Dame IN: University of Notre Dame Press, 2007), pp. 13–62.

Hugh of Saint Victor, *The Didascalicon of Hugh of Saint Victor, A Medieval Guide to the Arts*, trans. Jerome Taylor (New York: Columbia University Press, 1961).

Hutchinson, Gillian, *Medieval Ships and Shipping* (Rutherford NJ: Fairleigh Dickinson University Press, 1994).

Huyghe, René, *Larousse Encyclopedia of Byzantine and Medieval Art* (New York: Prometheus Press, 1958).

Institut du Monde Arabe, *Terres secrètes de Samarcande, Ceramiques du VIIIe au XIIIe siècle* (Paris: Institut du Monde Arabe, 1992).

Jackson, Richard A., *'Ordines coronationis Franciae': Texts and Ordines for the Coronation of Frankish and French Kings and Queens in the Middle Ages* (2 vols, Philadelphia: University of Pennsylvania Press, 1995–2000).

_____ , *Vive le roi! A History of the French Coronation from Charles V to Charles XI* (Chapel Hill: University of North Carolina Press, 1984).

Jacoby, David, *Commercial Exchange Across the Mediterranean: Byzantium, the Crusader Levant, Egypt, and Italy* (Aldershot: Ashgate Variorum, 2005).

_____ , 'The Production of Silk Textiles in Latin Greece,' in *Commercial Exchange Across the Mediterranean: Byzantium, the Crusader Levant, Egypt, and Italy* (Aldershot: Ashgate Variorum, 2005), 22–35.

_____ , 'Silk Economics and Cross-Cultural Artistic Interaction: Byzantium, the Muslim World, and the Christian West,' *Dumbarton Oaks Papers*, 58 (2004), pp. 197–240.

_____ , lecture during *Byzantine Textile Study Day*, British Museum, 11 April 1995.

_____ , 'Silk in Western Byzantium before the Fourth Crusade,' *Byzantinische Zeitschrift*, 84–5 (1991–92): 452–500.

Jenkins, H.J.K., 'Medieval Barge Traffic and the Building of Peterborough Cathedral,' *Northamptonshire Past and Present*, 8 (1992–93): 255–61.

Jenkins, Marilyn, 'Al-Andalus: Crucible of the Mediterranean,' in J.D. Dodds et al. (eds), *The Art of Medieval Spain, AD 500–1200* (New York: Metropolitan Museum of Art, 1993), p. 81.

John of Salisbury, *The Metalogicon, A Twelfth-Century Defense of the Verbal and Logical Arts of the Trivium*, trans. Daniel D. McGarry (Berkeley: University of California Press, 1955).

Joubert, Fabienne, *La sculpture gothique en France: XIIe–XIIIe siècles* (Paris: Picard, 2008).

——— , 'Recent Aquisitions, Musée de Cluny, Paris, Tête de Moïse provenant du portail de droite de Saint-Denis,' *Gesta*, 28 (1) (1989): 107.

——— , 'Une tête provenant de la basilique de Saint-Denis récemment acquise par le Musée de Cluny,' *Bulletin monumental*, 146 (1988): 359.

Joubert, Fabienne, Dany Sandron, and Anne Prache, *Pierre, lumière, couleur: études d'histoire de l'art du Moyen Age en l'honneur d'Anne Prache* (Paris: Presses de l'Université de Paris-Sorbonne, 1999).

Kahn, Deborah, 'The West Doorway at Rochester Cathedral,' in *Romanesque and Gothic: Essays for George Zarnecki* (Woodbridge and Wolfboro NH: Boydell Press, 1987), pp. 129–34.

Kantorowicz, Ernst H., *The King's Two Bodies, A Study in Mediaeval Political Theology* (Princeton: Princeton University Press, 1957).

——— , 'The "King's Advent" and Enigmatic Panels in the Doors of S. Sabina,' *Art Bulletin*, 26 (1944): 207–31.

Katzenellenbogen, Adolf, *The Sculptural Programs of Chartres Cathedral: Christ, Mary, Ecclesia* (Baltimore: Johns Hopkins University Press, 1959).

Kenny, Michael G., 'A Place for Memory: The Interface between Individual and Collective History,' *Comparative Studies in Society and History*, 41 (3) (July 1999): 420–37.

Kidson, Peter, 'Panofsky, Suger, and Saint-Denis,' *Journal of the Warburg and Courtauld Institutes*, 50 (1987): 1–17.

——— , *Sculpture at Chartres* (London: Alec Tiranti, 1958).

Kimpel, Dieter, 'Le développement de la taille en série dans l'architecture médiévale et son rôle dans l'histoire économique,' *Bulletin monumental*, 85 (1977): 195–222.

——— and Robert Suckale, *Die gotische Architektur in Frankreich 1130–1270* (Munich: Hirmer Verlag, 1985).

Kipling, Gordon, *Enter the King: Theatre, Liturgy, and Ritual in the Medieval Civic Triumph* (Oxford: Clarendon Press, 1998).

Kitzinger, Ernst, 'The Mosaics of the Capella Palatina in Palermo: An Essay on the Choice and Arrangement of Subjects,' *Art Bulletin*, 31 (1949): 269–92.

Klinkenberg, Emanuel, 'Die Identität der Säulenstatuen in Etampes und Chartres,' *Zeitschrift für Kunstgeschichte*, 71 (2008): 145–87.

Kortekaas, G.A.A., *Historia Apollonii Regis Tyri, Prolegomena: Text Edition of the Two Principal Latin Recensions, Bibliography, Indices and Appendices* (Groningen: Bouma's Boekhuis, 1984).

Koziol, Geoffrey, 'Political Culture,' in Marcus Bull (ed.), *France in the Central Middle Ages 900–1200* (Oxford and New York: Oxford University Press, 2002), pp. 43–76.

_____ , 'England, France, and the Problem of Sacrality in Twelfth-Century Ritual,' in Thomas N. Bisson (ed.), *Cultures of Power: Lordship, Status, and Process in Twelfth-Century Europe* (Philadelphia: University of Pennsylvania Press, 1995), pp. 124–8.

_____ , *Begging Pardon and Favor: Ritual and Political Order in Early Medieval France* (Ithaca NY and London: Cornell University Press, 1992).

Krautheimer, Richard, 'Introduction to an "Iconography of Mediaeval Architecture",' *Journal of the Warburg and Courtauld Institutes*, 5 (1942): 1–33.

Kretzmann, Norman, 'The Culmination of the Old Logic in Peter Abelard,' in Robert L. Benson and Giles Constable (eds), *Renaissance and Renewal in the Twelfth Century* (Cambridge MA: Harvard University Press, 1982), pp. 488–511.

Krueger, Hilmar C., 'The Wares of Exchange in the Genoese–African Traffic of the Twelfth Century,' *Speculum*, 12 (1937): 57–71.

_____ , 'Genoese Trade with Northwest Africa in the Twelfth Century,' *Speculum*, 8 (1933): 377–95.

Lane, Evelyn Staudinger, 'The Integration of a Twelfth-Century Tower into a Thirteenth-Century Church: The Case of Notre-Dame de Donnemarie-en-Montois,' *Journal of the Society of Architectural Historians*, 64 (1) (March 2005): 74–99.

Lapeyre, André, *Des façades occidentales de Saint-Denis et de Chartres aux portails de Laon; études sur la sculpture monumental dans l'Ile de France et les régions voisines au XIIe siècle*, Thèse principale pour le doctorat ès lettres présentée à la faculté des lettres del'université de Paris, 1960 (Paris: Université de Paris, 1960).

Laurent, Henri, *Un grand commerce d'exportation au Moyen-Âge: la draperie des Pays-Bas en France et dans les pays méditerranéens, XIIe–XVe siècle* (Paris: Librairie E. Droz, 1935).

Lehmann-Brockhaus, Otto, *Lateinische Schriftquellen zur Kunst in England, Wales und Schottland vom Jahre 901 bis zum Jahre 1307* (5 vols, Munich: Prestel Verlag, 1955–60).

Leighton, Albert C., *Transport and Communication in Early Medieval Europe AD 500–1100* (Newton Abbot: David & Charles, 1972).

Leix, Alfred, 'Trade Routes of the Middle Ages; Medieval Dye Markets in Europe; Oriental Dye Markets: Dyeing Techniques, etc.,' *Ciba Review*, 10 (June 1938): 314–48.

_____ , 'Dyes of the Middle Ages,' and 'Dyeing and Dyers' Guilds in Medieval Craftsmanship,' *Ciba Review*, 1 (September 1937): 16–25.

Lévis-Godechot, Nicole, *Chartres révélée par sa sculpture et ses vitraux* (Paris: Zodiac, 1987).

Lewis, Andrew W., 'Suger's Views on Kingship,' in Paula Gerson (ed.), *Abbot Suger and Saint-Denis. A Symposium* (New York: Metropolitan Museum of Art, 1986), pp. 49–54.

_____ , *Royal Succession in Capetian France: Studies on Familial Order and the State* (Cambridge MA: Harvard University Press, 1981).

Lewis, Archibald, 'Byzantium as an Integral Part of European Christendom: Political and Military Factors, 568–1204 AD,' in *The Sea and Medieval Civilizations*, essay 14, 1–12 (London: Variorum Reprints, 1978).

Lightbown, Ronald W., *Mediaeval European Jewellery, with a Catalogue of the Collection in the Victoria and Albert Museum* (London: Victoria and Albert Museum, 1992).

Little, Charles T., '13. Head of King David,' in Charles Little (ed.), *Set in Stone: The Face in Medieval Sculpture* (New York: Metropolitan Museum of Art, 2006), pp. 50–51.

_____ , 'Searching for the Provenances of Medieval Stone Sculpture: Possibilities and Limitations,' *Gesta*, 33 (1) (1994): 29–37.

_____ , 'Relief with the Adoration of the Magi,' in J.D. Dodds et al. (eds), *The Art of Medieval Spain, AD 500–1200* (New York: Metropolitan Museum of Art, 1993), p. 287.

_____ , 'Column Figure of a Nimbed King, From the Old Cloister,' in Paula Gerson (ed.), *The Royal Abbey of Saint-Denis in the Time of Abbot Suger (1122–1151)* (New York: Metropolitan Museum of Art, 1981).

_____ (ed.), *Set in Stone: The Face in Medieval Sculpture* (New York: Metropolitan Museum of Art, 2006).

Little, Charles T., with David Simon and Leslie Bussis, 'Romanesque Sculpture in North American Collections. XXV. The Metropolitan Museum of Art. Part V. Southwestern France,' *Gesta*, 26 (1) (1987): 61–75.

Limestone Sculpture Provenance Project, available at <http://www/medievalart.org/limestone>.

Liu, Xinru, *Silk and Religion, An Exploration of Material Life and the Thought of People (600–1200)* (New York: Oxford University Press, 1996).

Livas, Charles de (Chevalier), 'Rapport sur les anciens vêtements sacerdotaux et les anciennes étoffes du Trésor de Sens,' *La revue des sociétés savantes*, 2 (1857).

Lombard, Maurice, *Etudes d'économie médiévale*, vol. 3, *Les textiles dans le monde musulman du VIIe au XIIe siècle*, Civilisations et Sociétés 61 (Paris: Mouton Editeur, 1978).

Lopez, Robert S., *The Commercial Revolution of the Middle Ages 950–1350* (Englewood Cliffs NJ: Prentice-Hall, 1971).

_____ , 'Silk Industry in the Byzantine Empire,' *Speculum*, 20 (1) (January 1945): 1–42.

_____ and Irving W. Raymond, *Medieval Trade in the Mediterranean World* (New York: Columbia University Press, 1955).

LoPrete, Kimberly A., 'Adèla of Blois: Familial Alliances and Female Lordship,' in Theodore Evergates (ed.), *Aristocratic Women in Medieval France* (Philadelphia: University of Pennsylvania Press, 1999).

Lorenz, Claude, and Jacqueline Lorenz, with Annie Blanc, 'Observations stratigraphiques et sédimentologiques sur le calcaire grossier Lutétien des anciennes carrières du Val-de-Grâce à Paris,' *Bulletin d'information des géologues du Bassin de Paris*, 19 (4) (1982): 3–13.

Lorenz, Jacqueline, Paul Benoît, and Daniel Obert, *Pierres et carrières: géologie, archéologie, histoire: textes réunis en hommage à Claude Lorenz: actes des journées Claude Lorenz, Paris, Centre de recherches historiques et juridiques de l'Université Paris I, 17 et 18 novembre 1995* (Paris: Association des géologues du Bassin de Paris, Editeur AEDEH, 1997).

Louvre, Musée du, *Byzance, L'art byzantin dans les collections publiques français* (Paris: Editions de la réunion des musées nationaux, 1992).

Luchaire, Achille, *Louis VI le Gros, annales de sa vie et de son règne (1081–1137)* (Paris: Librarie des Archives nationales et de la Société de l'École des chartes 1890; repr. Brussels, Culture et Civilisation, 1964).

_____ , *Etudes sur les Actes de Louis VII; histoire des institutions monarchiques de la France sous les premiers capétiens (mémoires et documents)* (Paris: Libraire des Archives nationales et de la Société de l'École des chartes, 1885).

Luetkens, Charlotte, 'Forerunners of the Exchange,' *Ciba Review*, 19 (March 1939): 665–71.

Mabillon, Dom Jean, *Annales Ordinis S. Benedicti Occidentalium Monachorum Patriarchae. In quibus non modò res monasticae, sed etiam ecclesiasticae historiae non minima pars continetur* (6 vols, Paris, 1703–39).

MacGregor, Arthur, *Bone, Antler, Ivory and Horn, The Technology of Skeletal Materials since the Roman Period* (Totowa NJ: Barnes & Noble, 1985).

Madou, Mireille, *Le costume civil* (Turnhout: Brepols, 1986).

Maines, Clark, *The Western Portal of Saint-Loup-de-Naud*, PhD dissertation, University Park: Pennsylvania State University (New York: Garland, 1979).

_____ , 'A Figure of St. Thomas Becket at Chartres,' *Zeitschift für Kunstgeschichte*, 36 (1973): 163–73.

Malone, Carolyn, 'Saint-Bénigne in Dijon as Exemplum of Rodulfus Glaber's Metaphoric "White Mantle",' in Nigel Hiscock (ed.), *The White Mantle of Churches* (Turnhout: Brepols, 2003), pp. 160–79.

Mâle, Emile, 'The Senlis Portal and its Influence,' in *Art and Artists of the Middle Ages*, trans. Sylvia Stallings Lowe (Redding Ridge CT: Black Swan Books, 1986), pp. 50–163.

_____ , *Religious Art in France, The Twelfth Century, A Study of the Origins of Medieval Iconography* (Princeton: Princeton University Press, 1978).

Mann, Janice, 'Majestat Batlló,' in J.D. Dodds et al. (eds), *The Art of Medieval Spain, AD 500–1200* (New York: Metropolitan Museum of Art, 1993), pp. 322–3.

Mann, Vivian Beth, 'Mythological Subjects on Northern French Tablemen,' *Gesta*, 20 (1) (1981): 161.

_____ , *Romanesque Ivory Tablemen*, PhD dissertation (New York University, 1977).

Mantz, Paul, *La peinture française du IXe siècle à la fin du XVIe* (Paris, 1897).

Marie de France, *Fables*, ed. and trans. Harriet Spiegel (Toronto: University of Toronto Press, 1987).

_____ , *The Lais of Marie de France*, trans. Robert Hanning and Joan Ferrante (Durham NC: Labyrinth Press, 1978).

Martin, Rebecca, *Textiles in Daily Life in the Middle Ages* (Cleveland: Cleveland Museum of Art/Indiana University Press, 1985).

Martiniani-Reber, Marielle, 'Les textiles IXe–XIIe siècle,' in *Byzance: L'art byzantin dans les collections publiques français*, Musée du Louvre (Paris: Editions de la Réunion des musées nationaux, 1992): pp. 370–80.

_____ , *Lyon, musée historique des tissus: Soieries sassanides, coptes et byzantine, Ve–XIe siècles* (Paris: Ministère de la Culture et de la Communication, 1986).

May, Florence Lewis, *Silk Textiles of Spain, Eighth to Fifteenth Century* (New York: Hispanic Society of America, 1957).

Mazzaouzi, Maureen Fennell, *The Italian Cotton Industry of the Later Middle Ages, 1100–1600* (Cambridge and New York: Cambridge University Press, 1981).

McAleer, J. Philip, *Rochester Cathedral, 604–1540, An Architectural History* (Toronto, Buffalo, and London: University of Toronto Press, 1999).

——— , 'The Significance of the West Front of Rochester Cathedral,' *Archaeologia Cantiana*, 99 (1984): 139–58.

Meier, Dirk, *Seafarers, Merchants and Pirates in the Middle Ages*, trans. Angus McGeogh (Woodbridge: Boydell Press, 2006).

Mérindol, Christian de, 'Signes de hiérarchie sociale a la fin du moyen âge d'après le vêtement méthodes et recherches,' in Michel Pastoureau (ed.), *Le vêtement: Histoire, archéologie et symbolique vestimentaires au Moyen Age*, Cahiers du Léopard d'Or (Paris: Editions Léopard d'Or, 1989), pp. 181–223.

Mickenberg, David, *Songs of Glory, Medieval Art from 900 to 1500* (Oklahoma City: Oklahoma Museum of Art, 1985).

Migeon, Gaston, *Les arts du tissu* (Paris: Librairie Renouard, 1909).

Migne, J.-P. (Abbé), *Saeculum XII Sugerii, Abbatis s. Dionysii, Opuscula et Epistolae Patrologiae Cursus Completus. Omnium SS. Patrum, Doctorum, Scriptorumque Ecclesiasticorum sive latinorum, sive graecorum* (Turnhout: Brepols, 1843).

Milne, Gustav, *Timber Building Techniques in London, c.900–1400*, Special Paper 15 (London and Middlesex Archaeological Society, 1992).

Les miracles de saint Augustin de Cantorbéry, 'Goscelini Miracula sancti Augustini episcopi Cantuariensis,' in *Acta Sanctorum quotquot toto orbe coluntur, vel à catholicis scriptoribus celebrantur quae ex Latin & Graecis, aliarumque gentium antiquis monumentis. Collegit, digessit, notis illustravit Joannes Bolandus* [1596–1665] …; *operam et studium contulit Godefridus Henschenius* [1601–81] (Brussels: Culture et Civilisation, 1965), Mai, V, 398–9, c. 16 à 20; 399, c. 23.

Molesworth, H.D., *Sculpture in England: Mediaeval* (London: Longmans, Green, 1951).

Montfaucon, Dom Bernard de, *Les monumens de monarchie française, qui comprennent l'histoire de France* (Paris, 1729).

Morby, John E., *Dynasties of the World* (Oxford: Oxford University Press, 2002).

Morrison, K., *History as Visual Art in the Twelfth-Century Renaissance* (Princeton: Princeton University Press, 1990).

Mortet, Victor, and Paul Deschamps, *Recueil de textes relatifs à l'histoire de l'architecture, XIIe–XIII siècles* (Paris: A Picard, 1911; 1929).

Müller-Christensen, Sigrid, 'Examples of Mediaeval Tablet-Woven Bands,' in Veronica Gervers (ed.), *Studies in History in Memory of Harold B. Burnham* (Toronto: Royal Ontario Museum, 1977), pp. 232–7.

Murray, Stephen, *Building Troyes Cathedral, The Late Gothic Campaigns* (Bloomington: Indiana University Press, 1987).

Musset, Lucien, 'La pierre de Caen: extraction et commerce, XIe–XVe siècles,' in Odette Chapelot and Paul Benoit (eds), *Pierre et métal dans le bâtiment au Moyen Age* (Paris: Editions de l'Ecole des hautes études en sciences sociales, 1985).

Muthesius, Anna, 'The Byzantine Silk Industry: Lopez and Beyond,' *Journal of Medieval History*, 19 (1–2) (March/June 1993): 1–67.

——— , 'From Seed to Samite: Aspects of Byzantine Silk Production,' *Textile History*, 20 (2) (Autumn 1989): 135–6.

_____ , 'The Silk over the Spine of the Mondsee Gospel Lectionary,' *Journal of the Walters Art Gallery*, 37 (1978): 50–73.

Nelson, Janet L., *Charles the Bald* (London and New York: Longman, 1992).

_____ , *Politics and Ritual in Early Medieval Europe* (London and Ronceverte WV: Hambledon Press, 1986).

_____ , 'Charles the Bald in Town and Countryside,' *Church in Town and Countryside*, Studies in Church History 16 (Oxford, 1979): 103–18.

Nelson, Robert S., 'To Say and to See: Ekphrasis and Vision in Byzantium,' in Robert S. Nelson (ed.), *Visuality Before and Beyond the Renaissance: Seeing as Others Saw* (New York: Cambridge University Press, 2000), pp. 143–68.

_____ (ed.), *Visuality Before and Beyond the Renaissance: Seeing as Others Saw* (New York: Cambridge University Press, 2000).

NESAT (North European Symposium for Archaeological Textiles), *Textiles in Northern Archaeology. NESAT III: Textile Symposium in York, 6–9 May, 1987*, eds P. Walton and J.P. Wild (London: Archetype Publications, 1990).

NESAT IX, *Archaologische Textilfunde – Archaeological Textiles*, eds Antoinette Rast-Eicher and Renate Windler, Archeotex Frau A. Rast-Eicher, Ennenda (2007).

New-Smith, Ann, *Twelfth-Century Sculpture at the Cathedral of Bourges*, PhD dissertation (Boston University Graduate School, 1975).

Nicole, J., *The Book of the Eparch* (London: Variorum Reprint, 1970).

Nockert, Margarita, 'Medeltida dräkt i bild och verklighet,' in *Den Ljusa Medeltiden* (Stockholm: Museum of National Antiquities, 1984), pp. 191–6.

Nolan, Kathleen, 'Narrative in the Capital Frieze of Notre-Dame at Etampes,' *Art Bulletin*, 71 (2) (June 1989): 166–84.

Le nouveau petit Robert (Paris: Publications Robert, 1996).

Oakley, Francis, *The Medieval Experience, Foundations of Western Cultural Singularity* (Toronto, Buffalo and London: University of Toronto Press, Medieval Academy of America, 1988).

Olson, Vibeke, 'Oh Master, You are Wonderful! The Problem of Labor in the Ornamental Sculpture of the Chartres Royal Portal,' *AVISTA Forum Journal*, 13 (1) (2003): 6–13.

Orderic Vitalis, *The Ecclesiastical History of Orderic Vitalis*, ed. and trans. Marjorie Chibnall (Oxford: Oxford University Press, 1978).

Ostoia, Vera K., 'A Statue from Saint-Denis,' *Metropolitan Museum of Art Bulletin*, new series, 13 (10) (June 1955): 298–304.

Oursel, Charles, *Miniatures cisterciennes* (Macon: Impr. Protat Frères, 1960).

Pacaut, Marcel, *Louis VII et son royaume* (Paris: SEVPEN, 1964).

_____ , *Louis VII et les élections épiscopales dans le royaume de France* (Paris: Librairie Philosophique J. Vrin, 1957).

_____ , *La théocratie, L'Eglise et le pouvoir au Moyen Age* (Paris: Aubier, 1957).

Panofsky, Erwin (ed. and trans.), *Abbot Suger on the Abbey Church of Saint Denis and its Art Treasures* (Princeton: Princeton University Press, 1946; 1979).

Papadopoulo, Alexandre, *Islam and Muslim Art* (New York: Harry N. Abrams, 1979).

Parsons, David, 'Stone,' in John Blair and Nigel Ramsay (eds), *English Medieval Industries: Craftsmen, Techniques, Products* (London and Rio Grande OH: Hambledon Press, 1991), pp. 1–28.

Pastoureau, Michel, 'Introduction,' in *Le vêtement: Histoire, archéologie et symbolique vestimentaires au Moyen Age*, Cahiers du Léopard d'Or (Paris: Editions Léopard d'Or, 1989).

_____ , *La vie quotidienne en France et en Angleterre au temps des chevaliers de la table ronde (XII–XIII siècles)* (Paris: Hachette, 1976).

Paupert-Bouchez, Anne, *Blanc, rouge, or et vert: Les couleurs de la merveille dans les lais. Les couleurs au moyen age* (Aix: Centre Universitaire d'Etudes et de Recherches Médiévales d'Aix, 1988).

Payne, Blanche, *History of Costume from the Ancient Egyptians to the Twentieth Century* (New York: Harper & Row, 1965).

Petit-Dutaillis, Charles, *The Feudal Monarchy in France and England from the Tenth to the Thirteenth Century (La monarchie féodale en France et en Angleterre 10e–13e siècles)*, trans. E.D. Hunt (New York: Barnes & Noble, 1964).

Philippon, Jacques, Daniel Jeannette, and Roger-Alexandre Lefevre (eds), *La conservation de la pierre monumental en France* (Paris: CNRS, 1992).

Piltz, Elisabeth, 'Costume in Life and Death in Byzantium,' in *Le costume officiel des dignitaires byzantins à l'époque paléologue*, Figura Nova Series 26 (Uppsala: Acta Universitatis Upsaliensis, 1994), pp. 153–65.

Piponnier, Françoise, and Perrine Mane, *Dress in the Middle Ages*, trans. Caroline Beamish (New Haven and London: Yale University Press, 1997).

Pirenne, Henri, *Economic and Social History of Medieval Europe* (New York: Harcourt, Brace, 1937).

_____ , *Medieval Cities, Their Origins and the Revival of Trade* (Princeton: Princeton University Press, 1925; repr. Garden City NY: Doubleday, 1956).

Plancher, Dom Urbain, *Histoire générale et particulière de Bourgogne* (Dijon, 1739; repr. Paris: Editions du Palais Royal, 1974).

Poiret, Marie-Françoise, and Marie-Dominique Nivière, *Brou, Bourg en Bresse*, photos by Hervé Nègre (Paris: Association des Amis de Brou, Caisse Nationale des Monuments Historiques et Sites, 1990).

Pomerol, Charles, *Geology of France with Twelve Itineraries* (Paris and New York: Masson, 1980).

Pommeau, Charles, and Véronique Bonte, *A la découverte des vieux chemins* (Bellevue, Moulins: Société Scientifique du Bourbonnais, 1995).

Porter, Arthur Kingsley, *Romanesque Sculpture of the Pilgrimage Roads* (10 vols, Boston: Marshall Jones, 1923).

Postan, M.M., and E. Miller (eds), *The Cambridge Economic History of Europe*, vol. 1, *The Agrarian Life of the Middle Ages*, 2nd edn (Cambridge and New York, Cambridge University Press, 1987).

Prache, Anne, 'Une expérience d'analyse par activation neutronique sur des sculptures chartraines,' unpublished report to Medieval Congress at Leeds, 1996.

_____ , *Chartres Cathedral, Image of the Heavenly Jerusalem*, trans. Janet Abbott (Paris: Caisse nationale des monuments historiques et des sites, 1993).

_____ , *Ile-de France romane* (Paris: Zodiaque, 1989).

_____ , Hubert Collin, Marie-Clotilde Hubert, Mgr André Marsat, and Henri Ronot, *Champagne romane* (Paris: Zodiaque, 1981).

Pressouyre, Léon, 'Réflexions sur la sculpture du XIIème siècle en Champagne,' *Gesta*, 9 (2) (1970): 16–31.

Pressouyre, Sylvie, and Léon Pressouyre, *The Cloister of Notre-Dame-en-Vaux at Châlons-sur-Marne*, trans. Danielle Valin Johnson (Nancy: Editions Helio-Nancy, 1981).

Prior, Edward S., and Arthur Gardner, *An Account of Medieval Figure-Sculpture in England* (Cambridge: Cambridge University Press, 1912).

Pritchard, Frances, 'Self-Patterned Twills from Late Saxon London,' *Weavers Journal*, 130 (1984): 11–14.

Proust, Evelyne, *La sculpture romane en Bas-Limousin* (Paris: Picard, 2004).

Pugin, A. Wilby, *Glossary of Ecclesiastical Ornament and Costume, compiled from Ancient Authorities and Examples* (London: Henry G. Bohn, 1846).

Quarre, Pierre, 'Les statues de l'Atelier de Rougemont,' in *The Year 1200: A Symposium* (New York: Metropolitan Museum of Art, 1975), pp. 579–85.

_____ , 'Le portail de Saint-Thibault et la sculpture Bourguignonne du XIII siècle,' *Bulletin monumental*, 123 (1965): 181–92.

_____ , 'La sculpture des anciens portails de Saint-Bénigne de Dijon,' *Gazette des beaux-arts*, 50 (1957): 177–94.

Quicherat, Jules, *Histoire du costume en France depuis les temps les plus reculés jusqu'à la fin du XVIIIe siècle* (Paris: Librairie Hachette, 1875, 1877).

Raeder Knudsen, Lise, 'Written Patterns in Early Tablet Weaving,' in Jerzy Malik (ed.), *Priceless Invention of Humanity – Textiles*, NESAT VIII, Acta Archaeologica Lodziensia no. 50/1 (2004), Ch. 17.

Recht, Roland, et al., *The Great Workshop: Pathways of Art in Europe, 5th to 18th Centuries* (Brussels: Mercatorfonds, 2007).

Reininger, Walter, 'The Florentine Textile Industry in the Middle Ages,' *Ciba Review*, 27 (November 1939): 957–73.

Reynolds, R.L., 'Genoese Trade in the Late Twelfth Century, Particularly in Cloth from the Fairs of Champagne,' *Journal of Economic and Business History*, 3 (3) (1931): 362–81.

_____ , 'Merchants of Arras and the Overland Trade,' *Revue belge de philologie et d'histoire*, 9 (2) (June 1930): 503.

Riefstahl, Rudolf M., 'Persian Islamic Stucco Sculpture,' *Art Bulletin*, 13 (1) (1931): 439–63.

Rieth, Eric, *Des bateaux et des fleuves; Archéologie de la batellerie du Néolithique aux temps modernes en France* (Paris: Editions Errance: 1998).

Rockwell, Peter, *The Art of Stoneworking: A Reference Guide* (Cambridge and New York: Cambridge University Press, 1993).

Romanelli, Susan, 'Medieval Jewelry 900–1500,' in David Mickenberg, *Songs of Glory, Medieval Art from 900 to 1500* (Oklahoma City: Oklahoma Museum of Art, 1985).

Rudolph, Conrad, *Artistic Change at St-Denis: Abbot Suger's Program and the Early Twelfth-Century Controversy over Art* (Princeton: Princeton University Press: 1990).

Sabbe, Etienne, 'L'importation des tissus orientaux en Europe occidentale du haut Moyen Age (IXe et Xe siècles),' *Revue belge de philologie et d'histoire* (July–December 1935): 1261–88.

Salet, François, *Cluny et Vézelay, l'oeuvre des sculpteurs* (Paris, Société française d'archéologie, 1995).

_____ , 'Notre-Dame de Corbeil,' *Bulletin monumental*, 100 (1941): 81–118.

Saltzman, Max, 'Identifying Dyes in Textiles,' *American Scientist*, 80 (September–October 1992): 474–81.

Sanders, Paula, 'Robes of Honor in Fatimid Egypt,' in Stewart Gordon (ed.), *Robes and Honor, the Medieval World of Investiture* (New York: Palgrave, 2001), pp. 225–39.

Sandron, Dany, 'Review of 1995 Leeds Program,' *Bulletin monumental*, 154 (1) (1996): 80–81.

Santi, Bruno, *San Miniato al Monte* (Florence: Becocci, 1999).

Sassier, Yves, *Louis VII* (Paris: Fayard, 1991).

Sauerländer, Willibald, 'The Fate of the Face in Medieval Art,' in Charles Little (ed.), *Set in Stone: The Face in Medieval Sculpture* (New York: Metropolitan Museum of Art, 2006), pp. 3–17.

_____ , *Le monde gothique: Le siècle des cathédrales, 1140–1260* (Paris: Gallimard, 1989).

_____ , *Das Königsportal in Chartres: Heilgeschichte und Lebenswirklichkeit* (Frankfurt am Main: Fischer Taschenbuch Verlag, 1984).

_____ , *Gothic Sculpture in France 1140–1270*, trans. J. Sondheimer (New York: Abrams, 1972). Previously publ. as *Gotische Skulptur in Frankreich* (Munich: Hirmer Verlag, 1970).

_____ , 'Sculpture on Early Gothic Churches: The State of Research and Open Questions,' *Gesta*, 9 (2) (1970): 32–48.

_____ , 'Die Marienkrönungsportale von Senlis und Mantes,' *Wallraf-Richartz Jahrbuch*, 20 (1958): 126–36.

Saulnier, Lydwine, and Neil Stratford, *La sculpture oubliée de Vézelay* (Geneva: Droz, 1984).

Schapiro, Meyer, *Romanesque Art* (New York: George Braziller: 1977).

Schneidmüller, Bernd, 'Constructing Identities of Medieval France: Constructing the Medieval Nation,' in Marcus Bull (ed.), *France in the Central Middle Ages: 900–120* (Oxford and New York: Oxford University Press, 2002), pp. 15–42.

Schramm, Percy E., *Kaiser, Könige und Päpste, Gesammelte Aufsätze zur Geschichte des Mittlealters* (5 vols, Stuttgart: Anton Hiersemann, 1969–71), vol. 3.

Schuette, Marie, and Sigrid Müller-Christensen, *A Pictorial History of Embroidery*, trans. Donald King (New York: Praeger, 1963)

Seidel, Linda, *Songs of Glory, The Romanesque Façades of Aquitaine* (Chicago: University of Chicago Press, 1981).

Seipel, Wilfried, *Nobiles officinae: die königlichen Hofwerkstätten zu Palermo zur Zeit der Normannen und Staufer in 12. und 13. Jahrhundert: Kunsthhistorisches Museum, 31 März bis 13 Juni 2004: Palermo, Palazzo dei Normanni, 17 Dezember 2003 bis 10 März 2004* (Milan: Skira, 2004).

Shepherd, William R., *Historical Atlas* (New York: Barnes & Noble, 1929).

Simson, Otto von, *The Gothic Cathedral: Origins of Gothic Architecture and the Medieval Concept of Order*, Bollingen Series 48 (New York: Pantheon Books, 1956).

Skemer, Don C., *Binding Words: Textual Amulets in the Middle Ages* (University Park: Pennsylvania State University Press, 2006).

Smyth, Albert Henry, *Shakespeare's Pericles and Apollonius of Tyre: A Study in Comparative Literature* (New York: AMS Press, 1972).

Snyder, Janet, 'Written in Stone: The Impact of the Properties of Quarried Stone on the Design of Medieval Sculpture,' *AVISTA Forum Journal*, 13 (1) (2003): 1–5.

_____ , 'The Regal Significance of the Dalmatic: The Robes of *Le Sacre* represented in Sculpture of Northern Mid-Twelfth-Century France,' in Stewart Gordon (ed.), *Robes and Honor, The Medieval World of Investiture* (New York: Palgrave/St. Martin's Press, 2001), pp. 291–304.

Sokoly, Jochen A., 'Between Life and Death: The Funerary Context of Ṭirāz Textiles,' *Islamische Textilkunst des Mittelalters: Aktuelle Probleme* (Riggisberg: Abegg-Stiftung, 1997).

Southern, R.W., 'The Schools of Paris and the School of Chartres,' in Robert L. Benson and Giles Constable with Carol D. Lanham (eds), *Renaissance and Renewal in the Twelfth Century* (Toronto: University of Toronto Press, Medieval Academy of America, 1991).

_____ , 'Platonism, Scholastic Method, and the School of Chartres,' *The Stanton Lecture*, 1978, University of Reading.

Spitzer, Laura, 'The Cult of the Virgin and Gothic Sculpture: Evaluating Opposition in the Chartres West Façade Capital Frieze,' *Gesta*, 33 (2) (1994): 132–50.

Staniland, Kay, *Embroiderers*, Medieval Craftsmen series (London: British Museum Press, 1991).

Starensier, Adèle La Barre, *An Art Historical Study of the Byzantine Silk Industry*, PhD dissertation (Columbia University, 1982).

Stauffer, Annemarie, *Textiles d'Egypte de la collection Bouvier, Antiquité tardive, période copte, premiers temps de l'Islam*, exhib. cat. September 1991–January 1992, Musée d'art et d'histoire Fribourg (Bern: Benteli Verlag, 1991).

Stillman, Yedida K., 'The Importance of the Cairo Geniza Manuscripts for the History of Medieval Female Attire,' *International Journal of Middle East Studies*, 7 (1976): 579–89.

Stillman, Yedida K., and Paula Sanders, 'Ṭiraz,' in Nadia El Cheikh (ed.), *The Encyclopaedia of Islam. Glossary and Index of Terms* (Leiden: Brill, 2006), p. 537b.

Stoddard, Whitney S., *Monastery and Cathedral in France* (Boston: Wesleyan University Press, 1966).

_____ , 'Review of *The Sculptural Programs of Chartres Cathedral ...* by Adolf Katzenellenbodgen,' *Speculum*, 35 (4) (October 1960): 613–16.

———, *The West Portals of Saint-Denis and Chartres: Sculpture in the Ile de France from 1140 to 1190, Theory of Origins* (Cambridge MA: Harvard University Press, 1952).

———, *Sculptors of the West Portals of Chartres Cathedral: Their Origins in the Romanesque and Their Role in Chartrain Sculpture including the West Portals of Saint-Denis and Chartres*, PhD dissertation (Harvard University, 1952; rev. and repr. New York and London: Norton, 1987).

Stone, Lawrence, *Sculpture in Britain: The Middle Ages* (Baltimore: Penguin, 1955).

Stratford, Neil, *The Lewis Chessmen and the Enigma of the Hoard* (London: British Museum Press, 1997).

———, *Catalogue of the Medieval Enamels in the British Museum*, vol. 2, *Northern Romanesque Enamel* (London: British Museum Press, 1993).

———, 'The Moutiers-Saint-Jean Portal in the Cloisters,' in Elizabeth C. Parker and Mary B. Shepard (eds), *The Cloisters* (New York: Metropolitan Museum of Art, 1992), pp. 261–81.

———, 'Chronologie et filiations stylistiques des sculptures de la façade nord du porche de Charlieu,' *Actes des journées d'études d'histoire et d'archeologie organisées à l'occasion du XIe centenaire de la fondations de l'abbaye et de la ville de Charlieu* (Charlieu: Société des amies des arts de Charlieu, 1973).

Suger, *La geste de Louis VI et autres oeuvres*, introd. Michel Bur (Paris: Imprimerie Nationale Editions, 1994).

———, [*Vie de Louis VI, Le Gros*] *The Deeds of Louis the Fat*, trans. R. Cusimano and J. Moorhead (Washington DC: Catholic University of America Press, 1992).

———, *Libellus Alter de Consecratione ecclesiae Sancti Dionysii, II*, in Erwin Panofsky (ed.), *Abbot Suger on the Abbey Church of Saint Denis and its Art Treasures* (Princeton: Princeton University Press, 1979).

———, *Vie de Louis VI le Gros*, ed. and trans. Henri Waquet, Les classiques de l'histoire de France au Moyen Age 11 (Paris: Les Belles Lettres, 1964).

———, *De Administratione*, in Erwin Panofsky (ed.), *Abbot Suger on the Abbey Church of Saint-Denis and its Art Treasures* (Princeton: Princeton University Press, 1946, 1979).

———, *De Consecratione*, in Erwin Panofsky (ed.), *Abbot Suger on the Abbey Church of Saint-Denis and its Art Treasures* (Princeton: Princeton University Press, 1946, 1979).

———, *Oeuvres complètes de Suger, recueillies, annotées et publiées d'après des manuscrits pour la société de l'histoire de France par A. Lecoy de la Marche* (Paris: Mme. Ve. Jules Renouard, Libraire de la Société de l'histoire de France, 1867).

———, *Life of King Louis the Fat*, available in translation in the *Medieval Sourcebook* at <http://www.fordham.edu/halsall.basis/suger-louisthefat.html>.

Sullivan, Ruth Wilkins, 'Saint Peter and Paul: Some Ironic Aspects of their Imaging,' *Art History*, 17 (1) (March 1994): 59–80.

Tatlock, J.S.P., 'The English Journey of the Laon Canons,' *Speculum*, 8 (1933): 454–64.

Taylor, Michael, *The Lewis Chessmen* (London: British Museum Publications, 1978).

Theophilus, *The Various Arts (De Diversis Artibus)*, trans. C.R. Dodwell (London: Nelson, 1961).

Thiébaux, Marcelle, *The Writings of Medieval Women* (New York: Routledge, 1994).

Thirion, Jacques, 'La polychromie dans les monuments du Moyen-Age,' Entretiens du patrimoine, in *Architecture et decors peint: Amiens, octobre 1989* (Paris: Ministère de la culture de la communication des grands travaux et du bicentenaire, 1990), pp. 54–7.

_____ , 'Les plus anciennes sculptures de Notre-Dame de Paris,' *Comptes rendus des séances de l'année 1970* (Paris: Académie des inscriptions et belles-lettres, 1970), pp. 85–112.

Thomas, Thelma, *Textiles from Medieval Egypt AD 300–1300* (Pittsburgh PA: Carnegie Museum of Natural History, 1990).

Tissus d'Egypte: témoins du monde arab, VIIIe–XVe siècles: collection Bouvier, exhib. cat., Musée d'art et d'histoire (Geneva: Institut du monde arabe, Paris, 1993).

Twyman, Susan, *Papal Ceremonial at Rome in the Twelfth Century* (London: Henry Bradshaw Society, 2002).

Tronzo, William, 'The Mantle of Roger II of Sicily,' in Stewart Gordon (ed.), *Robes and Honor, The Medieval World of Investiture* (New York: Palgrave, 2001), pp. 241–53.

Tuchscherer, Jean-Michel, 'Woven Textiles,' in M. Calano and L. Salmon (eds), *French Textiles from the Middle Ages through the Second Empire* (Hartford CT: Wadsworth Antheneum, 1985), pp. 17–44.

Turnau, Irena, 'The Diffusion of Knitting in Medieval Europe,' in N.B. Harte and Kenneth G. Ponting (eds), *Cloth and Clothing in Medieval Europe. Essays in Memory of Professor E.M. Carus-Wilson*, Pasold Studies in Textile History 2 (London: Heinemann Educational and the Pasold Research Fund, 1983), pp. 368–89.

Ullmann, Walter, *The Carolingian Renaissance and the Idea of Kingship* (London: Meuthen, 1969).

Unger, Richard W., *The Ship in the Medieval Economy 600–1600* (London: Croom Helm: 1980).

Van Der Meulen, Jan, 'Sculpture and its Architectural Context at Chartres around 1200,' in *The Year 1200: A Symposium* (New York: Metropolitan Museum of Art, 1975), pp. 509–60.

van Engen, John, 'Sacred Sanctions for Lordship,' in Thomas N. Bisson (ed.), *Cultures of Power: Lordship, Status, and Process in Twelfth-Century Europe* (Philadelphia: University of Pennsylvania Press, 1995), pp. 203–30.

van Gennep, Arnold, *Rites of Passage*, trans. M.B. Vizedom and G.L. Caffee (Chicago: University of Chicago Press, 1960).

Vanuxem, Jacques, 'The Theories of Mabillon and Montfaucon on French Sculpture of the Twelfth Century,' *Journal of the Warburg and Courtauld Institute*, 20 (1957): 45–58.

_____ , 'La sculpture du XIIe siècle à Cambrai et à Arras,' *Bulletin monumental*, 113 (1955): 113–33.

van Uytven, Raymond, 'Cloth in Medieval Literature of Western Europe,' in N.B. Harte and K.G. Ponting (eds), *Cloth and Clothing in Medieval Europe. Essays in Memory of Professor E.M. Carus-Wilson*, Pasold Studies in Textile History 2 (London: Heinemann Educational and the Pasold Research Fund, 1983), pp. 151–83.

Verret, Denis, and Delphine Steyaert (eds), *La couleur et la pierre: Polychromie des portails gothiques* (Paris: Editions A. et J. Picard, 2002).

Verzár, Christine (Verzár Bornstein) and Priscilla Parsons Soucek, *The Meeting of Two Worlds: The Crusades and the Mediterranean Context* (Ann Arbor: University of Michigan Museum of Art, 1981).

Viollet-le-Duc, Eugène-Emmanuel, *Dictionnaire raisonné du mobilier français de l'époque carolingienne à la renaissance* (Paris: V.S. Morel, 1872), vols 3 and 4.

Viré, Marc, 'Les matériaux de construction de la Tour du Village et de l'enceinte du chateaux de Vincennes,' *Colloque carrières et constructions, 117e congrès national des sociétés savantes, Clermont-Ferrand, 1992* (2nd colloquy *Carrières et constructions*) (Paris, Colloque CTHS, 1993): 163–78.

Vita b. Lanfranci archiepiscopi Cantuariensis, C.9, in O. Lehmann-Brockhaus, *Lateinische Schriftquellen zur Kunst in England, Wales und Schottland, vom Jahre 901 bis zum Jahre 1307* (Munich, 1955), vol. 1, pl. 179, no. 664.

Vitry, Paul, and Gaston Brière, *Documents de sculpture française du Moyen Age* (Paris: D.A. Longuet, n.d.).

Vöge, Wilhelm, *Die Anfänge des monumentalen Stiles im Mittelalter. Eine Untersuchung über die erste Blütezeit französisch Plastik* (Strassburg: Jeitz & Mündel, 1894).

Volbach, W. Fritz, *Early Decorative Textiles* (New York: Paul Hamlyn, 1969).

Vollrath, Fritz, 'Spider Webs and Silks,' *Scientific American* (March 1992): 70–76.

Wace, *Le Roman de Brut: The French Book of Brutus*, trans. Arthur Wayne Glowka (Tempe AZ: Arizona Center for Medieval and Renaissance Studies, 2005).

Walker, Daniel, 'Chasuble of Saint Edmund,' in J.D. Dodds et al. (eds), *The Art of Medieval Spain, AD 500–1200* (New York: Metropolitan Museum of Art, 1993), p. 107.

———, 'Fragment of a Textile,' in J.D. Dodds et al. (eds), *The Art of Medieval Spain, AD 500–1200* (New York: Metropolitan Museum of Art, 1993), pp. 108–9.

Ward, Susan Leibacher, *The Sculpture of the South Porch at Le Mans Cathedral*, PhD dissertation (Brown University, 1984).

Warner, David A., 'Ritual and Memory in the Ottonian Reich: The Ceremony of Adventus,' *Speculum*, 76 (2) (April 2001): 255–83.

Watt, James C.Y., and Anne E. Wardwell, *When Silk Was Gold, Central Asian and Chinese Textiles* (New York: Harry N. Abrams, 1997).

Weibel, Adèle Coulin, *2,000 Years of Silk Weaving* (New York: E. Weyhe, 1944).

Weiner, Annette B., and Jane Schneider, *Cloth and Human Experience* (Washington DC: Smithsonian Institution Press, 1989).

Weit, G., and G. Marcais, 'Le voile de Sainte Anne d'Apt,' *Monuments et mémoires publiés par l'Academie des Inscriptions et Belles-Lettres*, 34 (Paris: Fondation Eugène Piot, 1934): 177–94.

Wescher, H., 'The Cloth Trade and the Fairs of Champagne,' *Ciba Review*, 65 (March 1948): 2362–96.

———, 'The Beginnings of the Cotton Industry in Europe,' *Ciba Review*, 64 (Basle, February 1948): 2328–37.

———, 'Burgundy in the Middle Ages; Fashion and Elegance at the Court of Burgundy,' *Ciba Review*, 51 (July 1946): 1831–41.

White, Lynn, Jr., *Medieval Technology and Social Change* (London: Oxford University Press, 1962).

Wild, John Peter, 'Some Early Silk Finds in Northwest Europe,' *Textile Museum Journal*, 23 (1984): 17–23.

Wilks, Michael, *The World of John of Salisbury* (Oxford: Blackwell, 1994).

Williamson, Paul, *Gothic Sculpture 1140–1300* (New Haven and London: Yale University Press: 1995).

_____ , 'Sculpture,' in J. Alexander and Paul Binski (eds), *Age of Chivalry, Art in Plantagenet England 1200–1400* (Royal Academy of Arts, London, 1987), pp. 98–103.

Willmes, P., *Der Herrscher-Adventus im Kloster des Frühmittelalters*, Münstersche Mittelalter-Schriften 22 (Munich: Fink, 1976).

Wilson, Katharina M., and Nadia Margolis (eds), *Women in the Middle Ages: An Encyclopedia* (2 vols, Westport CT: Greenwood Press, 2004).

Wixom, William D. (ed.), *Mirror of the Medieval World* (New York: Metropolitan Museum of Art, 1999).

Wu, Nancy Y., 'Hugues Libergier and his Instruments,' *Nexus Network Journal*, 2 (2000): 93–102.

Zarnecki, George, 'Sculpture,' in *English Romanesque Art 1066–1200* (London: Weidenfeld & Nicolson, 1984).

_____ , 'English 12th-Century Sculpture and its Resistance to Saint-Denis,' in *Tribute to an Antiquary: Essays Presented to Marc Fitch by some of his Friends* (London: Leopard's Head Press, 1976), pp. 83–92.

_____ , *Later Romanesque Sculpture 1140–1210* (London: Alec Tianti, 1953).

INDEX

Illustrations cited in parentheses; dates cited in brackets.

portal design as affirmation 123, 125, 127

Elite 11, 15n8, 23, 53–5, 59, 72, 87, 197–201 (1.12, 1.16–1.17, 1.39, 1.62, 1.68–1.69, 1.70–1.71, 1.111)

embroidery 19, 39, 43, 49, 53, 78, 80, 95n28, 116 (I.8, 1.62); *see also* Bayeux Embroidery

Étampes, Notre-Dame du Fort 1, 6, 41, 43–4, 46, 84, 100n93, 128n6, 134n81, 181, 183, 196, 213, 218–19, 224n30, 224n33 (I.2, 1.14, 1.77)

interior column-figures 51, 83, 87, 121, 169–70 (1.64–1.65, 1.76, 1.136)

represented *ṭirāz* 179 (1.14, 1.64–1.65, 1.76–1.77, 1.136)

Evergates, Theodore 11, 132n53, 134n88

fairs of Champagne and Brie 12, 46, 48, 72, 135–6n100, 140, 147–54, 159–60n59, 186–7; *see also* Thibaut le Grand; Henri le Liberal

conduit des foires 126, 135n99, 149, 219, 226n62, 227n68

grandes routes 218–19

mercantile center 46, 140, 148

money/income 12, 148–50, 152–3, 161n83, 187; *see also* Provins; *tonlieux*

Fassler, Margot 8, 11, 133n64

feet and footwear 87 (I.8, 1.5, 1.11, 1.20, 1.38, 1.66–1.69, 1.101, 1.104, 1.133–1.135, 1.142)

bare feet 9, 87, 198–201 (1.12, 1.18, 1.28, 1.64, 1.65, 1.128, 1.136–1.139); *see also* Associates

'goose-footed queen' (1.121)

fermail 84, 86, 103n119, 115, 126, 147 (I.7, 1.18, 1.20, 1.27, 1.39, 1.49, 1.54, 1.58, 1.60, 1.79, 1.83–1.84, 1.92/Pl.7, 1.112, 1.129, 1.130, 1.132/Pl.12)

fief-holding 65–6, 99n77, 123, 131n36, 134–5nn88–9, 149–150

France (as an entity) 113, 129n19, 131n38

fur 84–5, 144–7, 154, 158n40, 158n42, 168, 170, 175 (I.7, 1.91/Pl.6, 1.92/Pl.7, 1.130, 3.4)

Gamla Lödöse textiles 166, 95n27

Geary, Patrick J. 108

Geniza, *see* Cairo/Fustat geniza

Gentlewoman, *see* Court Lady

Geoffroi le Bel (Geoffrey V Plantagenet) 62, 65, 71, 84, 98n67, 145 (1.91/Pl.6)

gisant (tomb effigy relief) 14n7, 77–8, 101n97, 200, 220 (1.118)

Goitein, Shelomo Dov 9, 12, 142, 158n43, 169

Grande Dame/Matron 21, 34, 86, 92, 197, 202 (1.8, 1.9, 1.21, 1.31, 4.19/Pl.18)

guimple 43, 96n36 (1.2, 1.8, 1.27, 1.50, 1.54–1.55, 1.77)

hairstyles

of men 29, 81–3 (1.16, 1.21, 1.63, 1.93, 1.97, 1.112, 1.127, 4.6, 4.21, 4.22); *see also* beards; Monarch

– 'long-haired kings' 81–3, 102n112 (1.7, 1.20, 1.66/Pl.4, 1.72, 1.79, 1.123–1.126, 4.4, 4.20)

of women 29, 43–6 (1.2, 1.27, 1.40, 1.50–1.52, 1.54/Pl.3, 1.55, 1.77, 1.55)

– *en galonné* 36, 46, 96n43 (1.3, 1.14, 1.49, 1.53, 1.57–1.60, 1.121, 4.17)

– *en trecié* 43–4, 96n39 (1.2, 1.8, 1.27, 1.33–1.34, 140, 1.52, 1.54/Pl.3, 1.55, 1.69, 1.77, 1.132/Pl.13, 4.8)

– *grève* (center part) 43, 96n37 (1.53)

Hansa bowl 20, 84, 93n9, 192n75 (4.2); *see also* Cadmus

Hardham, St. Botolph's Church 85

headgear 29–30, 43, 59, 77, 80, 82, 94nn16–18, 96n36, 114 (1.8, 1.10, 1.21–30, 1.48, 1.50, 1.53, 1.66–1.67, 1.81, 1.83–1.84, 1.89, 1.93, 1.102, 1.111, 1.121, 2.3, 4.21)

mitre 80, 102nn110–111 (1.19, 1.59–1.60, 1.81, 1.102, 1.110, 4.21)

Henri le Liberal [1126–81], son of Thibaut II, le Grand, son-in-law of Louis VII, Count of Troyes 126

development of fairs 135–6n100, 148–51, 159–60n59, 160n73

Henri of Blois [1129–71] bishop of Winchester 80, 102n108 (1.122/Pl.11)